Mastering the Nikon D90

Darrell Young - Author

Darrell Young (*DigitalDarrell*) is an information technology engineer by trade and has been an avid photographer for over 35 years. He has a rather large family, with his wife and five children, so he has a constantly interesting flow of photographic opportunities. In fact, his entire family uses Nikon cameras to pursue what has become a cohesive family hobby.

Darrell delights in using Nikon's newest digital cameras but if pressed, he will admit to being a "closet" film user too. Living next to the Great Smoky Mountains National Park has given him a real concern for, and interest in, nature photography. Darrell loves to write, as you can see in the Resources area of the Nikonians. org community. He joined the community in the year 2000, and his literary contributions led to his invitation to become a Founding Member of the Nikonians Writers Guild.

Mastering the Nikon D90

Darrell Young

Darrell Young (aka Digital Darrell)

Editor (Rocky Nook): Gerhard Rossbach
Editor (Nikonians): Tom Boné
Production editor: Joan Dixon
Copyeditor: Judy Flynn
Proof reader: Lisa Danhi
Layout and type: Jan Martí, Command Z
Cover design: Helmut Kraus, www.exclam.de
Printer: Lifetouch, Inc. through Four Colour Print Group, Louisville, Kentucky
Printed in USA
Cover photo: Nikon USA
Back cover photo: Brenda Young

1st Edition
© Nikonians North America 2009
Rocky Nook Inc.
26 West Mission Street Ste 3
Santa Barbara, CA 93101-2432

Library of Congress Cataloging-in-Publication Data

Young, Darrell, 1958-
Mastering the Nikon D90 / Darrell Young. -- 1st ed.
 p. cm.
Includes bibliographical references and index.
ISBN 978-1-933952-50-5 (alk. paper)
1. Nikon digital cameras--Handbooks, manuals, etc. 2. Single-lens reflex cameras--Handbooks,
manuals, etc. 3. Photography--Digital techniques--Handbooks, manuals, etc. I. Title.
TR263.N5Y65 2009
771.3'2--dc22
 2009031276

Distributed by O'Reilly Media
1005 Gravenstein Highway North
Sebastopol, CA 95472

This book is printed on acid-free paper.

Table of Contents

Foreword

Nikonian Darrell Young, known to us for many years as Digital Darrell, has consistently been a reliable source of instructional wisdom delivered with a touch of friendly humor.

His extensive collection of informative articles has been a valuable resource in our articles knowledge base, Resources at Nikonians.

After the success of his previous books, Mastering the Nikon D300 and Mastering the Nikon D700, this book represents yet another progression in the rapid growth of our international community of photographers from all walks of life, recently exceeding 200,000 members from nearly 160 countries.

Darrell's efforts exemplify and confirm the Nikonians vocation in education, expanding an additional communication channel—books—to our more than 70 existing interactive forums including The Nikonian eZine, Nikonians Academy Workshops, Nikonians News Blog, Nikonians podcasts, etc.

Entering our tenth year, Nikonians has earned a reputation as a friendly, reliable, informative, and passionate Nikon users community thanks in great measure to members like our own Digital Darrell, who, despite the pressures of their day jobs, have taken the time to share the results of their intense and extensive experiences with Nikon imaging equipment.

The Nikonians community has long been known as a welcoming worldwide home for Nikon users, and Darrell's specialty in his writing is the ability to share his knowledge in the spirit of a friendly uncle in the comfort of your own living room. His easy and friendly approach is appreciated by the increasing number of our community members who have been fortunate enough to acquire the extraordinary Nikon D90 DSLR. The camera is a spectacular piece of highly technical photographic engineering, and Darrell cuts through the technical jargon to help his readers understand not only the camera, but also the wealth of photographic advantages it can deliver thanks to the ingenuity of Nikon engineering.

We would like to congratulate Darrell for his work on this project, and special thanks goes to Tom Boné, Nikonians Chief Editor, who has streamlined the publication process of this, the fourth of the Nikonians Press books in association with Rocky Nook.

Bo Stahlbrandt (bgs) and J. Ramón Palacios (jrp)
Nikonians Founders
www.nikonians.org

Preface

I grew up looking at pictures!

Since I was a baby, back in 1958, my mother took hundreds of photographs of our family life throughout the years, capturing small pieces of time frozen in little negative squares. Today, I can still look back at those images and they awaken memories that would otherwise be forgotten.

In 1968, my dear Mom gave me a Brownie Hawkeye camera and ignited a fire in me for taking pictures. I remember her words of instruction, "Load the film in a dark place, never open the film door until after you rewind, and keep the sun behind you when you shoot."

From that day on I carried a camera with me often. I took the fuzzy pictures of a 13-year-old as I hiked up Roosevelt Mountain in Rockwood, Tennessee, USA, with my brother Steven and a friend named Scott. Every major event of my life has a few frames attached. In 1979, I began photographing my own family, and documented the growth of my five children up until today. Photography has been a part of my life all the way back to my earliest memories, and I'll keep on shooting as long as I am able!

The year 1980 was a milestone for me; that's when I got my first Nikon camera. It was a nearly new Nikon FM, and I reveled in its incredible construction and the unbelievable images it made. Before then, I had been shooting with Kodak 110 and 126 cameras, and although the images have priceless personal value, they would win no contests. I graduated from negatives to transparencies in 1981, as I realized that even sharper and less grainy images could be created in those delightful little two-inch squares. I loved film, and shot a lot of it. I wanted to shoot even more, but the cost of raising kids took precedence.

I had been playing around with a Kodak P&S digital, and then a Nikon Coolpix 990. While the images were fun and easy to make, they did not equal my 35mm in quality, so I viewed digital as only a toy. Then the year 2002 changed everything for me photographically. Nikon released the 6MP D100, and I became Digital Darrell. Never before had I shot so many images. With the basically free use of the camera I took thousands of photographs that I would never have considered taking with expensive film, and in the process I moved to a new level of photography. Digital cameras are an educational course in photography within themselves.

My love of digital grew, as did my relationship with the world's premier Nikon User Community, Nikonians (www.nikonians.org). I came on board as a charter member in late 2000, and after my D100 arrived I really turned it on as a member. I wrote a camera review that J. Ramon Palacios liked, (JRP is co-founder of the Nikonians.org

website, along with Bo Stahlbrandt) and he asked me if I'd like to write a few articles for them. I didn't even know I was a writer! Thank you, JRP!

I basically lived on Nikonians.org, spending hours there each day, first as a moderator, then as founding member of the Nikonians Writer's Guild. JRP asked me to write as often as I could, and he would post my articles for others to read. Wow, did my ego swell!

In 2005, I bought yet another of Nikon's excellent workhorse cameras—the D200. This camera seemed to reflect a direction toward a truly professional build in a smaller-bodied camera. It has a 10MP resolution, a weather-sealed frame, and a flexible feature set, including the ability to fully use non-CPU lenses, such as Nikkor AI and AI-S primes. I used this camera on an almost daily basis as a "carry" camera, since the size was reasonable and the image quality outstanding. Generation Two!

In 2007 my photographic world was enriched tremendously. Nikon released a camera that made my eyes pop, and my Nikon Acquisition Syndrome (NAS) become overwhelming. This was the Nikon D300. This is third-generation 12MP digital photography! This is the affordable yet professional-level tool for passionate creativity!

In 2008 yet another milestone was reached when the fourth-generation Nikon D90 was released. Not only did the D90 inherit most of the functionality of the pro-level D300—making it what Nikon calls an "Advanced" camera—it brought to the world the very first DSLR with the ability to capture high-definition video movies. The D-Movie mode is a powerful addition to still photography. I had no big interest in making videos until I was using the D90 in the Great Smoky Mountains of Tennessee, USA. On a whim, I took several videos of waterfalls and cascades in the Little Pigeon River to see what the camera could accomplish. Later, when I was relaxing at home, I opened the videos on my computer in HD mode and was simply blown away by the clear, crisp quality of the D-Movie.

I am now completely addicted to having video capability. It is a great deal of fun and adds a dimension to my still photographs that I never expected to find. I often take still pictures and video clips, and then combine them in-computer, with appropriate music, creating a presentation that amazes family and friends. I absolutely love having both a still and video camera with me at all times. My enjoyment of photography has

at least doubled with the use of this new technology. I think you'll find the same thing happens to you!

As soon as Nikon announced the D90, I was commissioned to create this book and have been working hard to present more than just knowledge of how the camera works. I have tried to show the strong personality of the camera, in both still and video modes. Your photography is bound to improve with the D90. If you don't have one yet, go get it today! It's complex, but not overly so. This book is a joint effort between Rocky Nook and Nikonians.org to bring you a resource that will help you understand the complexities of the important, most used parts of Nikon's latest creation. It's also designed to help you have some fun with your D90.

Much help is available to you at Nikonians.org, the world's premier Nikon User Community; a true international community of over 150,000 Nikon users. Talk about a Nikon resource! You, as a Nikon user, are probably already a member, but if not, please log onto www.Nikonians.org and become at least a Silver member. Nikonians. org is a goldmine of photographic knowledge for Nikon users and is unmatched by any other resource available. In the back of this book you'll find a coupon that offers a generous discount on an annual Nikonians.org membership. Why not take advantage of this powerful resource, and use the coupon? (If you do, the cost of this book is basically free.)

I feel greatly privileged to be a Nikonian, to have such knowledgeable and friendly associates, and to help to provide yet another, much requested resource, in the form of a printed book. I hope you enjoy this book and get much benefit from it, along with more joy in using your chosen photographic tool ... the Nikon D90.

Keep on capturing time ...

Digital Darrell

(Darrell Young, August 2009)

Using the Nikon D90

The difficulty in writing a book on a powerful camera like the Nikon D90 is balancing it for multiple types of users—and their varying levels of knowledge. Too much technical detail and the book will read like a user's manual. Too little technical detail and advanced users will get no benefit from the book.

Many new users of the Nikon D90 digital single lens reflex (DSLR) camera have come over from the world of fully automated point-and-shoot cameras. On the other hand, many photographers are upgrading to the D90 from cameras like the Nikon D40, D60, D70, and D80. Then there are professionals who buy the D90 to have a backup for their pro-level cameras like the Nikon D300, D700, D3, and D3x. Others are coming over from the film world, drawn by the siren call of immediate image use and very high quality.

In *Mastering the Nikon D90* I've tried my best to balance the needs of new and experienced users. I remember my first DSLR (the Nikon D100 in 2002) and my confusion about how to configure the camera compared to my old film SLR. *"What's all this 'white balance' and 'color space' stuff?"*

The bottom line is that the Nikon D90 is a rather complex camera, and it requires careful study of resources like this book, and the User's Manual, to really get a grasp on the large range of features and functions. According to Nikon, it's an "advanced" camera, with features not found in lesser "consumer" models.

It's designed for people who really love photography and have a passion for image making that far exceeds just taking some nice pictures at a family event. The D90 has most of the features found in cameras like the D300 and D700, which are considered "professional" cameras by most.

Following the publication of my book *Mastering the Nikon D300*, I have compared the D300 and D90 side by side. I'm here to tell you today that the Nikon D90 has all the critical functions found in the D300. It even includes extra features like D-Movie, a more robust Nikon Picture Control System, and better in-camera image manipulation.

The D90 has a full range of functions that allow you to shoot images and "post-process" them in the camera instead of on your computer. If you don't like computers but want to take digital photographs and videos, the Nikon D90 is the camera for you!

I could go on for hours raving about all the cool features in the D90, like the fact that it is Nikon's first DSLR that can take both still images and 24 frames-per-second (fps) video. In fact, I do go on raving about this camera for the next 11 chapters. I hope you can sense my enthusiasm for this cool imaging device as you read this book. There are few cameras in the world with this level of capability, and you own one!

First Use of the Nikon D90

In this section, I'll help you set your camera up for first-time use. There are important functions scattered through the various menus of the camera that you need to consider and set. Even if you've been using your D90 for a while, please consider using this section as a brief refresher since you might have overlooked some things that will benefit your use of the camera.

Some of the features discussed in this chapter are already configured the way I ask you to set them. Nikon uses many of these settings as factory defaults. However, I want to cover these areas for two reasons:

- You may have purchased a pre-owned D90, and some of these items may not be configured well for your style of shooting.
- I want you to become familiar with where these settings are because they are important and you may be changing them as you shoot different types of images.

Charging the Battery

If you're like me, you'll open the box, put the lens on your camera, insert a battery, and take your first picture. Wouldn't it be a better idea to wait an hour to charge the battery, and only then take the first picture? Sure it would, but I've never done that, and I bet you haven't either. Nikon knows this and it doesn't send out new cameras with dead batteries.

Most of the time the battery is not fully charged, but it has enough charge for you to set the time and date and then take and review a few pictures. Think about it. How do you test a brand-new battery? You charge it and see if it will hold a charge. Do you think Nikon is in the habit of sending out batteries that ar

Nikon D90 front view

untested? No! So most of the time, you can play with your camera for at least a few minutes before charging the battery. I've purchased nearly every DSLR Nikon has made since 2002, and not one of them has come in with a dead battery.

When my D90 arrived, the battery was about 75 percent charged. I played with the camera for an hour or two before I charged the battery. However, let me mention one important thing. If you plug in the battery and it is very low, such as below 25 percent, it would be a good idea to go ahead and charge it before shooting and reviewing too many pictures. Maybe you can get the time and date set and test the camera a time or two, but go no further with a seriously low battery.

The D90 uses a lithium-ion (li-ion) battery pack. While this type of battery doesn't develop the memory effects of the old nickel-cadmium (ni-cad) batteries from years past, they can be a problem if you allow them to get too low. *A li-ion battery should never be used to complete exhaustion.* The battery can develop metal shunts internally if you run it completely down, and that will cause it to short out and stop working. *When your camera's li-ion battery gets down to the 25 percent level, please recharge it.* I don't let mine go below 50 percent for any extended use.

All that said, the optimum situation would be to restrain yourself from turning on the camera until after the battery is charged. That'll give you some time to read the section of this book on initial configuration and check out the User's Manual.

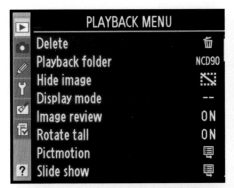

PLAYBACK MENU	
Delete	🗑
Playback folder	NCD90
Hide image	🖾
Display mode	--
Image review	ON
Rotate tall	ON
Pictmotion	🗐
Slide show	🗐

SHOOTING MENU	
Set Picture Control	🖾SD
Manage Picture Control	--
Image quality	FINE
Image size	⬜
White balance	AUTO
ISO sensitivity settings	🗐
Active D-Lighting	🖾 L
Color space	Adobe

CUSTOM SETTING MENU	
ℝ Reset custom settings	--
a Autofocus	
b Metering/exposure	
c Timers/AE lock	
d Shooting/display	
e Bracketing/flash	
f Controls	

SETUP MENU	
Format memory card	--
LCD brightness	0
Clean image sensor	--
Lock mirror up for cleaning	--
Video mode	NTSC
HDMI	480p
World time	--
Language	En

Figure 1 – The four critical camera configuration menus

Initial Camera Setup

Let's look at the most important functions for initial configuration. In this chapter I'll just point you to the critical and most-used functions. Use the other chapters in the book to read about the advanced configuration of these items.

I'll start with the absolutely necessary items and then advance through the various menus touching on features that, in my opinion, you should learn for the best initial imaging experience with the D90.

There are seven menu systems in the D90 that you'll have to deal with over time. *Figure 1* shows a view of the four menus that affect initial camera setup: the *Playback Menu*, the *Shooting Menu*, the *Custom Setting Menu*, and the *Setup Menu*.

Setup Menu – World Time

When you open the box on a new D90, insert the battery, and turn it on, it will ask you to set the *World time*. Let's look at this in detail since you really do need to set this up before you do anything else.

There are several functions to set under the *World time* section of the *Setup Menu*:

• Time zone
• Date and time
• Date format
• Daylight saving time

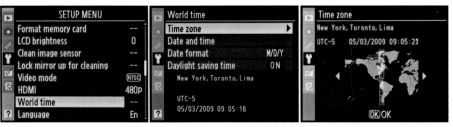

Figure 2 – *Time zone* screens

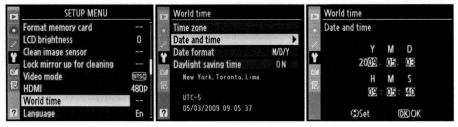

Figure 2A – *Date and time* screens

Time zone – *Figure 2* shows the *Time zone* configuration screens. The screen used to set the zone uses a familiar world map interface to select the area of the world in which you are using the camera. To set the Time zone, follow these steps:

• Press the *MENU* button and scroll to the *Setup Menu*.

• Select *World time*, and then scroll to the right.

• Select *Time zone*, and then scroll to the right.

• Use the multi selector button to scroll left or right until your time zone is under the yellow vertical bar in the center of the world map screen.

• Once you have selected your time zone, press the *OK* button to save the setting.

Date and time – *Figure 2A* shows the three *Date and time* configuration screens. The final screen in the series allows you to select the year, month, and day (Y, M, D), and the hour, minute, and second (H, M, S):

• Press the MENU button and scroll to the Setup Menu.

• Select *World time*, and then scroll to the right.

• Select *Date and time*, and then scroll to the right.

• Using the multi selector button, scroll left or right until you have selected the value you want to change. Then scroll up or down to actually change the value.

• When you have set the correct date and time, press the *OK* button to save the settings. Please note that the time setting uses the 24-hour military-style clock. To set 3 p.m., you would set the H and M settings to 15:00.

24 Hour Time Equivalents

For your convenience, here is a listing of the 24-hour time equivalents:

A.M. Settings:

12:00 a.m. = 00:00 (midnight)
01:00 a.m. = 01:00
02:00 a.m. = 02:00
03:00 a.m. = 03:00
04:00 a.m. = 04:00
05:00 a.m. = 05:00
06:00 a.m. = 06:00
07:00 a.m. = 07:00
08:00 a.m. = 08:00
09:00 a.m. = 09:00
10:00 a.m. = 10:00
11:00 a.m. = 11:00

P.M. Settings:

12:00 p.m. = 12:00 (noon)
01:00 p.m. = 13:00
02:00 p.m. = 14:00
03:00 p.m. = 15:00
04:00 p.m. = 16:00
05:00 p.m. = 17:00
06:00 p.m. = 18:00
07:00 p.m. = 19:00
08:00 p.m. = 20:00
09:00 p.m. = 21:00
10:00 p.m. = 22:00
11:00 p.m. = 23:00

Interestingly, there is no 24:00 time (midnight). After 23:59 comes 00:00.

Date format – The D90 gives you three different ways to format the date (see *figure 2B*):

1. Y/M/D = Year/Month/Day (2010/12/31)
2. M/D/Y = Month/Day/Year (12/31/2010)
3. D/M/Y = Day/Month/Year (31/12/2010)

United States D90 owners will probably use setting # 2, which matches the MM/DD/YYYY format so familiar to Americans. Other areas of the world can select their favorite date format.

To select the date format of your choice, do the following:

- Press the *MENU* button and scroll to the *Setup Menu*.
- Select *World time*, and then scroll to the right.
- Select *Date format*, and then scroll to the right.
- Choose the format you like best from the three available formats.
- Press the *OK* button.

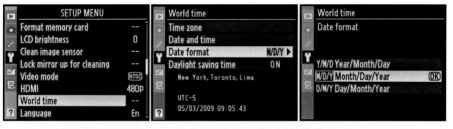

Figure 2B – *Date format* screens

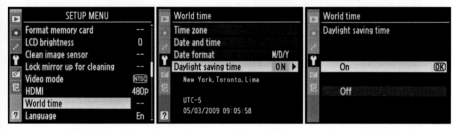

Figure 2C – *Daylight saving time* screens

Daylight saving time – Many areas of the United States use daylight savings time. In the spring, many American residents set their time forward by one hour on a specified day each year. Then in the fall, they set it back, leading to the clever saying "spring forward or fall back."

To enable automatic *Daylight saving time*, take the following steps (see *figure 2C*):

- Press the *MENU* button and scroll to the *Setup Menu*.
- Select *World time*, and then scroll to the right.
- Select *Daylight saving time*, and then scroll to the right.
- Select *On* or *Off* from the menu.
- Press the *OK* button.

If you set it to *On*, your D90 will now automatically "spring forward and fall back," adjusting your time forward by one hour in the spring and back one hour in the fall.

Since you are already in the *Setup Menu*, let's see what else you might want to initially configure while here. (See chapter 8, "Setup Menu," for full details.)

Setup Menu – Format Memory Card

While you are in the *Setup Menu*, notice the location of the SD memory card formatter. When you insert a card into a new camera for the first time, it's a good idea to format the card with that camera. This will match the card to the camera and give you greater reliability in the long run.

Nikon D90 back view

Here are the four steps to formatting a memory card using the menus:

- Press the *MENU* button and scroll to the *Setup Menu*.
- Select *Format memory card*, and then scroll to the right.
- Select *Yes* from the screen with the big red exclamation mark and the words *All images on memory card will be deleted. OK?*
- Press the *OK* button.

Once you press the *OK* button, you'll see the two screens in quick succession. One says *Formatting memory card*, and the next says *Formatting complete*. Then the camera switches back to the *Setup Menu's* first screen. The card is now formatted, and you can take lots of pictures.

You can use this *Format memory card* menu selection to format the card or you can use external camera controls. Since

this is an initial configuration section, let's also look briefly at how to format a card using the external camera controls. I use this method to format memory cards because it's faster and easier than the menu method.

Referring to *figure 3A*, do the following steps to format a card with camera buttons:

- Hold down the *Delete* and *Metering* buttons at the same time until you see the word *For* and the image count number flashing in the top control panel LCD.
- Briefly release and reapply the *Delete* and *Metering* buttons again, and the memory card formatting operation will take place.

Notice how the *Delete* and *Metering* buttons have a dual purpose. They

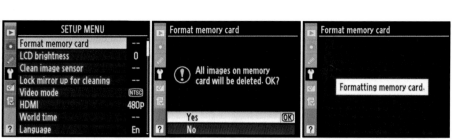

Figure 3 – *Format memory card*

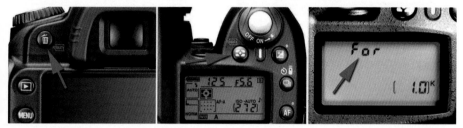

Figure 3A – External camera controls to format a memory card

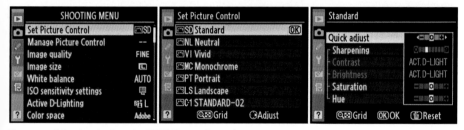

Figure 4 – Selecting the Standard (SD) Picture Control

normally control image deletion and metering functions, but if you hold both down at the same time, for several seconds, the format function is activated.

Now, let's move to the *Shooting Menu* for several important configuration changes.

Shooting Menu – Set Picture Control

Later, in chapter 6, "Shooting Menu," I'll cover picture controls in detail, including how to use the Nikon picture controls to create new custom picture controls that you can use and share with others. For now, until you get a sufficient

understanding of picture controls, let's select one for initial use.

Using the menu screens in *figure 4*, select the SD-Standard picture control:

- Press the *MENU* button and scroll to the *Shooting Menu*.
- Select *Set picture control*, and then scroll to the right.
- Select *SD-Standard* from the menu, and then press the *OK* button.

This SD picture control sets your camera up for medium contrast and color saturation for a look resembling Fuji Provia 100F slide film or Kodak Gold

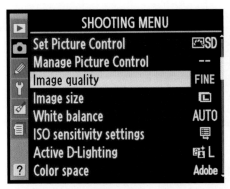
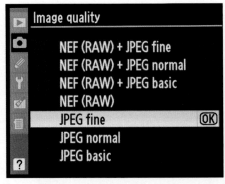

Figure 5 – Selecting JPEG fine image quality with menus

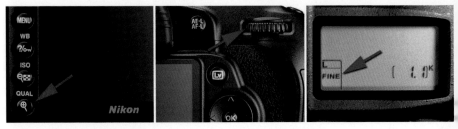

Figure 5A – Selecting JPEG fine image quality with external controls

100. This setting is a good starting point for how your camera captures contrast and color, with enough contrast for solid blacks and sufficient color saturation for a realistic look in skin tones and foliage. Later you can experiment with the other controls and make more informed choices. This is a good "starter" *picture control* to use until you understand the others more fully.

Shooting Menu – Image Quality

If you're new to digital photography and are not experienced with post-processing images later in the computer, or if you have no interest in working on images after the fact, you'll need to select the *Image quality - JPEG fine* setting. This setting allows your camera to create excellent,

immediate-use images that are compatible with virtually all types of printing or display of images. The JPEG format is the standard basic final format for almost everything done in photography today.

In chapter 6, we'll consider all the formats available in the D90, and even which are best to use for various types of photography. The JPEG fine format is the factory default for the D90, but I wanted you to know where it is located if you decide to change it. Here's how (see the menu screens in *figure 5*):

- Press the *MENU* button and scroll to the *Shooting Menu*.
- Select *Image quality*, and then scroll to the right.
- Select *JPEG fine* from the menu, and then press the *OK* button.

You can set the image quality using external camera controls also. In fact, this is my preference. In *figure 5A*'s rightmost image you'll see a little box in the lower-left corner of the control panel LCD. When you hold the *QUAL* button and turn the rear main-command dial, you'll see the values scroll there.

Referring to *figure 5A*, why not give it a try on your D90. This is the fastest way to change formats.

Here are the steps to select *JPEG fine*:
• Press the *QUAL* button and hold it.
• Rotate the rear main-command dial until you see *FINE* appear on the left of the upper control panel LCD.
• Release the *QUAL* button.

Shooting Menu – Image Size

The Nikon D90 can shoot in three image sizes. I have never taken mine off of the *L-Large* setting since I have no need for smaller pictures. Here are the three options under *Image size*:

• Large – 4288 x 2848 – 12.2 megapixels
• Medium – 3216 x 2136 – 6.9 megapixels
• Small – 2144 x 1424 – 3.1 megapixels

Here are the steps to select the large size (see *figure 5B*):

1. Press the *MENU* button and select *Shooting Menu*.
2. Choose *Image size*, and then scroll right.
3. Choose the size of the image.
4. Press the *OK* button.

Shooting Menu – White Balance

White balance is a subject that few digital photographers fully understand. In chapter 6, I'll discuss the basic configuration of the white balance settings. Also, there is an entire chapter of this book, chapter 3, devoted to complete coverage of this very important subject.

For now, let's just validate that the default setting for white balance is *Auto*. This will allow your camera to make decisions about the ambient color of the light in which it finds itself. This will produce reasonably colored images initially, without harmful tints. Please take the time later to fully understand how white balance works. It will make you a better digital photographer.

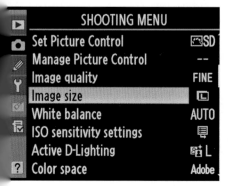
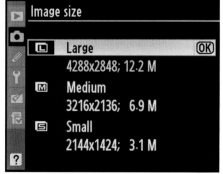

igure 5B – Selecting the large image size

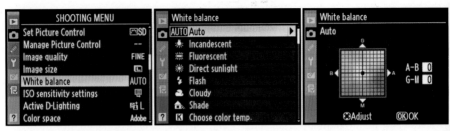

Figure 6 – Selecting *White* balance – *Auto* with menus

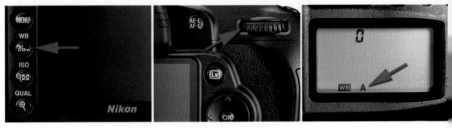

Figure 6A – Selecting *White* balance – *Auto* with external camera controls

Using the menus in *figure 6*, follow these steps:

1. Press the *MENU* button and scroll to the *Shooting Menu*.
2. Select *White balance*, and then scroll to the right.
3. Select *Auto* from the menu, and then scroll to the right.
4. Press the *OK* button.

When you get to the third screen with the color Adjust box, which lets you fine-tune the white balance, just press *OK*. (Leave the little black square directly in the center of the Adjust box.) This is a fine-tuning screen, and at this time, you may not have sufficient need or experience to adjust this. If you accidentally moved the little black square in the color Adjust box, just put it back in the center and press *OK*.

Also, you can use external camera controls to adjust which White balance mode you use. For now, stay with WB *A*, since the *A* icon represents *Auto*. In *Figure 6A* are the controls and steps used.

Follow these steps to set WB with the external controls (see *figure 6A*):

1. Hold down the *WB* button on back of the D90.
2. Turn the rear *Main* command dial, until the WB *A* shows on the upper control panel LCD.
3. Release the *WB* button.

The factory default is *A*, or *Auto*, but I want you to know where this important control is located for later use. Understanding and using the white balance settings are critical for consistently excellent images. (See chapter 3, "White Balance.")

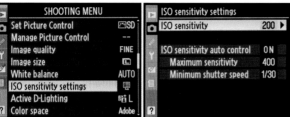
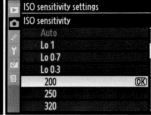

Figure 7 – ISO sensitivity settings by menu

Figure 7A – ISO sensitivity settings by external controls

Shooting Menu – ISO Sensitivity Settings

ISO is the abbreviation for the International Organization of Standardization. In the film days, we used to use another standard called ASA, but the bottom line is that it refers to the sensitivity of the film (and in this case, the image sensor) to light. This was commonly called film speed.

An ISO sensitivity number (such as 200 or 800) is an agreed-upon sensitivity for the image capturing sensor. Virtually everywhere you go, all camera ISO numbers will mean the same thing. Therefore, camera bodies and lenses can be designed to take advantage of the ISO sensitivity ranges they will use.

In the D90, the ISO numbers are sensitivity equivalents. The higher the ISO sensitivity, the less light needed for the exposure. A high ISO setting allows faster shutter speeds and smaller apertures. A low ISO setting requires slower shutter speeds and larger apertures.

The default value of your D90's ISO is 200. This will work for normal bright images found in daylight, but at night or in darker areas you might want to increase the ISO sensitivity to get nonblurry pictures from slow shutter speeds. Be careful when using high ISO settings because somewhere above 800 ISO, noise (graininess) will start appearing in the images. Above 1600 ISO the noise becomes increasingly apparent.

To select an ISO setting, do the following (see *figure 7*):

1. Press the *MENU* button and select *Shooting Menu*.
2. Choose *ISO sensitivity*, and then scroll right.
3. Choose an ISO number and press the *OK* button.

A faster way to choose ISO sensitivity is to use the external camera controls. Here's how:

1. Hold down the *ISO* button on the back of the D90.
2. Turn the rear main-command dial and watch the top control panel LCD
3. Find the ISO setting you want to use.
4. Release the *ISO* button.

Shooting Menu – Color Space

The color space is another thing that newer digital photographers often don't fully understand. It, too, is discussed further in chapter 6. The industry-standard color space for conversion to CMYK (four colors—cyan, magenta, yellow, and black) offset printing is Adobe RGB. The D90 defaults to the sRGB color space because it is the default color space for home printing and for many retail places where you can get prints made.

Let me give you a basic understanding of why color space is important. There is a big color space called LAB CIE that basically represents the range of human color vision. The Adobe RGB color space allows your camera to capture about 50 percent of that color range. The sRGB color space allows the D90 to capture only about 35 percent of that color range.

Color space is basically an agreement between manufacturers of all sorts of equipment. If you take a picture using the *sRGB* or *Adobe RGB* color spaces built into your D90, it helps match your picture's color to the output of a device like an inkjet printer, an offset press, a computer monitor, or an HDTV screen. All these devices have color space standards. Your Nikon D90 must fit within the standards or your images might print or display with inaccurate colors.

Which color space should you use? This depends on what you intend to do with your images. Roughly, if you intend to sell your images in some format, it is usually best to use the Adobe RGB color space, which is the industry-standard starting place for color printing on most commercial devices. If you only intend to print your own images on an inkjet printer, or send them off to the superstore lab, then sRGB is usually sufficient. This is not a

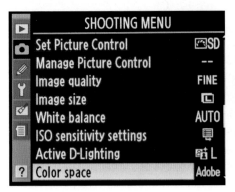

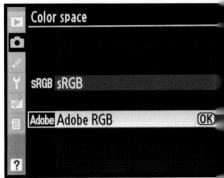

Figure 8 – Selecting a Color Space

hard-and-fast rule. However, this should give you a basic understanding to start off your voyage into digital imaging.

Using *figure 8* as a guide, select either *sRGB* (factory default) or *Adobe RGB*, and then press the *OK* button. If you are still unsure what to do, just select *sRGB* and don't worry about it. With *sRGB*, you'll be selecting a color space that does a great job with JPEG image shooting and printing. Later, you can take time to study this and other resources for more detailed information on the very important issue of color space.

Shooting Menu – Movie Settings

Since the D90 is also a movie camera (imagine that!), you should select an initial format for your movies. Plan on shooting short video segments of 5 minutes each. The 5-minute limitation applies to only the highest-resolution mode.

You can record for longer periods in lower resolutions, up to 20 minutes.

Before shooting, you can turn mono sound on or off, and select the video quality (size) from the following (see *figure 9*):

- 1280 x 720
- 640 x 424 (default)
- 320 x 216

Since autofocus doesn't work in movie mode, you'll need to prefocus in Live View mode before starting the movie and then manually refocus if you significantly change the distance from your subject.

Your video is saved in the familiar AVI format, which will display on most computers since it's compatible with Windows Media Player and Apple QuickTime, among other computer applications. You can even connect the D90 to an HDTV, with an optional HDMI cable, and show your video to friends and family.

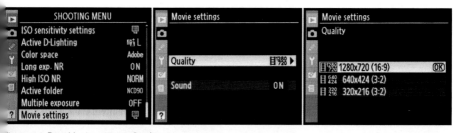

igure 9 – D90 *Movie settings - Quality*

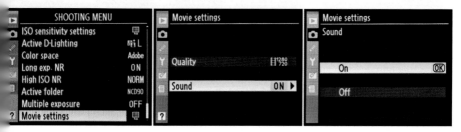

gure 9A – D90 *Movie settings - Sound*

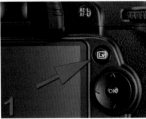

Figure 9B – Recording a D90 movie

Using the menus shown in *figures 9* and *9A*, select one of the *Quality* and *Sound* settings:

1. Press the *MENU* button and select the *Shooting Menu*.
2. Choose *Movie settings*, and then scroll to the right.
3. Choose a *Quality* level and press the *OK* button.
4. Now, select *Sound*, and then scroll to the right.
5. Select *On* or *Off* and then press the *OK* button.

Now, simply follow these steps to start recording D-Movie:

1. Turn the camera on, and remove the lens cap.
2. Press the LV button on the D90's back (*figure 9B*, image 1).
3. Prefocus the camera on your subject by pressing the shutter release button half-way down until the little green square stops flashing (*figure 9B*, image 2).
4. Press the *OK* button to start the video recording (*figure 9B*, image 3).
5. When you are finished, press the *OK* button again to stop recording.

When you have recorded your video, press the *Playback* button, and you'll see the first frame of your movie. Press *OK* to play the movie. (Be sure to have some popcorn ready!)

Look at *figure 9C*—you can tell it's a movie instead of an image in the camera display when you see a little movie camera icon in the upper-left corner along with a minutes and seconds counter at the top in the middle. *OK Play* will show at the bottom of the display.

Note: See chapter 12 for detailed information on using the D-Movie mode.

Figure 9C – Identifying a movie on the playback screen

Custom Setting Menu – Autofocus Area Mode

Until you've had an opportunity to study the configuration of the autofocus system, let's select a safe setting so that you can get excellent in-focus images. Autofocus is another of those confusing systems that most people have problems with. Chapter 10, "Multi-CAM 1000 Autofocus," is devoted to teaching you the entire autofocus system in great detail, along with related functionality like area and release modes.

We really should set an autofocus Area mode. Later, when you are more familiar with what these modes do, you can experiment with different modes. In the meantime, we'll set *Auto-area AF* so that your camera can use face recognition technology to take clear portraits and assist you with the autofocus process for all your other subjects. *Figure 10* shows the menu screens to set the autofocus area modes.

Notice that there are four *AF-area mode* settings shown in *Custom Setting a1*:

- *Single-point*
- *Dynamic-area*
- *Auto-area*
- *3D-tracking (11 points)*

For now, select *Auto-area*. This will let the camera decide which autofocus area mode is best for the subject. After you read chapter 10, you'll be ready to take control of this functionality.

Here are the steps to set the *Auto-area* mode (see *figure 10*):

1. Press the *MENU* button and select the *Custom Setting Menu*.
2. Choose *Autofocus*, and then scroll right.
3. Choose *a1 AF-area mode*, and then scroll to the right.
4. Select *Auto-area*, and press the *OK* button.

Figure 10 – Setting *Auto-area* autofocus mode

**Custom Setting Menu –
Viewfinder Grid Display**

This setting is not absolutely necessary for everyday shooting, but it sure does make a difference in keeping images level. Most of us tend to tilt the camera in one direction or another. In our excitement to capture a great image, we might be tilting the camera a few degrees. Having gridlines on the viewfinder makes it much easier to keep things level.

Selections available in *Custom Setting d2*:

- *On* – On-demand gridlines are displayed in the viewfinder.
- *Off* (default) – No gridlines are displayed.

Here are the steps to configure on-demand gridlines (see *figure 11*):

1. Press the *MENU* button and scroll to the *Custom Setting Menu*
2. Select *d Shooting/display*, and then scroll to the right.

3. Select *d2 Viewfinder grid display* from the menu, and then scroll to the right.
4. Select *On* from the menu.
5. Press the *OK* button.

If you turn on-demand gridlines on, I doubt you'll turn them back off. You *can* turn them on and off, at will, using *Custom Setting d2*. This will be discussed in more detail in chapter 7, "Custom Settings."

**Custom Setting Menu –
File Number Sequence**

Wouldn't you like to know how many images you've shot with the D90 and make sure each image has its own unique image number? With *File number sequence* set to *On*, your camera will keep count of the image numbers in a running sequence from 0001 to 9999 (after 9999, it rolls back to 0001).

Otherwise, anytime you format the memory card or insert a different card,

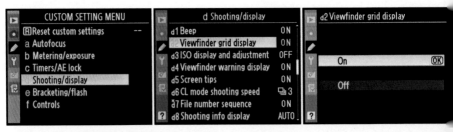

Figure 11 – Enabling viewfinder gridlines

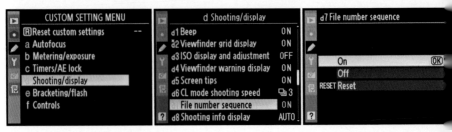

Figure 12 – Enabling *File number* sequence

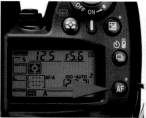

Figure 13 – Autofocus set to *AF-A*

the D90 will start over at 0001. You could accidentally copy a set of images right over the top of another set with the same image numbers. At least with *File number sequence* set to *On*, you only have to worry about accidentally overwriting other images after every 9,999 images.

Here's how to modify the settings under *Custom Setting d7* (see *figure 12*):

1. Press the *MENU* button and scroll to the *Custom Setting Menu*
2. Select *d Shooting/display*, and then scroll to the right.
3. Select *d7 File number sequence* from the menu, and then scroll to the right.
4. Select *On* from the menu, and then press the *OK* button.

Customizing your file numbering will be discussed in more detail in chapter 7.

Setting the Autofocus Mode

Now, let's consider another set of external controls, the autofocus control. We'll set the D90 to use *AF-A* mode. This mode is the best of both worlds for a less-experienced user or for someone who doesn't want to be bothered with selecting AF modes. There are two other modes, *AF-S* and *AF-C*, but the *AF-A* mode will automatically imitate one of the other two, according to what your subject is doing.

Here's how it works when you set your camera to *AF-A* mode:

Subject is not moving: The camera sees a static subject so it uses *Single-servo AF (AF-S)* mode automatically. Focus becomes static on the subject and does not continue updating unless the subject starts moving.

Subject is, or starts, moving: The D90 uses *Continuous-servo AF (AF-C)*, and as long as the subject is moving, the camera keeps seeking the best focus.

Until you are experienced with the autofocus system, I suggest you leave the camera set to *AF-A*. Later, after you've read chapter 10, "Multi-CAM 1000 Autofocus," you'll have a much better understanding of how to use these modes under different conditions.

Here are the steps to make sure your camera is set to *AF-A* (see *figure 13*):

1. Hold down the *AF* button (*figure 13*, left image).
2. Turn the rear main-command dial until *AF-A* appears on the upper control panel LCD (*figure 13*, middle and right images).
3. Release the *AF* button.

Setting the Release Mode

The D90 has several release modes, which decide how many images per second can be taken and how fast. Until you've learned to use the release modes, as covered in chapter 10, let's use *S-Single Frame Release* mode. This mode only takes one picture each time you press the shutter release button.

Here are the steps to makes sure your camera is set to *S-Single Frame Release* (see *figure 14*):

1. Hold down the *Release Mode* button (*figure 14*, right image).
2. Turn the rear main-command dial until *S* appears on the upper control panel LCD (*figure 14*, middle and right images).
3. Stop pressing the *Release Mode* button.

Playback Menu – Image Review

When you take a picture with your D90, it should display an image on the rear LCD monitor. Let's validate your D90 and see that it is configured correctly. Figure 15 shows the two menus screens to use.

The *Image review* settings are as follows:

- *On* – Shows a picture on the monitor after each shutter release (default).
- *Off* – Monitor stays off when you take pictures.

Using *figure 15* as your guide, do the following steps:

1. Press the *MENU* button and scroll to the *Playback Menu*
2. Select *Image review*, and then scroll to the right.
3. Select *On* from the menu, and then press the *OK* button.

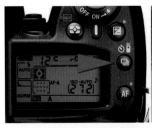

Figure 14 – Setting the release mode to *S-Single Frame Release*

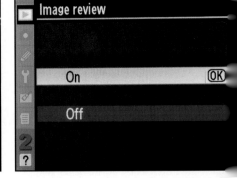

Figure 15 – Enabling *Image review*

Playback Menu – Rotate Tall

When you shoot a vertical image and view it immediately, Nikon assumes that you will still be holding the camera in the ro-tated position, so the image displays in a position correctly oriented for how you're currently holding the camera. Later, when you are reviewing the images as a group and using the D90's playback function, the image will be displayed as an upright vertical image on the horizontal monitor.

Here are the two available display settings:

- *On* (default) – When you take a verti-cal image, the D90 will rotate it so that you don't have to turn your camera to view it naturally in later playback.
- *Off* – Vertical images are left in a hori-zontal direction so that you'll need to turn the camera to view it as it was taken.

Here are the steps to configure *Rotate tall*:

1. Press the *MENU* button and scroll to the *Playback Menu*
2. Select *Rotate tall*, and then scroll to the right.
3. Select *On* from the menu, and then press the *OK* button.

Summary

This chapter takes you through some of the most important items to configure in the camera. As you read through this book, you'll find plenty of other issues to think about and configure. For instance, the *Custom Setting Menu* has 41 separate items to consider. Each of them is com-posed of multiple selections that you'll need to understand.

When you consider the fact that the D90 has seven separate menu systems, you may realize that this chapter has only barely scratched the surface of the possible configurations. The Nikon D90 is a complex camera, with functions designed to appeal to a wide range of people shooting all sorts of image styles. Fortunately, you do not have to configure all the settings in the camera. You can safely get by with just the settings we've covered in this chapter (for a while anyway). As your skill in photography increases and you discov-er ways to use the more esoteric features of the D90, you'll have a resource in this book to help you grow in your mastery of the camera. It is surely a powerful and flexible imaging system.

Enjoy your new D90!

Figure 16 – Enabling Rotate Tall

Exposure Metering System, Exposure Modes, and Histogram

I've been using Nikon cameras since way back in 1980. It seems that with each camera released by Nikon there have been improvements in its light metering modes. The Nikon D90 is no exception.

With this camera, Nikon has designed metering to work not only with still images but also with moving pictures and video.

In this chapter, you'll learn how the exposure metering system and modes work. We'll look at how each of three different light meter types is best used. We'll examine the various modes you can use when using your camera, including several presets for when you want the camera to do most of the work while you enjoy shooting. And finally, we'll look in detail at how the histogram works on the Nikon D90.

The histogram is a new feature to those who are coming over from film photography. This little readout gives you great control over metering and will help you make the most accurate exposures you've ever made. It is very important that you understand the histogram, so we'll look at it in detail.

This chapter is divided into three parts:

- **Metering Systems** –The exposure metering systems: matrix, spot, and center-weighted.
- **Exposure Modes** – Programmed auto, shutter priority, aperture priority, and manual. In addition, there are five preset modes that give the new user command of a certain style of shooting.
- **Histogram** – How to read it and better control your exposures.

Let's get started by looking into the three exposure metering systems.

Section 1 – Metering Systems

(User's Manual pages 87–94)

The basis for the Nikon D90's exposure meter is a 420-segment RGB sensor that meters a wide area of the frame. When used with a G or D Nikkor lens containing a CPU, the camera can set exposure based on the distribution of brightness, color, distance, and composition. Most people leave their camera set to matrix metering and enjoy excellent results. Let's look more closely at each of the Nikon D90's exposure metering systems.

Figure 1 shows the metering button near the shutter release button on top of the D90 (1), the Control Panel LCD readout set to matrix metering (2), and the main-command dial used to change the meter to a different type (3).

You press and hold the metering button and rotate the rear main-command dial to one of the three settings. Rotating the main-command dial to the

right changes from the default of matrix metering to spot metering and finally to center-weighted metering.

3D Color Matrix II Metering

The Nikon D90 contains a 3D Color Matrix II metering system that's one of the most powerful and accurate automatic exposure meters in any camera today. (User's Manual page 87.) *Figure 2* shows the Control Panel LCD set to matrix metering.

Through complex mathematical formulas, there are characteristics for many thousands of images stored in the camera. These characteristics are used along with proprietary Nikon software and complex evaluative computations to analyze the image that appears in your viewfinder. The meter is then set to provide accurate exposures for the greatest majority of your images.

A simple example of this might be when the horizon runs through the middle of an image. The sky above is bright, and the earth below is much dimmer. The metering system evaluates this image and compares it to hundreds of similar images in the camera's database and automatically selects and inputs a meter setting for you.

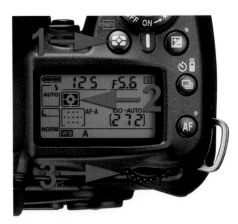

Figure 1 – Metering button, control panel set to matrix metering, and the main-command dial

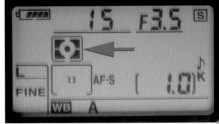

Figure 2 – Meter control set to matrix metering

The meter examines four critical areas of each picture. It compares the levels of *brightness* in various parts of the scene to determine the total range of EV values. It then notices the *color* of the subject and surroundings. If you are using a G or D lens with a CPU chip, it also determines how far away your lens is focused so that it can determine the *distance* to your subject. Finally, it looks at the *compositional* elements of the subject.

Once it has all that information, it compares your image to tens of thousands of image characteristics in its image database, makes complex evaluations, and comes up with an exposure value that is usually right on the money, even in complex lighting situations.

However, I'd like to qualify that with the following recommendation.

Recommendation:
Fine-Tuning Matrix Metering

Like all digital cameras, the Nikon D90 tends to be a bit conservative when light values get too bright. If the D90 encounters a situation in which the light values exceed the range of the sensor, it will tend to expose for the highlights and let the darker areas of the image lose detail. We'll talk more about this in section 3 when we learn about histograms. In all cases, it tries to keep the bright values from "blowing out" by preventing the meter from fully approaching pure white with no detail. In my experience, the D90 tries to keep the exposure from 1/3 to 1/2 stop of EV (exposure value) below the maximum white value.

Fortunately, Nikon has given us a way to fine-tune the matrix meter to closely match our type of shooting. As a stock image shooter, I'm always concerned about shooting images that are as noise free as possible. The "noise" reference is used in digital photography to describe unwanted degradation of an image caused by a variety of factors. I generally try to expose as close to the maximum brightness I can get without completely blowing out the highlights. Underexposure means noise, so I tend toward the highlight or bright edge of normal exposure to keep noise under control.

I've found that running my D90 about a half stop over what the matrix meter suggests gives me images that have no serious blowout and very little noise. From time to time I have a little problem with white subjects, but generally I do well using my half stop over rule. I'm being a bit aggressive in overriding the meter, but I find that the camera does well for me at that setting. The ability to "fine-tune" the meter is one of the nice features of the D90 and shows its semiprofessional heritage. I'm not recommending that you set your D90 to overexpose by 1/2 stop as I do because your style of shooting might not benefit from that method. I'm just saying to give it a try.

If you want to experiment with fine-tuning your matrix meter to see what you can "get away with," please refer to chapter 7, "Custom Settings," and see the section "Custom Setting b4 – Fine-Tune Optimal Exposure." This setting allows you to fine-tune each of the exposure

metering modes individually, in 1/6 stops. I leave my D90 set to 3/6 stops over exposure constantly, which equals a 1/2 EV step or stop. You can experiment with your D90. Don't be afraid to since you can always change your fine-tuning back to zero.

You might find that 1/2 stop is too much for you or that you don't even need any compensation at all. The point is that you are not limited with this camera. You can use the matrix meter with factory settings or fine-tune endlessly. The D90 has so many options to fine-tune and adjust that it fits my personality quite well!

The D90 User's Manual, on page 178, says, "Exposure compensation is preferred in most situations." So, if you do not have a "fine-tuning"–type personality, you may want to stick with plain old exposure compensation.(User's Manual page 90)

Using Flash with Matrix Metering

When you are using flash with matrix metering, you might find that the D90 is especially conservative. I have used the popup speedlight, an SB-600, and an SB-800 with my camera, and it consistently underexposes by about 1/3 stop in matrix metering.

To overcome this perceived tendency in my D90, I have reprogrammed my D90's *FUNC.* button to activate the spot meter while I hold the button down. (See *Custom Setting f3* – Assign FUNC. button in chapter 7.) I find that a good spot reading directly off my subject gives me nearly perfect exposures using flash.

Note

You could also use flash compensation as described on page 91 of the D90 User's Manual.

Center-Weighted Metering

If you're a bit old-fashioned, having been raised on a classic center-weighted meter, and still prefer that type, the D90's exposure meter can be transformed into a flexible center-weighted meter with a variable-sized weighting that you can control. (User's Manual page 87.) *Figure 3* shows the Control Panel LCD set to center-weighted metering.

The center-weighted meter in the D90 meters the entire frame but concentrates 75 percent of the metering into an 8 mm circle in the middle of the frame. The other 25 percent of the frame outside the circle provides the rest of the metering. If you'd like, you can make the circle as small as 6 mm or as large as 10 mm. Let's examine the center-weighted meter more closely.

Using *Custom setting b3*, you can change the size of the circle where the D90 concentrates the meter reading. (See "Custom Setting b3 – Center-weighted

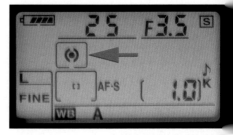

Figure 3 – Meter control set to center-weighted metering

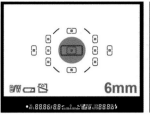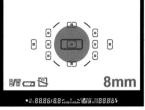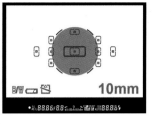

Figure 3A – Approximate center-weighting circle sizes, 6, 8, and 10 mm

area" in chapter 7, and the D90 User's Manual, page 178.)

As mentioned previously, the circle is normally 8 mm in size in your viewfinder. However, by using *Custom setting b3*, you can adjust this size to one of the following:

1. 6 mm (.24 inch)
2. 8 mm (.32 inch) – default setting
3. 10 mm (.39 inch)

The center-weighted meter is a pretty simple concept, really. Whatever part of your subject that's in the center of your D90's viewfinder influences the meter more than the edges of the frame, on a 75/25 basis. The circle gets 75 percent importance.

Where's the Circle?

You can't actually see any indication of a circle in the viewfinder, so you'll have to imagine one.

Here's how (see *figure 3A*): Locate your current autofocus (AF) sensor in the middle of your viewfinder. Now imagine an 8 mm circle, which at .32 inches is about 1/3 of an inch. The 10 mm maximum size circle, at .39 inches, is a little bigger. This unseen circle in the center area of the viewfinder provides the most important 75 percent metering area. For information

on fine-tuning center-weighted metering, see "Custom Setting b4 – Fine-tune optimal exposure" in chapter 7.

Recommendation:

If I were to use the center-weighted meter often, I would stay with the default setting of 8 mm (*Custom setting b3*). This is a pretty small circle (almost in the spot metering range), so it should give you good readings. It is large enough to see more than a pure spot meter though, so you have the best of both worlds. There is so little difference between 6 mm and 10 mm that it probably makes little difference which one you use. If you are concerned, then experiment with the three settings and see which works best for you.

Spot Metering

Often no other meter but a spot meter will do. In situations where you must get an accurate exposure for a very small section of the frame, or you must get several

Figure 4 – Meter Control Set to Spot Metering

meter readings from various small areas, the D90 can, once again, be adjusted to fit your needs. (User's Manual pages 87 and 173)

The D90's spot meter consists of a 3.5 mm circle (0.14 inch) surrounding the currently active autofocus (AF) point if you are using single or continuous AF modes (AF-S or AF-C). In AF Auto-select mode (AF-A) the spot meter is metering from the center AF sensor only and does not move when other AF sensors are automatically selected. If you are going to use the spot meter effectively, you might want to set your D90 to AF-S or AF-C modes!

The spot meter evaluates only 2.5 percent of the frame, so it is indeed a "spot" meter. Since the spot is surrounding the currently active AF sensor, you can move the spot meter around the viewfinder within the 11 AF points.

How big is the 3.5 mm spot? Well, the spot meter barely surrounds the little AF point square in your viewfinder. It is fairly close to the size of the little brackets that appear around the active AF sensor when you slightly press the shutter release button.

Recommendation

When your D90 is in spot meter mode and you move the AF point to some small section of your subject, you can rest assured that you're getting a true spot reading. In fact, you can use your spot meter to determine an approximate EV range of light values in the entire image. You can do this by metering the lightest and darkest spots in the frame. If this value exceeds 5 or 6 stops difference, you've got to decide which part of your subject is most important to you and meter only for it.

On an overcast day, you can usually get by with no worries since the range of light values is often within the recording capability of the sensor. On a bright sunny day, the range of light exceeds what your sensor can record by as much as two times, which can often be as much as 12 stops, while your sensor can record a maximum of only 6 or 7 stops.

Don't let the numbers make you nervous. Just remember that spot metering is often a trade-off. You trade the highly specific ability to ensure that a certain portion of an image is "spot-on" for the ability of the camera's multiple "averaging" skills to generally get the correct exposure throughout the frame. The choice is yours, depending on the shooting situation.

If you spot-meter a person's face while they are standing in the sun, the shadows around that person will contain little or no data. The shadows will be underexposed and look like solid black. Then, if you spot-meter from the shadows instead, the person's face is likely to "blow out" to solid white. We'll discuss

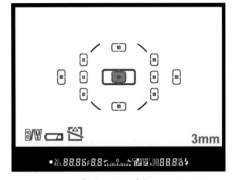

Figure 4A – Viewfinder view of the 3 mm spot

this in more detail in section 3 of this chapter, about the histogram.

Use your spot meter to get specific meter readings of small areas on and around your subject; then make some exposure decisions yourself, and your subject should be well exposed. Just remember that the spot meter evaluates only for the small area that it sees, so it cannot adjust the camera for anything except that one tiny area. Spot metering requires some practice, but it is a very professional way to compose images.

For information on fine-tuning spot metering, see "Custom Setting b4 – Fine tune optimal exposure" in chapter 7.

Which Metering Mode Would I Use?

Most of the time, I leave my camera set to matrix metering. I use the spot metering mode only when I am using flash to get the best reading from my subject or when I need to meter a difficult subject with a range of light wider than my sensor can contain. I haven't used center-weighted metering since back in the film days and look at it as an old-fashioned system. However, there are those who love the old-style center-weighted meter. It's there if you want it.

Section 2 – Exposure Modes

(User's Manual pages 78–86)

My first Nikon was an FM back in 1980, which I remember with fondness because that was when I first got serious about photography. It's hard for me to imagine that it has already been nearly 30 years since I last used my FM! Things were simpler back then. When I say simple, I mean that the FM had a basic center-weighted light meter, a manual exposure dial, and manual aperture settings. I had to decide how to create the image in all aspects. It was a camera with only one mode—M, or manual.

Later on, I bought a Nikon FE and was amazed to use its A mode, or Aperture Priority. I could set the aperture manually and the camera would adjust the shutter speed for me. Luxury! The FE had two modes, M-manual and A-aperture priority.

A few more years went by and I bought a Nikon F4 that was loaded with features and was much more complex. It had four modes, including the two I was used to, M and A, and two new modes, S-shutter priority and P-programmed auto. I had to learn even more stuff! The F4 was my first P,S,A,M camera.

Does this sound anything like your progression? If you are over 40, maybe so; if not, you may just be getting into the digital photography realm with your D90, and I ought to stop reminiscing and get to the point. The point is that today's cameras are amazingly complex compared to

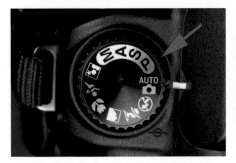

Figure 5 – Mode dial for exposure modes

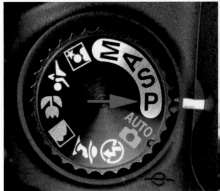

Figure 6 – Mode dial set to programmed auto mode, or P mode

cameras only a few years ago. Let's examine how we can use that flexibility for our benefit. The D90 is also a P,S,A,M camera. That's the abbreviated progression of primary modes that allow you to control the camera's shutter speed and aperture yourself. In addition, the D90 has several scene modes, and a fully auto mode for when you just want to take good pictures without thinking about exposure. Let's examine each in detail.

There is just one control on the D90 to set the auto, scene, or P,S,A,M modes. It is a convenient dial called the mode dial. (See *figure 5* and pages 3 and 6 of the User's Manual.)

Now, let's discuss each exposure mode in detail.

P - Programmed Auto Mode

Programmed auto mode (P) is designed for those times that you just want to shoot pictures and not think much about camera settings but still want emergency control when needed. The camera takes care of the shutter speed and aperture for you and uses your selected exposure meter type to create the best pictures it can without human intervention. *Figure 6* shows the mode dial set to P - programmed auto mode. (User's Manual page 80)

This mode is called programmed auto because it uses an internal software program built into the D90. It tries its best to create optimal images in most situations. However, even the manual (on page 78) calls this a "snapshot" mode. P mode can handle a wide variety of situations well, but I personally wouldn't depend on it for my important shooting. It can be great at a party, for example, where I want some nice snapshots. I don't have to think about the camera then, and I can just enjoy the party. P mode to me is *P for Party*.

P mode actually comes in two parts: programmed auto and flexible program. Flexible program works similarly to *A*-aperture-priority auto mode. Why do I say that? Let me explain.

Get Down, Grandma!

You're shooting at a family party and suddenly you see a perfect shot of Grandma dancing on the dinner table and Grandpa standing on the floor behind her with his

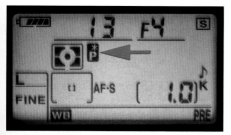

Figure 6A – Flexible program mode P* with control panel symbol

hand over his mouth. You (being a well-trained photographer) glance down at your camera and realize that the f/4 aperture showing on the control panel won't give you enough depth of field to focus on Grandma and still have a sharp image of Grandpa, who by this time is tugging at her pant leg. With only seconds to spare, you turn your rear main-command dial to the left. The D90 realizes that it is being called upon to leave snapshot mode and give you some control. It displays a small P with an asterisk above it on the control panel (see *figure 6A*) to let you know it realizes you are taking over control of the aperture. Since you are turning the dial to the left, it obligingly starts cranking down the aperture. A few clicks to the left and your aperture is now at f/8. As soon as the D90 detected you were turning the command dial, it started adjusting the shutter speed to match the new aperture. With only milliseconds before Grandpa starts dragging Grandma off the dinner table, you get the camera to your eye, compose the shot, press the shutter, and the D90 starts grabbing frames. You get several frames off in the few seconds it takes Grandpa to get Grandma down from the table.

From P to P* and Back Again

Once you've entered flexible program mode, you have to turn the command dial back the same number of clicks to get back into normal P mode. This is a little weird and has a strange side effect. If you have your D90 in P mode and turn the main-command dial to the right, the D90 goes into P* mode and starts counting clicks to the right. In order to get back into normal P mode, you have to turn the command dial back to the left that same number of clicks, up to 10 clicks. The reason I know that the D90 is actually counting clicks is that I counted it counting clicks. Here's what I did: I set my D90 to P mode and got into a darker area where it was at maximum aperture. I then started cranking the main-command dial to the right, which should increase the aperture. Since I was already at maximum aperture, the D90 could not increase the aperture size, so it just sat there counting clicks instead. In order for me to get back into normal P mode, and out of flexible program, I had to turn back to the left the exact number of clicks I turned to the right, up to 10 clicks. I am telling you this just in case you do what I did. Then you'll already know that the D90 will only let you out of P*-flexible program mode when you return to the original position on the dial. You can also turn the camera off or turn the mode dial to get out of the flexible program mode.

What you did in my imaginary scenario was invoke the flexible program mode in your D90. How? As soon as you turned the rear main-command dial, the D90 left normal P mode and switched to flexible program. Before you turned the rear command dial, the D90 was happily

controlling both shutter speed and aperture for you. When you turned the dial, the D90 immediately switched to flexible program mode and let you have control of the aperture. It then controlled only the shutter speed. In effect, the D90 allowed you to exercise your knowledge of photography very quickly and only assisted you from that point.

When you enter *P**-flexible program mode, you control only the aperture and the D90 controls the shutter speed. If you turn the rear main-command dial to the left, the aperture gets smaller. Turn it to the right and the aperture gets larger. Nothing happens if you turn the front sub-command dial. Nikon only gave you control of the aperture in flexible program mode. Can you see why I say flexible program mode acts like A-aperture priority mode?

S - Shutter-Priority Auto Mode

Shutter-priority auto is for those who need to control their camera's shutter speed while allowing the camera to maintain the correct aperture for the available

light. *Figure 7* shows the mode dial set to S for *shutter-priority auto mode.* (User's Manual page 81)

If you find yourself shooting action, you'll want too keep the shutter speed high enough to capture an image without excessive blurring. Shooting sports, air shows, auto races, or any quickly moving subject requires careful control of the shutter. Sometimes you might want to set your shutter speed to slower settings for special effects or time exposures. For instance, if you shoot a helicopter in flight, you may want to use a shutter speed that allows for just a tiny bit of motion blur on the helicopter blades.

If the light changes drastically and the D90 cannot maintain a correct exposure, it will inform you by replacing the normal aperture reading with either *HI* or *Lo*. They mean what they imply. *HI* means there is too much light for a good exposure. *Lo* means there is not enough light for a good exposure.

To change the shutter speed, simply rotate the rear main-command dial to any value between 30 seconds and 1/4000 of a second. Turn the wheel to the right for faster shutter speeds and left for slower. The camera will adjust your aperture to maintain a correct exposure and will warn you when it can't.

A - Aperture-Priority Auto Mode

Nature and macro shooters, and anyone concerned with carefully controlling depth of field, will often leave their D90 set to *aperture-priority* mode (A). *Figure 8* shows the *mode dial* set to aperture-priority auto mode. (User's Manual page 82)

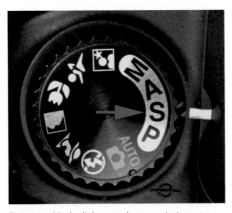

Figure 7 – Mode dial set to shutter-priority auto mode, or S mode

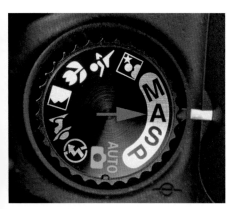

Figure 8 – Mode dial set to aperture-priority auto mode, or A mode

The aperture directly controls the amount of depth of field (DOF) in an image. DOF is an extremely important concept for photographers to understand. Simply put, it allows you to control the range or depth of sharp focus in your images. If you are focused on a person's face, will the person standing behind him also be in focus? DOF controls that! See chapter 4, "Aperture, Shutter Speed, and Focal Length," for detailed information on DOF.

A-aperture priority mode allows you to control the aperture while the D90 takes care of the shutter speed for optimal exposures. To select an aperture, you'll use the front sub-command dial. Turn the wheel to the right for smaller apertures and to the left for larger.

The minimum and maximum aperture settings are controlled by the minimum and maximum aperture available on the lens you've mounted on the camera. Most consumer lenses run from f/3.5 to f/22. More pricey pro-style lenses may have apertures as large as f/1.4, but they generally start at f/2.8 and end at f/22.

M - Manual Mode

Manual mode takes a big step backward to days of old. It gives you complete control of your camera's shutter and aperture so that you can make all the exposure decisions, with suggestions from the exposure meter. The image on the left in *figure 9* shows the mode dial set to manual mode. (User's Manual page 83)

Also, on the right in *figure 9*, notice the electronic analog exposure display. This display, found when you press the INFO button on the back of the camera, has a plus sign (+) on the left and a minus sign (-) on the right. Each dot on the scale

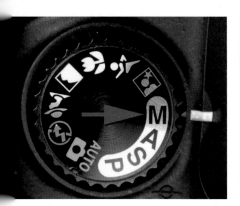

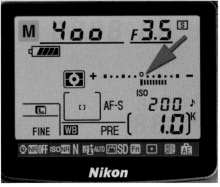

igure 9 – Mode dial set to manual mode, or M mode and "Info" exposure display

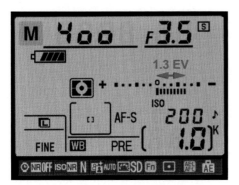

Figure 9A – Exposure display with 1.3 EV steps of overexposure

represents 1/3 EV step, and each line represents 1 EV step. There is a miniature version of the same scale at the bottom of the viewfinder when you look through the eyepiece.

You can control how sensitive this scale is by changing *Custom Setting b1 – EV steps for exposure control*. (See chapter 7, or page 177 in the User's Manual.) You can set *b1* to 1/3 or 1/2 EV steps.

When you are metering your subject, a bar will extend from the zero in the center toward the plus side to indicate overexposure, or toward the minus side to indicate underexposure (see *figure 9A*). You can gauge the amount of over- or underexposure by the number of dots and lines the bar passes as it heads toward one side or the other. The goal in *Manual mode* is to make the bar disappear. In *figure 9A*, the bar is indicating 1 1/3 EV or 1.3 EV steps (stops) overexposure.

You'll adjust the aperture with the front sub-command dial and the shutter speed with the rear main-command dial. When in *Manual mode*, you have control over the aperture for depth of field or the shutter speed for motion control. If

your subject needs a little more depth of field, just make the aperture smaller, but be sure to slow down the shutter speed as well (or your image may be underexposed). If you suddenly need a faster shutter speed, then set it faster, but be sure to open the aperture to compensate.

The point is, you are in complete control of the camera and must make decisions for both the shutter speed and aperture. The camera makes suggestions with its meter, but you make the final decision about how the exposure will look. *Manual mode* is for taking your time and enjoying your photography. It gives you the most control of how the image looks but also expects you to have a higher level of knowledge to get correct exposures.

Aperture, Shutter Speed, Depth of Field, and lens use are discussed in more detail in chapter 4, "Aperture and Shutter Speed."

Recommendations on Exposure Mode Selection

As a nature photographer, I am mostly concerned with getting a nice sharp image with deep depth of field. About 90 percent of the time, my camera is set to *A-aperture-priority* and f/8. I started using this mode back in about 1986 when I bought my Nikon FE and have stayed with it since.

However, if I were shooting sports or action, I would have my camera set to *S-shutter-priority* most often, which would allow me to control the speed of the shutter and capture those fast-moving subjects without a lot of blur. The

camera will control the aperture so that I only have to concentrate on which shutter speed best fits my subject's movement.

I only use the other two modes, *P-programmed auto*, and *M-manual*, for special occasions.

M-manual mode is for when I have time to just enjoy my photography. When I want to control the camera absolutely, I'll go to manual. I've even been known to carry a small blanket with me so that when I'm shooting in manual mode, I can toss it over the back of the camera and my head. That way I can feel like Ansel Adams or another view camera artist.

I probably use *P-programmed auto* mode least of all. I might use it when I am at a party and just want to take nice pictures for my own use. I'll let the camera make most of the decisions by using *P* mode while still having the ability to quickly jump into *P*-flexible program* mode when events call for a little more aperture control.

ull Auto and Scene Modes

Some people have recently switched from using a point-and-shoot (P&S) camera o a more powerful DSLR like the Nikon D90. Most P&S cameras have a completely auto mode and some scene modes, epresenting common photographic opportunities.

The Nikon D90 is (in my opinion) "bridging" camera. It is like a bridge etween point-and-shoot cameras and rofessional level cameras like the D300 r D3x. The D90 is an excellent camera for dvanced amateurs and will even serve as a ice backup to a professional camera. This

versatility in features allows you to choose how you want the camera to support you while you are taking your pictures.

If you have come over from the P&S world, you might enjoy using the auto or scene modes while learning the more advanced uses of the *P,S,A,* and *M* modes. Let's look into how these extra modes work.

Auto Exposure Mode

The *Auto exposure* mode is for those times you want to get the picture with no thought as to how the camera works. (See *figure 9B* and the User's Manual, page 34)

All you need be concerned about in *Auto* mode is how well the image is composed and whether the battery is fully charged.

The D90 becomes a big point-and-shoot camera, like a heavy Coolpix. Many of its internal modes go to auto too. For instance, here are some important camera features that become automatic:

- White balance
- Active D-Lighting
- ISO sensitivity

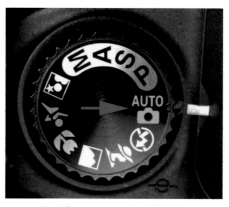

Figure 9B – Full Auto exposure mode

In addition, quite a few of the Shooting Menu settings and Custom Settings are disabled while in auto. In effect, you relinquish control of the camera's functions for a "guarantee" that some sort of picture will be provided. In most cases, the D90 will provide its normal excellent images when you've selected Auto. However, in difficult circumstances, the camera is free to turn up the ISO sensitivity and D-Lighting range extension to get a picture even at the expense of image quality. If an alien spaceship lands in the local superstore parking lot, I might be convinced to use Auto since I am going to get a picture no matter what. I don't have to think about anything except framing the subject and pressing the shutter release.

If you want to loan your camera to your grandmother and she has no interest in how cameras work, the D90 will happily make nice images for her in Auto mode. While you are learning to use the more advanced functions of the camera, you too might benefit from using this mode for a while. You'll usually get better pictures when you control the camera, but the D90 has some awfully efficient software for when you don't want to take control yet.

Portrait Scene Mode

Portrait Scene mode is best used when you are taking pictures of people or static subjects. Set the *Mode* dial to the icon that looks like a lady wearing a fancy hat (see *figure 9C*). The camera tends to emphasize shallow depth of field (large apertures) so that only your subject is in sharp focus, which is a more flattering way to focus attention on your subject while trying to blur out the background as much as possible. If you are taking pictures of friends (alone or in small groups), use this mode.

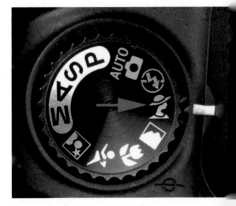

Figure 9C – Portrait scene mode

Landscape Scene Mode

If you are spending a day in the mountains, you'll want to use the *Landscape Scene* mode. Its icon on the Mode dial looks like a couple of mountain peaks with a square around them (see *figure 9D*). Landscapes are usually best photographed on a tripod at small apertures so that the entire scenic view is nice and sharp. The landscape mode will emphasize smaller apertures for more depth of field. This is sort of like using the *A-aperture-priority auto* mode but with much less control over the aperture. Here, the camera decides.

Close Up Scene Mode

Another name for the *Close Up Scene* mode might be "flower mode," or even "macro mode." Its icon on the *Mode* dial is a flower (*see figure 9E*). It's designed to let you to take close-up pictures of flowers, insects, and other small items. It's difficult for me to tell what this mode emphasizes. If anything, it seems a bit neutral, trying to balance a shutter speed that is fast enough to cut down on camera shake while providing enough depth of field to give your subject a chance for sharp focus. It acts somewhat like *P-programmed auto* mode.

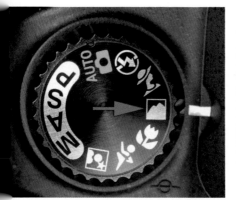

Figure 9D – Landscape scene mode

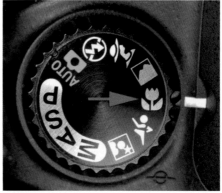

Figure 9E – Close up scene mode

Sports Scene Mode

Since sports usually have people and other subjects moving at a rapid pace, the *Sports Scene* mode emphasizes faster shutter speeds. Its icon on the *Mode* dial is a person in running motion (see *figure 9F*). Since you certainly don't want slow shutter speeds at a car race or air show, the camera will attempt to use the fastest shutter speed that the light will allow and will open up the aperture to keep the exposure reasonable. Expect shallow depth of field in sports mode. This mode is similar to using *S-shutter-priority* mode, but with less control over specific shutter speeds.

Night Portrait Scene Mode

The *Night Portrait Scene* mode is also a bit difficult for me to interpret. It acts somewhat similar to *Close Up Scene* mode in that it tends to use medium apertures and shutter speeds. Its icon on the *Mode* dial looks like a small man with a star on the right side of his head and is surrounded by a square frame (see *figure 9G*). Once again, if a person is shooting handheld at night, it is best to try to balance the shutter speed and aperture so that the shutter stays fast enough to handhold the shot while the aperture is open as much as possible to let in dim light. It seems to emphasize large apertures more than faster shutter speeds.

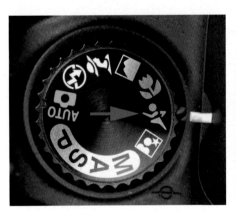

Figure 9F – Sports Scene Mode

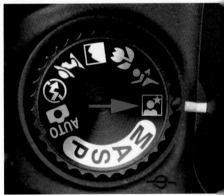

Figure 9G – Night portrait scene mode

Why Have Scene Modes?

These Scene modes are considered "creative photography" modes by Nikon. In fact, they allow an average, beginning photographers to emulate the camera settings they would be inclined to use if they had more experience. These modes allow you to make consistently good images, and later, as your experience grows, you can use the P,S,A,M modes to get more creative control over the image.

Since the Nikon D90 has 30,000 images stored in its matrix metering system, I wouldn't be surprised if each of these modes uses a subset of stored image types that more closely match the selected scene mode. This might hold true in matrix metering mode. I have no way to prove this, so don't quote me!

If you choose to use scene modes, do so with the understanding that you can eventually learn to control the image to a finer degree with the P,S,A,M modes. Don't be afraid to experiment with the more powerful features of the D90. You can always fall back on the scene modes if you feel uncomfortable. With the *P,S,A,M, Auto,* and *Scene* modes, Nikon has given us the best of both worlds in one camera. Full or partial automation, or complete manual control. What flexibility!

Section 3 – Histogram

Back in the "good old" film days we had no histogram, so we had to depend on our experience and a light meter to get a good exposure. Since we couldn't see the exposure until after we had left the scene, we measured our success by the number of usable images we were able to create. With the exposure meter/histogram combination found in the D90, and the ability to zoom into our images with the high-resolution monitor on the back of our cameras, the potential success rate we can attain is higher than ever before.

The histogram can be as important, or even more so, than the exposure meter. The meter sets the camera up for the exposure, and the histogram allows you to visually verify that the exposure is properly balanced.

If your exposure meter stopped working, you could still get perfect exposures using only the histogram. In fact, I gauge my efforts more by how the histogram looks than anything else. The exposure meter and histogram work together to make sure you get excellent results from your photographic efforts.

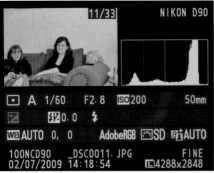

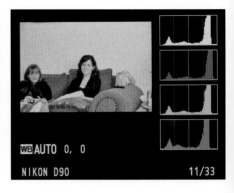

Figure 10 – Two D90 histogram screens

In *figure 10* is a picture of the D90's histogram screens. The screen on the left is a basic informational screen with only a luminance histogram shown in white. It will always be available on your camera; you can access it by scrolling up or down with the multi selector thumb switch during image review. (You can follow all of the screen data displayed by checking page 134 in the User's Manual.)

The second histogram screen in *figure 10* is actually a series of histograms. On the upper right is a white-colored luminance histogram. Next is the red channel, then the green channel, and at the bottom is the blue channel (RGB = **r**ed, **g**reen, **b**lue).

When you examine the top white luminance histogram, notice how it looks very similar to the green channel. This is because the human eye is more sensitive to green light than red or blue. Doesn't it make sense to give us a histogram that helps us accurately meter the light that our eyes perceive best?

Let's discuss the use of a histogram in detail.

Understanding the Histogram

Using the histogram screens on your D90's image viewing LCD will guarantee you a much higher percentage of well-exposed images. It is well worth the work to understand the histogram, which is not overly complicated. (User's Manual page 130)

I'll try to cover this feature with enough detail to give you a working knowledge of how to use the histogram to make better pictures. If you are deeply interested in the histogram, there is much research material available on the Internet. This section covers only a small amount of the information that is actually available, but it will present enough knowledge to immediately improve your technique.

Light Range

The D90's sensor can record only a certain range of light values. It seems able to record about 6 to 8 usable EV stops. Unfortunately, many of the higher-contrast subjects we shoot can contain over 12 stops of light values. This is quite a bit more than it is possible to capture in a single exposure. It's important to understand how your camera records light so that you can better control how the image is captured.

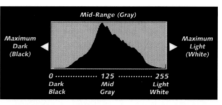

Figure 11 – Basic histogram

Look at *figure 11* closely. The gray rectangular area is a representation of an in-camera histogram.

Basically, the histogram is a graph that represents the maximum range of light values your camera can capture shown in 256 steps (0 = pure black and 255 = pure white) In the middle of the histogram are the mid-range values that represent middle colors like grays, light browns, and greens. The values from just above zero and just below 255 contain detail.

The actual histogram graph looks like a mountain peak, or a series of peaks, and the more of a particular color in the scene, the taller the peak. In some cases the graph will be rounded on top or flattened.

The left side of the histogram represents the maximum dark values that your camera can record. The right side represents the maximum white values your camera can capture. On either end of the histogram the light values contain no detail. They are either completely black or completely white.

The top of the histogram (top of mountain peaks) represents the amount of individual light values, a parameter you cannot control in-camera, so it is for your information only.

We are mostly concerned with the left and right side values of the histogram because we do have control over those (dark vs. light). So, basically, the histogram's left-to-right directions are related to the darkness and lightness of the image, while the up and down directions of the histogram (valleys and peaks) have to do with color information. I repeated this for emphasis!

The left (dark) to right (light) directions are *very* important for your picture taking. If the image is too dark, the histogram will show that by clipping off the light values on the left, and if it's too light, by clipping on the right. This will become easier to understand as we look at well-exposed and poorly-exposed images. Check out the histogram basic tutorial in *figure 12*; then we'll look at things in more detail.

When you see the three histograms next to each other, does it make more sense? See how the underexposed histogram is all the way to the left of the histogram window and clipped mid-peak? Then note the well-exposed histogram, and how both edges of the histogram just touch the edges of the histogram window.

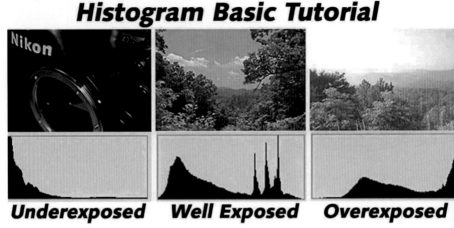

Figure 12 – Three histograms – underexposed, correct, overexposed

Finally, see how the overexposed image's histogram is crammed and clipped on the right. I hope this helps somewhat! Now let's look at some histogram detail.

Image and Histogram Shape

Look at the image in *figure 13*. It is well exposed, with no serious problems. The entire light range of this particular image fits within the histogram window, which means that it is neither too light nor too dark and will take very little or no adjustment to view or print. It contains no more than 4 or 5 stops of light range.

Look at the left side of the histogram graph in *figure 13*. See how it does not cram itself against the dark value side? In other words, the dark values are not clipped off on the left. This means that the camera recorded all the dark values in this image, with no loss of shadow detail.

Then look at the right side of the histogram graph and note that it is not completely against the right side, although quite close. The image contains all the light values available. Everything in between is exposed quite well, with full detail. A histogram does not have to cover the entire window for the exposure to be fine. When there is a very limited range of light, the histogram may be rather narrow.

The image in *figure 13* is a relatively bland image with smooth graduations of tone, so it makes a nice smooth mountain peak histogram graph. This will not occur every time because most images contain quite a bit more color information. Each prominent color will be represented with its own peak on the histogram graph. The most prominent colors will have higher peaks, while the less prominent will have lower or no peaks.

As we progress into examples with more color or light information, you'll see that the histogram looks quite different. Look at the image in *figure 14*. This is an image that far exceeds the range of the D90's digital sensor.

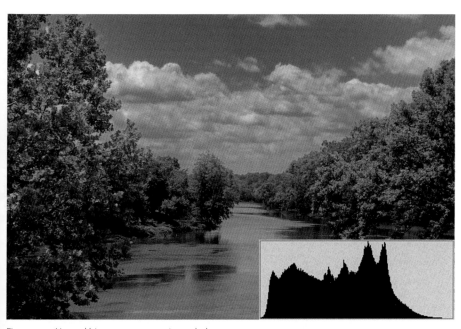

Figure 13 – Normal histogram mountain peak shape

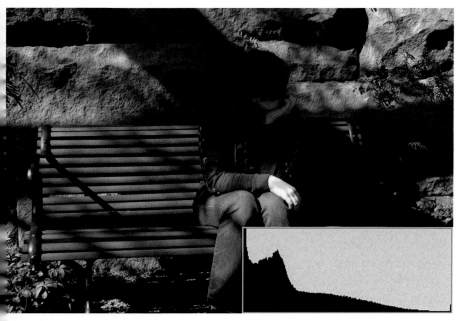

Figure 14 – Underexposed histogram

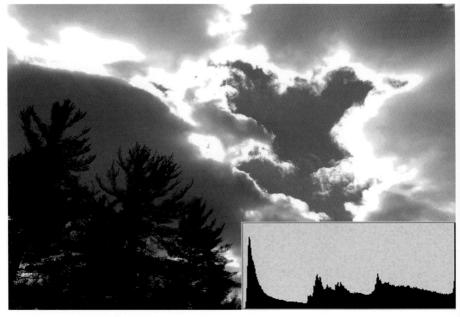

Figure 15 – Overexposed histogram

Notice that, overall, this image is dark and appears underexposed. The histogram in *figure 14* is crammed to the left, effectively being clipped off there. There are no gradual climbs like on a mountain range, from valley to peak and back to valley. Instead, the image shows up on the left side in mid-peak, meaning it is "clipped." This is an underexposed image and the histogram reflects that well.

The most important thing to understand when you see a histogram like the one in *figure 14*, with part of the peak and valley clipped off on the left, is that *some or all of the image is underexposed*.

Now look the image in *figure 15*. In this image, a larger aperture was used and more light was allowed in. We can now see much more detail. However, once again, the range of light is too wide for the sensor, so it is now clipped off on the

highlight side (right). The dark-side graph value is not clipped; instead, the graph extends to the left dark-side edge but stops there.

The image in *figure 15* shows more detail, but it's not professional looking and will win no awards. The range of light is simply too wide to be fully recorded. Many of the details are overly light, and this can be seen by the histogram's clipping on the right side. The most important thing to remember with this image's histogram is that when you see a histogram that is crammed all the way to the right and is therefore clipped, *some or all of the image is too light*. Overall, a great deal of the image in *figure 15* is recorded as pure white and is permanently lost. In other words, it is "blown out."

It is important that you try to center the histogram without either edge being clipped off. This is not always possible since there is often too wide a light range and the sensor or histogram window can't contain it. If you center the histogram, your images will be better exposed. If you take a picture and the histogram graph is shifted far to the left or right, then you can then retake it, exposing in the direction of the opposite light value.

If the light range is too wide to allow centering the histogram, you must decide which part of the image is more important, the light or dark values. Does that make sense? You must expose either for the highlights or the dark values, for you will lose detail in one or the other. Which is more important, the dark areas or the light areas?

How Does the Eye React to Light Values?

The D90 camera with its imaging sensor and glass lenses is only a weak imitation of our marvelously designed eye and brain combination. There are very few situations in which our eyes cannot adjust to the available light range. So, as photographers we are always seeking ways to record even a small portion of what our eyes and minds can perceive.

Since our eyes tend to know that shadows are black, and we expect that, it is usually better to expose for the highlights. If you see dark shadows, that seems normal. We're simply not used to seeing light that's so bright that all detail is lost. An image exposed to maintain the dark values will look strange because most highlight detail will be burned out.

Your eye can see a *huge* range of light in comparison to your digital sensor. The only time you will ever see light values that are so bright that detail is lost is when you are looking directly at an overwhelmingly bright light, such as the sun. So, in a worst-case scenario, expose the image so that the right side of the histogram just touches the right side of the histogram window and the image will appear more normal.

Since photography's beginning we have fought with limitations of being able to record only a limited range of light. But with the digital camera and its histogram, we can now see a visual representation of the light values and can immediately approve of the image, reshoot it with emphasis on lighter or darker values, or see that we must use a filter or multiple-exposure high dynamic range (HDR) imaging to capture it at all.

Computer Adjustment of Images

Looking at the image in *figure 16*, taken in mid-day overhead sunshine, you see an example of a range of light that is too great to be captured by a digital sensor but is exposed in such a way that we can get a usable photo later.

Notice in *figure 16's* histogram how the dark values are clipped off and dark detail is lost. But look to the right side of the histogram and notice how the light values are not clipped off. This shows that the camera recorded all the light values but lost some dark values. Since our eye sees this as normal, this image looks okay.

If we were standing there looking at the cabin ourselves, our eyes would be

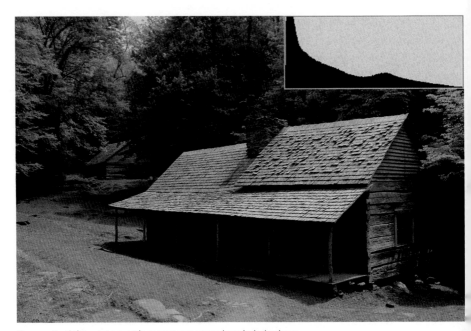

Figure 16 – Cabin picture with correct exposure, but dark shadows

able to see much more detail in the front porch area. But the camera just can't record that large a light range. If we want to get a bit more detail in the shadows than this image seems to contain, we can do it. Normally, a camera doesn't give us enough control to add light values on the fly, so we use the histogram to get the best possible exposure and then adjust the image later in the computer. Some cameras can be "profiled" to capture light ranges more effectively in one direction or the other, but when you push one area, then the opposite area must give. We need a way to take all this light and compress it into a more usable range.

We are now entering the realm of post-processing, or of in-computer image manipulation. Look at the image in *figure 17*. This is the exact same image as the one in *figure 16* but it has been adjusted in

Photoshop to cram more image detail into the histogram by compressing the mid-range values. Notice that the entire histogram seems to be farther right toward the light side. Also notice that the mid-range peaks are basically gone. We removed a good bit of the mid-range, but since there was already a lot of mid-range there, our image did not suffer greatly.

How this computer post-processing was done is outside the scope of this book, but it is not very difficult. This can by carried out using a graphics program designed for photographers, such as Nikon Capture NX2, Photoshop, Photoshop Elements, Lightroom, etc. Your digital camera and your computer are a powerful imaging combination—a digital darkroom where you are in control from start to finish, from clicking the shutter to printing the image. But,

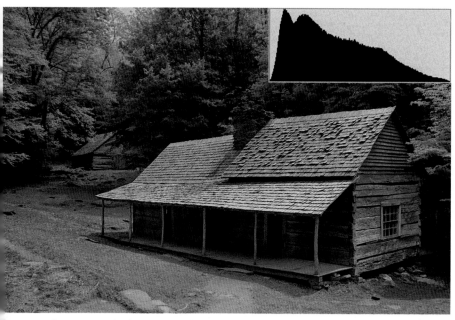

Figure 17 – Post-processed cabin picture with correct exposure, and lightened shadows

etreating from philosophy, let's continue with histogram exploration.

Notice in *figure 17* how the histogram dge is just touching the highlight side of he histogram window? A small amount f clipping is taking place, and you can see he slightly blown-out area on the peak of he cabin's roof. Sometimes a very small mount of clipping does not seriously arm the image. The photographer must e the judge.

The increase in apparent detail in this nage is the result of compressing the id-range of the light values a bit in the mputer. If you compress or make the id-range light values smaller, that will nd to pull the dark values toward the ght side and the light values toward e dark side, resulting in more appar-t detail in your image. It's like cutting section out of the middle of a garden

hose. If you pull both of the cut ends together, the other two ends of the hose will move toward the middle and the hose will be shorter overall. If you compress or remove the mid-range of the histo-gram, both ends of the graph will move toward the middle. If one end of the graph is beyond the edge of the histogram window, or is clipped off, it will be less so when the mid-range is compressed.

We are simply trying to make the histo-gram fit into the frame of its window. If we have to cut out some of the middle (to bring both ends into the window), there is usually plenty in the middle to cut out, so the image rarely suffers. Remember, this is being done outside of the camera on a computer. You can't really control the in-camera histogram to compress values, but you need to be aware that it can be done on the computer so that you can

expose accordingly with your camera's histogram. Then you will have the option for later post-processing of the image in your computer.

In fact, now that we have compressed the mid-range values, the image in *figure 17* more closely resembles what our eye normally sees therefore it looks more normal to us.

You have even more flexibility by choosing to shoot in NEF/RAW mode. Check page 62 of the User's Manual for more details on combining both RAW and JPEG images in a single shot.

A RAW digital image contains an adjustable range of light. With a RAW image, you can use controls in Capture NX2, Photoshop, or even the basic Nikon Picture Project software included with the D90, to select from the range of light within the big RAW image file. It's like moving the histogram window to the left or right over all that wide range of RAW image data. You select a final resting place for the histogram window, capture the underlying RAW data, and then your image is ready for use.

This is a serious oversimplification of the process but, I hope, makes it more understandable. In reality, the digital sensor records a wider range of light than you can use in one image. While you might be able to use about 5 stops of light range in a normal image, the digital sensor is probably recording about 7 stops of light range. You just can't get all of that range into the final image. It is there in the RAW file as a selectable range. I prefer to think of it as a built-in bracket because it works the same way.

This bracketed light range within the image is present to a very limited degree in JPEG, and a bit more in TIFF images, but is the most pronounced in pure RAW images. That is why many choose to shoot in RAW mode instead of JPEG or TIFF.

Summary

The Nikon D90 has a Multi selector rocker thumb switch that can be pressed right or left to scroll through the images you have already taken. You can also press the Multi selector switch up or down to scroll through the various informational modes, such as the histogram screen. When you take a picture of an important subject, find the histogram view of your image. If you can't find the screen with multiple histograms as shown in *figure 10*, see the *Playback Menu – Display mode* and select *RGB histogram*. (For more information, see chapter 5, "Playback Menu.")

Your camera meter should be used to get the initial exposure only. Then you can look at the histogram and see if the image's light range is contained within the limited range of the sensor. If it is clipped off to the right or the left, you may want to add or subtract light with your +/- EV compensation button or use your manual mode. Expose for the light range with your histogram. Let your light meter get you close, then fine-tune with the histogram.

There are also other LCD viewing modes that you can use along with the histogram, such as the *Highlights* (blinky mode for blown-out highlights (see the *Playback Menu – Display mode* and select

Highlights). This causes your image to blink from light to dark in the blown-out highlight areas, which is a rough representation of a highlight-value clipped histogram and is useful for quick shooting. Using your camera's light meter, histogram, and the highlight burnout blinky mode together is a very powerful method to control your exposures.

If you master this method, you will have a very fine degree of control over where you place your image's light ranges. This is sort of like using the famous black and white Ansel Adams Zone System but it is represented visually on the LCD of your D90.

The manipulation of the histogram "levels" in-computer is a detailed study in itself. It's part of having a digital darkroom. Learn to use your computer to tweak your images and you'll be able to produce superior results most of the time. More importantly, learn to use your histogram to capture a nicely balanced image in the first place!

Your histogram is simply a graph that allows you to see at a glance how well (or poorly) your image's light values were captured by your camera. Too far left and the image is too dark—too far right and the image is too light. Learn to use the histogram well and your images are bound to improve!

White Balance

The human eye and brain can adjust to virtually any lighting situation.

Let's say you're reading a book with an old-fashioned incandescent light bulb in your lamp. You probably won't notice that the normally white pages of your book have a warm orange tint. Your brain adjusts your color perception so that the pages of the book look white to your eye. If you take your book outside and sit under a tree in the shade, the color of the light is now a cool bluish, yet your eyes keep right on perceiving the book's pages as white.

Every light source has a different color. If you're taking pictures in direct sunlight and suddenly a cloud's shadow covers your subject, there is a difference in the color of the light. This is referred to as the *color temperature* of the light. Your brain adjusts automatically to various color temperatures and you perceive everything with normal colors, no matter what the light source.

Unfortunately, a camera does not have the power of your brain. The Nikon D90 has an auto white balance setting that does its best to adjust to the current lighting color temperature, and most of the time it does a good job. However, sometimes it needs a little help, especially when you want very consistent results.

It will significantly benefit your photography to understand how the white balance features of your camera operate. Let's consider them in detail.

How does White Balance (WB) Work?

Normally, the WB settings are used to adjust the camera so that whites are truly white and other colors are accurate under whatever light source you are shooting. You can also use the white balance controls to deliberately introduce color casts into your image for interesting special effects.

Camera WB color temperatures are exactly backwards from the Kelvin scale we learned in school for star temperatures. Remember that a red giant star is "cool" while a blue/white star is "hot." The WB color temperatures are backwards because the camera's WB system is adding color to make up for a deficit of color in the original light of the subject.

For instance, under a fluorescent light, there is a deficit of blue, which makes the image appear greenish yellow. When blue is added, the image is balanced to a more normal appearance.

Another example might be shooting on a cloudy, overcast day. The ambient light could cause the image to look bluish if left unadjusted. The WB control in your camera sees the "cool" color temperature and adds some red to "warm" the colors a bit. Normal camera WB on a cloudy overcast day might be about 6000 kelvin (K).

Just remember that we use the real Kelvin temperature range in reverse and that warm colors are considered reddish while blue colors are cool. Even though this is backwards from what we were taught in school, it fits our situation better. Blue seems cool while red seems warm to photographers! Just don't let your astronomer friends convince you otherwise.

> **Main Point**
> Understanding WB in a simplified way is simply realizing that light has a range of colors that go from cool to warm. We can adjust our cameras to use the available light in an accurate, neutral, "balanced" way that matches the actual light source or we can allow a color cast to enter the image by unbalancing the settings.
>
> We will discuss these options from the standpoint of the Nikon D90's camera controls and how they deal with WB.

Color Temperature

The WB range, as allowed by the D90, can vary from a very cool 2500 K to a very warm 10000 K.

Figure 1 shows the same picture adjusted in Photoshop to three WB settings manually: 2500 K, 5000 K, and 10000 K. Notice how the 2500 K image is much bluer or cooler than the 10000 K image. The 5000 K image is about right for the picture's actual daylight. The 10000 K image is much too warm.

In the good old film days, many of us used daylight-balanced film and an 81A filter to warm up our subjects. Or maybe we added a filter to put some blue in on a foggy day to make the image feel cold and foreboding. You can get the same results with the hard-coded white balance settings built into the D90.

To achieve the same effect as daylight film and a warming filter, simply select the *cloudy* white balance setting while shooting in normal daylight. This sets the D90 to balance at about 6000 K and makes nice warm-looking images. If you want to really warm the image up, set the controls to *shade*, which sets the camera to 8000 K.

On the other hand, if you want to make the image appear cool or bluish, try using the *fluorescent* (4200 K) or *incandescent* (3000 K) settings in normal daylight.

Remember, the color temperature shifts from "cool" values to "warm" values. The D90 can record your images with any color temperature from 2500 K (very cool or bluish) to 10000 K (very

Figure 1 – Same image with different WB settings

warm or reddish) and any major value in between. There's no need to carry different film emulsions or filters in order to deal with light color range. The D90 has very easy-to-use color temperature controls and a full range of color temperature settings available.

There are two methods of setting the WB on the D90. (User's Manual pages 95–107):

- Manually setting WB using the WB button
- Manually setting WB using the rear LCD menu and selecting options.

We'll consider each of these methods in the following sections since you may prefer to use different methods according to the time you have to shoot and the color accuracy you want. Most critical photographers will use method 2, the PRE measurement method.

Method 1 – Manually Setting White Balance Using the WB Button

Sometimes you might simply want to control the WB in a totally manual way. This method and the next are basically the same, only one is set using buttons and dials while the other is set using menu options.

Each method will allow you to set a particular WB temperature. If you want your image to appear cool, medium, or warm, you can set the appropriate color temperature and take the picture; then look at the image on the LCD. *Figure 2* shows the external camera controls used to adjust WB.

WB Button

Here is how to manually choose a WB color temperature value using the WB button, the *Main command* dial, and the Control Panel LCD:

1. Press and hold the WB button on the top left of your D90 (see *Figure 2*).
2. Rotate the *Main command* dial. Each click of the dial will change the display to one of the symbols in the chart below. They'll appear in sequence on the Control Panel LCD. (User's Manual pages 128–130.) These symbols, options, and their Kelvin values are as follows:

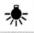 Auto White Balance, 3500-8000K.

 Incandescent, 3000K.

 Fluorescent, 4200K.

 Direct Sunlight, 5200K.

 Flash, 5400K.

 Cloudy, 6000K.

 Shade, 8000K.

 K, Choose your own color temp from 2500 to 10000K.

PRE PRE, Use to measure WB for the actual ambient light. If no measurement is taken, the value used is whatever was last stored in camera memory location *d-0*.

Manually Selecting a Color Temperature between 2,500 and 10,000 K

The K, or choose color temp., selection is a flexible one that allows you to select a WB value manually between 2,500 and 10,000 K. Once you have selected the K symbol by holding down the WB button and rotating the rear main-command dial, you rotate the front sub-command dial to select the actual WB temperature you desire.

Measuring Actual Ambient Light and Using PRE (PrE)

This method allows you to measure ambient light values and set the camera's WB. It's not hard to learn and is very accurate since it's an actual through-the-lens measurement of the Kelvin temperature of the source light. You'll need a white or gray card to accomplish this measurement.

How to select the PrE white balance measurement method:

1. Press and hold the WB button.
2. Rotate the rear command-dial until PRE shows in the lower-right portion of the control Panel LCD. You'll also see *d-o* in the upper-left corner of the LCD
3. Release the WB button.
4. Press and hold the WB button again until the *PrE* starts flashing.
5. Point the camera at a white or neutral gray card in the light source in which you will be taking pictures. It does not have to focus on the card, just pointed at it so that it fills the frame.

6. Press the shutter release fully as if you were photographing the white card. It will fire the shutter, but nothing will appear on the main image-viewing LCD.
7. Check the control panel LCD on top and see if *Good* is flashing.
 If you see *no Gd* flashing, instead of *Good*, then the operation was *not* successful (see *figure 3*).

The PrE measurement is very sensitive because it is using the light coming through the lens to set the WB. Unless you are measuring in an extremely low light level, it will virtually always be successful.

Please remember that the flashing *Good* means a successful WB reading was taken and your camera is now color-balanced for that light source. If you do not see a flashing *Good* but instead see a flashing *no Gd*, the operation was unsuccessful and the light may not be bright enough to take an accurate WB reading.

Figure 3 – PrE, Good, and *no Gd* on top control panel LCD

Storing White Balance Values for Future Use

In step 2 earlier, I mention *d-0* in the upper-left corner of the control panel LCD during a WB measurement. This *d-0* indicates where the current WB value is stored. The other memory locations, *d-1* to *d-4*, are four locations that you can use to store WB values you regularly use. Later you can copy a value stored in *d-1* to *d-4* back into *d-0*.

If you have previously used the manual "measured" PRE method to set the WB, you will have a value already in WB memory location *d-0*. You can keep up to five WB values stored in your D90. In *d-0*, you'll find the current PRE WB, and in *d-1* through *d-4* you'll find any stored WB values. They appear as tiny images, as shown in *figure 4*.

If you shoot under a certain light source on a frequent basis, such as in a studio, you may want to store one or more of your PRE set white balance values in one of the four permanent storage areas in your camera (*d-1* to *d-4*).

I tried to do a white balance measurement directly into *d-1* to *d-4* by selecting one of the memory locations before doing the light measurement. However, my values did not show up in *d-1* to *d-4* but instead overwrote the value in *d-0* each time. It is only possible to *copy* a value from *d-0* into one of the other four storage locations. I suppose Nikon was concerned that one might accidentally overwrite a carefully prepared white balance setting, so it added a copy step between the measurement and long-term storage.

In effect, you may have up to five white balance values stored in your camera. One is the current temporary setting (*d-0*), and the other four are in memory for longer-term reuse (*d-1* to *d-4*). In *figure 5* are the steps and shooting menus used to copy the current white balance value in location *d-0* to one of the other four areas. You'll see a visual representation—a tiny picture—of the stored WB values. If there is nothing stored in *d-1* through *d-4*, there will only be a blank spot above the number (see *figure 4*).

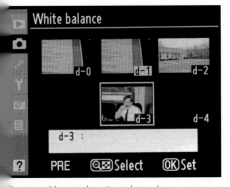

Figure 4 –Memory locations *d-0* to *d-4*

Saving a Current WB Reading to Memory Locations d-0 to d-4:

1. Use method 1 to obtain a *Good* PRE white balance readi ng. It will automatically be placed in memory location *d-0*.

2. Use the screens in *figure 5* to find the current *d-0* value.

3. Select a blank memory location (*d-1* to *d-4*) or one that you want to overwrite (*figure 6, image 1*), and press the ISO-thumbnail/playback zoom out button. (See page 5 of the D90 User's Manual for button names.)

4. As shown in *figure 6, image 2*, select the menu selection *Copy d-0*, and press the *OK* button. You'll then see that *d-0* has written a copy of itself into the memory location you selected.

Optional: As shown in *figure 7*, rename the memory location that you just stored by selecting it with the ISO–thumbnail/playback zoom out button and then selecting *Edit comment* from the menu. Change the name of the memory location to something that will remind you of its use, if you'd like, by using the following steps.

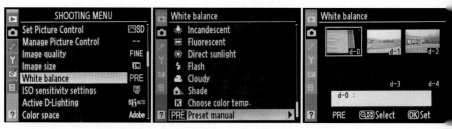

Figure 5 – Menus to access *d-0* through *d-4* screen

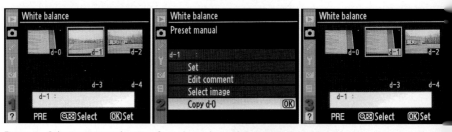

Figure 6 – Select a memory location from *d-1* to *d-4*, and then copy *d-0* contents.

Figure 7 – Renaming a memory location by using *Edit comment*

When you have the character selection screen open (see rightmost image in *figure 7*), do the following:

1. Use the thumb multi selector button to scroll through the character list and select a character to add.
2. Press QUAL–playback zoom in button to add the selected character to the comment.
3. Continue selecting characters until the comment is complete.
4. Press the *OK* button to save the memory location comment.

Note

The blank space character is on the top left of the list of characters.

To change or delete characters, do the following:

1. Hold the ISO–Thumbnail/playback zoom out button down.
2. Toggle to the left or right with the thumb multi selector switch until the small yellow cursor is over the character you want to change.
3. Release the ISO–Thumbnail/playback zoom out button.
4. Press the delete button (garbage can on top left of camera) to delete the current character.
5. Use the thumb multi selector button to scroll through the list of characters and select a replacement character.
6. Press the QUAL–playback zoom in button to add the selected character to the comment.
7. Press the *OK* button to save the memory location comment.

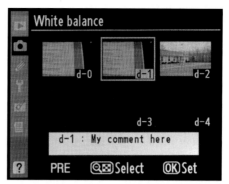

Figure 7A –A comment added to a WB memory location *d-1*

The comment you just created will show up on the bottom of the LCD screen next to the currently selected memory location name, as shown in *figure 7A*. The name of the actual memory location *d-1* to *d-4* will not change.

Using the Values Stored in Memory Locations d-0 to d-4

Once you've written a WB value to one of the memory locations *d-1* to *d-4*, it will remain there for future use as needed. You can access any of the saved WB values by selecting PRE with the WB button and then rotating the front sub-command dial until you find the one you want (*d-0* to *d-4*). Or you can use the menus to directly select the specific memory location (see *figure 5*).

Storing and Selecting the White Balance from a Previously Taken Image

It is also quite possible to select a white balance value from an image you have already successfully taken. This image's value can be applied to the image you are about to take, or it can be copied to *d-1* through *d-4,* using the method described earlier, for use later.

Here are the steps and shooting menus to recover the white balance from an image already taken and stored on your Compact Flash (CF) memory card:

1. Use the *Shooting Menu* screens shown in *figure 5* to get to the *d-0* through *d-4* memory location screen (*figure 8*).

2. Use the thumb toggle switch to select the memory location you want to set with the value from an image. You must select *d-1* through *d-4* only. You can't use *d-0* for this operation. Press the ISO–Thumbnail/playback zoom out button to select the memory location you want to replace.

3. As shown in *figure 8, image 2,* scroll down and choose *Select image.* It will be grayed out if there are no images on your current CF card.

4. Scroll to the right on *Select image* and you'll see the image selection screen, shown in *figure 8, image 3.*

5. Toggle through the available images with the thumb multi selector button until you find the one you want to use for white balance information.

6. Press the *OK* button and a small thumbnail of the image will show under the selected white balance memory location (*d-1* to *d-4*).

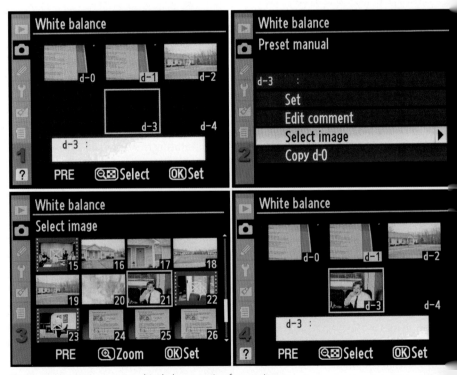

Figure 8 – Menus to recover a white balance setting from an image

Note

Some images in the list of images might have a small box with an X in it. You will not be able to select these images for WB information. These are movie files, not images. Movie files cannot be used to select a WB color temperature because the WB varies constantly during a movie's recording time.

Customizing Your White Balance

If you feel that one of the D90's preset values is not exactly what you would like it to be, you can fine-tune the color temperature values for that preset by adjusting it along the horizontal or vertical color directions. (User's Manual pages 97–98)

Method 2 – Manually Setting White Balance Using the Rear LCD Menu and Selecting Options

This method is similar to method 1, but you use camera *Shooting Menu* screens to select the WB range. Instead of using the WB button and the main-command dial, you'll open up your menus and set the WB by selecting from them.

Figure 9 shows the steps to set the WB selection in your D90's *Shooting Menu*.

Normally, you'll use only the first two screens to set one of the preset WB values, such as *Cloudy*, *Shade*, or *Direct Sunlight*, and then you'll just press the *OK* button on the final screen without changing anything.

One of methods used in measuring color temperatures uses micro reciprocal degrees, and it is commonly referred to by the abbreviation *mired*.

If you choose to fine-tune any of the color temperature settings after you have

selected one of the preset WB values, the last menu screen shown in *figure 9* allows you to do so by "mired" clicks. Each press of the thumb multi selector button is equal to five mired each in the four color directions. Up is green (G), down is magenta (M), left is blue (B), and right is amber (A). For Nikon's technical information on what *mired* means, see your D90 User's Manual on the bottom of page 98.

If you aren't familiar with adjusting a preset's default color temperature, or you don't want to change it (most won't), then simply press the *OK* button without moving the little square from the center. If you've accidentally moved it, simply move it back with the thumb multi selector button until it's in the middle again, then press *OK*, which will select the preset WB value you wanted to use without modifying its default value. (The example default value is Flash at 5400 K.)

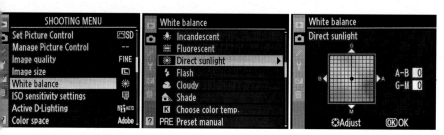

Figure 9 – Screens to set WB via camera menus

Review: The steps to set the preset you want to use are as follows (see *figure 5*):

1. Select *White balance* from the *Shooting Menu*, and then scroll right to the next screen.
2. Select one of the preset values, such as *Flash* or *Cloudy*, and then scroll right to the next screen.
3. Press *OK* immediately, without moving the little square from its center position.

That's all there is to selecting a preset WB from within the *Shooting Menu* system. The only difference is that by doing it this way, you can fine-tune the color temperature values in the third screen shown in *figure 9*.

If you do decide to fine-tune a WB preset, an asterisk will appear next to the *Shooting Menu* white balance symbol for that preset. You'll see this symbol on the main *Shooting Menu* screen, to the right of the symbol for that WB preset.

Recommendation

I normally do not use method 2 because method 1 allows me to select a preset WB value without accidentally modifying the settings of its default color temperature and doesn't require me to use the menus. I find that method 1 is much faster than using the *Shooting Menu*. Since I am using external camera controls, it takes only seconds to set the values, or even do a PRE reading of ambient light.

Note

You cannot do a PRE ambient light reading from the Shooting Menu. Instead, you must do the reading of ambient light using method 1. Later you can select one of the PRE values d-0 to d-4 from the Shooting Menu if you'd like.

White Balance Bracketing

WB bracketing is similar to flash or exposure bracketing. If you want to use bracketing, you must change *Custom Setting e4 (Auto bracketing set)* from *AE & flash* (default) to *WB bracketing*. This means that flash or exposure bracketing will not work during the time *e4* is set to WB bracketing. (User's Manual pages 191–195)

Recommendation

Personally, I prefer to shoot in RAW mode (NEF files) and make minor or major WB adjustments in the computer post-processing stage of the image's preparation. However, since others want to use WB bracketing and Nikon has given it to us, so let's consider it.

WB Bracketing and RAW Mode

WB bracketing does not work when your camera is in RAW mode! If you are shooting in RAW, the BKT button does not activate the bracketing system on the top control panel LCD.

Figure 10A – Camera controls for white balance bracketing

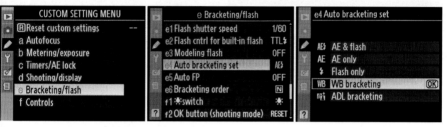

Figure 10B – Menu controls for white balance bracketing

In *figure's 10 A and B,* you can see the controls and menus used to set up WB bracketing.

Here are the steps to set up WB bracketing:

1. Set *Custom Setting e4* to *WB bracketing* (see *figure 10B* and the D90 User's Manual, page 191).
2. As shown in *figure 11*, choose the number of shots in the bracket by pressing and holding the *BKT* button next to the D90 label on the front of the D90. Turn the rear main-command dial to select the number of shots in the bracket.

Figure 11 – Top control panel LCD showing number of shots

There are four potential image sequence settings in the bracket, each being represented by a certain code for a certain number of shots, with a certain color change. Here are the selections:

- *oF* – The bracket is not set up and only one normal image will be taken.
- *B2F* – Two shots, normal exposure, and extra blue shot (cooler).
- *A2F* – Two shots, normal exposure, and amber shot (warmer).
- *3F* – Three shots, normal, amber, blue (normal, warm, cool).

3. Now that you have selected the number of shots, you must select the range of color change in "mired" values. Select the WB color temperature increment by pressing and holding the function *BKT* button and rotating the front sub-command dial. Choose 1, 2, or 3 (1=5 mired,

2=10 mired, 3=15 mired). The D90 will expose the sequence of shots over and under according to what you've selected in step 2 (*figure 12*).

4. Take the entire WB bracketed picture sequence by pressing the shutter release button *once*.

Figure 12 – Top control panel LCD showing color increment value

Press Once for Bracketed Images

There is no need to press the shutter release button more than once to get the bracketed sequence of images. The highly sophisticated D90 knows the number of images you want in the bracketed sequence and takes them all with one press of the shutter release button. If you have the WB bracket set to 3F, the D90 actually takes only a single picture and then saves it to the memory card into three separate pictures, each with a different white balance. If you had 20 pictures on your card, when you press the shutter button once, you will then have 23 pictures on the card. Three pictures in one shutter press! Be careful that your bracket sequence will not fill up your memory card. If you are shooting 3F with its resulting three pictures and you have room on your card for only two pictures, the D90 will disable the shutter release and flash *FULL* on the top control panel LCD. If this happens, simply insert a new memory card and shoot the sequence again.

Auto White Balance

Auto WB works pretty well in the D90. As the camera's RGB meter senses colors, it does its best to balance to any white or mid-range grays it can find in the image. However, the color may vary a little on each shot. If you shoot only in auto WB mode, your camera considers each image a new WB problem and solves it without reference to the last image taken. Therefore, there may be variance in the color balance of each image with Auto WB.

The Auto WB setting also has the fine-tuning screen mentioned in method 2 earlier. When you select *AUTO*, you can toggle to the next screen and fine-tune the colors. I don't see how that is particularly useful because each image is likely to have slightly different color temperatures to deal with, so the fine-tuning would have little value for more than an image or two. If you were shooting in the exact same light for a period of time, I suppose the fine-tuning would be useful, but wouldn't it make more sense to do a PRE reading of the light for exact WB? Maybe you can figure out what *AUTO* and fine-tuning have in common. I can't.

My Opinion About Auto WB

If you are concerned with a series of images having the same color settings so that they look similar and require no extra post-processing, it is best to actually adjust the WB to one of the preset or measured values, then each image taken will have the same color balance. Auto WB takes control of the image away from you! The D90 is very good at auto WB, but I still shoot at a predefined WB setting most of the time. Call me old-fashioned!

If you are not overly concerned with having your white balance consistent from image to image, then leave it set to Auto WB and go shoot pictures. The AUTO setting will give you excellent results 98 percent of the time, with a little variation in the white balance of each picture.

If I'm at a party shooting images of friends for small snapshot prints, I'll often put my camera in Auto WB and program P exposure mode. Then, I'll just take lots of pictures without worrying about a thing. However, if I'm shooting for commercial reasons, or have a need for maximum image quality, I use a gray or white card and balance my camera to the available light. I only rebalance if the light source changes.

Should I Worry About White Balance If I Shoot in RAW Mode?

The quick answer to the question above is no, but maybe it's not the best answer. When you take a picture using RAW mode (creating NEF files), the sensor image data has no WB, sharpening, or color saturation information applied. Instead, the information about your camera settings is stored as "markers" along with the RAW black and white sensor data. Color information is only applied permanently to the image when you post-process and save the image in another format, like JPG, TIF, or EPS.

When you open the image in Nikon Capture NX2, or another RAW conversion program, the camera settings are applied to the sensor data in a temporary way so that you can view the image on your computer screen. If you don't like the color balance or any other setting you used in-camera, you simply change it in the conversion software and the image looks as if you originally used the new settings when you took the picture.

Does that mean I am not concerned about my WB settings, since I shoot RAW most of the time? No. As mentioned at the beginning of this chapter, the human brain can quickly adjust to an image's colors and perceive them as normal, even when they are not, which is one of the dangers of not using correct WB. Since

an unbalanced image on-screen is not compared to another correctly balanced image side-by-side, there is a danger that your brain may accept the slightly incorrect camera settings as normal and your image will be saved with an undesirable color cast.

Use your WB correctly at all times and you'll make better images for it. You'll do less post-processing work if the WB is correctly set in the first place. As RAW shooters, we already have a lot of post-processing work to do on our images. Why add WB corrections to the workflow?

Additionally, you might decide to switch to JPEG mode in the middle of a shoot, and if you are not accustomed to using your WB controls, you'll be in trouble. When you shoot JPEGs, your camera will apply the WB information directly to the image and save it on your card... *permanently*. Be safe and always use good WB technique!

White Balance Tips and Tricks

Tips for using a gray/white card: When measuring WB with a gray or white card, keep in mind that your camera does not need to focus on the card. In PRE mode, it will not focus anyway because it is only trying to read light values, not take a picture. The important thing is to put your lens close enough to the card to prevent it from seeing anything other than the card. Three or four inches (about 75 to 100 mm) away from the card is about right for most lenses.

Also, be careful that the source light is not casting a shadow from the lens itself onto the card in such a way that some of the shadow can be seen through your lens. This will make the measurement less accurate. Be sure that your source light does not make a glare on the card, which is a little harder to do since the card has a matte surface, but it still can be done. You may want to hold the card at a slight angle to the source light if it is particularly bright and might cause glare.

Finally, when the light is dim, use the white side of the card since it has more reflectivity. This may prevent a *no Gd* reading in low light. The gray card may be more accurate for color balancing, but it might be a little dark for a good measurement in dim light. If you are shooting in normal light, the gray card is best for balancing. I doubt it makes much difference, however, you might want to experiment in normal light with your camera and see which you prefer.

Summary

Pages 95 to 107 of your D90's User's Manual have extensive WB information. By using the simple tips in the preceding section and studying the manual a little, you can become a D90 WB expert. Learn to use the color temperature features of your camera to make superior images.

You'll be able to capture very accurate colors or make pictures with intentional color casts that reflect how you feel about the image. Practice a bit and you'll find it easy to remember how to set your WB in the field.

Your histogram is simply a graph that allows you to see at a glance how well (or poorly) your image's light values were captured by your camera. Too far left and the image is too dark—too far right and the image is too light. Learn to use the histogram well and your images are bound to improve!

Aperture and Shutter Speed

The Nikon D90 allows you to take excellent pictures without understanding how the aperture and shutter speed works or what a focal length is. You can simply select either aperture-priority auto or shutter priority or just go fully automatic and the camera has you covered. So why have I included a chapter devoted to aperture and shutter speed?

Many D90 owners are interested in going beyond basic photography. Previously, they might have been using a camera with fewer features or even a point-and-shoot model. The D90 is a semiprofessional camera in that it provides a fine degree of control over the final look of the image and is robustly built. Many professionals use the Nikon D90 as a "carry camera" for when they want to go out and shoot for fun, or even as a backup camera in case their main pro-level camera develops a problem.

Since beginners may need a little help with how these most basic of camera and lens functions work, I decided to include this chapter. Even if you feel that you understand the concepts well enough, why not do a quick review? Maybe you'll learn something helpful.

The relationship between the aperture and shutter speed seems to be a difficult thing to understand for quite a few photographers. Yet, it is one of the most important concepts to understand since it significantly affects how an image looks.

In this chapter, we'll look at the aperture and shutter speed settings in a comprehensive way. Then, we'll explore how the relationship between the two settings changes the appearance of an image. Finally, we'll consider how the various focal lengths of your lenses will affect your choice of lens.

Understanding the Camera's Aperture

You've probably read about or seen what's called a pinhole camera. A few years back, many people liked to experiment with them for fun and education. All you needed was a box or tube, a piece of film, and a pinhole to use instead of a lens.

The concept involves fastening a piece of film on an inside wall of a light-proof box and pricking a tiny pinhole in the opposite wall of the box. This will later allow light to shine through the pinhole onto the film on the opposite side. To use the pinhole camera, you temporarily cover the pinhole, take the box out into the sunlight, place it in front of an interesting scene, uncover the pinhole, and leave for while.

When you return, you cover the pinhole, go into a darkroom, cut the box open, and develop the film. If your pinhole was the right size for the amount of time the light was shining on the film through the pinhole, you'll have a nice image taken in a very basic way. If you guessed wrong about the amount of time you let the light shine through the pinhole onto the film, the image will be either over- or underexposed.

It seems a lot easier to use your D90 instead of a pinhole camera, doesn't it? While it might be fun to use a pinhole camera a few times, it certainly wouldn't

allow you to take the wide range of beautiful images you've been getting from your complex digital camera. However, the D90 and the basic pinhole camera work in a similar way. The difference is variability. You can vary the size of the "pinhole" with the D90.

With the pinhole camera, if you wanted to leave the box out in the sun for a longer period, you'd make a very small pinhole so only a little light shines on the film. If you wanted to leave the box out in the sun for a shorter period, you'd make the pinhole bigger so that more light would hit the film. That's the concept of an aperture. It is basically a variably sized pinhole, and you (or the camera) can choose the size. Instead of a hole in a box with film taped to one wall, you have a light-proof camera "box" with a lens that has aperture blades that allow you to vary the size

of the pinhole. Instead of shining light on a piece film, you have a digital sensor.

Figure 1 shows a sample of lenses with the aperture blades set to various aperture sizes. We are looking at the outer end of the lens, which would normally be pointed at the subject.

If you look at the front of your lens, with the lens cap off, you'll see the actual maximum aperture of your camera. Hold your D90 so that you can look from the front of your lens from about half an arm's length away. Make sure that something bright is behind the eyepiece on the back of the camera. You can actually see through the front of your lens, right through the rear eyepiece of the camera. It's sort of like the time you looked through a pair of binoculars backwards when you were a child. Everything was small and distant, but you could see things.

Figure 1 – Aperture variability

The hole you see behind the glass of the lens is the biggest aperture (or largest pinhole) your D90 can use with the particular lens mounted on the camera. Basically, the hole in the lens is your camera's "aperture."

How Does the Aperture Work? – An Experiment

Now, go to an area bright enough that your D90 will *not* need to use the popup Speedlight flash. It's best, for this experiment, if you go outside so that there's a lot of light. Now, I want you to take a picture of your face from an arm's length away. You can keep the picture as an example of how you look while concentrating.

While you take the picture, pay careful attention to the aperture opening you saw earlier. If the light is bright enough you will see the D90 do something quite interesting. At the moment the picture is taken, the camera meters the light and adjusts the aperture size by moving a series of blades around the aperture opening (see *figure 1*). You will see the aperture size change very briefly as the picture is being taken. If there is bright

light outside, the opening will appear to get darker and smaller very briefly.

This aperture opening can be adjusted from large to small so that the amount of light getting into the camera can be accurately adjusted for a correct exposure. The size of that opening—chosen either by you in a manual mode or by the camera in the automatic mode—is referred to as an aperture number.

What Is an Aperture Number?

If you look through the eyepiece of your D90, you can see the shutter speed and aperture shown on the lower-left side of the viewfinder screen. You'll see something like *125* **F***5.6* or *30* **F***3.5* displayed. The number on the left is the shutter speed, and on the right is the aperture size. You'll also see these same characters displayed in the upper-right corner of the control panel LCD on top of your camera.

In *figure 1A* you'll see the two settings from both the viewfinder and control panel LCD.

We'll look at the shutter speed in the next major section of this chapter. For now, let's examine the aperture

figure 1A – Shutter speed and aperture settings

numbering system. This system has evolved through many generations to standardize on what we now commonly refer to as f-stops or f-numbers. The *f* traces its roots to terms such as focal length and focal ratio, and the usual method for referring to a specific aperture setting like the one in *figure 1A* is f/5.6.

If you bought the "kit" version of the Nikon D90, you will have received the AF-S Nikkor 18-105mm f/3.5-5.6 zoom lens with your camera body. You may have chosen a different lens or already had some lenses when you bought your D90. However, for this chapter we'll assume that the 18-105mm is the lens on your camera. Let's talk about aperture numbers for this and other lenses.

I am going to discuss only lenses for normal use on a Nikon D90. There are all sorts of specialty lenses out there with aperture numbers outside the normal range you'll likely use. Most of us will have lenses that run from about f/1.4 to f/32. The AF-S Nikkor 18-105mm f/3.5-5.6 has a range of aperture openings varying between f/3.5 to f/22, although it can actually go all the way down to f/38 when fully zoomed out. What does this mean?

Since it is easier to see, let's look at some aperture openings. In *figure 1B*, you'll see this 50mm f/1.8 lens set to a large aperture of f/3.5, a medium aperture of f/5.6, and a small aperture of f/11.

The aperture number works backwards from what many expect. A big number means a small aperture opening. A small number means a big aperture opening. In *figure 1B*, notice how f/3.5 is a big hole compared to f/11's small hole? The big aperture opening of f/3.5 allows more light into the camera, while the small aperture opening of f/11 allows less light to pass through.

Moving from a large aperture opening to a smaller aperture opening is called "stopping down." The word *stop* comes from the time when we had aperture rings on virtually all our lenses instead of only a few. As you turned the aperture ring, you would feel a click or a stopping point for each aperture. Moving the ring one stop meant moving between these click points by one click. In older lenses, each of the click stops is equal to 1 EV of light transmission—either half or double the brightness according to the direction you turned the ring. Newer manual-use lenses generally have 1/2 and 1 EV click stops as well.

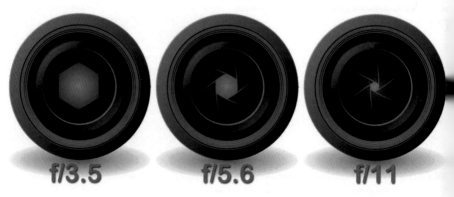

Figure 1B – Aperture settings f/3.5, f/5.6, and f/11

On the left in *figure 1C*, you can see the aperture adjustment ring on my AF Nikkor 80-400mm f/4-5.6 lens, which is designed for use on older and newer cameras. The large arrow points to the ring, while the small arrow points to the ring lock.

In *figure 1C*, the image at right shows a G Nikkor lens, which has no external aperture ring. Most lenses produced today are G-type lenses with no aperture adjustment rings.

If you have an older lens with an aperture ring, you need to set it (and lock it) to its smallest aperture, like f/22, if you want to adjust the aperture using normal camera controls. If you don't lock it to the smallest aperture setting on the lens, your D90 will give you an *FEE* error on its upper control panel LCD and will disable the shutter. Look at your lens, and if it doesn't have an aperture adjustment ring, you don't have to worry about locking it. Yours probably does *not* have an external aperture adjustment ring. Now, back to aperture information.

An aperture opening of f/8 is one stop down from aperture opening f/5.6. F/8 lets in one stop less light than f/5.6,

which simply means that f/8 transmits one-half as much light as f/5.6.

The amount of light entering the camera is measured in stops, or EV steps. EV stands for *exposure value*. You could express this by saying f/5.6 allows 1 EV step more light into the camera than f/8, which is a fancy way of saying that f/5.6 allows twice as much light into the camera as f/8 does.

So 1 EV step, or one stop, is simply a value with one-half or twice as much light as the previous step, depending on which direction you are changing the aperture opening. One stop up allows in twice as much light. For example, opening the aperture from f/8 to f/5.6 allows the camera to receive twice as much light. One stop down reduces the light by one-half. Closing the aperture from f/5.6 to f/8 allows only one-half the amount of light into the camera.

Figure 1B shows the lens "stopping down" from f/3.5 to f/5.6, then to f/11.

When you "stop down" from a large aperture to a smaller aperture, you do so in EV steps, or stops. Here is a list of f/stops for the AF-S Nikkor 18-105mm f/3.5-5.6 in 1/3 or 1/2 EV steps. You

Figure 1C – Manual aperture ring with lock and G lens with no aperture ring

can modify this step value by changing *Custom Setting b1 (EV steps for exposure cntrl.)* to either 1/3 or 1/2. The default is 1/3. We'll consider the various custom controls in detail in Chapter 7, "Custom Settings." Here are the apertures available with your 18-105mm f/3.5-5.6 lens:

Custom Setting b1 set to 1/3 EV step (1/3 of a full stop):

Moving from big aperture (large opening) to small aperture (small opening)

- f/3.5, f/4, f/4.5, f/5, f/5.6, f/6.3, f/7.1, f/8, f/9, f/10, f/11, f/13, f/14, f/16, f/18, f/20, f/22

Custom Setting b1 set to 1/2 EV step (1/2 of a full stop):

Moving from big aperture (large opening) to small aperture (small opening)

- f/3.5, f/4, f/4.8, f/5.6, f/6.7, f/8, f/9.5, f/11, f/13, f/16, f/19, f/22

Each step in the preceding lists lets in either more or less light, depending on which direction you are moving in the list. When you are using aperture-priority auto or manual mode, as discussed in Chapter 2, "Exposure Metering System, Exposure Modes, and Histogram," you'll be able to control the aperture with the sub-command dial on the front of your D90.

Remember that you can buy other lenses that will have a larger maximum aperture, such as Nikon's professional-level AF-S Nikkor 17-55mm f/2.8 lens. These lenses cost more than the D90 itself, sometimes significantly more. What do you get for your money? A bigger maximum aperture that lets in more light for low-light shooting, along with premium lens glass and a more robust lens build (less plastic).

The basic concept to learn and remember about the aperture on the Nikon D90 is that the aperture controls the *amount* of light entering the lens during an exposure. In the next section, we'll also discuss the shutter speed, which allows you to control the other side of the issue—*how long* the light is allowed to enter the camera.

Understanding Depth of Field

Depth of field (DOF) is one of those things that confuse many new DSLR users, yet it is very important! The aperture opening controls the depth of field, or range of sharp focus, in your images. I'm going to attempt to explain this concept with pictures.

Let's say you are taking a picture of a friend, who is standing 6 feet (2m) away from you. About 6 feet behind your friend is another person. There is also a third person standing about 6 feet behind the second person. Imagine three people total, each about 6 feet apart, with the friend in front.

You are shooting with a 50mm f/1.8 lens. You focus on your friend's face, the young lady in red, and take a picture. It looks like the image in *figure 2A*.

Notice in the figure that your friend (in red) is in good focus since the focus is on her face. The girl standing behind her, to the right, is not in focus, nor is the young lad even farther away to the left. This is the result of shooting with a big aperture. F/1.8 is a big opening in the aperture blades of your lens. A large aperture opening causes the depth of field, or zone of sharp focus, to be shallow. Only the girl in front is in focus

at f/1.8. Not much else is in focus, so there is very little depth of field probably something like 1.5 feet (.45m). The zone of sharp focus, or depth of field, is only about 1.5 feet deep.

So what would happen if we made the aperture opening smaller, or "stopped" down," to a medium aperture like f/8? *Figure 2B* shows the resulting depth of field.

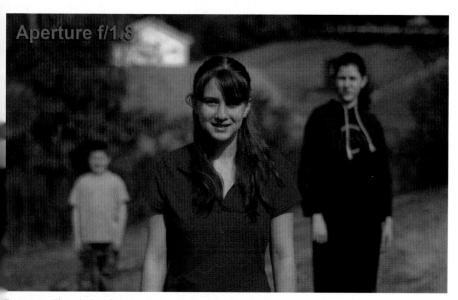

Figure 2A – Three kids at f/1.8 aperture—shallow depth of field

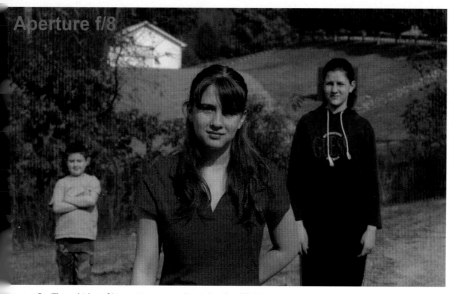

gure 2B – Three kids at f/8 aperture—medium depth of field

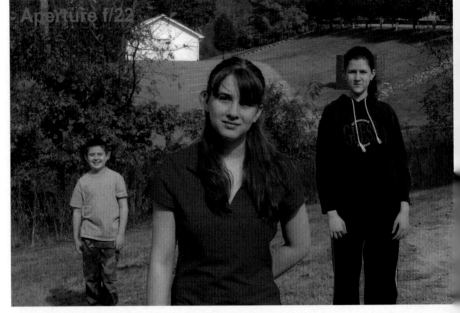

Figure 2C – Three kids at f/22 aperture—deep depth of field

In the previous picture, *figure 2A*, the camera is focused on the young lady in front, and at the large aperture opening of f/1.8, the others were out of focus. In *figure 2B*, without changing the focus in any way, you adjusted your aperture (stopped down) to f/8. Something changed!

Notice, in *figure 2B*, how the girl in front still looks sharp, but now the girl to the right looks sharp too. You focused your camera on the girl in front, but now the girl to the right is in the zone of sharp focus, even though you didn't change your focus point on the first girl's face. The depth of field, or zone of sharp focus, now extends past the girl in front and covers the girl in back. The zone got deeper.

However, also notice that the boy to the left is still not in focus. The background is not in focus either. The depth of field is deeper, but it's still not deep enough to cover all your subjects.

This image is the result of a medium aperture opening (f/8), not large (f/1.8) and not small (f/22). Now, let's consider what happens if we "stop down," or close the aperture to a small opening like f/22.

Aha! Now everything in the picture is sharp. An aperture as slow and small as f/22 makes it easy to get sharp focus. Remember, you focused on the girl in front in all these pictures. At first she was in focus (f/1.8), and as the aperture got smaller, more and more of the surroundings came into sharp focus (f/8 and f/22).

So, *depth of field* is simply the zone of sharp focus. It extends in front of and behind your focused subject and gets

Apertures In Review

An aperture is simply the opening at the front of your lens controlled by blades. It lets light come in through the lens to expose your D90's sensor. You normally can't see the aperture blades when you look into the front of your lens because your D90 allows you to focus with the aperture blades wide open and out of the way. The aperture closes down to its selected setting when you press the shutter release to take your picture, or press the depth-of-field preview button. That's why the viewfinder often gets darker when you press the depth-of-field preview button on your camera. Apertures are referred to with numbers such as f/1.8 or f/4.

Special Note

The aperture on your zoom lens probably starts at about f/3.5 (big aperture) and stops at f/22 (small aperture). You may have heard of a certain lens as being a "fast lens" or heard of a lens disparagingly called a "slow lens." Fast or slow means how large the maximum aperture size is. A fast lens will have a large maximum aperture, like f/1.4, f/1.8, or f/2.8, while a slower lens might have a maximum aperture of f/3.5, f/4, or f/5.6. In the lens world, the larger the maximum aperture, the "faster" the lens and the greater the cost. The 18-105mm f/3.5-5.6 kit lens included with the D90 is a medium-speed lens.

deeper in both directions, toward the camera and away from it, as you "stop down" your lens. If you set your camera to aperture-priority auto (or manual mode), you can adjust this powerful functionality to control what is in focus in your pictures. (See chapter 2.)

Here's a basic exposure rule:

- Aperture = How *much* light comes in.
- Shutter speed = How *long* the light comes in.

Effect of Focal Length on Depth of Field

One other issue to consider is how the focal length of a lens affects depth of field. When you use a wide-angle lens on your D90, such as an 18mm, you have significantly more depth of field available. A wide-angle lens is considered a "short"

focal length. The shorter the focal length, the greater the potential depth of field. If you are using a "longer" lens, such as a telephoto of 105mm, which reaches out and pulls a subject in closer, the depth of field that's available will be considerably more shallow. Longer lenses, because they compress perspective, have a smaller zone of sharp focus. So, if you are interested in maximum depth of field, use the shortest focal length that will cover the subject.

Now, let's move on to a detailed discussion of the shutter speed and how it works.

Understanding the Camera's Shutter Speed

While the camera's aperture is concerned with *how much* light gets to the image sensor, the shutter speed is concerned with *how long* the light shines on the sensor.

Here is a list of many of the shutter speeds available in your D90 with *Custom Setting b1* set to either 1/3 step or 1/2 step EV (fastest speed is 1/4000 of a second, slowest speed is 30 seconds):

Custom Setting b1 set to 1/3 EV step (1/3 of a full stop):

Moving from fast shutter speed to a slow shutter speed (s = second)

- 1/4000s, 1/3000s, 1/2000s, 1/1500s, 1/1000s, 1/750s, 1/500s, 1/350s, 1/250s, 1/180s, 1/125s, 1/90s, 1/60s, 1/45s, 1/30s, 1/20s, 1/15s, 1/10s, 1/8s, 1/6s, 1/4s, etc. to 30s

Custom Setting b1 set to 1/2 EV step (1/2 of a full stop):

Moving from fast shutter speed to a slow shutter speed (s = second)

- 1/4000s, 1/3200s, 1/2500s, 1/2000s, 1/1600s, 1/1250s, 1/1000s, 1/800s, 1/640s, 1/500s, 1/400s, 1/320s, 1/250s, 1/200s, 1/160s, 1/125s, 1/100s, 1/80s, 1/60s, 1/50s, etc. to 30s

What does shutter speed do for an image? It allows you to control movement. A fast shutter speed stops action, while a slow shutter speed blurs movement.

In *figure 3*, you see a small waterfall. The water in the "Fast Shutter" image looks agitated and frozen. It was taken using a shutter speed of 1/250 of a second. Now look at the "Slow Shutter" picture. The water seems to be flowing and has a smooth, more natural appearance. It was taken using a 1/2 second shutter speed. I was shooting from a tripod when I took this picture, so the rocks look about the same in both images. The slower shutter speed is more appropriate for taking this type of image.

Primarily, we use shutter speed to control movement, including camera shake. If you try to handhold your camera at shutter speeds below 1/60 of a second, you may get images that look like the one in *figure 3A*, taken with a shutter speed of 1/10 of a second.

Figure 3 – Fast and slow shutter speeds compared

Figure3A – Handheld at 1/10 of a second. Use a tripod instead!

If you want sharp pictures when you are handholding a camera, you must keep your shutter speed above a minimum number that varies with the steadiness of a person. Most people can handhold a camera and create a relatively sharp image at 1/60 of a second. Some can't! You'll have to try it yourself to see what your limit is. Below those speeds, you must do one of the following:

- Hold your elbows against your chest with your camera at your eye, standing with one foot slightly in front of the other, and several inches apart. (You are steadying yourself.)
- Brace yourself against something like a tree or post.
- Use a tripod or monopod.

Using a tripod is the preferable method of dealing with slow shutter speed camera shake, especially when using long telephoto lenses, which greatly magnify camera shake when photographing distant subjects.

If you are taking pictures of a car race, birds flying, or quickly moving people, you'll need to use a faster shutter speed to stop the action. In *figure 3B*, you see a young woman leaping gracefully into the air. There is no blur or apparent movement in this image, which was accomplished by using a fast shutter speed of at least 1/1000 of a second.

Figure3B – Fast shutter speed stops action! (© Kristian Sekulic)

If you plan to shoot action subjects, you'll need to control the shutter speed. If you set your camera to shutter priority (or manual) mode, you can adjust this powerful functionality to control movement in your pictures. (See Chapter 2.) When you are using shutter priority or manual exposure mode, you'll control the shutter speed by turning the rear main-command dial.

Shutter Speed In Review

A camera's shutter speed is primarily used to keep a moving subject sharp (jumping woman) or to allow it to show motion blur (flowing water). Handholding a camera at slow shutter speeds can lead to blurry pictures. Use a tripod for the sharpest images!

Using the Aperture and Shutter Speed Together for Great Pictures

Now, combining our understanding that the camera's aperture is concerned with *how much* light gets to the image sensor and the shutter speed is concerned with *how long* the light shines on the sensor, we can put that knowledge to work.

In *figure 4*, you see a test image with three exposures of the same subject. The first exposure is underexposed (too dark), the second exposure is just right, and the third exposure is overexposed (too light).

You must understand how to control both depth of field (aperture) and subject movement (shutter speed) in your pictures. Which is most important? The answer varies according to the type of subject you are shooting.

Let's say you are taking a picture of a bird flying through the air. You want the bird to be in sharp focus including its eye, body, and both wings, if possible; therefore you need enough depth of field to achieve this. You could set a small aperture, which you know will give you a sufficiently deep depth of field so that the bird is entirely in focus. However, when you use a small aperture for deep depth of field, the opening the aperture blades form is rather small, and not much light gets into the camera. So to compensate, you'll need to let the light come in for a longer time period, which means using a slower shutter speed. Unfortunately, a slow shutter speed means the bird will appear blurred in the picture. You've got yourself into a real quandary!

How can you balance your need for stopping action (a fast shutter speed) with your need to keep all parts of your subject in focus (small aperture)? Great question! Let's find an answer.

Now, let's say you're taking a picture of a beautiful scenic view of the mountains. You need deep depth of field focus to cover the distance out past the mountain ridges to infinity, which means a small aperture. You also want to compensate for the wind blowing the tree limbs, so you want a faster shutter speed to avoid motion blur.

This solution to this quandary is what makes photography a learned skill. We are always balancing our need for *depth of field* with our need to *stop motion*. When there's a lot of light, like on a bright sunny day, there may be enough light to have a small aperture *and* a fast shutter

speed. However, if there is less light on our subject, we can't have both.

You can artificially make your camera more sensitive to light by raising the International Organization for Standardization (ISO) sensitivity of the sensor. (In the old days, we called it "film speed.") That can be helpful, but when you take your camera much above the native ISO (200), you start introducing digital artifacts called "noise" into your picture. We had the same results with very high-speed films, and we called it "grain." High ISO sensitivity can create so much noise that your image is no longer aesthetically pleasing. So, higher ISO sensitivity is used only in an emergency when the shot *must* be acquired at all costs.

What you have to learn to do is to balance your shutter speed and aperture according to the most important goal you are trying to accomplish. What do you think is more important in our flying bird example? Should every part of the bird be in critical focus, or do you want to stop the action of the bird flying through the air? Clearly, if the bird is blurry from movement, it doesn't matter if you have good focus and depth of field, does it? So, in the bird example, the most important thing is the shutter speed. You have to use whatever shutter speed will stop the bird's movement, even if you have to sacrifice some of your depth of field. In other words, you'll need to open the aperture to let enough light in so that you can limit the time it comes in with a fast shutter.

In our mountain scene example, the mountain is not moving very fast, is it?

Figure 4 – Imaginary units of light

So, the most important thing in that picture is to have as much depth of field as possible. You want everything from the foreground all the way out to the far distance to be in sharp focus. You have to use a small aperture for depth of field (letting in less light), which means your shutter speed must be slower to let the light in for a longer time period. You still want to have a shutter speed fast enough to keep the blowing tree limbs from blurring, but that's not as important overall as the deep depth of field.

In order to enjoy your pictures, they must be exposed properly in the first place. So, you'll have to learn how to balance aperture and shutter speed to get a proper exposure while still capturing the image in the best way for the subject.

Let's discuss how a correct exposure is made using a combination of aperture and shutter speed. We'll use an *imaginary* amount of light called "units." In *figure 4*, you see a picture that takes 10 units of light to properly expose our subject. The picture with 10 units is correctly exposed, while the other two are not. How can we get a pleasing "10 unit" exposure and make sure we have good depth of focus and movement control?

We put the camera in manual exposure mode and focus on the scene. The light meter reports that to get 10 units of light we need a shutter speed of 1/500s at an aperture of f/2. Now think about this for a minute. At f/2, a big aperture, we will have very little depth of field. Surely, the limbs blowing in the wind will be stopped since the shutter speed is so fast at 1/500s, but the depth of field will be so shallow that the mountains in the distance will not be in focus.

Let me show you a series of exposure amounts that all give us exactly 10 of our imaginary "units" of light:

- Exposure amount 1: 1/60s at f/16
- Exposure amount 2: 1/125s at f/8
- Exposure amount 3: 1/250s at f/4
- Exposure amount 4: 1/500s at f/2

Our light meter tells us that our current setting (1/500s at f2) gives us a an acceptable exposure, but we want more depth of field for a good distant focus. What can we do? We can select one of the other exposure amounts in the list with a better aperture for our needs. Which is best? Well, Exposure amount 4 (aperture f/2) will not work. Exposure amount 3 (aperture f/4) is better but only marginally so. Exposure amount 2

(aperture f/8) is getting much better, but since our distance is so great, it still may not provide deep enough depth of field to reach all the way out to infinity while keeping the foreground sharp too. It looks like our solution is to use Exposure amount 1 (aperture f/16), which gives us a good aperture for deep depth of field and should cover our scene well. However, the shutter speed is so slow at 1/60s that we might just blur the image from camera movement, especially if the wind is blowing.

What's our solution?

- Go ahead and use Exposure amount 2 (aperture f/8) since we have to hand-hold the camera to get our picture and know we'll ruin it with a too-slow shutter speed.

or

- Put our camera on a tripod and use the best value, Exposure amount 1 (aperture f/16) to keep our image sharp from foreground to distant mountains.

The whole point of inventing this imaginary "10 units of light" exposure system is to show you that you can arrive at a correct exposure using various combinations of aperture and shutter speed settings.

A combination of 1/125s at f/8 gives the camera the correct exposure, and 1/60s at f/16 gives the camera exactly the same amount of light for a great exposure. The 1/60s at f/16 is best for the mountain scene because the f/16 aperture gives so much depth of field and deep focus from foreground to infinity.

A Little More Exposure Detail

Let's play with our exposure amounts for a bit until this makes sense. I'll explain why 1/125s at f/8 and 1/60s at f/16 are exactly the same amount of exposure and either one will give a "10 unit" well-exposed picture, as in *figure 4*.

If 1/125s at f/8 lets in 10 units of light, how many units would 1/125s at f/16 let in? Remember, when the aperture number gets bigger, the aperture opening gets smaller. Since f/16 is one-half the aperture size of f/8, consequently it will let in only one-half as much light. 1/125s at f/16 would then only give us 5 units of light and our exposure would be dark, as in *figure 4*'s underexposed "5 unit" picture.

The second exposure setting below uses the same shutter speed, with an aperture half the size and one-half the light:

- 1/125 at f/8 = 10 units
- 1/125 at f/16 = 5 units (aperture is half the size, so lets in half as much light)

How can we compensate so that we get back to 10 units of light without changing our aperture? We'll have to change the shutter speed! Since we've cut our light in half by using a smaller aperture opening, what would happen if we held the smaller aperture open for twice as long?

Aha! Holding the half-size f/16 aperture open for twice as long gives us exactly the same amount of light as an aperture opening of f/8.

We change our setting, as shown below, so that now our shutter speed is twice as long.

- 1/125 at f/8 = 10 units
- 1/60 at f/16 = 10 units (aperture half sized, shutter speed double the time)

Since the aperture is half the size, we must allow more time for the light to come into the camera by increasing the length of time the shutter is open. We double the time the shutter is open, putting light through the half-sized f/16

aperture for twice as long. That gives us our 10 units of light, for a correct exposure.

To arrive at a similar exposure, you have to first use the light meter to get a correct exposure reading. Then you think about what the aperture/shutter speed combination will give you. Do you need a faster shutter speed to control motion? Do you need a smaller aperture to have more depth of field? Only you can make those decisions. The camera just suggests a combination that will give you a correct

Shutter Speed/Aperture Exposure General Rule

1. Get an accurate meter reading.

2. Decide whether you need an aperture or shutter speed that differs from what the meter recommends.

3. Let's say the camera suggested 1/125s at f/8 for a good exposure but you want a faster shutter speed to stop action. If you select a shutter speed one step faster, or 1/250s, which cuts the exposure to the sensor by one-half, you must open the aperture to let in more light. If you set the shutter speed one step higher (restricting light), you'll need to open the aperture one step larger too (adding light). So if your original exposure was 1/125s at f/8 and you select 1/250s instead, simply open the aperture to f/4 and you get the same amount of exposure. By increasing your shutter speed by one step, you cut the time the light comes into the camera by one-half, so there is only one-half as much light reaching the sensor. To compensate, you open the aperture to twice the previous size so that twice as much light reaches the sensor. You have the exact same exposure with a different combination of aperture/shutter speed: 1/125s at f/8 = 1/250s at f/4.

4. Likewise, if you wanted more depth of field than the metered amount of 1/125s at f/8 would allow, you could close the aperture to the smaller size (stop down) of f/11. The aperture f/11 lets in exactly one-half the light of f/8, so your exposure is exactly one-half of the suggested good exposure. To compensate, you could use the slower shutter speed of 1/60s, which lets light in twice as long. Now you are giving the camera exactly the amount of light that it needs to make a good exposure. If you close the aperture by one step (restricting light), you'll need to slow the shutter speed by one step (adding light). F/8 at 1/125s = f/4 at 1/250s.

exposure, nothing more (unless you are using one of the scene modes—see chapter 2).

The two most important considerations are how much and how long. Use your aperture to control *how much* light gets on to the sensor. Use your shutter speed to control *how long* the light gets to the sensor. Balance the two for a correct exposure!

My Conclusions

The concept of exposure can be rather difficult to understand. If you don't quite get it yet, put your camera in manual mode and reread this section while adjusting your camera's aperture and shutter speed. Focus on something that is not varying in light amounts and see if you can get a correct exposure with various aperture and shutter speed combinations.

This is sort of like learning to ride a bicycle. You cannot understand it until suddenly you do. Keep studying this subject because it will make you a better photographer who is able to control your camera for best image results. Obviously, I can only review this subject here since this book is not a tutorial on exposure. Instead, it is a tutorial on the Nikon D90.

I'd like to see you use the D90 very effectively and enjoyably. You have an advanced camera, and you are a passionate photographer. Learning to effectively use the aperture and shutter speed in combination will only increase your enjoyment!

Playback Menu

The Nikon D90 makes it quite enjoyable to preview the images you've just taken. It has an ample, luxurious, 3-inch monitor screen with enough resolution, size, and viewing angle to really see images in "pixel peeping" detail. Plus, the battery lasts long enough that you can enjoy the results of your work immediately without seriously reducing shooting time.

Everything you need to control your D90's image playback is concentrated in a series of menu selections that are found under the first menu in the camera, called the *Playback Menu*.

We'll examine the nine selections of the Playback menu in detail in the following sections.

Delete Menu & Playback Folder Configuration

The *Delete* menu selection has a close relationship with the next selection, *Playback folder*. Please understand that the deletion of images is affected by how you have *Playback folder* configured. In other words, be sure you understand that the D90 might delete more images than you expect if you have the *Playback folder* set to *All*.

Delete Function

The *Delete* function allows you to selectively delete individual images from a group of images in a single or multiple folders on your camera's memory card. It also allows you to clear all folders of images without deleting the folders. This is sort of like a card format that affects only images. However, note that if you have protected or hidden images, this function will not delete them.

There are three parts to the *Delete* menus (see also the D90 User's Manual, page 162):

- *Selected*
- *Selected date*
- *All*

Selected - Figure 1A shows the menu screens you'll use to control the *Delete* function for selected images.

Notice in image 3 of *figure 1A* that there is a list of images, each with a number in its lower-right corner. These numbers run in a sequence from 1 to however many images you have in your current image folder, or in the entire memory card. The number of images shown will vary according to how you have the *Playback folder* settings configured. (See the next section of this chapter.)

If you have *Playback folder* set to *Current* (factory default), the camera will show you only the images found in your current playback folder. If you don't have *Playback folder* set to *Current* but are using

All instead, the D90 will display all the images it can find in all the folders on your camera's memory card. I leave mine set to *All*.

To delete one or more images, you'll need to locate them with the Multi Selector and then press the checkered thumbnail/playback zoom out button just under ISO on the rear bottom left of the camera. (See the D90 User's Manual, page 5, selection 8.) This button will mark or unmark images for deletion. It toggles a small trash can symbol on and off like a light switch on the top right of the selected image (see the red arrow in *figure 1A*, *image 3*).

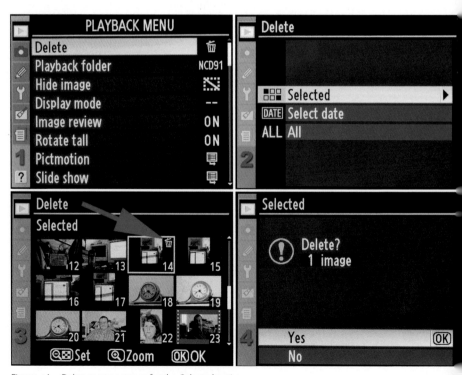

Figure 1A – *Delete* menu screens for the *Selected* option

Select the number of images you want to throw away, and when you have them selected, press the *OK* button. A screen like the last image in *figure 1A* will appear asking you to confirm the deletion of the images you have selected. To delete them, select *Yes* and press *OK*. To cancel, select *No* and *OK*, or just press the *MENU* button.

Selected date – Using the *Selected date* method is simple. When you preview your images for deletion, you won't be shown a list of all the images, as with the *Delete* option. Instead, the *Select date* screen (*image 3* in *figure 1B*) will give you a list of dates with a single representative image following each date. Notice how there's a

check box to the left of each date. You'll check this box by scrolling up or down to the date of your choice with the Multi Selector, and then scrolling to the right, where you'll see a tiny black arrow and the word *Set*. This "sets" the check box to give the camera permission to delete all images it finds with the date you've checked. This selection ability also serves as a reminder that one of the first things you should do when you get your brand-new camera is to set the date and time.

If the single tiny representative image next to the date is insufficient to help you remember which images you took on that date, you can confirm the images you want to delete by viewing them. Press the

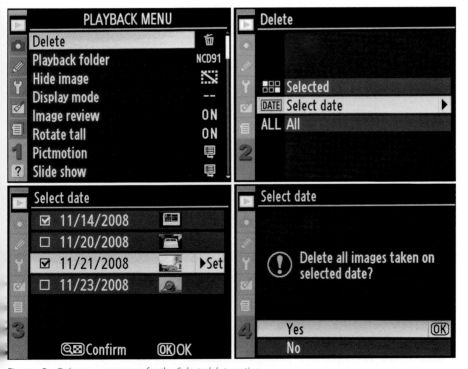

Figure 1B – *Delete* menu screens for the *Selected date* option

checkered thumbnail/playback zoom out button just under ISO on the rear lower-left corner of the camera and the D90 will show you the images under that date. If you want to examine an image more closely, you can use the playback zoom in button under QUAL to temporarily zoom in on individual images. (See page 5 of the D90 User's Manual, selection 9.)

Once you're satisfied that none of the images in the folder are worth keeping, just press the *OK* button (or the thumbnail/playback zoom out ISO button) and you will be returned to your list of dates to delete. Make sure the date is checked as described earlier, and click *OK* to delete the images. A final screen will appear asking you to confirm your deletion for the last time (see *figure 1B*, *image 4*). This screen has a big red exclamation point and asks you, "*Delete all images taken on selected date?*" If you scroll to *Yes* and press *OK*, the images will be deleted. Be careful! If you decide not to delete them, just press the *MENU* button instead.

All – This is like a card format, except that it will not delete folders, only images. As mentioned previously, it will not delete protected or hidden images either. Using this option is a quick way to "format" your card while maintaining a favorite folder structure.

To delete images, simply select *All*, then *Yes* from the next screen with the big red exclamation point and dire warning of imminent deletion.

If you have *Playback folder* set to *Current*, the camera will delete only images in the current folder and the warning will ask, *All images will be deleted. OK?* If you have *Playback folder* set to *All*, the warning will ask, *All pictures in all folders will be deleted. OK?* (See the next section for information on the *Playback folder* option.)

When you select *Yes* and *OK*, a final screen will pop up briefly informing you that the deed has been accomplished.

Being the paranoid type, I tested this thoroughly and found that the D90 really will not delete protected and hidden images. Plus, it will keep any folders you have created. However, if you are a worrier, maybe you should transfer the images off the card before deleting any images.

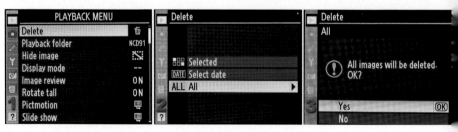

Figure 1C – *Delete* menu screens for the *All* images option

Recovering Deleted Images

If you accidentally delete an image or a group of images, or even format the entire memory card and then realize with great pain that you didn't really mean to, all is not lost. Simply remove the card from your camera immediately and do not use it until you can run image recovery software on the card. Deleting or formatting doesn't permanently remove the images from the card. It merely marks them as deleted and removes the references to them in the memory card's File Allocation Table (FAT). The images are still there and can usually be recovered as long as you don't write any new data to the card before trying to recover them. As a digital photographer, it's wise to have a good image recovery program on your computer at all times. Sooner or later you'll have a problem with a card and will need to recover images. Many of the better brands of memory cards include recovery software either on the card itself or on a separate CD that comes packaged with the card. Make sure you install the software on your computer before formatting the brand-new memory card!

Playback Folder

The *Playback folder* setting is used to allow your camera to display images for you during preview and slide shows. You can have the D90 show you images only in the current image folder (usually NCD90) or in all the folders on the memory card.

If you regularly use your memory card in multiple cameras as I do, and sometimes forget to transfer images, adjusting the playback folder is a good idea. I use a D90 and D40x on a fairly regular basis. Often, I'll grab a 4-gigabyte card out of one of the cameras and stick it in another for a few shots. If I'm not careful, later I'll transfer the images from one camera and forget that I have more folders on the memory card created by the other camera. It's usually only after I have pressed the format buttons that I remember the D40x images on my D90's memory card. The D90 comes to my rescue with its *Playback folder – All* function.

Let's look at how the *Playback folder* function works by first looking at the menus screens in *Figure 2*.

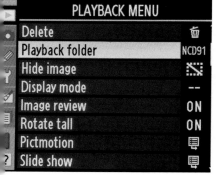

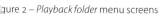
Figure 2 – *Playback folder* menu screens

There are the two selections you can choose from (see also the D90 User's Manual, page 162):

- *Current* (default)
- *All*

Current – This is the most limited playback mode available. Whatever playback folder your camera is using currently will be displayed during playback. No other images or folders will be displayed.

All – When you select *All*, your D90 will obligingly show you every image it can find in all the folders on the memory card. This maximum flexibility setting has saved my buns several times when I thought to check my camera for images *before* I formatted the card and found that I had other images on the card besides D90 images. During playback, or before deletion, the D90 will display images from other Nikons you've used with the current memory card. Each camera usually creates its own unique folders, and normally the other cameras do not report that they are there, except by showing a reduced image capacity. The D90 intelligently displays its own images and any other Nikon images on the card.

Recommendation

I leave my D90 set to the *All* playback mode because I want to be sure I can see every image on the memory card. This helps me avoid being worried about losing images as a result of my own mistakes. One day memory cards might be big enough to leave months of picture

taking in various folders as another form of image backup. I'd like to be able to see all those images without switching folders.

Hide Image

If you sometimes take images that would not be appropriate for others to view until you have a chance to transfer them to your computer, this setting is for you. You can hide one or many images, and once hidden, they cannot be viewed on the camera's monitor screen in the normal way. Once hidden, the only way the images can be viewed in-camera is by using the *Hide Image* menu, shown in *figure 3A*.

There are three selections in this menu (see also the D90 User's Manual, page 162)

- *Select/set*
- *Select date*
- *Deselect all?*

Select/set – This selection allows you to hide one or many images. You'll see them as shown in *image 3* of *figure 3A*.

Here's how to hide an image:

1. Scroll to the image.
2. Press the thumbnail/playback zoom out button to select one or more images.
3. Press the *OK* button to hide the image(s).

You can select multiple images before pressing the *OK* button to hide more than one image at once. When an image is selected for hiding, it will show a little dotted rectangle with a slash.

Whatever number of images you have selected with the thumbnail/playback zoom out button (under ISO) will be hidden when you press the *OK* button. When you have selected and hidden the images, the camera will briefly display *Done* on the LCD monitor.

The number of images reported does not change when you hide images. If you have 50 images on the card and you hide 10, the camera still displays 50 as the number of images on the card. A clever person could figure out that there are hidden images by watching the number of images as they scroll through the viewable ones. If you hide all the images on the card and then try to view images, the

D90 will tersely inform you, *All images are hidden*.

You can also use these menus to unhide one or many images, by reversing the process described earlier. As you scroll through the images, as shown in *image 3* of *figure 3A*, you can unselect them with the thumbnail/playback zoom out button and then press *OK* to unhide them.

While you are selecting or unselecting images to hide, you can use the playback zoom in button (under QUAL) to see a larger version of the image you currently have selected. This lets you examine the image in more detail to see if you really want to hide it.

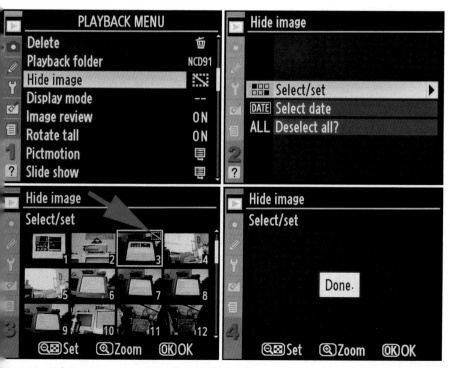

gure 3A – *Hide image* menu screens – *Select/set* selection

Select date – This function allows you to hide a series of images by date taken. You might have been shooting a nature series in the wilds of Africa one day and a "glamour" series for a national magazine the next day. You wouldn't mind your kids seeing the nature shots, but you might not want them to see the more glamorous ones. So you simply select the date(s) you took the shots you want to hide and they are not viewable on the camera monitor. Use the screens found in *figure 3B* to accomplish this.

As shown in *figure 3B's image 3*, you'll select the date you took images you want to hide from the list of available dates by scrolling up or down with the multi selector button. Once your chosen date is highlighted, scroll to the right with the multi selector where you see the arrow and the word *Set* and a check mark will appear in the box to the left of the date. The images taken on this date are now selected for hiding. If you press the *OK* button, all the images with the date selected will be hidden immediately, and the camera will return to the main *Playback Menu*.

If you'd like to review the images under a certain date before hiding them, simply select the date in question and press the thumbnail/playback zoom out (ISO) button. This will open only the images from the selected date in the monitor window. You can review individual images in detail with the playback zoom in (QUAL) button.

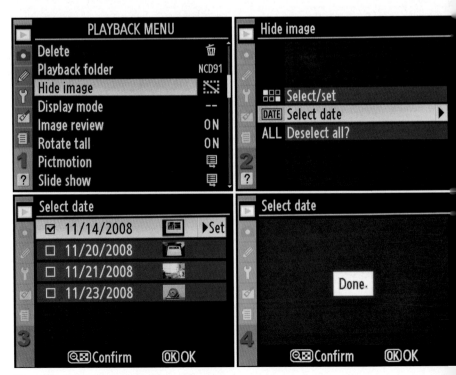

Figure 3B – *Hide image* menu screens – *Select date*

Deselect all? – This is a much simpler way to unhide *all* the images on the card at once. As shown in *image 3* of *figure 3 C*, at the *Reveal all hidden images?* screen, select *Yes* and press *OK*. All hidden images on the card will then be revealed and viewable. As the images are being unhidden, the camera's monitor will display *Marking removed from all images*.

Losing Protection When You Unhide

If you have images that are both hidden and protected and then unhide them, the protection is also removed at the same time. (User's Manual page 139)

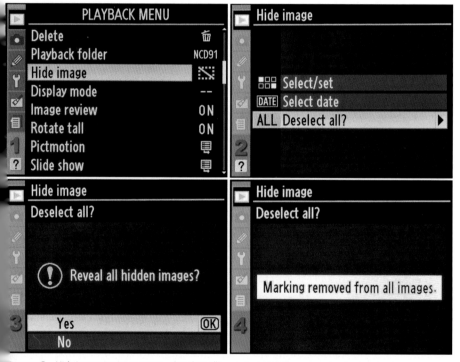

igure 3C – *Hide image* menu screens – *Deselect all?*

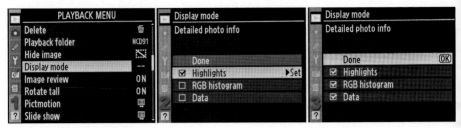

Figure 4A – *Display mode* menu screens

Display Mode

The *Display mode* selection allows you to customize how the D90 displays all those histogram and data screens for each image. If you want to see a lot of information on each image, you can select it here. Or, if you would rather take a minimalist approach to image information, turn off some of the screens.

If you turn off certain screens, the camera still records the information for each image, such as lens used, shutter speed, and aperture. However, with no data screens selected, you'll see only two screens. One is the main image view, and the other is a summary screen with a luminance histogram and basic shooting information. I've not found a way to turn this summary screen off. You get to the screens by scrolling with your multi selector button in the direction opposite from

the direction for viewing images. I leave my camera set so that I can scroll through my images by pressing left or right on the multi selector button. Then I can scroll through the data screens by scrolling up or down with the multi selector button.

Here are the selections found in this customized setting and a description of what each does (see also the *D90 User's Manual*, page 163):

Detailed photo information

- *Highlights*
- *RGB histogram*
- *Data*

When you make changes to these selections, be sure to scroll up to the word *Done* and press the *OK* button to save your setting. I keep forgetting to do this when I make changes (see *figure 4B*).

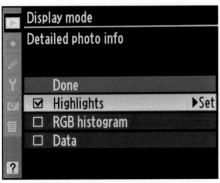

Figure 4B –- *Display mode* menu screens – *Highlights*

Highlights – If you put a check mark next to the *Highlights* selection, as shown in *figure 4B*, you will turn on what I call the "blinky" mode of the camera. The D90 adds a new *Highlights* screen so that you can view the image with special emphasis on any areas that might be overexposed. It looks very similar to the normal viewing screen except that the only information on the new screen is information about *Highlights*. You'll see the word *Highlights* in the lower-left portion of the camera monitor, just above the words *NIKON D90*. You can leave this screen selected as your normal viewing screen if you want. If you turn the camera off and back on when this screen is selected, it will remember and return to this screen instead of the regular image viewing screen. You can get to the normal viewing screen, or the image summary screen, by scrolling up or down with the multi selector.

What does the *Highlights* screen do? When *Highlights* is enabled and any part of the image is overexposed, that section will blink an alternating white and black. This is a warning that certain areas of the image are overexposed and have lost detail. You will need to use exposure

compensation or manually control the camera to contain the exposure within the dynamic range of the camera's sensor.

Figure 4C shows how an image looks when an area has been overexposed. The same image is displayed on either side of the *Highlights* blink. The image on the left is showing the white blink, and the one on the right is showing the black blink.

Anytime you see the blinking white to black to white, that section of the image has lost all detail, or has "blown out." If you examine the histogram for the image, you'll see that it's cut off, or "clipped," on the right side. Current software cannot usually recover any image detail from the blown-out sections. The exposure has exceeded the range of the sensor and has become completely overexposed in the blinking area. All previous detail in the image has gone to pure white. (See chapter 2, "Exposure Metering System, Exposure Modes, and Histogram," for information about the histogram.)

Highlights mode allows your camera to warn you when you have surpassed what its sensor can capture and you're losing image data.

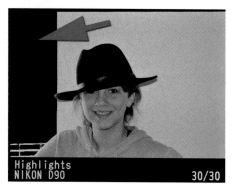

Figure 4C – *Highlights* "blinky" mode in action

RGB histogram – I like this feature! It allows me to view not just a basic luminance histogram, which is a combination of all three color channels, but it displays all three color histograms and a luminance histogram in one screen (see *figure 4D*).

Each color channel, red, green, and blue (or RGB), is displayed with its own small histogram. This is quite useful because it is possible to overexpose, or "blow out," only one color channel, which happens often with the red channel in my case.

You can view the luminance histogram on top in white and the three RGB color histograms below it. When you examine the *Histogram* screen, you'll see that each of the RGB color channel histograms is different. R=red will look different from B=blue, for instance. The luminance histogram on top always seems to resemble the G=green channel histogram very closely. It makes me wonder if the white luminance histogram is basically just a copy of the green channel histogram with a bit of minor influence from the other two channels. The luminance and green histograms are not absolutely identical, but they're very close, so it appears that green colors influence the luminance histogram more than the other two (red and blue).

Data – Checking this setting will give you three additional image data screens to scroll though. The data found on these screens is quite detailed and includes the following information:

Image Data Screen 1

- **Light meter in use** (Matrix, Spot, or Center-weighted)
- **Shutter speed and aperture** (e.g., 1/40, F3.5)
- **Exposure mode** (P,S,A,M) and ISO (e.g., 200)
- **Exposure compensation** (+/- EV)
- **Lens focal length** (e.g., 18mm)
- **Lens overview** (e.g., 18–105mm f/3.5 – 5.6)
- **AF/VR** (e.g., AF / VR-On)
- **Flash mode and compensation** (e.g., Built-in, TTL, +0.7)

Image Data Screen 2

- **White balance** (Auto, 0, 0)
- **Color space** (sRGB, AdobeRGB)
- **Picture control detail** (Standard, Neutral, Vivid, Monochrome, Portrait, Landscape)
- **Picture control fine-tuning** (Quick Adjust, Sharpening, Contrast, Brightness, Saturation, Hue)

Image Data Screen 3

- **Noise reduction** (e.g., Long exp., High ISO, Norm)
- **Active D-Lighting** (Auto, Extra high, High, Normal, Low, Off)
- **Retouching** (D-Lighting, Red-eye correction, Trim, Monochrome, Filter effects, Color balance, Small picture)
- **Comment** (Up to 36 characters attached to each image)

Although there are many screens to scroll through, they provide a great deal of information on the image. Look how far we've come from the old film days of writing some date information on the lower-right corner of the image, permanently marking it, or between the frames on the pro-level cameras.

In fact, there are seven screens just brimming with data, if you enable all the *Display mode* settings (eight, if you used a GPS). Or, you can get by with the main image display and one summary display. Complex control at your fingertips!

Figure 4D – *Display mode* menu screens – *RGB histogram*

igure 4E – *Display mode* menu screens – *Data*

My Personal Settings

I always leave the *Highlights* and *RGB histogram* settings turned on because I want to confirm that I'm not accidentally "blowing out" important sections of my image. The *Highlights* "blinky mode" warns me when my images have overexposed areas, thereby allowing me to adjust my exposure and reshoot the image.

The *RGB histogram* setting is also very important to me because it allows me to see all the color channels, just in case one of them is being clipped off on the light or dark sides. It also allows me to see how well I am keeping my exposure balanced for light and dark. (See chapter 2 for more information on histogram usage.)

The *Data* screens are not terribly important to me since the D90 has a summary screen with the most important exposure information displayed. Also, by having the *Data* screens enabled, I have to scroll through three more screens to get to my *RGB histogram* screen.

So my recommendation is to enable only the *Highlights* and *RGB histogram* screens. If you really feel the need to examine a large amount of extra image data, then enable the *Data* screens too.

Chimping Defined

Chimping means reviewing images on the monitor after each shot. It is derived from the words **check image preview**. I guess people think you look like a monkey if you review each image. Well, I do it anyway! Sometimes I even make monkey noises when I'm chimping my images. Try saying, "Ooh, ooh, ooh, aah, aah, aah" real fast when you are looking at an image and are happy with it. That's chimping with style, and probably why the term was coined.

Image Review

The factory default for the D90 is to display the just-taken image on the monitor for 4 seconds. You can adjust this value from 4 seconds to 10 minutes using *Custom Setting c4*. Figure 5 shows how to turn *Image review* on or off.

Here are the *Image review* settings (User's Manual page 163):

1. **On** – Shows a picture on the monitor after each shutter release (default).
2. **Off** – Monitor stays off when you take pictures.

Most of us will leave this function set to *On*; otherwise, the only way to view an image after taking it is to press the *Playback* button. The battery life will be affected if you review images constantly, and for longer periods of time than the default 4 seconds. However, with the overall low power consumption of the camera, you will find that your battery lasts long enough for a full day of shooting in most instances. I carry one extra battery, just in case, because I am a world-class image "chimper."

Recommendation

I don't want to waste hard drive space by storing hundreds of *almost good* images, so I delete many images right after I take them. I have to review them to know whether I want to keep them or not, so I leave my *Image review* selection set to *On*.

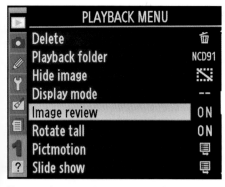

Figure 5 – Image review menu screens

Rotate Tall

When you shoot an image as a vertical or portrait image, while turning your camera sideways, the image is recorded to the card as a horizontal image lying on its side. If you chimp the image (or view it immediately after capture) Nikon assumes that you will still be holding the camera in the rotated position, so the image is left lying on its side in portrait mode. Later, when you are reviewing the images as a group using the D90's *Playback* function, the image will be displayed as an upright vertical image that is quite a bit smaller in size so that it will fit on the horizontal monitor.

If you would rather that the camera leave the image in a horizontal view, forcing you to turn the camera sideways to view it normally, you'll need to turn the *Rotate tall* setting *Off*. The default is *On*.

Here are the two available settings (see figure 6 and the D90 User's Manual, page 163):

1. **On** (default) – When you take a vertical image, the D90 will rotate it so that you don't have to turn your camera to view it in later playback. This sizes the image so that a vertical fits in the normal horizontal frame of the monitor. The image will appear a bit smaller than normal. When you first view

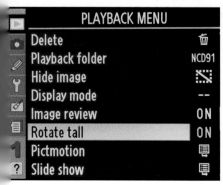

igure 6 – *Rotate tall* menu screens

(chimp) the image after taking it, the camera does not rotate it because it assumes you are still holding the camera in a vertical orientation.

2. **Off** – Vertical images are left in a horizontal direction and you'll need to turn the camera to view them as they were taken. This provides a slightly larger view of the image.

Recommendation

I leave *Rotate tall* set to *On*. This allows me to view a vertical image during playback in its natural vertical orientation without rotating my camera. I can zoom in if I want more detail.

Pictmotion

This and the next section describe cool ways to display your images in an automatic sequence for yourself or others to view. Where the next section describes how to do a basic slide show, this section shows you how to do a slide show on steroids. I don't even call *Pictmotion* a slide show, even though it acts like one, because it has so much more functionality

than a mere slide show. Instead, I call what Pictmotion does a "presentation."

If you've ever enjoyed a computer-based Microsoft PowerPoint presentation, with music and various screen fades and wipes, you'll love the new *Pictmotion* functions in your D90. If you have some images on your camera right now, just select *Pictmotion* from the *Playback Menu*, and then *Start*. The default settings will show you all your images, with high-speed background music and zoom bounce screen effects. Try it! (See *figure 7A*.)

There are several configurable parts to the *Pictmotion* presentation (User's Manual pages 141–142):

1. *Start*
2. *Select pictures*
3. *Background music*
4. *Effects*

Start – When you select *Start*, the camera starts presenting images using your current settings in the other options. The default is *Select pictures = All*; *Background music = High speed*; and *Effects = Zoom bounce*.

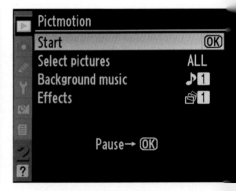

Figure 7A – *Pictmotion* menu screen

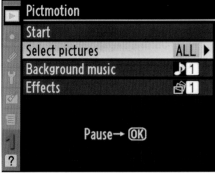

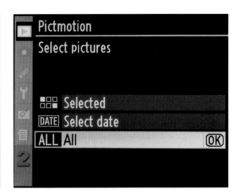

Figure 7B – *Pictmotion* main *Select pictures* screens

Select pictures – The three selections from the *Select pictures* menu are as follows:

- **Selected** – This selection shows you the images found on your memory card and allows you to select the images you want to show in the Pictmotion presentation (see figure 7C). You can select them individually with the thumbnail/playback zoom out (ISO) button. You can also examine an image in detail during the process with the playback zoom in button so you can decide if the quality is high enough for your purposes.

- **Select date** – Often you'll want to show only the pictures from a certain date instead of all the pictures available. With the *Select date* selection, you can choose one image or a series of dated images to display during the Pictmotion presentation. You'll select a date with the Multi Selector by scrolling up or down (see figure 7D). When you have a date selected, just scroll once to the right toward the arrow and the word *Set* until a check mark appears on the left side of the date you want. You can select more than one date if you want to. When you have

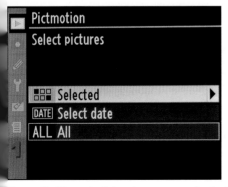

Figure 7C – *Pictmotion Select pictures* screens for the *Selected* option

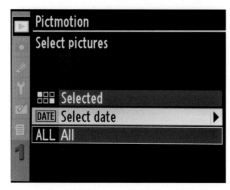 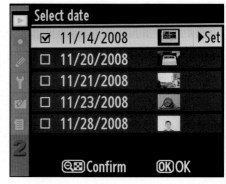

Figure 7D – *Pictmotion Select pictures* screens for the *Select date* option

chosen and checked all the dates you want in the presentation, just select *OK*. If you'd like to review any of the images within a certain date, you can do so by selecting a date and pressing the thumbnail/playback zoom out (ISO) button. This presents all the images within the date so that you can review them with the playback zoom in (QUAL) button. It doesn't appear to me that you can select individual pictures within a certain date but must select all the images taken on a certain date. You'll have to use the Selected function to choose individual pictures.

- **All** (default) – This one's pretty easy. If you want to show all available images, select All (see figure 7E). The number of images actually selected is governed by whether the Playback Menu's Playback folder selection is set to a single folder using Current (i.e., NCD90) or to all images found within all folders on the memory card by using Playback folder's *All* selection. (See the section on the Playback folder option earlier in this chapter and in figure 2A.)

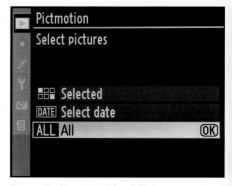

Figure 7E – *Pictmotion Select "All" pictures* screens

Background music – Since Nikon is interested in giving you plenty of choices these days, you can choose from no less than five types of background music for your *Pictmotion* presentation (see *figure 7F*):

- *High-speed* (Techno synthesizer)
- *Emotional* (Smooth guitar)
- *Natural* (Smooth piano)
- *Up-tempo* (Jazzy piano and synthesizer)
- *Relaxed* (Strings and synthesizer)

Recommendation

I think my favorite music selection is *Natural*. I take many nature pictures and feel that the display is naturally better with smooth piano-style music. You'll have to

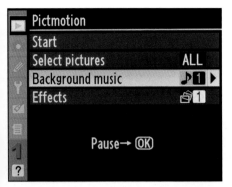
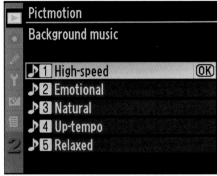

Figure 7F – The *Background music* screens for *Pictmotion*

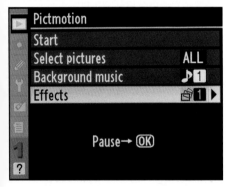
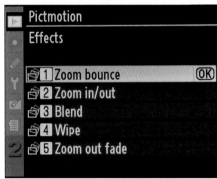

Figure 7G – The *Effects* screens for *Pictmotion*

listen to each musical style to select your favorite. Make sure you're displaying images that match the style of your chosen *Background music* selection.

Effects – The *Effects* menu controls how the images are displayed on your camera screen during the presentation (see *figure 7G*). Here are your choices:

- *Zoom bounce* (default)
- *Zoom in/out*
- *Blend*
- *Wipe*
- *Zoom out fade*

Zoom bounce – The image starts off on the various edges of the screen as a tiny thumbnail, then grows to fill the whole screen. At the end of the image display, it fades out to black and the next tiny thumbnail appears.

Zoom in/out – Two images are shown on the screen at the same time. One is reducing in size while the other grows until it encompasses the entire screen. After its display time is up, it starts getting smaller and a second image starts growing until it becomes the next one to be displayed.

Blend – The same image is shown twice, coming from two edges of the screen. As they near the center of the screen, they become one. (This acts like an image overlay, but until the overlay is complete, it makes me feel cross-eyed.)

Wipe – This is a weird little effect. At first the image slides in from one side of the screen, stops for the delay, then slides off the other side of the screen. Then, just when you expect the next image to appear, the same image you've just seen kind of zips back across the screen on its way back home.

Zoom fade out – An image slides in from the side of the screen and hesitates for the delay. When the delay is complete, the image starts reducing in size and slides into the background while a new image appears and grows in size to takes over the screen.

When you first select *Start* from *Pictmotion*, you can expect a delay as the camera prepares the images and music. You'll see an hourglass display for several seconds before the *Pictmotion* presentation begins.

Recommendation

I like the *Zoom in/out* setting the best because the images fade in and out in a pleasing way. This is a completely subjective comment, though, so you'll need to experiment and select your favorite. It's good we have so many selections to choose from!

During the presentation you can press the *OK* button and pause the display. When you want to restart the presentation, you can select *Restart* from the

Figure 7H – The pause screen for a *Pictmotion* presentation

Pause menu that pops up and press *OK* (see *figure 7H*). The presentation will continue. Or, if you want to exit, just select *Exit* from the menu and press *OK*. The *Playback Menu* will then display.

Slide Show

I used to do slide shows back in the old film days. I'd set up my screen, warm up my projector, load my slides, and watch everyone fall asleep by the 100th slide. For that reason, I hadn't been using the slide show function of my camera. However, all that has changed recently.

Now, instead of hauling out a slide projector and a box of slides, you can just plug your D90 into the closest high definition (HD) device, such as a television. The camera has a cool High-Definition Multimedia Interface (HDMI) port on the left side under a rubber flap. We'll talk more about HDMI in a later chapter.

Or, if you prefer, you can just set your camera up on a table and have a few friends gather around for a slide show. It's very fast and simple to start one.

As shown in *figure 8A*, it's easy to simply select the *Playback Menu's Slide show* setting, scroll right, and select *Start*

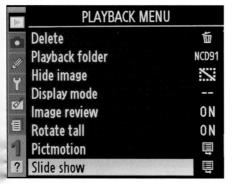

Figure 8A – *Slide show* menu screens

Figure 8B – The *Slide show* option's *Frame interval* menu screens

The slide show will commence immediately and have a default display time of 2 seconds per image. (User's Manual page 143)

There are two settings available under *Slide show*:

Start

Frame interval

Start – This does what it says and starts the slide show.

Frame interval – This setting controls the amount of time each image displays in seconds. You'll need to change the display time to a value from 2 to 10 seconds. The default value is *2s*, or 2 seconds.

Figure 8B shows the menu screens to make the change. You can select from the following settings:

- **2s** – 2 seconds (default)
- **3s** – 3 seconds
- **5s** – 5 seconds
- **10s** – 10 seconds

To start the slide show, repeat the steps shown in *figure 8A*, except this time, the show will run at your new chosen speed.

Recommendation

I usually set my slide *Frame interval* to 3 seconds. If the images are especially beautiful, I might set it to 5 seconds.

I've found that 2 seconds are not quite enough, and 5 or 10 seconds may be too long. I wish we had a 4-second setting, but 3 seems to work well most of the time.

There are several actions that will affect how the images display during the slide show:

Skip back/skip ahead – During the slide show you can go back to the previous image for another 2-second viewing by simply pressing left on the multi selector button. You can also see the next image with no delay by pressing right on the multi selector. This is just a quick way to skip images or review previous images without stopping the slide show.

View additional photo info – While the slide show is running, you can press up or down on the multi selector button to view the additional data screens. This is dependant on how you have your D90's *Display mode* settings configured (see the section on the *Display mode* settings earlier in this chapter) for *Highlights*, *Histogram*, and *Data*. If any of these screens are available, they can be used during the slide show.

Pause slide show – During the slide show, you may need to pause, change the image display time, or even exit. By pressing the *OK* button, you can pause the slide show and access the menu screen shown in *figure 8C*).

Using this menu screen, you can select from the following options:

- **Restart** - Pressing *OK* or scrolling to the right on the multi selector button continues the slide show from the image following the one last viewed.
- **Frame interval** – Scrolling to the right with the multi selector button takes you to the screen that allows you to change the display time to one of four values. You can choose 2, 3, 5, or 10 seconds. After choosing the new frame interval, you'll have to select *Restart* to continue where you left off in the slide show.
- **Exit** – This does what it says—exits the slide show.

Exit to Playback Menu – If you want to quickly exit the slide show, simply press the *MENU* button and you'll jump directly back to the *Playback Menu* with no items selected.

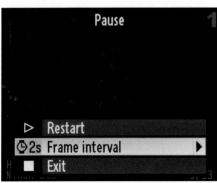
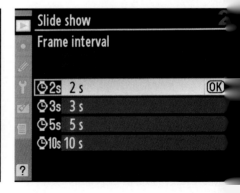

Figure 8C –The *Pause* menu screens for slide shows

Exit to playback mode – By pressing the *Playback* button (the right arrow key, with a rectangle around it, on the upper-left portion of the back of the D90), you'll stop the slide show and change to normal full-frame or thumbnail image view of the last image seen in the show. This exits the show on the last image viewed.

Exit to shooting mode – Pressing the shutter button halfway down stops the slide show. The camera is now in shooting mode, meaning that it is ready to take some pictures.

Using any of these buttons affects the slide show in the ways listed.

Should I Use Slide Show or Pictmotion?

If I'm just going to briefly review some images in a series, I'll use the *Slide show* function. However, if I want to impress my friends and family with my lovely images, accompanied by music and screen fades, I'll use a *Pictmotion* presentation instead.

Print Set

User's Manual pages 150–158 and 274)

This feature allows you to connect your camera directly to a PictBridge-compatible printer, or any device that supports the Digital Print Order format (DPOF). You will be creating a "print order" that allows a connected PictBridge-compatible printer (or service) to print only the images you have selected on your memory card via the PictBridge menu of the D90. This is not a difficult process to use, but it's quite complex to describe. In fact, it would almost take another entire chapter

in this book to go over the nuances of PictBridge printing.

Semipro and professional users of the D90 are highly unlikely to be interested in printing directly to PictBridge printers, preferring to use their computers to carefully post-process each image prior to printing, and then they would probably use a professional lab service to obtain optimum print quality for themselves and their clients. The D90 User's Manual on pages 150 to 158 gives a very detailed description of how to use PictBridge and DPOF for those who want to make use of this feature.

My Conclusions

I remember the old days when you'd have to find the old shoebox full of pictures or open an album and flip pages in order to "play back" some images. Sometimes I miss photo albums. You know what? I'm going to run down to the superstore right now and buy several albums. Then, I'll have some actual images printed and will put them into those old albums. Have you printed any images today?

In the meantime, though, I'll use the playback features of my D90 to impress my friends with my images and my really cool camera!

Shooting Menu

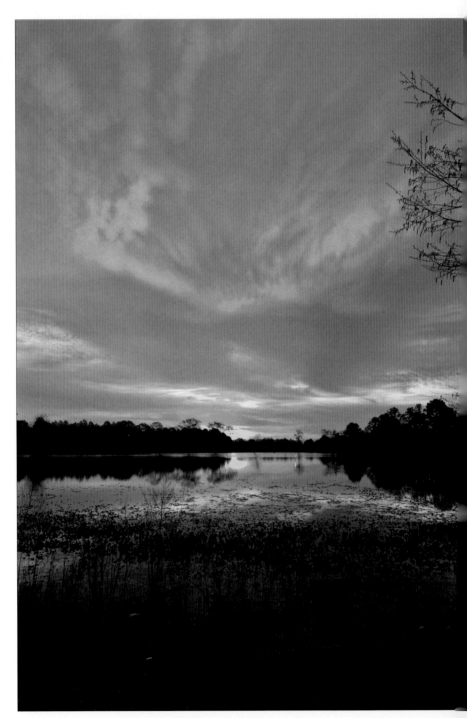

One of the hallmarks of the Nikon D90 camera is how its many functions are flexibly configurable. Between the *Shooting Menu* and the *Custom Settings Menu* (detailed in the next chapter), you can configure the camera for several distinct shooting styles. It's easy to change styles with just a few button presses.

The *Shooting Menu* allows you to configure functions such as picture control style, image quality modes (RAW, JPEG, etc.), white balance, ISO sensitivity, sharpening, D-Lighting, and color space. In fact, there are total of 13 separate menu items to configure in the *Shooting Menu*.

Let's look into each menu item and discover the best settings for your style of photography.

Figure 1 – *Shooting Menu* screen

Setting Up the Shooting Menu

Press the *MENU* button on the back of your D90, and use the multi selector thumb toggle switch to scroll to the left, then up or down until you find the *Shooting Menu*, shown in *figure 1*. (The icon is a small green camera on the left side of the screen.)

Let's examine each of the 13 configurable items on the *Shooting Menu*.

Picture Controls

First, we'll investigate the Picture Control system built into the Nikon D90. This flexible image control system was designed by Nikon to allow you to customize how you create images. There are six different Nikon Picture Controls in your D90. For those who used to shoot film, this is sort of like having six different films types available at all times.

Each control makes the image look different, with different levels of color saturation, contrast, brightness, hue, and sharpening. You can modify any of these Nikon-supplied controls to make your own custom Picture Controls. Each of your custom Picture Controls can be saved with unique names in-camera or to your memory card for sharing with other cameras, devices, and software that support the Picture Control system.

Downloadable Picture Controls have been around for a while, but the Nikon D90 has made using them easier than ever before. The Nikon Picture Control specification provides for compatibility between various cameras. You can load your D90 Picture Controls into other Nikon cameras and your images will look the same as they do in the D90. This is one of the reasons for the existence of Picture Controls; to allow "nearly the same results on all cameras that support the Nikon Picture Control system" (User's Manual, page 108).

So, if you have a Nikon D90 and another camera such as a D5000, why not develop some Picture Controls and

share them with your other cameras, and your friends' cameras too. You'll become known as the picture control guru!

Now let's look at how to use the six supplied Nikon Picture Controls.

Set Picture Control

(User's Manual pages 109-112)

To select a particular Picture Control, simply follow these steps:

1. Press the *MENU* button and select the *Shooting Menu* (small green camera).
2. Scroll to *Set Picture Control,* and then scroll to the right.
3. Select one of the Nikon Picture Controls from the menu (as you can see, I have selected *Vivid* in *figure 2*). Now scroll to the right.
4. If you want to modify the sharpening, contrast, brightness, saturation, or hue, scroll to the right for the fine-tuning screen. (See the image on the right in *figure 2*.)
5. Press the *OK* button to activate the selected control. The two-letter abbreviation for the control will show on the *Shooting Menu*. (See the image on the left in *figure 2*. To the right of *Set Picture Control*, you'll see *VI*.)

Note

You may notice a Picture Control called *STANDARD-03* in the image in the middle in *figure 2*. This is a custom Picture Control that I created on my camera. I'll show you how to create custom controls in the next section, "Manage Picture Control."

Here is a list of the six Nikon Picture Controls and details on each of them (User's Manual page 109):

- *SD - Standard*
- *NL - Neutral*
- *VI - Vivid*
- *MC - Monochrome*
- *PT - Portrait*
- *LS - Landscape*

Standard – This is the most balanced picture control. It does not make your image too colorful or too "contrasty," but it does provide a great look. If I were to compare this control to a certain film, I would say it looks most like Fuji Provia. It has medium contrast and saturation. I wouldn't consider this a portrait film but would tend to use it when I wanted natural and realistic colors in nature or indoor settings.

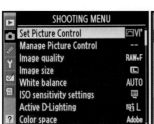
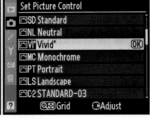

Figure 2 – *Set Picture Control* menu screens

Neutral – This is for individuals wanting an image that will be easier to post-process later in the computer. It has a somewhat extended dynamic range, so it can capture more shadow and highlight detail. If you used Fuji NPS in the past, you'll find that this has a somewhat similar look. It can be used for portraits or nature and has lower contrast for ease of post-processing the image. If you are forced to shoot in extremely bright conditions with high contrast (such as on a bright sunny day), this control works well to try to tame some of that deep contrast.

Vivid – Are you a hard-core nature shooter who loved Fuji Velvia? Do you regularly add a little saturation to your colors? Do you boost contrast to get that "snap" needed for great nature images? If so, here's your picture control! This mode is an "in your face" deep saturation, high-contrast, "make it green, blue, and beautiful" picture control. Are the colors accurate? Well, were they accurate with Fuji Velvia? No! However, if you want beautiful nature shots, this will do it. Be careful when using this on a sunny day because it tends to increase contrast to higher levels. You will get deep, dark blacks and very saturated greens, reds, and blues with this control. If you are shooting on a low-contrast overcast day, this mode will add contrast for you.

Monochrome – Have you wanted to experiment with black and white (B&W) pictures? This picture control makes fairly decent B&W images, with rich blacks and clean whites. In addition, you can tone the images with various tints such as the old-style sepia (warm reddish) and

cyanotype (cool bluish) tints. Nikon also provides other tints for your experimentation, including red, yellow, green, blue-green, blue, purple, blue, and red-purple. The normal B&W mode looks to me like Kodak Plus-X film but has slightly less black. It is hard to fully imitate the effect of silver-based film with a digital sensor. However, this control gives you a good starting point for deepening the blacks and brightening the whites so that the image will look the way you want it to.

Portrait – Nikon's User Manual claims that this control "lends a natural texture and rounded feel to the skin of portrait subjects" (page 109). I've taken numerous images with this *Portrait* control and shot the same images with the *Neutral* control. The results are very similar. I'm sure that Nikon has included some software enhancements specifically for skin tones in this control, so I recommend this control for shooting portraits. The results from this control look a bit like smooth Kodak Portra film to me.

Landscape – This control "produces vibrant landscape and cityscapes" according to Nikon, which sounds like the *Vivid* control to me. I shot a series of images using both the *Landscape* and *Vivid* controls and got similar results. Compared to the *Vivid* control, the *Landscape* control seemed to have only slightly less saturation in the reds and a tiny bit more saturation in the greens, while blues stayed about the same. It could be that Nikon has created the *Landscape* control to be similar but not quite as drastic as the *Vivid* control. There is so little difference between the two that

you would have to compare them side-by-side to notice. Maybe this control is meant to be slightly more natural than the supersaturated *Vivid* control. It will certainly improve the look of your landscape images. I'd say the look of this control is somewhere between Fuji Velvia and Provia, providing great saturation and contrast with emphasis on the greens of natural settings.

Each control is fully configurable. You can fine-tune them and the camera will remember your changes. In the middle image in *figure 2*, notice how the *Vivid* control has an asterisk after it. It looks like this: *VI* Vivid**.

I added a couple of levels of sharpening to *Vivid* as an experiment. It shows the asterisk to remind me that the default values of the control have been changed. Any control that you've fine-tuned stays the way you set it until you change it back to the normal factory settings. You can't save the Nikon Picture Controls from this menu. Instead, you'll need to use the *Manage Picture Control* menus, detailed in the next section. However, your values will stay with the control until you change them again.

Which Picture Control Should You Use?
Good question! It really boils down to whether you like to shoot in RAW mode and later post-process the images into their final form, or if you simply enjoy taking great pictures in JPEG mode and will use them immediately.

Personally, I am a post-processing kind of guy. I use the *Neutral* control most of the time since I'm shooting in RAW mode

and want to get extra dynamic range from lower contrast for later computer enhancement. I realize that by shooting in *Neutral* I am not going to create images with immediate "snap" or deep color saturation. However, I've found that when I use *Neutral*, I can make superior images later in Nikon Capture NX2. I boost the color until it matches what I remember and raise the contrast until it is just right to my eyes. It is extra work, of course, but I feel deeply satisfied when I create a great-looking image. For me, digital imaging is a two-part process.

First, shoot the RAW picture, and second, finish it in Capture NX2. *Since I am shooting in RAW mode, it really makes no difference what Picture Control I'm using since the RAW file is completely adjustable after shooting..* I find when I have shot in *Neutral*, Capture NX2 displays it as a low-contrast, low-saturation image, so I can easily see the effects I am trying to achieve when I make modifications.

If you are allergic to computers or have no interest in post-processing, then you should carefully match the Picture Control to the type of images you are shooting. If you're shooting portraits of people, you may want to use *Neutral*, *Standard*, or *Portrait* controls. For scenics, landscapes, and indoor events, you might want to use *Landscape*, *Vivid*, *Standard*, or even *Neutral* if you are conservative. This is especially important if you are shooting in JPEG mode, because you can only modify a JPEG a small amount later without causing problems from image recompression losses.

Ask yourself, "When I shot film, what type did I prefer?" Did you shoot Kodak Gold negative film? Then you should probably use the *Standard* control. Did you shoot Velvia slide film? Then go for *Vivid* or *Landscape*. Was your imaging mostly pictures of people using negative film? In that case, *Portrait*, *Standard*, or even *Neutral* might work best.

Nikon has given us a wide selection of Picture Controls as a base. Now let's discuss how we can modify these controls to suit our own styles and then save the results as our own custom Picture Controls.

Manage Picture Control

(User's Manual pages 110-118) "Managing" a Picture Control refers to adjusting and saving a base Nikon Picture Control as a newly named custom Picture Control. It can also mean saving, deleting, renaming, and copying those controls. We'll look at each of those processes in this section.

Creating Custom Picture Controls

Let's visually examine the steps and screens used to change a base Nikon Picture Control into your own custom Picture Control.

Here is a detailed look at the steps to set up a custom Picture Control (see *figure 3*):

1. Press the *MENU* button and select the *Shooting Menu* (small green camera).
2. Scroll down to *Manage Picture Control* and scroll to the right.
3. Select *Save/edit* from the menu and scroll to the right.
4. Select one of the base Nikon Picture Controls and scroll to the right. (If an asterisk follows the control name, it means you have already modified the control.)
5. On the *Quick adjust* screen, make your favorite modifications to *Sharpening, Contrast, Brightness, Saturation,* or *Hue*. Note that if you have Active D-Lighting turned on in any way, you will not be able to modify the *Contrast* or

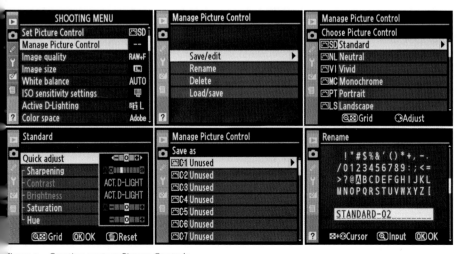

Figure 3 – Creating custom Picture Controls

Brightness setting. Both will be grayed out. When Active D-Lighting is on, it handles those two settings automatically. After the *Contrast* and *Brightness* settings you'll see the words *ACT.D-LIGHT*. We'll talk about Active D-Lighting later in this chapter.

6. Click the *OK* button to let the camera know that you are done modifying the settings. It will switch to the *Save as* screen.

7. Select one of the nine unused save locations, *C-1* through *C-9*, and then scroll to the right. The camera will put words in the *Rename* screen for you that reflect the type of control you're working with. If you are modifying a *Standard* Picture Control, you'll see the words *STANDARD-01*. For a *Vivid* Picture Control, you'll see the words *VIVID-01*. You can leave these words the way they are and press *OK* to save the control. The words will become the new name of your custom control and will show up under the *Set Picture Control* list. You also have the option of creating a more descriptive name of your choice (a maximum of 19 characters).

- **To create a new name**, hold down the ISO–thumbnail/playback zoom out button and use the Multi Selector to scroll back and forth within the name. When you have the small gray cursor positioned over a character, you can delete it with the trash can delete button. To insert a new character, position the yellow cursor in the character list above and press the QUAL–playback zoom in button. The character that is under the yellow cursor will appear on the name line below, at the position of the gray cursor. If a character is already under the gray cursor, it will be pushed to the right. Press the *OK* button when you have completed the new name. (See #3, 8, 9, 13, and 14 on page 5 in the User's Manual.)

8. Click the *OK* button to save the new custom Picture Control name. It will now be available in the *Set Picture Control* list.

If you've previously fine-tuned a Nikon Picture Control, it will be there for you to save it as a custom Picture Control, using the preceding steps. Once you have created and saved your own custom Picture Control, it will show up in the *Set Picture Control* selection list, where normally there are only the basic Nikon Picture Controls. (See the section "Set Picture Control" earlier in this chapter.) Your new custom control will stay in the list with the Nikon controls until you remove it. You can also rename them, delete them, save them out to your memory card for later use, or trade them with friends. Next we'll see how.

Sharing Custom Picture Controls

You can share any of the custom Picture Controls you create by copying them to your memory card and transferring them to your computer.

Here is a description of how to save a custom Picture Control to your camera's memory card (see *figure 4*):

1. Press the *MENU* button and select the *Shooting Menu* (small green camera).
2. Scroll down to *Manage Picture Control* and scroll to the right.
3. Select *Load/save* from the menu and scroll to the right.
4. Select *Copy to card* and scroll to the right.
5. Select one of your previously created custom Picture Controls from the list and scroll to the right.

6. Your camera now displays a *Choose destination* screen. These "destinations" simply represent an index on your memory card. You can have up to 99 custom Picture Controls on any one memory card. If there are already custom controls on the memory card, you'll see them in the *Choose destination* list.
7. Click *OK* and you'll see a brief pop-up screen saying, *Data saved to memory card*.

Once you've saved a custom Picture Control to your memory card, you can transfer it to your computer for use with software or other cameras. If one of your friends makes a new control you'd like to try, or you find one on the Internet and download it, you can transfer it into your D90. I'll show you how next.

igure 4 – Sharing custom Picture Controls

Copying Custom Picture Controls to Your D90

To transfer a custom Picture Control from your camera's memory card to your *Set Picture Control* list, do the following (see figure 5):

1. Press the *MENU* button and select the *Shooting menu* (small green camera).

2. Scroll down to *Manage Picture Control* and scroll to the right.

3. Select *Load/save* from the menu and scroll to the right.

4. Select *Copy to camera* and scroll to the right.

5. You'll be presented with a *Copy to camera* list. This list shows the total number of custom Picture Controls that are currently on the memory card in your camera. Select one of them and click the *OK* button. (If you scroll to the right instead, you can examine and adjust the control before saving it to your camera. If you don't want to modify it, simply press *OK*.)

6. You will now be shown the *Save as* screen, which lists any custom Picture Controls already on your camera. There are nine memory locations, labeled *C-1* through *C-9*. Select one of the memory locations marked *Unused* and press the *OK* button.

7. You'll now be presented with the *Rename* screen, just in case you want to change the name of the custom control. If you don't want to change the name, simply press the *OK* button and the custom control will be added to your *Set Picture Control* list.

- **To create a different name**, hold down the ISO–thumbnail/playback zoom out button and use the Multi Selector to scroll back and forth within the old name. When you have the small gray cursor positioned over a character, you can delete it with the trash can delete button. To insert a new character, position the yellow cursor in the character list above and press the QUAL–playback zoom in

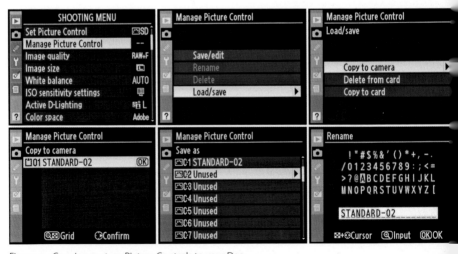

Figure 5 – Copying custom Picture Controls to your D90

button. Whatever character is under the yellow cursor will appear on the name line below, at the position of the gray cursor. If a character is already under the gray cursor, it will be pushed to the right. Please limit the name to a maximum of 19 characters. Press the *OK* button when you've completed the new name. (See #3, 8, 9, 13, and 14 on page 5 in the User's Manual.)

You can also create custom Picture Controls in programs like Nikon Capture NX2 and later load them into your camera using the preceding steps.

What if you decide to rename an already existing custom Picture Control? You can do it by following the next set of steps.

Renaming a Custom Picture Control

If you decide to rename a custom Picture Control, do the following (see *figure 6*):

1. Press the *MENU* button and select the *Shooting Menu* (small green camera).
2. Scroll down to *Manage Picture Control* and scroll to the right.
3. Select *Rename* from the menu and scroll to the right.
4. Select one of your custom Picture Controls from the list (*C-1* to *C-9*), and scroll to the right.
5. You'll now be presented with the *Rename* screen, To create a different name, hold down the ISO–thumbnail/playback zoom out button and use the thumb multi selector switch to scroll back and forth within the old name. When you have the small gray cursor

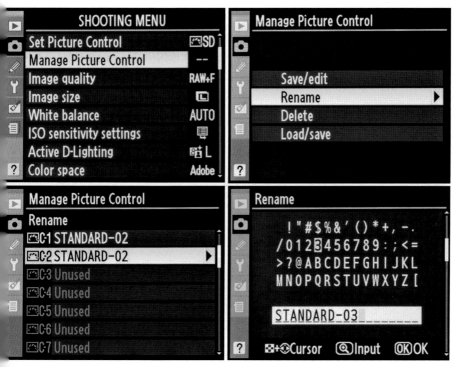

gure 6 – Renaming custom Picture Controls

positioned over a character, you can delete it with the trash can delete button. To insert a new character, position the yellow cursor in the character list above and press the QUAL–playback zoom in button. Whatever character is under the yellow cursor will appear on the name line below, at the position of the gray cursor. If a character is already under the gray cursor, it will be pushed to the right. Make sure you limit the name to a maximum of 19 characters. Press the *OK* button when you have completed the new name. (See #3, 8, 9, 13, and 14 on page 5 in the User's Manual.) I renamed this control in *figure 6 STANDARD-03*.

Note on Naming Picture Controls

As you can see in the lower-left image in *figure 6* you can have multiple controls with the same name in your list of custom Picture Controls. The camera does not get confused because it has the memory locations *C-1* to *C-9* to keep them separate.

When a custom Picture Control is no longer needed, you can easily delete it.

Deleting Custom Picture Controls from the Camera

When you are ready to delete a custom Picture Control from within your Nikon D90, removing it permanently from the *Set Picture Control* list, just follow these steps (see *figure 7*):

1. Press the *MENU* button and select the *Shooting Menu* (small green camera).
2. Scroll down to *Manage Picture Control* and scroll to the right.
3. Select *Delete* from the menu and scroll to the right.
4. Select one of your custom Picture Controls from the list (*C-1* to *C-9*), and then scroll to the right.
5. You'll be presented with the *Delete* screen and a question: *Delete Picture Control?*
6. Scroll up to *Yes* and press the *OK* button.
7. You'll briefly see *Done* pop up on your screen, and the custom control is no more.

What if you have some controls on the memory card and want to use the D90 to remove them? That's also easy to do.

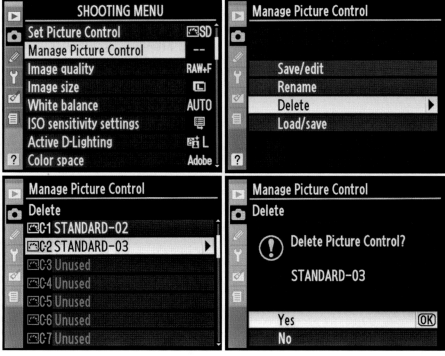

Figure 7 – Deleting custom Picture Controls from the D90

Deleting Custom Picture Controls from an Inserted Card

Previously, we looked at how to remove a custom Picture Control from within the Nikon D90's *Set Picture Control* list. If you have old custom Picture Controls on your inserted memory card, you can remove them by doing the following (see *figure 8*):

1. Press the *MENU* button and select the *Shooting Menu* (small green camera).
2. Scroll down to *Manage Picture Control* and scroll to the right.
3. Select *Load/save* from the menu and scroll to the right.
4. Select *Delete from card* from the list and scroll to the right.
5. You'll be presented with the first *Delete from card* screen. It shows a list of all the custom Picture Controls it can find on the memory card, numbered from 01 to 99. (As *figure 8* shows, I had only one control, named *STANDARD-02*, on the card.)

6. Now you'll see the final *Delete from card* screen and the question *Delete Picture Control?*
7. Scroll up to *Yes* and press the *OK* button.
8. You'll briefly see *Done* pop up on your screen, and the custom control is now deleted from the memory card.

Custom Picture Controls give you the ability to make your camera take pictures that look the way you want them to. Don't be afraid to experiment with different looks; you can always delete or adjust a control you don't like. You can't delete the basic Nikon Picture Controls from which your custom controls are derived, so don't let that worry you. Enjoy the flexibility your D90 gives you and use it to the fullest!

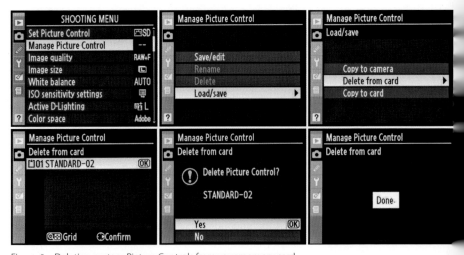

Figure 8 – Deleting custom Picture Controls from your memory card

Image Quality

(User's Manual page 62)

The "quality" of your image is directly related to what image format or type you use. The Nikon D90 has two specific image types that can be used individually or together.

It supports the following image types:
- NEF (RAW). The *NEF* stands for Nikon Electronic Format.
- JPEG fine, normal, and basic
- Combination of both NEF and JPEG. (Same image stored twice, one as a NEF, the other as a JPEG.)

Let's look at each of these formats and see which you might want to use regularly. Following this section is a special supplement called "Supplementary Section – Understanding Image Formats." This special section goes beyond just how to turn the different formats on and off and discusses why you might want to use a particular format over another. *It will discuss details you should know as a digital photographer.*

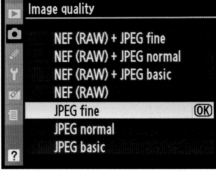

Figure 9 – *Image quality* screens on the *Shooting Menu*

Figure 10 – *NEF (RAW)* Image quality selection

NEF (RAW) Format

This Nikon-exclusive format, NEF, stores RAW image data directly to the camera's memory card in files and can easily be recognized because the filename ends with .nef. This is not an image format used in day-to-day graphical work (like JPEG), and an NEF image is not yet really even an image. Instead, NEF is a base storage format used to store images for conversion to another format like JPEG, TIFF, or EPS. Other than initial compression, it stores all available image data and can be easily manipulated later.

You must use conversion software, such as Nikon ViewNX or Nikon Capture NX2 to later change your NEF format RAW file into a format like TIFF or JPEG. There are also several after-market RAW conversion applications available, such as Bibble, Capture One, and Photoshop Adobe Camera Ready (ACR).

Before you go out shooting in the NEF (RAW) format, why not install your conversion software of choice so that you'll be able to view, adjust, and save the images to another format when you return?

You may not be able to view NEF files directly on your computer unless you have RAW conversion software installed, such as the included Nikon ViewNX. Some operating systems provide a downloadable "patch" or "codec" that allows you to at least see NEF files as small thumbnails. Do a Google search on "microsoft RAW thumbnail viewer download" and you'll find Microsoft Windows XP patch for NEF files. You'll be able to download a file called RAWViewerSetup.exe (about 5.8 MB), which allows XP to display small NEF file "thumbnails" when you view a folder containing them.

Nikon provides a CD with the D90 that includes Nikon Software Suite for both Macintosh and Windows computers. It provides Nikon ViewNX, which can be used to examine your NEF (RAW) files in

detail and convert them to other formats. It also has Nikon Transfer, a program that helps you download your images from your camera and onto your computer.

NEF (RAW) mode uses an image data compression type known as *visually loss-less*. Compression is applied to the image and reduces its size by 40 to 55 percent (which varies according to the amount of detail in the image). There is a small amount of data loss involved in this compression method because the file size is reduced by a considerable degree. Most people won't be able to see the loss because it doesn't affect the image visually. I have never really seen any loss in my RAW images. However, I have read that some people notice slightly less highlight detail, so there may be a small amount of dynamic range loss toward the highlights.

Nikon says that this is a *nonreversible* compression, so once you've taken an NEF image, it is permanently compressed and any small amount of compression data loss is permanent. Not to worry though, since the compression type used in NEF (RAW) images throws away far less data than any form of JPEG image. Maximum quality will always come from a RAW image.

The reported image storage capacity for the D90 for RAW (NEF) format is 539 images on an 8 GB SanDisk Extreme III SD memory card.

My Personal Software Choices

Nikon ViewNX RAW conversion software is supplied free with the D90, while Nikon Capture NX2 requires a separate purchase. Capture NX2 has become my favorite conversion software, along with Adobe Photoshop. I use ViewNX to look at my images, since it has an excellent browser-type interface, and then I push them to Capture NX2 for final post-processing. If I need to remove an ugly tree branch from the edge of an otherwise spotless image, or a blemish from a person's face, I'll use Photoshop's Clone and Healing tools.

Figure 11 – *JPEG Image quality* selection

JPEG (Joint Photographic Experts Group) Format

As shown in *figure 11*, the D90 has three JPEG modes. Each mode affects the final quality of the image. Let's look at each mode in detail:

- *JPEG fine* (compression approximately 1:4)
- *JPEG normal* (compression approximately 1:8)
- *JPEG basic* (compression approximately 1:16)

Each of the JPEG modes provides a certain level of *lossy* image compression. The human eye compensates for small color changes quite well, so the JPEG compression algorithm works effectively for viewing by humans. A useful thing feature of JPEG is that one can vary the file size of the image (via compression) without greatly affecting quality.

JPEG fine (or fine quality JPEG) uses a 1:4 compression ratio, so there is a significant difference in the file size, that can be as small as 25 percent of the original size. In this mode, an image can be compressed down to as little as 4 or 5 megabytes without significant loss of image quality. If you decide to shoot in JPEG, *this mode will give you the best quality JPEG your camera can produce*. Where a RAW setting only allows 539 images on an 8-gigabyte memory card, the *JPEG fine* setting raises that to about 1,100 files.

JPEG normal (or normal quality JPEG) uses a 1:8 compression ratio. This makes the D90 image file as small as 2.5 megabytes. The image quality is still very acceptable in this mode, so if you are just shooting at a party for an average 4x6 printed image size, this mode will allow you to capture a large quantity of images. An 8-gigabyte memory card will hold about 2,100 JPEG normal image files.

JPEG basic (or basic quality JPEG) uses a 1:16 compression ratio, so the D90's image file size drops to a 1.25 megabyte JPEG file. Remember, these are full-size files, so you can surely take a lot of pictures. If you are shooting for the Web, or just want to document an area well, this mode has sufficient quality. My D90 tells me it can store a whopping 4,200 JPEG basic files on my 8-gigabyte memory card.

Combined NEF and JPEG Shooting

Some shooters use a clever option of storage modes whereby the D90 takes two images at the same time. NEF (RAW) + JPEG is what it's called. This option gives you the best of both worlds in that you shoot a nice RAW file and a JPEG file each time you press the shutter button. In NEF (RAW) + JPEG fine, my camera's storage drops to about 361 images because it is storing an NEF and a JPEG file at the same time for each picture taken.

With this method you can use the RAW file to store all the image data and later to post-process it into a masterpiece, and you can use the JPEG file immediately

with no adjustment. Many people use one of these three modes quite often:

- *NEF (RAW) + JPEG fine*
- *NEF (RAW) + JPEG normal*
- *NEF (RAW) + JPEG basic*

There is no need to go into detail about these modes other than what I just discussed. The NEF + JPEG modes have the same features as their individual modes. In other words, the NEF (RAW) file works just like an NEF (RAW) file if you were using the stand-alone NEF (RAW) mode. The JPEG in a NEF + JPEG mode works just like a stand-alone JPEG shot without an NEF (RAW) file.

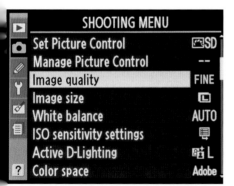
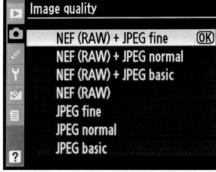

Figure 12 – *NEF (RAW) + JPEG fine Image quality* selection

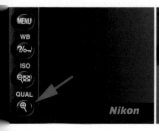
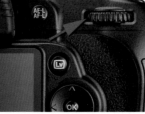

Figure 12A – Selecting image quality with external controls

If you need more information, just refer to the information on NEF (RAW) or JPEG earlier.

An easy way to change image formats is to hold down the *QUAL* button and rotate the rear main-command dial. Referring to *figure 12A*, why not give it a try on your D90. This is the fastest way to change formats.

Here are the steps (see *figure 12A*):

1. Press the *QUAL* button and hold it.
2. Rotate the rear main-command dial until you see your selected image quality appear on the left lower side of the upper control panel LCD.
3. Release the *QUAL* button.

Now, let's consider the benefits each of these formats might bring to your photography and which might become your favorite.

Supplementary Section – Understanding Image Formats

There are many discussions in Internet camera forums on the question "Which is the best image format?" To decide which format you may frequently use, it will help to examine the pros and cons of each. In this section, we'll do just that. We'll examine the two formats available in the D90: NEF (RAW), and JPEG.

NEF (RAW)

I am an NEF (RAW) photographer about 98 percent of the time. I think of a RAW file as I thought of my slides and negatives a few years ago. It's my original file that must be saved and protected. There are only a couple of problems I can think of with the RAW format:

- You must post-process every image you shoot and convert into a TIFF or JPEG (or other viewable format).
- There is no industry-standard RAW image format, and Nikon has the option of changing the NEF (RAW) format each time it comes out with a new camera.

Other than those drawbacks, many others and I shoot NEF (RAW) for maximum image quality.

It is important that you understand something that is very different about NEF (RAW) files. They are not really images...yet. Basically, a RAW file is composed only of black and white sensor data and camera setting information markers. The RAW file is saved in a form that must be converted to another image type in order to be used in print or on the Web.

When you take a picture in RAW, the camera records the sensor data and markers for how the camera's color, sharpening, and so on are set, but *the camera setting information is not applied to the image.* In your computer's post-processing software, the image will appear on-screen using the settings you initially set in your D90. However, they are only applied in a temporary manner.

If you do not like the white balance you had selected at the time you took the picture, simply apply a new white balance and the image will be just as if you had used the new white balance setting when you took the picture. If you had low sharpening set in-camera and change it to normal sharpening in-computer, then the image will look just like it would have looked if you had used normal in-camera sharpening when you took the image. This is quite powerful!

Virtually no camera settings are applied to a RAW file in a permanent way. That means you can change the image to completely different settings and the image will be as if you had used those settings when you first took the picture. This allows significant flexibility later. If you shot the image initially with the *Standard* Picture Control setting and now want to use *Vivid*, all you have to do is change the image to *Vivid* and it will be as if you used *Vivid* when you first took the picture. Complete flexibility!

NEF (RAW) is generally used by individuals concerned with maximum image quality and who have time to convert the image in the computer after taking it with the camera.

The Pros and Cons of NEF (RAW) Format

NEF (RAW) Pros

- It allows the manipulation of image data to achieve the highest-quality image available from the camera.
- All original detail stays in the image for future processing needs.
- No conversions, sharpening, sizing, or color rebalancing will be performed by the camera. Your images are untouched and pure!
- You can convert to any of the other image formats by using your computer's much more powerful processor instead of the camera processor.
- You have much more control over the final look of the image because you, not the camera, are making decisions as to the final appearance of the image.
- It uses 12-bit format for maximum image data.

NEF (RAW) Cons

- It's not often compatible with publishing industry requirements, except by conversion to another format.
- It requires post-processing by special proprietary software as provided by the camera manufacturer or third-party software programmers.
- The file sizes are larger (so you must have large storage media).
- There is no accepted industry-standard RAW mode. Each camera manufacturer has its own proprietary format. Adobe has a RAW format called DNG (Digital Negative) that might become an industry standard. We'll see!
- The 12-bit format is not really in use because 8-bit is industry standard.

JPEG Notes

JPEG (.jpg) is used by individuals who want excellent image quality but have little time or interest in post-processing images or converting images to another format. They want to immediately use the image when it comes out of the camera, with no major adjustments.

With JPEG format, the camera settings you have chosen are applied to the image when it is taken. It comes out of the camera ready to use, as long as you have exposed it properly and have all the other settings set in the best way for the image.

Since JPEG is a lossy format, one cannot modify and save an image more than a time or two before ruining it due to compression losses. However, since there is no post-processing required later, this format allows much quicker usage of the image. A person shooting a large quantity of images, or who does not have the time to convert RAW images, will usually use JPEG. That encompasses a lot of photographers!

While a nature photographer might want to use RAW because they have more time for processing images and wringing the last drop of quality out of them, an event or journalist photographer may not have the time or interest in processing images, so they'll use JPEG.

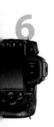

The Pros and Cons of JPEG Mode

JPEG Pros

- Maximum number of images on camera card and later on computer hard drive storage
- Fastest writes from camera memory buffer to memory card storage
- Absolute compatibility with everything and everybody in imaging
- Uses the industry standard 8 bits
- High-quality first-use images
- No special software needed to use the image right out of the camera (no post-processing)
- Immediate use on websites with minimal processing
- Easy transfer across Internet and as e-mail attachments

JPEG Cons

- JPEG is a lossy format, which means that it permanently throws away image data from compression algorithm losses as you select higher levels of compression (fine, normal, basic).
- You cannot use JPEG to manipulate an image more than once or twice before it degrades to an unusable state. Every time you modify and resave a JPEG image, it loses more data.

Final Image Format Ramblings

Which format do I prefer? Why, RAW, of course! But, it does require a bit of a commitment to shoot in this format. The D90 is simply an image-capturing device, and *you* are the image manipulator. You decide the final format, compression ratios, sizes, color balances, picture controls, and so on. In RAW mode, you have the absolute best image your camera can produce. It is not modified by the D90 and is ready for your personal touch. No in-camera processing allowed!

If you get nothing else from this section, remember this... *by letting your camera process the images in ANY way, it is modifying or throwing away image data.* There is only a finite amount of data for each image that can be stored on your camera, and later on the computer. With JPEG mode, your camera optimizes the image according to the assumptions recorded in its memory. Data is thrown away permanently, in varying amounts.

If you want to keep virtually all the image data that was recorded in the image, you must store your originals in RAW format. Otherwise you'll never again be able to access that original data to change how it looks. RAW format is the closest thing to a film negative or a transparency that your digital camera can

make. This is important if you would like to use the image later for modification.

If you are a photographer who is concerned with maximum quality, you should probably shoot and store your images in RAW format. Later, when you have the urge to make another masterpiece out of the original RAW image file, you will have *all* of your original data intact for the highest quality.

If you are concerned that the RAW format may change too much over time to be readable by future generations, then you might want to convert your images into TIFF, DNG, or JPEG files. TIFF is best if you want to modify them later. I often save a TIFF version of my best files just in case RAW changes too much in the future. Why not do a little more research on this subject and decide which you like best?

Figure 13 – *Image size* selection

Image Size

(User's Manual page 63)

This menu selection applies only to images captured in JPEG modes. If you are shooting with your D90 in NEF + JPEG modes, it applies only to the JPEG image in the pair. Here's how to select the size of the image (see *figure 13*):

1. Press the *MENU* button and select the *Shooting Menu* (small green camera).
2. Choose *Image size*, and then scroll right.
3. Choose the size of the image.
4. Press the *OK* button.

This is relatively simple since it affects just the megapixel (MP) size of the image. Here are the three settings under *Image size*:

- *Large – 4288x2848 – 12.2 M* (megapixels)
- *Medium – 3216x2136 – 6.9 M*
- *Small – 2144x1424 – 3.1 M*

I've been playing around with these settings for the fun of it. I'm certainly not interested in using my 12.2 MP D90 as a 6.9 MP or 3.1 MP camera. I suppose there may be some reasons to reduce the MP rating of the camera, but not for me.

If I set the D90's *Image quality* to *JPEG basic* and *Image size* to *Small*, my D90 will capture 15,500 images on an 8-gigabyte card. The images are 3.1 MP in size (2144 x 1424 = 3,053,056, or 3.1 MP) and compressed to the maximum the D90 will create, but there are a large number of them.

If I were to set off today to walk completely around the earth and I had only one 8-gigabyte memory card to take with me, well, if I set the *Image size* to *Small* my D90 would give me over 15,000 images on the one card, so I could at least document my trip very well.

White Balance

(User's Manual pages 95-107)

An entire chapter of this book has been devoted to white balance. Please turn to chapter 3 for detailed information on this very important subject.

White balance is so important because it makes sure your colors are accurate: whites are white, greens are green, and so on.

In *figure 14*, you will see three screens. The middle screen allows you to select one of the white balance modes according to the type of light in which you are shooting. For general shooting, *Auto* is usually sufficient. However, if you want the images to match each other in color response, it is important to use a preset white balance mode like Sunlight or Flash. If you are really a critical shooter, the *PRE* ambient light measurement method is best.

Besides these menus, you can also use camera controls to set the white balance as shown in *figure 15*.

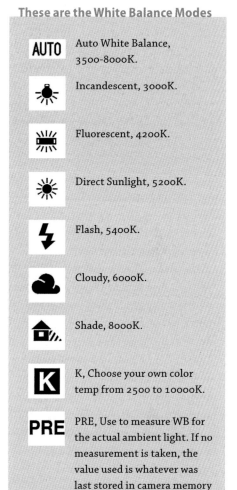

These are the White Balance Modes

AUTO — Auto White Balance, 3500-8000K.

Incandescent, 3000K.

Fluorescent, 4200K.

Direct Sunlight, 5200K.

Flash, 5400K.

Cloudy, 6000K.

Shade, 8000K.

K, Choose your own color temp from 2500 to 10000K.

PRE, Use to measure WB for the actual ambient light. If no measurement is taken, the value used is whatever was last stored in camera memory location *d-o*.

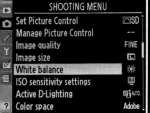
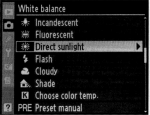

igure 14 – White balance selection and fine-tuning screens

Figure 15 – White balance manual selection by camera controls

To manually change the white balance using camera controls, you'll do the following:

1. Hold down the WB button, shown in the first image in *figure 15*.
2. Rotate the rear main-command dial, shown in the middle image in *figure 15*.
3. A series of symbols matching the symbols shown in the middle screen of *figure 14* will scroll by on the bottom of your upper control panel LCD. Each symbol has a meaning, as shown earlier. In the rightmost image in *figure 15*, you can see the arrow pointing at the *PRE* setting. This is in preparation for doing a manual white balance reading from a white card under the ambient light in which you find yourself shooting.

You can select from a total of nine white balance settings with the camera controls. You'll have to use the external controls to do an ambient white balance light reading because the menus don't support it.

Remember, this subject is so important that an entire chapter has been devoted to it. Besides these basics, please be sure and read chapter 3 for detailed information!

ISO Sensitivity Settings

(User's Manual, pages 74 and 166.)
After this section on how to set the ISO sensitivity settings, you'll find a section called "When and Why Should I Use ISO-AUTO?" This section goes beyond just how to set ISO-AUTO and explains the reasons you may or may not want to use it with your style of photography. Now, let's get to the configuration information.

An ISO number, such as 200 or 3200, is an agreed upon term for the sensitivity of the image capturing sensor. Virtually everywhere one goes in the world, all camera ISO numbers will mean the same thing. With that fact established, camera bodies and lenses can be designed to take advantage of the ISO sensitivity ranges they will have to deal with. Standards are good!

In the D90, the ISO numbers are sensitivity equivalents. To make it very simple ISO "sensitivity" is the digital equivalent of film speed. *The higher the ISO sensitivity, the less light needed for the exposure.* A high ISO setting allows faster shutter speeds and smaller apertures.

Figure 16 – External ISO camera controls

In *figure 16*, you see the external camera controls used to adjust ISO quickly. This is the easiest method to change the camera's ISO setting. Here are the steps:

1. Hold down the *ISO* button on the back of the D90.
2. Turn the rear main-command dial and watch the top control panel LCD.
3. Find the ISO you want to use.
4. Release the *ISO* button.

You can also use the *Shooting Menu*'s - *SO sensitivity settings* screens. *Figure 17* shows the three screens used to change he camera's ISO.

Notice in the third image in *figure* 7 that you have a scrollable list of ISO alues, from Lo 1.0 (100 ISO) to Hi 1.0 6400 ISO). The normal ISO range for the D90 is 200 to 3200 ISO. Select the ISO ou need from the list of available ISO umbers. Here's how:

1. Press the *MENU* button and select the *Shooting Menu* (small green camera).
2. Choose *ISO sensitivity settings*, and then scroll right.
3. Choose *ISO sensitivity*, and then scroll right.
4. Choose an ISO number.
5. Press the *OK* button.

The *standard* minimum *ISO sensitivity setting* value for the D90 is 200 ISO. You can adjust the camera in a range from 100 to 6400 ISO, in 1/3 steps.

Select your favorite ISO setting, either with the external camera controls or with the *Shooting Menu*'s *ISO sensitivity settings* screens.

If you would like, you can also simply let your camera decide which ISO it would like to use. In the next section, we'll consider this often misunderstood feature in detail.

 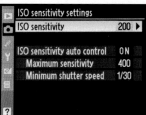 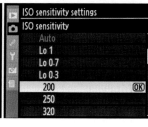

gure 17 – *Shooting Menu* screens to set ISO

Which ISO Setting Do I Use?

I often use ISO *Lo 1.0* (100 ISO equivalent) because I appreciate the smoothness and lack of noise that setting provides. As a stock shooter, I want to avoid noise in all my images, so I go with the lowest ISO my camera allows—if the light is bright enough. In thousands of shots, I have never seen a problem with shooting at that "nonstandard" setting.

I have read that some feel there is less dynamic range in the image if the nonstandard settings are used. However, I have not found that to be true. ISO 200 is a stop faster, so it provides a little more speed for handholding the camera. My most critical work is always done on a tripod, so I do not worry about slow shutter speeds as often as a "handholder" would. I can just detect the smallest amounts of noise showing up in images at ISO 200 when I underexpose by as little as 1/3 stop. You'll have to test your images and discover your noise tolerance level. I am an anti-noise fanatic. You may not be!

ISO Sensitivity Auto Control (ISO-AUTO)

You may have noticed in the second screen in *figure 17* that there is another setting available, *ISO sensitivity auto control*, which defaults to *OFF*. This was known on earlier Nikon cameras as ISO-AUTO.

This setting is used to allow the camera to control the ISO according to the light levels sensed by the camera meter. *Figure 18* shows the *Shooting Menu* screens used to enable ISO-AUTO:

To enable ISO-AUTO do the following:

1. Press the *MENU* button and select the *Shooting Menu* (small green camera).
2. Choose *ISO sensitivity settings*, and then scroll right.
3. Choose *ISO sensitivity auto control*, and then scroll right.
4. Select *On*.
5. Press the *OK* button.

Once you've turned ISO-AUTO on, you should set two values, according to how you shoot:

- *Maximum sensitivity*
- *Minimum shutter speed*

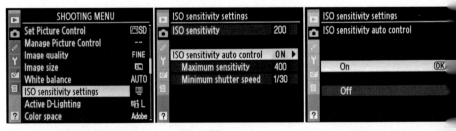

Figure 18 – *Shooting Menu* screens to set ISO-AUTO ranges

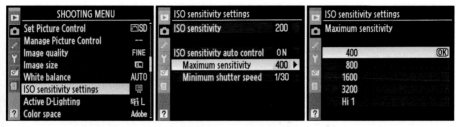

Figure 19 – ISO-AUTO *Maximum sensitivity* settings

Maximum sensitivity – This setting is a safeguard for you because it allows you to control how high the ISO will go when you shoot. If you would prefer that ISO-AUTO not exceed a certain ISO number, simply select from the list shown in the third screen in *figure 19.*

To select the maximum ISO sensitivity that your camera can use while in ISO-AUTO, simply follow these steps (see *figure 19*):

1. Press the *MENU* button and select the *Shooting Menu* (small green camera).
2. Choose *ISO sensitivity settings*, and then scroll right.
3. Choose *Maximum sensitivity,* and then scroll right.
4. Select the ISO maximum sensitivity that you want the camera to use.
5. Press the *OK* button.

You'll note that there are only five available settings:

- *400*
- *800*
- *1600*
- *3200*
- *Hi 1*

Whichever one of these settings you choose will be the maximum ISO the camera will use to get a good exposure when the light drops. To protect the image from excessive noise, it won't exceed this ISO level. Once again, you'll have to determine your personal noise-level tolerance to select one of these settings. *The higher the ISO, the higher the potential noise level.*

ISO Settings and Noise

In testing the Nikon D90 for noise, I find that it makes entirely usable images, with low noise, all the way up to ISO 1600. However, being noise sensitive, I do not often set ISO-AUTO *Maximum sensitivity* higher than ISO 800. I will leave it set to ISO 400 most of the time. If you are an action shooter who must get the image no matter what, then open the ISO maximum up to its highest levels. It will use them only when it can't get the shot otherwise.

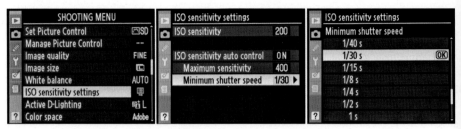

Figure 20 – ISO-AUTO *Minimum shutter speed*

Minimum shutter speed – Since shutter speed controls how sharp an image can be, due to camera shake and subject movement, you'll need some control over the minimum shutter speed allowed while ISO-AUTO is turned on. See *figure 20* for a list of shutter speeds.

You can select a shutter speed from the list to be used as the minimum shutter speed the camera will allow when the light diminishes. The available shutter speeds run between 1 second and 1/2000 second. Here are the steps (see *figure 20*):

1. Press the *MENU* button and select the *Shooting menu* (small green camera).
2. Choose *ISO sensitivity settings*, and then scroll right.
3. Choose *Minimum shutter speed*, and then scroll right.
4. Select a *Minimum shutter speed*, keeping in mind that most people have problems handholding a camera set lower than 1/30 second.
5. Click the *OK* button.

When you have enabled ISO-AUTO, the top control panel LCD and viewfinder will show and blink the words *ISO-AUTO*. The blinking is a reminder to turn it off when not needed so that you don't get unnecessarily noisy images.

Special Note

When you enable ISO-AUTO, it might be a good idea to also enable *High ISO Noise Reduction*. This is especially true if you leave the camera set to the higher ISO values above 800. Otherwise, you may have excessive noise when the light drops. High ISO noise reduction will be discussed later in this chapter.

When and Why Should I Use ISO-AUTO?

How much automation do you need in order to produce consistently excellent images? Let's explore how and when automatic self-adjusting ISO might improve or degrade your images. What is this feature all about? When and why should you use it? Are there any compromises in image quality in this mode?

Normally you will set your camera to a particular ISO number, such as 200 or 400, and shoot your images. As the light diminishes (or in the deep shade), you might increase the ISO number to allow the camera to continue making images when you handhold your camera.

If you are in circumstances where you absolutely *must* get the shot, ISO-AUTO will work nicely. Here are a few scenarios:

Scenario # 1: Let's say you are a photojournalist and you're shooting flash

pictures of a famous politician or celebrity as he quickly disembarks from his airplane, walks into the terminal, and departs in a limousine. Under those circumstances, you will have little time to check your ISO settings or shutter speeds and will be shooting in widely varying light conditions.

Scenario # 2: You are a wedding photographer in a church that does not allow the use of flash. As you follow the bride and groom from the dark inner rooms of the church, out into the lobby, and finally up to the altar, your lighting conditions will be varying constantly. You have no time to deal with the fluctuations in light by changing your ISO since things are moving too quickly.

Scenario # 3: You are at a party, and you want some pictures. You want to use flash, but the built-in pop-up flash may not be powerful enough to reach across the room at low ISO settings. You really don't want to be bothered with camera configuration at this time but still want some well-exposed images. Light will vary as you move around the room, talking, laughing, and snapping pictures.

These scenarios are excellent environments for using ISO-AUTO. The camera will use your normal settings (such as your normal ISO), shutter speed, and aperture until the light will not allow those settings to provide an accurate exposure. Only then will the camera raise or lower the ISO value to keep functioning within the shutter/aperture parameters you have set.

Look at ISO-AUTO as a "fail-safe" for times when you *must get the shot* but have little time to deal with camera settings, or when you don't want to vary the shutter/aperture settings but still want to be assured of a well-exposed image.

Use ISO–AUTO Only When Needed

Unless you are a private detective shooting handheld telephoto images from your car, or you're a photojournalist or sports photographer who *must get the shot every time* regardless of maximum quality, I personally would not recommend leaving your camera set to ISO-AUTO. Use it only when you really need to get the shot under any circumstances!

Of course, if you are unsure of how to use the "correct" ISO for the light level due to lack of experience, don't be afraid to experiment with this mode. At the very worst, all you might get are noisier-than-normal images. However, it may not be a good idea to depend on this mode over the long term because noisy images are not very desirable.

The Drawbacks to ISO–AUTO

Are there any drawbacks to using ISO-AUTO? Maybe. It really depends on how widely the light conditions will vary when you are shooting. Most of the time your camera will maintain normal ISO range settings in ISO-AUTO, so your images will be their normal low-noise, sharp masterpieces. However, at times the light may be so low that the ISO may exceed the "normal" range of 200 to 800 and will start getting into the noisier ranges above 800 ISO.

Just be aware that ISO-AUTO can and will push your ISO into a range that causes noisier images when light levels drop if you've set *ISO maximum sensitivity* to high levels. Use it with this understanding and you'll do fine. The 6400 ISO (*Hi 1*) setting is the maximum in ISO-AUTO unless you have set the maximum to a lower number.

Make sure you understand this or you might get some noisy images.

ISO-AUTO is yet another feature in our powerful Nikon cameras. Maybe not everyone needs this "fail-safe" feature, but for those who do, it is a great option. I use it myself in circumstances where getting the shot is the most important thing and where light levels may get too low for normal ISO image making.

Even if you think you might only use it from time to time, do learn how to use it for those times. Experiment with ISO-AUTO. It's fun and can be useful!

Active D-Lighting

(User's Manual pages 119-120)

Often the range of light around our image subject is broader than what our D90's sensor can capture. Where the D90 might be able to capture 4 to 6 stops of light, the light out in the world on a bright summer day might equal 12 stops in range. The contrast is too high!

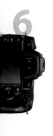

Since the D90 cannot grab the full range of light, and most people use the histogram to expose for the highlights, some of the image detail will be lost in shadow. The D90 allows you to "D-Light"

the image and bring out additional shadow detail to lower the image contrast.

Here's how to select a level of *Active D-Lighting* (see *figure 21*):

1. Press the *MENU* button and select the *Shooting menu* (small green camera).
2. Select *Active D-Lighting*, and then scroll right.
3. Select the level that you want to use, keeping in mind that the higher the D-Lighting setting, the lower the image contrast.
4. Press the *OK* button.

Active D-Lighting has these settings:
- AUTO *Auto*
- *H* Extra high*
- *H High*
- *N Normal*
- *L Low*
- *Off* (no Active D-Lighting)

If you are familiar with Nikon Capture NX2, you may know how D-Lighting works since it's a function in the software. You can use it to bring up "lost" shadow detail, at the expense of adding noise in the darker areas recovered.

Active D-Lighting will bring out detail in areas of your image that are hidden in

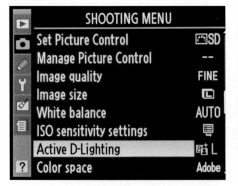

Figure 21 – *Active D-Lighting* screens

Figure 22 – Four example *Active D-Lighting* images: *Off, Low, Normal, High*

shadow due to excessive image contrast. *Figure 22* shows a series of four images with D-Lighting set to various levels.

In addition to the four levels shown in *figure 22*, the D90 has *Extra high* and *Auto* available. *Extra high* simply goes a step further in reducing shadows. *Auto* makes a decision based on the detected range of light in the image. *Auto* may cause the amount of D-Lighting to vary with each image, per the camera's decision. Use *Auto* only if you fully understand what happens with D-Lighting. Otherwise, you may get unexpected results.

You'll need to experiment with the *Active D-Lighting* settings to see which you like best. These options have the effect of lowering contrast, and many people do not like low-contrast images. Also, anytime you recover lost detail from shadows, there will be extra noise in the areas recovered. So watch the noise!

How I Use D-Lighting

I like D-Lighting, however, I only use it on *Low* unless there is a special need. D-Lighting tends to expand the dynamic range of the image. It not only opens up the shadow details, it also seems to protect the highlights so they don't blow out as quickly. If you are shooting on a bright sunny day, using your *Active D-Lighting* will improve the image because there is so much contrast.

However, I have noticed that using D-Lighting at higher levels will start to make the image look unnatural. The human eye expects that there will be little detail in shadows. If you see a picture that normally would have dark shadows and yet the shadows have detail, your brain might just do a double take. It can look weird. Also, I find that skin tones tend to get very pink looking at higher *Active D-Lighting* levels.

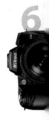

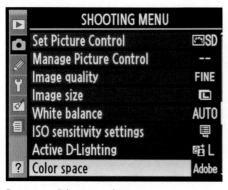
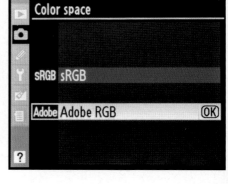

Figure 23 – *Color space* selection

Color Space

(User's Manual page 167)
Color spaces are an interesting and important part of digital photography. They help your images fit into a much broader range of imaging devices. Software, printers, monitors, and other devices recognize which color space is attached to your image and use it, along with other color profiles, to help balance the image to the correct output colors for the device in use. The two available color spaces have different *gamuts*, or ranges of color.

The Nikon D90 camera uses these two *color space* settings:

- *sRGB*
- *Adobe RGB*

Adobe RGB uses colors from a broader selection of the total color range. It has a wider gamut. So, if you are taking images that might later be printed, *Adobe RGB* is the best color space selection to use.

To get technical for a moment, Adobe RGB contains about 50 percent of the CIELAB color space, while *sRGB* only has 35 percent. CIELAB color space is

designed to approximate human vision. *Adobe RGB* gives your images access to significantly higher levels of cyans (bluish) and greens. That's what "wider gamut" means.

Here's how to select your favorite color space (see *figure 23*):

1. Press the *MENU* button and select the *Shooting menu* (small green camera).
2. Select *Color space*, and then scroll right.
3. Select the color space you want to use, keeping in mind that *Adobe RGB* has a larger color gamut.
4. Press the *OK* button.

Adobe RGB is for Me!

I personally always use *Adobe RGB* because I frequently take nature shots with a wide range of color. I want the color in my images to be as accurate as my camera will allow. *Adobe RGB* has a wider range of colors, or gamut, so it can be more accurate when a wide range of colors is present in my image's subject.

There are some drawbacks to using *Adobe RGB*, though. The *sRGB* color space is widely used in printing and display

devices. If you try to print directly to some inkjet printers using the *Adobe RGB* color space, the colors may not be as brilliant as with *sRGB*. If you aren't going to modify your images out-of-camera but just take them directly to print, you may want to use *sRGB*. If you shoot JPEGs only for computer display, it might be better to stay with *sRGB* for everyday shooting.

If you are a RAW shooter and regularly post-process your images, you should use *Adobe RGB*. You will then have a wider gamut of colors to work with and can make your images the best they can be. Later, you can convert your carefully crafted images to print with a good color profile and get great results from inkjet printers and other printing devices.

So, here's a rough guide:

- Many JPEG shooters use *sRGB*.
- Many RAW shooters use *Adobe RGB*.

This is not a hard-and-fast rule, but many people use these settings according to their style of shooting. I shoot RAW, so I use *Adobe RGB*. If you are shooting for money (such as for stock imaging), most

clients expect that you'll be using *Adobe RGB*. It has more colors, so it's the quality standard.

Long Exposure NR

(User's Manual page 167)

Nikon knows its sensors well. It feels that images taken at exposures longer than 8 seconds may exhibit more noise than is acceptable for normal use. It provides two settings for long exposure noise reduction (*Long exp. NR*), as shown in *figure 24*. Here's how to turn it on and off:

1. Press the *MENU* button and select the *Shooting Menu* (small green camera).
2. Select *Long exp. NR*, and then scroll right.
3. Select *On*.
4. Press the *OK* button.

There are two choices:

- *On*
- *Off*

On: When you select *On* and your exposure goes over 8 seconds, the D90 will take two exposures with the exact same time for each. The first exposure is

gure 24 – *Long exp. NR* screens

the normal picture-taking exposure. The second is a *black frame subtraction* exposure, in which an image is made for the same length of time as the first one, but with the shutter closed. The noise in the second black frame image is examined and subtracted from the original image. It's really quite effective, and it beats having to blur the image to get rid of noise. I've taken exposures of around 30 seconds and had perfectly usable results. The only drawback is that the exposure time is doubled because two exposures are taken, one right after the other.

When the second black frame exposure is being taken, the words *Job nr* will blink in the top control panel LCD and in the viewfinder. During this second exposure while *Job nr* is flashing, you cannot use the camera. If you turn it off while *Job nr*

is flashing, the camera still keeps the first image; it just does not do any noise reduction on it.

If long exposure noise reduction is on, the frame advance rate may slow down, and the capacity of the in-camera memory buffer will drop.

Off: If you select *Off*, then of course you will have no noise reduction with long exposures.

Recommendation

I always leave long exposure noise reduction turned on. I have found that the black frame subtraction method used gives me much higher-quality images with long exposures. *Figure 25* an example image of a lightning shot taken at 30 seconds. It has no appreciable noise.

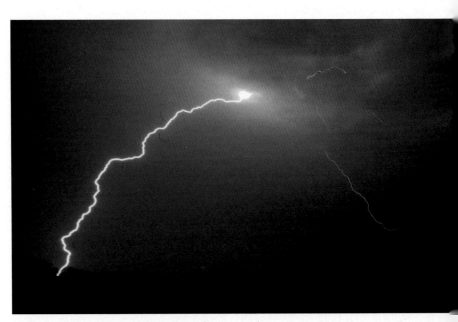

Figure 25 – Lightning shot with shutter open for 30 seconds

Figure 26 – *High ISO NR* selection

High ISO Noise Reduction

(User's Manual page 168)

The D90 has better noise control than most cameras, so it is able to shoot up to ISO 800 with little noise. However, no digital camera is completely without noise, so it's a good idea to use some noise reduction above a certain level of exposure gain. With the D90, the ISO can go up to 800 without reduction. After that, you must choose to allow or disallow high ISO noise reduction. Here are the steps to enable *High ISO NR* (see *figure 26*):

1. Press the *MENU* button and select *Shooting Menu* (small green camera).
2. Select *High ISO NR*, and then scroll right.
3. Select one of the noise reduction levels.
4. Press the *OK* button.

Here are the selections:
High
Normal
Low
Off

For any of the settings except *Off*, high ISO noise reduction will be performed starting at ISO 800. You'll need to shoot some high ISO exposures and decide for yourself whether you are comfortable with *High*, *Normal*, *Low*, or even *Off*. In *figure 27* is an image taken at a worst-case 3200 ISO with NR set to *Off*. I then show the same image at *Low*, *Normal*, and *High* settings.

Even if you turn high ISO noise reduction off, the D90 will still apply NR when you exceed 3200 ISO. The official starting point for forced high ISO noise reduction is HI 0.3, which is 1/3 step above 3200 ISO. There are two other 1/3 stop levels above HI 0.3, namely HI 0.7 and HI 1.0, the latter of which should approximate ISO 6400.

Recommendation

I leave high ISO noise reduction set to *Low*. I do want some noise reduction at any level above 800 ISO. However, since any form of noise reduction blurs the image, I don't go too far with it. Why not test a few images at high ISO settings with NR turned on. You may like the output of *High*, or you might prefer *Normal* or *Low*.

Note

If you have *High ISO NR* turned on, your in-camera memory buffer for images shot rapidly will be reduced by one image.

Figure 27 – A 3200 ISO image on all four settings

Active Folder

(User's Manual page 169)

The D90 creates a folder named NCD90 on your memory card. This folder can contain up to 999 images. If you feel that you might shoot more than 999 images on the current SD card, you might want to create a new folder, such as NCD91 or FLDR9. Folder names are limited to five characters within the camera but show up as eight-digit names on the memory card.

On the memory card, you'll notice that the folder names are preceded by a three-digit number. The name of your NCD90 folder will look like this: 100NCD90. If your folder ever contains 999 images, the camera will create a new folder with the same name except it will increment the digits it added to the front of the name. So exceeding 999 images in a folder named 100NCD90 will cause the camera to create a new folder named 101NCD90. Interestingly, the D90 treats any new folders it creates as an extension of the first folder. This allows you to continue shooting a certain style of images and have them stay in the correct folder. If you create and select a new folder, the D90 will do the same with it.

On a long photographic outing, this is a good way to isolate certain types of images. Maybe you'll put landscapes in a folder called LAND1 and people shots in PPL10. The D90 will then create folders called 100LAND1, and 100PPL10. If you exceed 999 images in either of the folders, it will create the next one automatically (101LAND1 and 101PPL10).

Select an Existing Folder: *Figure 28 shows the screens you use to select a folder.*

Here are the steps to select an existing folder:

1. Press the *MENU* button and select *Shooting Menu* (small green camera).
2. Choose *Active folder*, and then scroll right.
3. Choose *Select folder*, and then scroll right.
4. Choose the folder in which you want to save your images. The available folders are displayed in a list that looks like this:
 NCD90
 DELME
 LAND1
 PPL10
5. Press the *OK* button.

All images will now be saved to the latest folder selected until you change it to another. You can tell at a glance which folder is active by looking at the *Active*

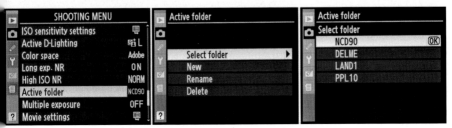

Figure 28 – Selecting an active folder

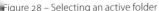

folder line in the *Shooting Menu*. To the right of the words *Active folder*, you'll see the five-character name of the current folder (see the first image in *figure 28*).

Notice how you don't see the three numeric characters in your list of folders (third image in *figure 28*). The camera keeps track of the numeric progression of folders that exceed 999 images and considers all folders with names in which the last five digits match a single folder (even though there might actually be several folders).

Create a New Folder: As shown in *figure 29*, to create a new folder, do the following:

1. Press the *MENU* button and select the *Shooting Menu* (small green camera).
2. Select *Active folder*, then scroll to the right.
3. Now scroll down and select *New*, then scroll to the right. You'll see a screen that allows you to name the new folder. **To create a new name**, hold down the ISO–thumbnail/playback zoom out

button and use the Multi Selector to scroll back and forth. When you have the small gray cursor positioned over an existing character, you can delete it with the trash can delete button. To insert a new character, position the yellow cursor in the character list above and press the QUAL–playback zoom in button. Whatever character is under the yellow cursor will appear on the name line below (at the position of the gray cursor). If a character is already under the gray cursor, it will be pushed to the right. Please limit the name to a maximum of five characters (see #3, 8, 9, 13, and 14 on page 5 in the User's Manual.)

4. Press the *OK* button when you've completed the new name. I named mine NEW01.

Once you have created a new folder, it will automatically become the current folder.

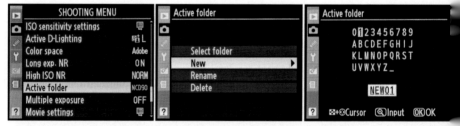

Figure 29 – Creating a new folder

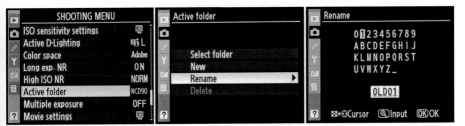

Figure 30 – Renaming an existing folder

Change a Folder Name: You can also change the name of an existing folder.

To rename a folder, follow these steps (see *figure 30*):

1. Press the *MENU* button and select the *Shooting Menu* (small green camera).
2. Select *Active folder*, then scroll to the right.
3. Scroll down and select *Rename*, then scroll to the right.
4. Select a folder name to modify, and then scroll right.
5. Hold down the ISO–thumbnail/playback zoom out button and use the Multi Selector to scroll back and forth. When you have the small gray cursor positioned over an existing character, you can delete it with the garbage can delete button. To insert a new character, position the yellow cursor in the character list above and press the QUAL–playback zoom in button. Whatever character is under the yellow cursor will appear on the name line below, at the position of the gray cursor. If a character is already under the gray cursor, it will be pushed to the right. The name is limited to a maximum of five characters (see #3, 8, 9, 13, and 14 on page 5 in the User's Manual). I renamed mine OLD01.

6. Press the *OK* button when you've completed the new name.

If you rename a folder, the camera will look at your memory card and see if there are any other folders in the series (100NCD90, 101NCD90, 102NCD90, etc.). If it finds other folders with names in which the last five digits match, it will rename those using the new name you created in the preceding steps. Remember, the D90 considers these folders as one folder.

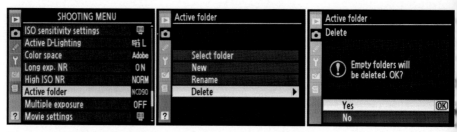

Figure 31 – Deleting an existing folder

Delete All Empty Folders: Now, let see how to delete all empty folders from the memory card by following these steps (see *figure 31*):

1. Press the *MENU* button and select the *Shooting Menu* (small green camera).
2. Select *Active folder*, then scroll to the right.
3. Scroll down and select *Delete*, then scroll to the right.
4. You'll be presented with the *Delete* screen and the message *Empty folders will be deleted. OK?*
5. Scroll up to *Yes* and press the *OK* button.
6. You'll see a message flash up briefly saying *Folder(s) deleted.*

Remember, when you do a delete operation, it will remove all empty folders. Be careful not to use this function if you have a series of folders you use regularly and want them to stay in place.

Multiple Exposure

(User's Manual pages 121-123)
Multiple exposure is the process whereby you take more than one exposure on a single "frame," or picture. Most of us will only do double exposures, which are two exposures on one frame. It requires you to figure the exposure values carefully for each exposure so that in the final picture, all the combined exposures equal one normal exposure. In other words, if you are going to do a nonmasked double exposure, your background will need two exposures at one-half the normal exposure value to equal one normal exposure. The D90 allows us to figure our own exposure settings and do them manually, but it also gives us *Auto gain* to help us with exposure calculations.

There are really only three steps to setting up a multiple-exposure session. However, there are four *Shooting Menu* screens we'll use to do these three steps (see *figure 32*). The steps are as follows:

1. Select the number of shots you want to take from the *Shooting Menu* screens.
2. Turn *Auto gain* on or off according to how you want to control exposure.
3. Take the picture.

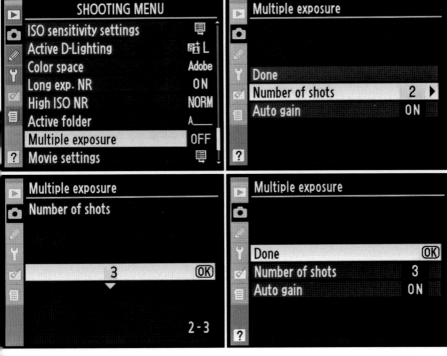

Figure 32 – *Multiple exposure* screens

As mentioned, there are four *Shooting Menu* screens involved in setting up multiple exposures. They are shown in *figure 32*.

Let's consider each of the screens we use, and discover how to set up the *Multiple exposure* system.

Use *figure 32* as a reference to do the following:

1. Select *Multiple exposure* from the *Shooting Menu*.
2. Select *Number of shots,* and then scroll right.
3. Change the number of shots; two or three exposures are allowed.
4. Press the *OK* button to lock in the number of shots, and the camera will return to the previous menu.
5. Select *Done* from screen, and press *OK*.
6. Shoot your images from a tripod.

Once you've selected a *Number of shots* setting, the camera remembers the value and comes back to it for the next session. To repeat another series of multiple exposures with the same settings, you'll have to select *Done* on the second screen (see *figure 32*) and then press the *OK* button. This prepares the camera to do the multiple exposures in the same way as last time. It remembers the previous *Number of shots* and other settings until you change them.

When you take the series of images, don't look for multiple images on your memory card that must later be combined. The D90 automatically combines the two or three shots you make in the single multiple-exposure image.

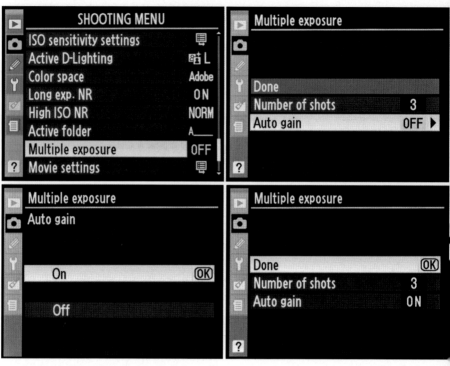

Figure 32A – Multiple Exposure Auto Gain

Understanding Auto Gain

Auto gain defaults to *On*, so you need to understand it well. Let's discuss it in detail. First we'll look at the steps needed to turn it on (in case you've turned it off).

Here are the steps to enable *Auto gain* (see *figure 32A*):

1. Select *Multiple exposure* from the Shooting Menu.
2. Select *Auto gain*, then scroll right.
3. Select *On*.
4. Press the *OK* button and the camera will return to the previous menu.
5. Select *Done* from screen.
6. Press the *OK* button.

Auto gain is designed for when you want to make a number of exposures with the exact same exposure value for each. If you want to make two exposures, the camera will meter for a normal exposure and then divide the exposure in half for the two shots. For three shots, it will divide the exposure in thirds.

In other words, it will take the normal exposure for a single shot and divide it by the number of shots you have selected so that when you are done, you have the equivalent of a single good exposure. Does this make sense?

Here's another way of looking at it: If I want a two-shot multiple exposure, I

normally want the background to get one-half of the normal exposure in each shot so that it will appear normal in the final image. *Auto gain* does that automatically. If I need three shots, I want the background to get only one-third of a normal exposure for each shot so that I'll have a normally exposed background when the three shots are taken.

The reason I mentioned this in such a repetitive fashion is that it took me a little while to wrap my brain around the confusing presentation of this fact in the User's Manual. Whoever heard of "gain" meaning dividing something into parts? What I think the Manual writers were trying to say is that each shot "gains" a portion of the normal exposure so that in the end, the exposure is complete and correct. I hope this makes sense to you.

Auto gain is like an automatic normal exposure "divider-upper" for multiple exposures. It divides up the exposure into appropriate sections so you won't have to fool with it.

When should you use auto gain? Only when you have no need for controlling exposure differently on each frame, but instead can use an exact division of similar exposures.

Auto gain works fine if you're not using masks. When you use a mask, you want a full normal exposure for each of the uncovered (nonmasked) sections of the image, so *Auto gain* will not work for this. You should use manual exposure with *Auto gain* turned off instead.

Note on Using Auto Gain

If you are in the middle of a multiple exposure and pause for 30 seconds, the operation will be canceled automatically. If you are shooting in continuous high (CH) or continuous low (CL) frame rate, you can simply hold down the shutter button and the D90 will fire the two or three exposures in a multiple exposure in one rapid burst. If you are using single (S) frame shutter release, you'll have to fire off the number of multiple-exposure frames manually. If you want to interrupt a multiple-exposure session between shots, the easiest way is to simply turn the camera off. There are other ways mentioned on page 123 of the User's Manual.

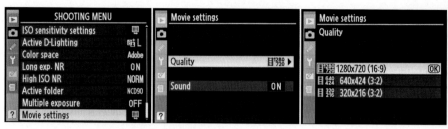

Figure 33 – The *Quality* selections for *Movie settings*

Movie Settings

(User's Manual pages 50 and 170)

Since the Nikon D90 is more than a still camera and also has video capability, we need to look at the movie settings, from which you can select the level of quality and whether you need sound.

There are three menu screens to set the quality of the video in the D90. They are shown in *figure 33*. The three levels of quality are as follows:

1. 1280 x 720 (16:9)
2. 640 x 424 (3:2)
3. 320 x 216 (3:2)

The camera records video at 24 frames per second, which is excellent speed. The file size of the finished video will be affected by how high the quality is set. The preceding numbers mean the number of pixels in the video image—for example, 1280 x 720 = 921,600, or almost 1 megapixel per frame. That is HD quality on a normal monitor and can even be fed directly into an HDTV with an optional HDMI cable. It provides a 16x9 image ratio, which is the long horizontal image format we've grown accustomed to seeing on HDTVs. The other two ratios are smaller and more square shaped, like a normal TV or CRT computer monitor.

To select the video quality you'd like to use, refer to *figure 33*, to do the following:

1. Press the *MENU* button and select the *Shooting Menu* (small green camera).
2. Select *Movie settings*, and then scroll right.
3. Select *Quality*, and then scroll right.
4. Choose from one of the *Quality* settings, and press the *OK* button

Recommendation on Video Format

I will most often shoot in 1280 x 720 mode because I like the HD format. It is nice and wide! The fact that I am using a zoom lens on my D90 allows me to take advantage of the wide view I can later show on my wide LCD computer monitor or HDTV. However, if you are displaying your videos on a PDA or a regular computer monitor or TV, you might want to use the smaller settings. Remember, the larger the setting, the bigger the resulting video file size.

Finally, let's examine how to turn the sound on and off while making movies.

There are only two simple sound selections:

1. *On*
2. *Off*

Select *On* and you'll hear surprisingly high-quality sound with each of your movies. Or, if you want to, switch your camera to B&W mode, turn off the sound, and do some silent movies. Use a few props and a movie editing program and you'll be able to produce films of much higher quality than the original B&W movies of yesteryear.

This is only a very brief overview of the video functions of the D90. We explore this feature in greater depth in chapter 12, which is devoted to D-Movies.

Summary

Using the D90's *Shooting Menu* allows for a great deal of flexibility in how your camera operates. Learn to use each of these settings by using them often. Your D90 is a still-frame and video camera all in one. Take full advantage of that power!

Congratulations! Now that you've fully configured your D90's *Shooting Menus*, let's move on to the Custom Settings in the next chapter.

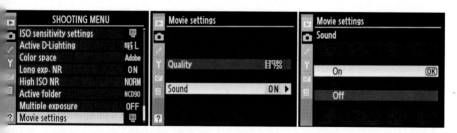

Figure 34 – The *Sound* selection for *Movie settings*

Custom Setting Menu

The D90 has 41 separate Custom Settings, a1 through f7. They're designed to allow personalized configuration of the camera. This will be the most extensive chapter in *Mastering the Nikon D90* because we have so many settings to cover in detail.

Combining these custom menu settings with the Shooting Menu functions covered in the previous chapter helps make your D90 a very personal device, customized to your particular style of shooting. Few cameras have this level of complexity or power, and for most average users, the default settings will suffice. There is so much available for your own personal customization based on your needs, so let's explore these settings step-by-step.

Keep this book in your camera bag with you so that you'll have a reference guide for future adjustments to the D90. You'll need it!

Configuring the Custom Settings

(User's Manual pages 171–201)
Let's start by looking at the *Reset custom settings* menu. Then we'll proceed through all 41 of the individual Custom Settings.

Reset Custom Settings

Be careful with this selection because it does what it sounds like. It resets the *Custom Setting Menu* back to the factory default settings. If you're interested, you can see what the default settings are by looking at a list in the User's Manual on pages 260 and 261. Here are the steps to reset the Custom Settings (see *figure 1*):

1. Press the *MENU* button and scroll to the *Custom Setting Menu* (pencil icon).
2. Select *Reset custom settings* and then scroll to the right.
3. Select *Yes* from the menu, then press the *OK* button.

Figure 1 – *Reset custom settings*

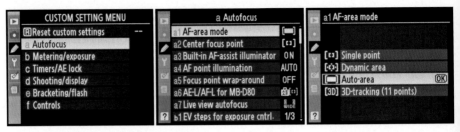

Figure 2 – Custom Setting a1 (AF-area mode)

Autofocus - Custom Settings a1 to a7

(User's Manual pages 173–176)

Custom Setting a1 (AF-area mode)

(User's Manual page 173)

This custom setting controls how the autofocus (AF) system selects a focus point. You can set the camera to use just one AF point, a movable AF pattern, or all 11 points at once. I have devoted an entire chapter to understanding the AF system. See chapter 10, "Multi-CAM 1000 Autofocus," for detailed information on how to use the D90's powerful autofocus feature. I'll list here only the basics and the configuration choices, with the understanding that chapter 10 is devoted to full understanding of autofocus issues.

Figure 2 shows the menu screens used to configure *Custom Setting a1*.

Notice that there are four *AF-area mode* settings:

- *Single point*
- *Dynamic area*
- *Auto-area*
- *3D-tracking (11 points)*

Single point – This mode is for subjects that aren't moving, or are moving very slowly. You can select a single AF point from of the 11 available points and move it around the viewfinder to focus on whatever part of your subject you'd like. You'll use the multi selector thumb switch to scroll among the 11 AF points and then select the single point you choose for autofocus accuracy.

Dynamic area – This mode works a lot like *Single point* except that you are moving an invisible cross-shaped pattern of 4 or 5 AF points around the 11 available sensor points. The AF points immediately surrounding the one you have selected are also active and seeking focus. These extra AF points are active in case the subject moves unexpectedly and you lose focus with the primary AF point.

Auto-area – Your camera decides where and what the subject is and does the autofocus operation without input from you. It uses face-recognition technology to identify humans in your picture and give them preferential focus. Generally, the camera will select the closest and brightest objects for nonhuman subjects. You'll see multiple AF points focusing on various parts of the camera's chosen subject. This is an automatic mode for those times when you just want to take pictures and not think about the camera.

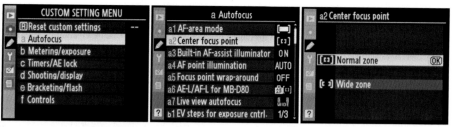

Figure 3 – *Custom Setting a2 (Center focus point)*

3D-tracking (11 points) – This is a mode for action shooters. The camera uses all 11 of its AF points to keep the subject in focus in case it moves. You select a single AF point to initiate autofocus, and the camera does its best to keep the focus on your subject, even if the initial AF point loses the subject. All the rest of the AF points are looking for the subject. This mode is also sensitive to the brightness and color of the subject and uses those two characteristics to help maintain a tracked focus. If you are shooting quickly moving subjects like animals, car races, or sports, this is your mode. In some cases, since all 11 of the sensors are active, this mode may be somewhat slower initially. The camera's microprocessor is working considerably harder since it is processing a lot more information. If your subject is the same color as the background, you may not want to use this mode.

Here's how to select an AF-area mode:

. Press the *MENU* button and scroll to the *Custom Setting Menu* (pencil icon).
. Select a *Autofocus*, and then scroll to the right.
. Select *a1 AF-area mode* from the menu, and then scroll to the right.
. Select one of the AF-area modes from the four available.
Press the *OK* button to choose the mode.

Custom Setting a2 (Center focus point)
(User's Manual page 174)
The center AF point is a cross-type sensor. This means it will autofocus on a horizontal or vertical subject. The other 10 AF points are sensitive only to horizontal subjects. You can expand the width of this focus point so that it will cover more of the subject.

There are two "zones" available (see *figure 3*):
1. *Normal zone*
2. *Wide zone*

Since many of us will use the center AF point most of the time, Nikon has provided the ability to increase the area of coverage on it, in comparison to the others. This can produce pleasant effects for some subjects and undesirable effects for others. With a wide zone, your D90 may focus on an area of the subject that you never intended. On the other hand, with some subjects, having that extra AF sensor point width could be beneficial.

For instance, if you are shooting an image of a subject that is smaller than the AF point brackets in *Wide zone* mode and something directly behind the subject is brighter and more noticeable to the camera's AF sensor, it may just focus on what it sees behind your intended

subject. If the subject is larger than the *Wide zone* AF bracket in the viewfinder, then AF will work fine in that mode. Experiment with this and see which works best for you.

Here's how to configure *Custom Setting a2* (see *figure 3*):

1. Press the *MENU* button and scroll to the *Custom Setting Menu* (pencil icon).
2. Select *a Autofocus*, and then scroll to the right.
3. Select *a2 Center focus point* from the menu, and then scroll to the right.
4. Select one of the AF point zone widths from the two available.
5. Press the *OK* button.

Which is My Favorite AF Setting?

I normally leave *Custom Setting a2* set to *Normal zone*. I like being able to pinpoint what area I want to get the best autofocus, and a narrow AF point is best for me. This is like using a spot meter for exposure metering. It measures only where you want it to measure. However, if I am shooting quickly, I might sometimes set it to the wider zone. This is especially true when I am shooting large, fast moving objects such as a car race. *Normal* is usually best for me as a nature shooter.

Custom Setting a3 (Built-in AF-assist illuminator)

(User's Manual page 174)

You've seen the little autofocus assist light on the front of the D90 (near the grip). Well, this setting allows you to control when that little light comes on. Nikon calls this the AF-assist illuminator and it lights up under low-light conditions and under certain autofocus and AF-area modes (not all) to help with autofocus.

Figure 4 shows the menu screens used to configure *Custom Setting a3*. There are two options:

1. **On** (default) – If the light level is low, the AF-assist illuminator sometimes lights up to help illuminate the subject enough for autofocus. It only works in certain modes though. When I was first writing this paragraph, I found myself experimenting with all the different modes. I was listing combinations of autofocus and AF-area modes that would work, in a long boring list that no one would ever find useful. After I wrote it, even I had a hard time using it. So, here is all I will tell you about Nikon's choices of when the AF-assist light will and won't work:

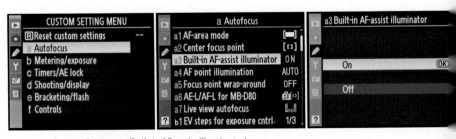

Figure 4 – *Custom Setting a3 (Built-in AF-assist illuminator)*

a. If you are using any form of continuous-servo AF (AF-C) autofocus mode, forget having an assist light. I could never get it to work in AF-C under any circumstances.

b. In most other autofocus modes, and AF-area modes, it will work *as long as you are using only the center AF point*. None of the other AF points will let the light shine. I guess they figure that your subject must be out of reach of the light if you are not using the center AF point.

The point is simply this: If the light doesn't come on, you are in a mode that it doesn't support. It isn't broken or flaky. It's just engineered in a way that is hard to describe. Don't try to understand this setting from reading the Option *On* description on page 174 of the User's Manual. In the history of user's manuals, that is the most complicated paragraph I've ever read. If the light *does* come on when you need it, consider yourself fortunate and make use of it.

. **Off** – The AF-assist illuminator does not light up to help you in low-light autofocus situations. The D90 may not be able to autofocus in low light.

Tips on Using the AF-Assist Illuminator

To use the AF-assist illuminator, stay out of continuous-servo autofocus mode (AF-C) and use the center AF focus point of the 11 available. Also, when I am trying to be sneaky and shoot pictures of people or animals without drawing attention to myself, I'll turn this feature off. Nothing grabs the attention of a living creature faster than blinking a light in its sight range.

To select either *On* or *Off* from the menu, follow these steps (see *figure 4*):

1. Press the *MENU* button and scroll to the *Custom Setting Menu* (pencil icon).

2. Select *a Autofocus*, and then scroll to the right.

3. Select *a3 Built-in AF-assist illuminator* from the menu, and then scroll to the right.

4. Select either *On* or *Off*.

5. Press the *OK* button.

The AF-assist illuminator has a limited range of about 10 feet (3 meters). Anything closer than about 2 feet (0.5 meters) will only be partially lit by the light because it is off axis with the center of the lens due to parallax failure and/or lens blockage.

Custom Setting a4
(AF point illumination)

(User's Manual page 175)

When focusing in darker areas, you might have trouble seeing which AF sensor point is currently in use. To remedy this, Nikon has created the *AF point illumination* setting. Normally, the AF points are displayed in black. *Custom Setting a4* can cause the AF focus points to light up briefly in red when you start an autofocus operation by pressing the shutter release halfway. While they are lit up, you will be able to see the viewfinder AF point brackets surrounding the points in use.

Figure 5 shows the menu screens used to configure *Custom Setting a4*.

Here are the three selections and what they do:

1. **Auto** (default) – If your background is dark, so that it might be difficult to see your AF sensor in use, it will briefly flash red when you start autofocus by pressing the shutter release halfway down. If the background is bright, and you'll have no trouble seeing your AF sensor's little black square, it does not flash red when you start autofocus.

2. **On** – The selected AF sensor is always highlighted in red when you start autofocus, regardless of the light level of the background.

3. **Off** - The selected AF sensor does not light up in red when you start autofocus. It always stays black.

These are the steps to select your favorite illumination method:

1. Press the *MENU* button and scroll to the *Custom Setting Menu* (pencil icon).
2. Select *a Autofocus*, and then scroll to the right.
3. Select *a4 AF point illumination* from the menu, and then scroll to the right.
4. Select *Auto, On,* or *Off*.
5. Press the *OK* button.

How I Use Custom Setting a4

I leave *Custom Setting a4* set to *Auto*. I like the fact that the camera will sense whether the viewfinder is bright enough, and then flash red if I need some illumination.

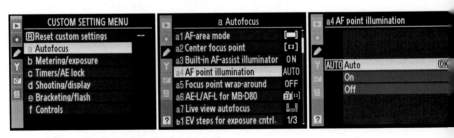

Figure 5 – *Custom Setting a4 (AF point illumination)*

Custom Setting a5
(Focus point wrap-around)

(User's Manual page 175)

When you are scrolling your selected AF sensor to the right or left (or even up and down) in the array of 11 sensors, eventually it will come to the edge of the sensor area or viewfinder. This setting allows you to control whether the AF sensor simply stops when it gets to the edge or scrolls to the other side. Normally, if you are moving the AF sensor to the left and come to the edge, it will stop. If you have *a5* set to *Wrap*, it will not stop but will reappear on the right side of the screen. It "wraps" around and works the same way in an up and down motion. If you scroll off the top of the sensor area, the AF sensor will reappear on the bottom if *Wrap* is selected.

The menu screens used to configure *Custom Setting a5* are shown in figure 6.

Here are descriptions of the available settings:

Wrap – This setting allows the selected AF sensor to scroll off of the viewfinder screen and then reappear on the other side.

No wrap (default) – If you scroll the AF sensor to the edge of the screen... it stops there! You'll have to press the thumb button in the opposite direction to go back toward the middle.

These are the steps to select your favorite AF sensor scrolling method (see *figure 6*):

1. Press the *MENU* button and scroll to the *Custom Setting Menu* (pencil icon).
2. Select *a Autofocus*, and then scroll to the right.
3. Select *a5 Focus point wrap around* from the menu, and then scroll to the right.
4. Select *Wrap* or *No wrap*.
5. Press the *OK* button.

To Wrap or Not to Wrap

Personally, I find it unnerving when the selected AF point jumps off the edge of the screen and reappears on the other side. I'll usually scroll all the way back across the screen before I figure out what's happening. On the other hand, it is faster to have it reappear on the other side than to scroll there. So, you'll have to experiment to see which you like best. I choose *No wrap* for myself.

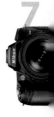

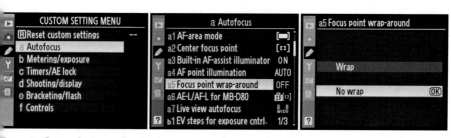

figure 6 – *Custom Setting a5 (Focus point wrap-around)*

Figure 7 – *Custom Setting a6 (AE-L/AF-L for MB-D80)*

Custom Setting a6 (AE-L/AF-L for MB-D80)

(User's Manual page 176)

Figure 7 shows the menu screens used to configure *Custom Setting a6*.

Only those who have an MB-D80 battery pack attached to their D90 camera bodies will use this custom setting. It modifies how the *extra* AF-ON button *on the MB-D80* works and provides some additional and useful functionality for MB-D80 users. This setting *does not modify* the functionality of the AF-ON button found on the D90 body. See the following details.

Here are the selections that are available under *Custom Setting a6*:

1. **AE/AF lock** (default) – Selecting this means that the MB-D80's extra AE/AF lock button executes exposure and autofocus lock.

2. **AE lock only** – Selecting this means that the MB-D80's extra AE/AF lock button executes exposure lock only, but autofocus is still free to work.

3. **AF lock only** – Exposure locks when the MB-D80's AE/AF lock button is pressed, and stays locked until it is pressed a second time, or the exposure meter goes off.

4. **AE lock (hold)** – Autofocus locks while the MB-D80's AE/AF lock button is held down.

5. **AF-ON** – Selecting this setting means that the extra AE/AF lock button on the MB-D80 battery pack will initiate autofocus.

6. **FV lock** – Flash values for a particular subject lock when the MB-D80's AE/AF lock button is pressed and stays locked until it is pressed a second time or the exposure meter goes off. This works for the pop-up flash or external Speedlights. (User's Manual page 178)

7. **Focus point selection** – Normally you'll use the multi selector thumb switch to select which AF focus point you'll use. However, with this selected you can also choose a focus point by pressing the MB-D80's AE/AF lock button and rotating the front sub-command dial. (User's Manual page 56)

These are the steps to select your favorite setting for the MB-D80's AE/AF lock button (see *figure 7*):

1. Press the *MENU* button and scroll to the *Custom Setting Menu* (pencil icon).
2. Select *a Autofocus*, and then scroll to the right.
3. Select *a6 AE-L/AF-L for MB-D80* from the menu, and then scroll to the right.
4. Select one of the button functions listed in the menu. For *AE/AF lock, AE lock only, AF lock only*, and *AF-ON*, you'll need to make your selection, scroll to the right for an *On* or *Off* selection, and then select *OK*. For *AE lock (hold), FV lock,* and *Focus point selection*, simply selecting *OK* is sufficient.

AE Lock Only Setting

Personally I like to set my AE/AF lock buttons on both the camera body and the MB-D80 to the *AE lock only* setting. I often want to get an exposure reading from one area of my image and then recompose to take the shot. With the *AE lock only* setting, I get exactly that—the ability to read and lock the exposure while autofocus continues functioning normally.

Custom Setting a7 (Live view autofocus)

(User's Manual page 176)

Live View allows you to use the big LCD on the back of your D90 instead of the viewfinder. The AF method is *Contrast detection*, which is slower than normal autofocus. (See chapter 10, where *Live View autofocus* is discussed in detail.)

Live view autofocus gives you three methods to select a subject (see figure 8).

Here are the menu selections available under *Custom Setting a7*:

- *Face priority*
- *Wide area*
- *Normal area*

Face priority – This allows the D90 to seek human faces by looking for the relationship between the eyes and nose area. The faces must be turned directly toward the camera to be found. When they're found, the LCD screen will show a jumpy yellow square centered on the nose of the human subject. When autofocus is initiated, the yellow square will turn green and move to an eye for final focus. If there are no human subjects (or if faces are available but in profile only), the D90 is still in *Face priority* mode but it acts more like *Wide area* mode.

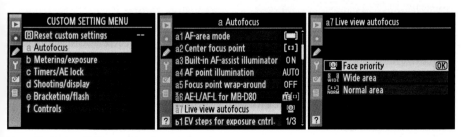

Figure 8 – *Custom Setting a7 (Live view autofocus)*

Wide area – This mode presents the user with a rather large red square that can be moved to any location in the viewfinder. Once the red square is focused on a subject, the square turns green.

Normal area – This mode presents the user with a small red square that can be moved to any location in the viewfinder. Once the red square is focused on a subject, the square turns green. This mode is more exact because the smaller square makes you focus on a much smaller area of your subject. You might want to consider this mode as a "tripod mode" because it is best used on a tripod for very accurate focusing.

Here's how to select one of the focus modes (see *figure 8*):

1. Press the *MENU* button and scroll to the *Custom Setting Menu* (pencil icon).
2. Select *a Autofocus*, and then scroll to the right.
3. Select *a7 Live view autofocus* from the menu, and then scroll to the right.
4. Select one of the autofocus functions listed in the menu (*Face, Wide,* or *Normal*).
5. Press the *OK* button to select it.

How I Use Live View Autofocus

When I use *Live view autofocus* handheld, I usually leave it set to *Face priority*. This mode works well whether or not I have a human subject. Only when I am using a tripod and trying to be very precise do I switch to *Normal area* mode. I like to use Live View *Normal area* mode for macro closeup shots since it takes strain off of my body from leaning over the viewfinder. Please read more detailed information in Chapter 10.

Metering/Exposure - Custom Settings b1 to b4

(User's Manual pages 177–178)

Custom Setting b1
(EV steps for exposure cntrl.)

(User's Manual page 177)

What is an EV? EV simply means exposure value, which is an internationally agreed-upon incremental value of exposure metering. It is spoken of in full or partial EV steps, like 1/3, 1/2, or 1. EV simply serves as a common denominator for various combinations of shutter speed, aperture, compensation, and bracketing that give similar exposures. An EV step corresponds to a standard logarithmic "power-of-2" exposure step, commonly referred to as a *stop*. So, instead of saying "1 EV," you could substitute "1 stop." EV 0 (zero) corresponds to an exposure time of 1 second at an aperture of f/1.0, or 15 seconds at f/4. EV can be positive or negative. EV -6 equals 60 seconds at f/1.0. EV 10 equals 1/1000 at f/1.0, or 1/60 at f/4. The EV step system was invented in Germany back in the 1950s. Interesting, huh?

Nikon chose to lump shutter speed, aperture, exposure, flash compensation, and bracketing EV increments under this one custom setting. If you set this custom setting to 1/3, it will affect all of the above. *1/3 step* is the factory default value for *Custom setting b1*.

Figure 9 shows the menu screens used to configure *Custom Setting b1*.

Exposure control (or exposure cntrl.) refers to the number of the steps in your shutter speed and aperture, since those

are your main exposure controls. It also encompasses the exposure compensation and bracketing system.

Here are the two settings available under the exposure control system:

1. *1/3 or 1/3 step* (EV is 1/3 step, Bracketing can be 1/3, 2/3, or 1 EV)
2. *1/2 or 1/2 step* (EV is 1/2 step, Bracketing can be 1/2 or 1 EV)

Here are the steps to configure *Custom Setting b1* (see *figure 9*):

1. Press the *MENU* button and scroll to the *Custom Setting Menu* (pencil icon).
2. Select *b Metering/exposure,* and then scroll to the right.
3. Select *b1 EV steps for exposure cntrl.* from the menu, and then scroll to the right.
4. Select either *1/3* or *1/2* from the menu.
5. Press the *OK* button.

All this really means is that when you are making exposure adjustments, they will work incrementally in the following steps:

Shutter and exposure (starting at a random shutter speed or aperture)
1/3 EV step:
- Shutter: 1/100, 1/125, 1/160, 1/200, 1/250, 1/320, etc.
- Aperture: f/5.6, f/6.3, f/7.1, f/8, f/9, f/10, etc.

1/2 EV step:
- Shutter: 1/90, 1/125, 1/180, 1/250, 1/350, 1/500, etc.
- Aperture: f/5.6, f/6.7, f/8, f/9.5, f/11, f/13, etc.

Compensation (add a +/- sign according to direction)
1/3 EV step:
- 0.3EV, 0.7EV, 1.0EV, 1.3EV, 1.7EV, 2.0 EV, 2.3EV, etc.

1/2 EV step:
- 0.5EV, 1.0EV, 1.5EV, 2.0EV, 2.5EV, 3.0EV, 3.5EV, etc.

Bracketing
1/3 EV step:
- Bracket: 0.3, 0.7, 1.0 (or 1/3, 2/3, 1 EV steps)

1/2 EV step:
- Bracket: 0.5, 1.0 (or 1/2 and 1 EV steps)

This is much more complex looking than it really is. Just remember that when you are making adjustments in shutter speed, aperture, compensation, or bracketing, you'll be using 1/3 or 1/2 steps (stops) EV.

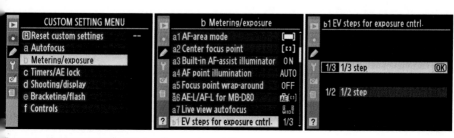

Figure 9 – *Custom Setting b1 (EV steps for exposure cntrl.)*

1/3 EV Steps to be Safe

I leave my camera set to the default of 1/3 EV step most of the time. This gives me fine control over my exposures and keeps me out of trouble. The only time I might consider using 1/2 EV steps is when I am bracketing for high dynamic range (HDR) photography. Often, I'll want to take fewer images than would be required were I to leave it set to 1/3 EV step. HDR does better with larger steps of exposure value difference.

Custom Setting b2
(Easy exposure compensation)

(User's Manual page 177)
It took me a bit of thinking to wrap my brain around this particular series of settings. The bottom line is that you can set the D90's exposure compensation without using the normal +/- exposure compensation button.

The menu screens used to configure *Custom Setting b2* are in *figure 10*.

There are two selections in *Custom Setting b2*:

1. *On*
2. *Off*

On - You can use the command dials to do exposure compensation instead of using the normal +/- exposure compensation button.

Off - Means what it says. If you use the normal exposure compensation button, it overrides the settings of *b2*.

Here is how to select the values in *Custom Setting b2* (see *figure 10*):

1. Press the *MENU* button and scroll to the *Custom Setting Menu* (pencil icon).
2. Select *b Metering/exposure,* and then scroll to the right.
3. Select *b2 Easy exposure compensation* from the menu, and then scroll to the right.
4. Select either *On* or *Off* from the menu.
5. Press the *OK* button.

Each exposure mode (P, S, A, M) reacts somewhat differently to *Custom Setting b2*. Let's consider how the *P-program, S-shutter priority,* and *A-aperture priority* modes act when you use the three settings above. The *M-manual* mode does not seem to be affected by *Custom Setting b2*, although it does work with the normal +/- exposure compensation button.

Notice in *figure 10A* how the top control panel LCD shows the compensation icon. When you see the compensation icon, just press the normal +/- compensation button to see the amount dialed in. You can also look in the viewfinder to see the actual exposure

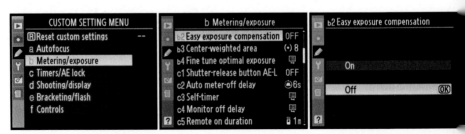

Figure 10 – *Custom Setting b2 (Easy exposure compensation)*

Figure 10A – The exposure compensation button and symbol

value as shown on the +/- exposure meter readout.

Here's how the *Easy exposure compensation* setting works with the P,S,A,M exposure modes:

P – programmed auto: Turn the front sub-command dial to the right for (-) negative exposures or to the left for positive (+) exposures. Press the normal +/- compensation button to see what actual value has been input. You can also look in the viewfinder to see the actual exposure value as shown on the +/- exposure meter readout.

S – shutter priority: Turn the front sub-command dial to the right for (-) negative exposures or to the left for positive (+) exposures. Press the normal +/- compensation button to see what actual value has been input. You can also look in the viewfinder to see the actual exposure value as shown on the +/- exposure meter readout.

A – aperture priority: Turn the rear main-command dial to the right for negative (-) exposures or to the left for positive (+) exposures. Press the normal +/- compensation button to see what

actual value has been input. You can also look in the viewfinder to see the actual exposure value as shown on the +/- exposure meter readout.

M – manual exposure: You cannot use *Easy exposure compensation* in manual exposure mode. Use the normal +/- exposure compensation button instead.

Remember that you can simply press the normal +/- compensation button to accomplish the same thing as these more complex methods.

Recommendation on Custom Setting b2

Custom Setting b2 is one of those odd features Nikon has included that tends to make little sense to me. It is so much easier to simply use the normal compensation button for this action. If the compensation button was reprogrammable, I suppose I could see a good reason for using another compensation method. However, I've not found a way to change the function of the normal compensation button. I've never found a compelling reason to use this custom setting.

Custom Setting b3 (Center-weighted area)

(User's Manual page 178)

This custom setting is discussed in great detail in chapter 2, "Exposure Metering System, Exposure Modes, and Histogram." We won't cover much detail here except to show how to configure the three available modes.

Here are the three settings used by the D90's center-weighted area metering system:

1. 6, or *6mm*
2. 8, or *8mm*
3. 10, or *10mm*

Here are the steps used to configure *Custom Setting b3* (see *figure 11*):

1. Press the *MENU* button and scroll to the *Custom Setting Menu* (pencil icon).
2. Select *b Metering/exposure* and then scroll to the right.
3. Select *b3 Center-weighted area* from the menu and then scroll to the right.
4. Select one of the options: *6mm*, *8mm*, or *10mm*.
5. Press the *OK* button.

In this mode, the metering system uses an invisible circle in the center of the viewfinder to meter the subject. If it's set down to *6mm*, it's almost small enough to be a spot meter, since the real spot metering mode of the D90 uses a 3.5mm circle surrounding the currently selected AF sensor. In *figure 11A* are approximations of the center-weighted metering circles.

The center-weighted meter in the D90 meters the entire frame but concentrates 75 percent of the metering into an 8mm circle in the middle of the frame. The other 25 percent of the frame outside the circle provides the rest of the metering.

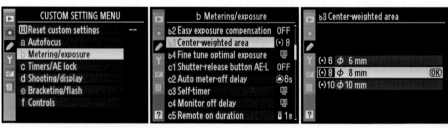

Figure 11 – *Custom Setting b3 (Center-weighted area)*

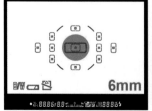
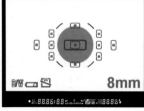
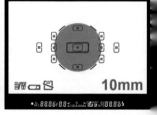

Figure 11A – Center-weighted circles

Center-Weighted Meter

I would stay with the default setting of *8mm*. That's a pretty small circle, and it should give you good center-weighted readings. There is so little difference between 6mm and 10mm that it probably makes little difference which you use. If you are concerned, experiment with the three settings and see which work best for you.

Custom Setting b4
(Fine tune optimal exposure)
(User's Manual page 178)

Nikon has taken the stance that the user should be able to fine-tune most major D90 systems. The exposure system is no exception. *Custom Setting b4* allows you to fine-tune the matrix, center-weighted, and spot metering systems by +1/-1 EV in 1/6 EV steps.

In other words, you can force the three metering systems to add or deduct a little exposure from what it normally would use to expose your subject. This stays in effect with no further notice until you set

it back to zero. It is indeed fine-tuning because the maximum 1 EV step up or down is divided into 6 parts (1/6). If you feel that your D90 is too conservative with the highlights (mildly underexposing) and you want to force your D90 to add 1/2 step exposure, you simply add 3/6 to the compensation system for that metering system.

This works like the normal compensation system except it only allows you one step instead of five steps of compensation. As the third screen of *figure 12* shows, an ominous looking warning appears, telling you that the D90 will not show a compensation icon as it does with the normal +/- compensation button when you use the metering fine-tuning system. This simply means that while you have this fine-tuning system dialed in for your light meter, the D90 will not keep reminding you that it is fine-tuned by showing you a compensation icon.

Figure 12 shows the menu screens used to configure *Custom Setting b4*.

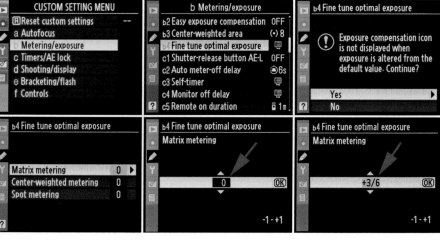

Figure 12 – *Custom Setting b4 (Fine tune optimal exposure)*

Here are the steps to fine-tune your favorite metering system:

1. Press the *MENU* button and scroll to the *Custom Setting Menu* (pencil icon).
2. Select setting *b – Metering/exposure*, and then scroll to the right.
3. Select *b4 Fine tune optimal exposure*, and then scroll to the right.
4. Select *Yes* from the warning screen, and scroll to the right.
5. Select the metering system you want to adjust. In *figure 12*, I have *Matrix metering* selected.
6. Scroll up or down in 1/6 EV steps until you reach the fine-tuning value you would like to use. I've selected +3/6, or 1.2 EV step.
7. Press the *OK* button.

That's all there is to it! You just have to remember when you have "optimal exposure" fine-tuning turned on; the D90 will not remind you. Watch your histogram to make sure you're not regularly underexposing or overexposing images once you have the fine-tuning adjustment in place. If so, just go back in and adjust the fine-tuning up or down, or turn it off.

Timers/AE Lock - Custom Settings c1 to c5

(User's Manual pages 179–180)

Custom Setting c1
(Shutter-release button AE-L)

(User's Manual page 179)

Normally, to lock the exposure you must press the AE-L/AF-L button. However, Nikon has provided another way to lock exposure for those who want to take an exposure reading from one area of the scene and then recompose to take the picture.

If you set *Custom Setting c1* to *On*, the exposure will lock each time you press the shutter release down halfway. With it set like this, you can easily take a reading and then move the camera to a new composition for the final exposure. The only settings available in *Custom Setting c1* are *On* and *Off*.

In *figure 13* are the screens used to set *Custom Setting c1* to *On* or *Off*.

Here are the steps to configure *Custom Setting c1*:

1. Press the *MENU* button and scroll to the *Custom Setting Menu* (pencil icon).
2. Select *c Timers/AE lock,* and then scroll to the right.
3. Select *c1 Shutter-release button AE-L* from the menu, and then scroll to the right.
4. Select either *On* or *Off* from the menu.
5. Press the *OK* button.

How I Use Custom Setting c1

I leave *Custom Setting c1* set to *On*. Since I am a nature shooter, I often have to deal with a wide range of exposures. Sometimes I want to try to average the exposures a little on my own. I might expose a beautiful sunset according to the best colors to the right or left of the setting sun disc. I simply aim my lens where I want it, hold the shutter button halfway down to get and lock the exposure, then recompose for the final image. If you would prefer to use only the AE-L/AF-L button for this purpose, then leave *c1* set to *Off*.

Custom Setting c2
(Auto meter-off delay)

(User's Manual page 179)

The default amount of time that your D90's light meter stays on after you press the shutter button halfway is 6 seconds. If you would like your light meter to stay on longer for any reason, such as for multiple exposures or to keep a GPS active, you can adjust it by changing *Custom Setting c2*.

Figure 14 shows the menu screens used to configure *Custom Setting* c2:

Here are the values you can select in *Custom Setting c2*.

- *4s* – 4 seconds
- *6s* – 6 seconds (default)
- *8s* – 8 seconds
- *16s* – 16 seconds
- *30s* – 30 seconds
- *1m* – 1 minute
- *5m* – 5 minutes
- *10m* – 10 minutes
- *30m* – 30 minutes

Here are the steps to set the meter delay time-out (see *figure 14*):

1. Press the *MENU* button and scroll to the *Custom Setting Menu* (pencil icon).
2. Select *c Timers/AE lock*, and then scroll to the right.
3. Select *c2 Auto meter-off delay* from the menu, and then scroll to the right.
4. Select the time-out delay period from 4 seconds to 30 minutes.
5. Press the *OK* button.

Adjusting the Auto Meter-Off Delay

There are times when you want the light meter to stay on for a longer or shorter amount of time than it normally would. When I'm shooting multiple exposures or using a GPS, I leave mine set to 5 minutes, but when I'm shooting normally, it stays at 6 seconds. You can adjust it from 4 seconds to 30 minutes. This setting stays on *My Menu* for quick access.

Figure 13 – *Custom Setting c1 (Shutter-release button AE-L)*

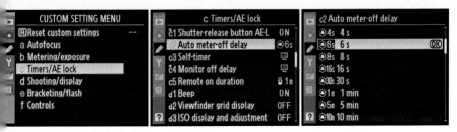

gure 14 – *Custom Setting c2 (Auto meter-off delay)*

Custom Setting c3 (Self-timer delay)

(User's Manual page 179)

The menu screens used to configure *Custom Setting c3* are shown in *figure 15*.

When you set your self-timer for group shots or self-portraits, do you find yourself running like a wild person trying to get in position before the camera fires? Have you ever knocked anyone or anything down or tripped and made a fool of yourself in the process?

Well, those problems are solved with the D90's adjustable self-timer delay. Whether you are shooting a group shot or just using the self-timer as a cheap cable release, it's good to be able to adjust the it up to 20 seconds or down to 2. At the

maximum 20 seconds, you have enough time to calmly walk at least 40 or 50 feet from the camera, position yourself, and smile.

One new feature that the D90 provides is the ability to take multiple pictures each time the self-timer makes the camera fire. You are not limited to just one picture. The D90 will allow you to take up to nine images with each self-timer cycle. You can set the self-timer delay to these time values:

- *2s* – 2 seconds
- *5s* – 5 seconds
- *10s* – 10 seconds (default)
- *20s* – 20 seconds

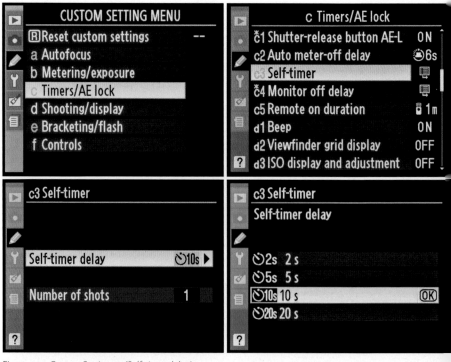

Figure 15 –*Custom Setting c3 (Self-timer delay)*
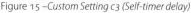

Each time the self-timer fires, it will take from one to nine images, based on the continuous low speed (CL) release mode. CL defaults to 3 frames per second and is controlled by *Custom Setting d6*, which we'll consider later in this chapter. CL frame rate can be varied from one to four frames per second.

Here's how to set your camera to take three pictures after a 5-second delay, for a nice group shot with extras in case someone blinks (see *figures 15 and 15A*):

1. Press the *Menu* Button and scroll to the *Custom Setting Menu* (pencil icon).

2. Select *c Timers/AE lock,* and then scroll to the right.

3. Select *c3 Self-timer* from the menu, and then scroll to the right.

4. Select *Self-timer delay*, then scroll to the right.

5. Select a time value from 2 to 20 seconds from the menu, then press the *OK* button.

6. Select *Number of shots* from the menu, then scroll to the right.

7. Using the multi selector thumb switch, scroll up and down until you have set the number of shots you want in this self-timer cycle, then click the OK button. (I selected 3.)

8. Press the *MENU* button to return to the main *Custom Setting Menu*.

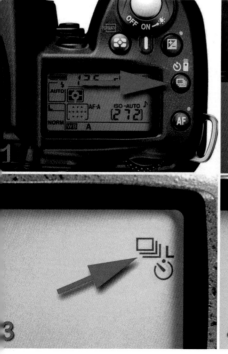

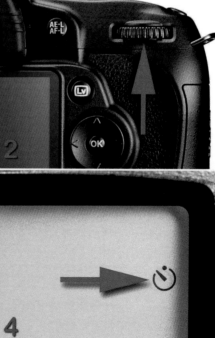

Figure 15A – Self-timer setup symbols

9. Now you'll need to set the camera for self-timer mode. Press the release mode button and rotate the rear main-command dial until you see the self-timer and L symbols. Remember that the L stands for *continuous low-speed (CL)* frame rate. It shows with the self-timer symbol because I selected more than one image in the self-timer shot. *Figure 15A* shows the release mode button and rear main-command dial in images 1 and 2, the self-timer and L symbols in image 3, and the self-timer symbol alone in image 4. If you select only one image for a self-timer cycle, you will see the symbol in image 4. If you select more than one picture for the self-timer cycle, you will see the symbols in image 3.

10. In this example, I set the camera to take three pictures after a 5-second delay, and now I'm ready to shoot. At this point I'd set the camera up on a tripod, press the shutter release, and run (or walk) to my assigned spot in the group image.

As the self-timer counts down, it flashes the AF-assist light in a slow pulse and the camera beeps. During the last couple of seconds of countdown, the light stays on continuously and the beep doubles in speed.

When the self-timer delay is finished, the D90 will take however many pictures you've set under *Custom Setting c3's Number of shots* setting. If you set it to take more than one, as in this example, the camera will fire the shots in rapid succession based on the frame rate speed set in *Custom Setting d6*.

Special Note About the Pop-Up Flash

If you've set your camera to take multiple pictures after a self-timer cycle and then open the pop-up flash, the camera will ignore the number of images you've set and only take one image. *The pop-up flash cannot recycle fast enough to take more than one image at a time, so the camera will not attempt to take multiple flash shots.* I used a Nikon SB-800 hot-shoe mounted flash instead of the pop-up and the D90 happily fired the multiple frames. The bigger flash unit was powerful enough to handle the rapid frame rate, so the camera complied. If you do not use flash, the camera will fire however many shots you've selected with no complaint.

In Praise of the D90's LCD

The LCD monitor on the D90 is one of the best ever invented for a camera, with 64 x 480 VGA resolution. It is like a small computer monitor. You can really zoom in and see how sharp a portion of the image is. For those of you who are interested in the specifics: The LCD resolution is listed as 920,600 dots. Each dot is composed of 3 pixels, one each of the RGB trio–one red, one green, and one blue. So the LCD screen uses only 307,200 pixels at any one time. If you multiply 640 times 480, you get those 307,200 pixels, which is referred to as a 640 x 480 Video Graphics Array (VGA) resolution. There was a time when we all thought of a 640 x 480 VGA display as a significant breakthrough for our home computers. Now, the D90 gives it to you on a brilliant 3-inch screen on the back of your camera.

Custom Setting c4 (Monitor off delay)

(User's Manual page 180)

Figure 16 shows the menu screens used to configure *Custom Setting c4*.

When I take a picture, I like to review it on the monitor. In the old film days, one could not tell whether the image was just right. Now that I have an opportunity, I love to look at each image. If it looks good, I then move on to another image opportunity.

I set my *Monitor off delay* for the *Image review* setting to *1m*, or 1 minute, since I often want to show the image to someone. The longer the monitor stays on, the shorter the battery life, so only extend the monitor time if you really need it. Like a small notebook computer screen, that big luxurious 3-inch VGA LCD requires considerable power.

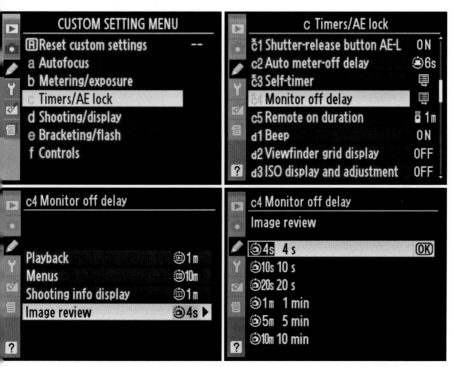

Figure 16 – Custom Setting c4 (Monitor off delay)

Not surprisingly, the LCD monitor and backlighting represent the greatest draws on the camera's batteries.

The D90 allows you to select a different monitor off delay for four separate camera functions: *Playback, Menus, Shooting info display,* and *Image review.* Each of these four functions, all of which use the LCD monitor, can have its own setting. Here are the timings available to the four camera functions:

- *4s* – 4 seconds
- *10s* – 10 seconds
- *20s* – 20 seconds
- *1m* – 1 minute
- *5m* – 5 minutes
- *10m* – 10 minutes

Follow these steps for each of the four camera functions with controllable monitor off delays (see *figure 16*):

1. Press the *MENU* button and scroll to the *Custom Setting Menu* (pencil icon).
2. Select *c Timers/AE lock,* and then scroll to the right.
3. Select *c4 Monitor off delay* from the menu, and then scroll to the right.
4. Select one of the following camera functions to adjust:
 a. *Playback*
 b. *Menus*
 c. *Shooting info display*
 d. *Image review*
5. Scroll to the right.
6. Select a delay time from 4 seconds to 10 minutes.
7. Click the *OK* button.
8. The camera will then return to the lower-left screen in *figure 16*, allowing you to select another camera function. Repeat steps 4 through 7 for each.

Playback Function Recommendation

For the *Playback* function, I set my D90 to 1 minute so that I'll have time to show the image to a person or two. For the *Menus* function, I set it to 20 seconds, which gives me enough time to see a menu, find the next, and make my changes. For *Shooting info display,* which is activated by the info button on the back of the D90, I set my delay time-out to 20 seconds. This is sufficient for me to review my camera settings before a shot. Finally, for the *Image review* function, I set it to a 1-minute delay. As mentioned earlier, I like to review my images!

Custom Setting c5
(Remote on duration)

(User's Manual pages 180 and 68)
This is an interesting function that controls how long the camera will wait for you to get into position after you press the button on your self-timer infrared remote. If you set the self-timer remote mode to either delayed remote or quick-response remote, the D90 will hold the camera in a ready state for the time delay set in *Custom Setting c5.* This means that the camera stays prepared for taking a picture, leaving the exposure meter active, until the *Remote on duration* times out.

In *figure 17* are two screens showing the self-timer remote displays in the control panel. The first is the symbol for the normal quick-response remote mode, which causes the camera to fire instantly when you press the infrared remote's button. The second is the symbol for the delayed remote mode, which causes the camera to fire two seconds after you

press the infrared remote's button (User's Manual page 68).

Here are the *Remote on duration* delay times:

1. *1 min* – 1 minute (default)
2. *5 min* – 5 minutes
3. *10 min* – 10 minutes
4. *15 min* - 15 minutes

Here are the steps to configure *Custom Setting c5* (see *figure 17A*):

1. Press the *MENU* button and scroll to the *Custom Setting Menu* (pencil icon).
2. Select *c Timers/AE lock,* and then scroll to the right.
3. Select *c5 Remote on duration* from the menu, and then scroll to the right.
4. Select the time-out delay period from 1 to 15 minutes.
5. Press the *OK* button.

My Wish List

At first, I was leaving my *Remote on duration* delay time set to *1 minute.* However, recently I have been leaving it on *5 minutes.* I wish there was a 2-minute setting because 1 minute is not quite enough time in some instances, especially where there is a large group involved.

Figure 17 – Self-timer remote symbols

Figure 17A – *Custom Setting c5 (Remote on duration)*

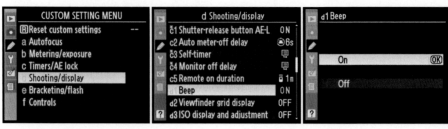

Figure 18 – *Custom Setting d1 (Beep)*

Shooting/Display - Custom Settings d1 to d12

(User's Manual pages 180–184)

Custom Setting d1 (Beep)

(User's Manual page 180)

I don't like my camera beeping at me. The D90's beeping sound is quite audible. In fact, it sets up a harmonic resonance with the bones in my skull and causes my eyeballs to vibrate. However, you may like it.

The D90's self-timer *Beep* function is used in a couple of ways. One is to let you know when the self-timer is about to fire. It counts down the seconds with a beep or two per second, then at the last moment it doubles the beeping frantically to say "Hurry up!" Another is when you are using autofocus in some of its modes, like AF-S and AF-A.

Figure 18A –The symbol in the control panel showing that *Beep* is enabled

Figure 18 shows the menu screens used to configure *Custom Setting d1*.

There are two selections for *Custom Setting d1*:

- *On*
- *Off*

Here are the steps to configure *Custom Setting d1* (see *figure 18*):

1. Press the *MENU* button and scroll to the *Custom Setting Menu* (pencil icon).
2. Select *d Shooting/display,* and then scroll to the right.
3. Select *d1 Beep* from the menu, and then scroll to the right.
4. Select *On* or *Off* from the menu.
5. Press the *OK* button.

If *Beep* is enabled (*On*), the D90 will let you know when you have focused successfully in single-servo autofocus (AF-S) and for stationary subjects in auto select autofocus (AF-A) by beeping once. It does not beep in continuous-servo autofocus (AF-C) because it would be beeping constantly as the focus adjusts to the subject.

The fact that the D90 is set to beep as a default belies the professional level of the camera. If I were using my camera in a quiet area, why would I want it beeping at me, disturbing those around me? I can just

imagine me zooming in on that big grizzly bear, pressing the shutter and listening to the grizzly roar his displeasure at my camera's beep and focus assist light. I want to live, so I turn off the beep. It seems to me that Nikon ought to set the default for beeping to *Off*. You may not agree.

When the beep is active, you'll see a little musical note displayed on the right side of your control panel LCD (see *figure 18A*).

I turn it off, but you may choose to keep the default setting of on.

Custom Setting d2
(Viewfinder grid display)

(User's Manual page 181)

Figure 19 shows the menu screens used to configure *Custom Setting d2*.

Back a few years ago, the 35mm film Nikon D80 (F80) was released with a viewfinder grid display and I was hooked. Later, as I bought more professional cameras, I was chagrined to find that they did not have the "on-demand" gridlines that I had grown to love. With the D90, you have the viewfinder gridlines.

There are two selections available in *Custom Setting d2*:

* *On* – On-demand gridlines are displayed in the viewfinder.
* *Off* (default) – No gridlines are displayed.

Here are the steps to configure on-demand gridlines (see *figure 19*):

1. Press the *MENU* button and scroll to the *Custom Setting Menu* (pencil icon).
2. Select *d Shooting/display*, and then scroll to the right.
3. Select *d2 Viewfinder grid display* from the menu, and then scroll to the right.
4. Select *On* or *Off* from the menu.
5. Press the *OK* button.

I use these gridlines to avoid weird and tilted horizons. If you turn on-demand gridlines on, I doubt you'll turn them back off. The nice thing is that you can turn them on and off at will. You don't have to buy an expensive viewfinder replacement screen for those times you need gridlines.

I Love These Gridlines!

They help me keep horizons level, and they help me pay attention to the overall level of all my images. I use them to line up with edges when I shoot buildings or other tall objects. They are a very useful feature in the D90. Try them yourself and see if you agree.

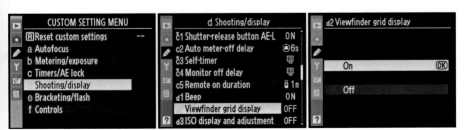

Figure 19 – *Custom Setting d2 (Viewfinder grid display)*

Custom Setting d3
(ISO display and adjustment)

(User's Manual page 181)

Normally, when you look at the lower-right corner of the top control panel LCD and the lower-right corner of the viewfinder, you'll see the frame count, or number of images the SD memory card will hold until full.

The D90 allows you to change this to a display of the ISO. You normally only see the ISO display in the control panel and viewfinder when you press and hold the ISO button on the back lower-left corner of the D90. If you feel that the current ISO is more important than the current display of frame count, you can change the display by adjusting *Custom Setting d3*.

Here are the three items that you can select in *Custom Setting d3*:

• *Show ISO sensitivity*
• *Show ISO/Easy ISO*
• *Show frame count*

Show ISO sensitivity – By selecting this setting, you will cause the D90 to display the current camera ISO sensitivity where it normally would display the frame count. You'll see the ISO in the control panel and the viewfinder. The info screen you get when you press the info button will continue displaying both ISO sensitivity and frame count.

Show ISO/Easy ISO – This works like the *Show ISO sensitivity* setting except that you have an additional feature. When you've selected this, you can also make an ISO adjustment by turning the front sub-command dial. That's what it means by *Easy ISO*. You can make an ISO sensitivity adjustment by turning the dial instead of having to hold down the ISO button and turn the dial. One less step!

Show frame count – This is the normal display that you expect to see when you look to see *"how many images can I take before the card is full?"* ISO sensitivity is not displayed unless you press the ISO button on back of the camera.

How Many Images Are Left?

I like being able to see how many images I have left. I don't change the ISO very often. If I do desire to change the ISO sensitivity, I find it quite simple to press the ISO button and turn the dial. However, if I were more concerned with changing my ISO on a constant basis, I suppose this would be a convenient feature. Use it if you feel the need for constant monitoring of your ISO status is more important than a quick reminder of how many frames you have left. I plan on ignoring it soundly. I leave my D90 set to *Show frame count*.

Figure 20 – *Custom Setting d3 (ISO display and adjustment)*

Here are the steps used to configure *Custom Setting d3* (see *figure 20*):

1. Press the *MENU* button and scroll to the *Custom Setting Menu* (pencil icon).
2. Select *d Shooting/display,* and then scroll to the right.
3. Select *d3 ISO display and adjustment* from the menu, and then scroll to the right.
4. Select one of the three display items from the menu.
5. Press the *OK* button.

Custom Setting d4 (Viewfinder warning display)

(User's Manual page 181)

Figure 21 shows the menu screens used to configure *Custom Setting d4.*

Don't you just hate it when that pesky low-battery warning in the viewfinder tells you your D90's battery is dying? Why do we need that? Or, maybe it upsets you when you've forgotten to insert an SD card and a viewfinder warning blinks. Could it be that you don't mind forgetting that you left the camera in B&W mode and are now shooting a colorful autumn scene?

Ok, I'm being sarcastic! We do need our battery-low, lack of memory card, and B&W mode warnings to blink in the viewfinder. However, if those viewfinder warnings *do* bug you, the D90 lets you turn them off.

There are two selections within *Custom Setting d4*:

- *On* (default)
- *Off*

On – When *Viewfinder warning display* is set to *On*, the D90 will warn you whenever you try to take a picture and the battery is about to die, a memory card has not been inserted, or your camera is in black and white mode.

Off – If you are shooting in a studio and have an external power source, are plugged into a computer directly and need no memory card, or shoot only in B&W mode, this setting is for you.

Here's how to adjust the settings in *Custom Setting d4* (see *figure 21*):

1. Press the *MENU* button and scroll to the *Custom Setting Menu* (pencil icon).
2. Select *d Shooting/display,* and then scroll to the right.
3. Select *d4 Viewfinder warning display* from the menu, and then scroll to the right.
4. Select *On* or *Off* from the menu.
5. Press the *OK* button.

Recommendation

For most of us, the default setting of *On* is the wisest setting. Warnings are there to keep us out of trouble.

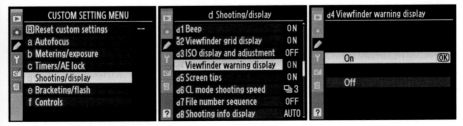

Figure 21 – *Custom Setting d4 (Viewfinder warning display)*

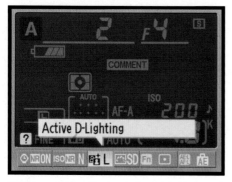

Figure 22 – *Custom Setting d5 (Screen tips)* help and navigation

Custom Setting d5 (Screen tips)

(User's Manual pages 182 and 12)
Screen tips is a built-in tip and navigation system available when you press the info button to open the shooting info display screen and then press the info button a second time.

As shown in *figure 22*, there are tips and navigation shortcuts for the following features:

- Long exposure noise reduction
- High ISO noise reduction
- Active D-Lighting
- Picture control
- Fn button assignment
- AE-L/AF-L button assignment
- Tip display

Figure 22A shows the menu screens used to configure *Custom Setting d5*.

Here's how to adjust the settings in *Custom Setting d5*:

1. Press the *MENU* button and scroll to the *Custom Setting Menu* (pencil icon).
2. Select *d Shooting/display*, and then scroll to the right.
3. Select *d5 Screen tips* from the menu, and then scroll to the right.
4. Select *On* or *Off* from the menu.
5. Press the *OK* button.

Basically, the point of *Custom Setting d5* is to allow you to quickly use an easy-access menu to jump to a configuration screen for six particular functions. It is sort of like a graphical version of *My Menu* except that you don't have any control over the items on the selection menu.

To use the functionality in the *Screen tips* system, do the following (see *figure 22*):

1. Press the info button on lower-right portion of the back of the D90.
2. The shooting info display will appear.
3. Press the info button again.
4. Now you can use the multi selector thumb switch to scroll right or left along the bottom screen tips bar of the shooting info display screen.
5. Select one of the six items along the bottom of the display screen.
6. Press the *OK* button and the D90 will switch to the configuration screen for that item.

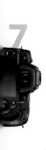

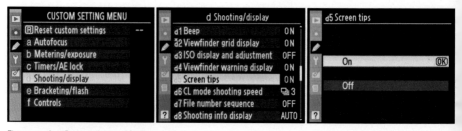

Figure 22A – *Custom Setting d5 (Screen tips)*

Tip on Screen Tips

I haven't found this item particularly useful because it requires me to remember which settings are on the bottom of the shooting info display screen. I suppose if I used it often, it would become second nature to me. Maybe I'll use it more often now that I took the time to understand the User's Manual entry while researching this section. Try it and see if you think it's useful for you.

Custom Setting d6
(CL mode shooting speed)

(User's Manual page 182)

The continuous low speed (CL) mode is for those of us who would like a conservative frame advance rate. The fastest the D90 can shoot is 4.5 frames per second in the continuous high speed (CH) mode (see page 65 of the User's Manual). However, unless you are shooting racecars speeding by at 200 miles per hour and have large memory cards, you may not want 43 frames of the same subject a few milliseconds apart. The CL mode allows you to slow the camera down to more reasonable frame rates when you don't need all those extra frames per second.

Figure 23 shows the menu screens used to configure *Custom Setting d6*.

Here are the configuration steps for *d6*:

1. Press the *MENU* button and scroll to the *Custom Setting Menu* (pencil icon).
2. Select *d Shooting/display,* and then scroll to the right.
3. Select *d6 CL mode shooting speed* from the menu, and then scroll to the right.
4. Select a frame rate of from 1 to 4 frames per second from the menu.
5. Press the *OK* button.

As *figure 23* shows, you can adjust *Custom Setting d6* so that your D90 shoots at any frame rate from 1 to 4 frames per second. The default is 3 frames per second. Remember, you always have CH mode for when you want to blast off images like there's no end to your memory card, or when you want to impress bystanders with that extra cool Nikon shutter-clicking sound.

Three Frames Per Second Works for Me

I haven't seen any need to change this from the default of 3 frames per second. This is about right for a quick burst of shots without wasting a lot of memory card space with extra unneeded images. I can always switch to CH mode if I need to get more frames.

Figure 23 – *Custom Setting d6 (CL mode shooting speed)*

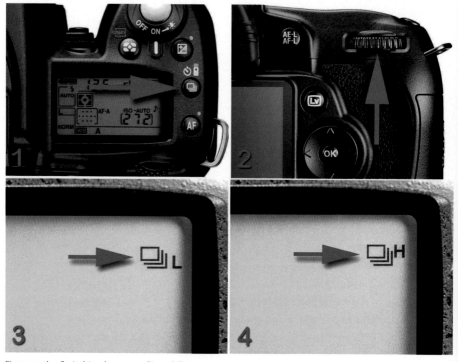

Figure 23A – Switching between CL and CH

In case you've forgotten, here are the steps to switch between CL and CH modes (see *figure 23A*):

1. Hold down the release mode button.
2. Turn the rear main-command dial until the L or H symbol appears in the top control panel LCD. L is the same as continuous low speed (CL) mode, while H is equivalent to continuous high-speed (CH) mode.
3. Stop pressing the release mode button.

Custom Setting d7 *(File number sequence)*

(User's Manual page 182)

Figure 24 shows the menu screens used to configure *Custom Setting d7*.

This setting allows your camera to keep count of the image numbers in a running sequence from 0001 to 9999. After 9999, it rolls back over to 0001. Or, you can cause it to reset the image number to 0001 when you format or insert a new memory card. Here are the settings available in *Custom Setting d7* and explanations of how they work:

- **On** – Image filename numbers start at 0001 and continue running in a series until you exceed 9999, at which time the numbers roll over to 0001 again. If

you exceed 9999 images during a shoot, the D90 will create a brand-new folder on the same memory card and start writing the new images in numbering order from 0001 into the new folder.

- **Off** (default) – Whenever you format or insert a new memory card, the number sequence starts over at 0001. If you exceed 999 images in a single folder, the D90 creates a new folder and starts counting images at 0001 again.

- **Reset** – This works in a similar way to the *On* setting. However, it is not a true running total to 9999 solution since the image number is dependent on the folder in use. The D90 simply takes the last number it finds in the current folder and adds 1 to it, up to 999. If you switch to an empty folder, the numbering starts over at 0001.

Here's how to modify the settings under *Custom Setting d7* (see *figure 24*):

1. Press the *MENU* button and scroll to the *Custom Setting Menu* (pencil icon).
2. Select *d Shooting/display,* and then scroll to the right.
3. Select *d7 File number sequence* from the menu, and then scroll to the right.
4. Select *On, Off,* or *Reset* from the menu.
5. Press the *OK* button.

Note on Image and Folder Numbering

The D90 manual on page 182 describes an unusual situation that few of us will ever see, unless we manually create folders in a certain way. Each time you exceed 999 images on a memory card, the D90 will create a new folder. If you ever exceed 999 folders (with 999 images in each) on a memory card (what a large card that would have to be) and your current folder (#999) has 999 images, or an image is numbered 9999, your D90 will stop responding to shutter button presses.

If this situation occurs, set *Custom Setting d7* to *Reset* and format or insert a new memory card. What I think Nikon means by this warning is clearly that you should never let a folder number go as high as 999 and then shoot over 999 images or let the D90's running total of images exceed 9999 in a folder numbered 999.

Basically, just keep your folder numbers lower than 999 if you are going to shoot more than 999 images that day or your number sequence is about to exceed 9999.

ɔure 24 – *Custom Setting d7 (File number sequence)*

Custom Setting d8
(Shooting info display)

(User's Manual page 183)

This is one of the reasons I say that the Nikon D90 is one of the coolest cameras I have ever seen. Look on the back of your D90 for the info button and press it. You will be presented with the shooting info display on the rear LCD monitor.

The extremely cool thing about this shooting info display is that it can adjust its color and brightness according to the ambient light the D90 senses through its lens. Try this: With your lens cap off, camera turned on, and nothing showing on the rear screen, press the info button. Even if you have dim ambient light where you are, you'll see a light blue info screen with black letters. Now, go into a dark area, or put your lens cap on, and cover the eyepiece with your hand. You'll see that anytime there is a dark ambient light condition, the D90 changes the info screen to whitish characters on a dark background. This keeps from blinding you when you need info in a dark area.

Figure 25 shows the menu screens used to configure *Custom Setting* d8.

Here are the selections in *Custom Setting* d8:

- **Auto** – The D90 decides through its uncapped lens or uncovered eyepiece how much ambient light there is and changes the color and contrast of the info screen accordingly.

- **Manual** – This manual setting allows you to select the light or dark versions of the info screen manually.

Figure 25 – *Custom Setting d8 (Shooting info display)*

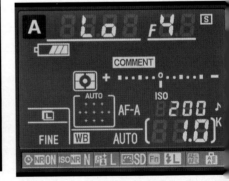

Figure 25A – Shooting info display color schemes

Figure 25A shows the two potential shooting info screen color schemes. First is the normal color screen, B (dark on light). Next is W (light on dark).

Here's how to modify the settings under *Custom Setting d8* (see *figure 25*):

1. Press the *MENU* button and scroll to the *Custom Setting Menu* (pencil icon).
2. Select *d Shooting/display,* and then scroll to the right.
3. Select *d8 Shooting info display* from the menu, and then scroll to the right.
4. Select *Auto* or *Manual* from the menu. If you choose *Auto,* simply press the *OK* button to select, and skip steps 5 and 6.
5. If you choose *Manual*, you'll need to scroll to the right to select a color scheme.
6. You have two choices, *B-Dark on light* and *W-Light on dark*. Choose one and press the *OK* button to select it.

My Shooting Info Display

I leave my D90 set to *Auto* on *Custom Setting d7*. I like to see it switch color schemes when the light drops. I also get to entertain my friends on how extra cool my D90 really is by merely displaying the shooting info screen and popping the lens cap on and off.

Custom Setting d9 (LCD illumination)

(User's Manual page 183)

Figure 26 shows the menu screens used to configure *Custom Setting d9*.

This is a simple little setting that allows you to set how the illumination of the top control panel LCD works. Here are the two choices in *Custom Setting d9*:

- *On*
- *Off* (default)

On – This setting makes the top control panel LCD illumination come on anytime the light meter is active. If you are frequently shooting in the dark and need to refer often to your control panel, then switch this setting to *On*.

Off - If you leave the LCD Illumination set to *Off,* the top control panel LCD will not turn on its backlight unless you tell it to with the "light on" setting on the ring surrounding the shutter button. If you use your shutter finger to pull the ring's lever to the right, the LCD will light up (see *figure 25*).

Here's how to modify *Custom Setting d9* (see *figure 26*):

1. Press the *MENU* button and scroll to the *Custom Setting Menu* (pencil icon).
2. Select *d Shooting/display,* and then scroll to the right.
3. Select *d9 LCD illumination* from the menu, and then scroll to the right.
4. Select *On* or *Off* from the menu.
5. Press the *OK* button.

To turn on the backlight illumination for testing this feature, simply pull the ring surrounding the shutter release button all the way to the right with your index finger. The ring will rotate past the Off/On settings until it is at the backlight setting. The control panel LCD backlight will come on (see *Figure 26A*).

Recommendation

This setting will affect battery life since backlights pull a lot of power. I wouldn't suggest using the *On* setting unless you really need it.

Custom Setting d10 (Exposure delay mode)

(User's Manual page 183)

This setting is *very* important to me. As a nature shooter, I use it frequently. When I am shooting handheld (or even on a tripod), I want a really sharp image. The image you see in your viewfinder is provided with the help of a mirror placed in front of the sensor. When you take the picture, the mirror quickly flips out of the way, and that sudden motion can cause a very small amount of vibration that you can easily feel each time you trip the shutter.

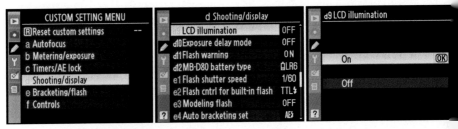

Figure 26 – Custom Setting d9 *(LCD illumination)*

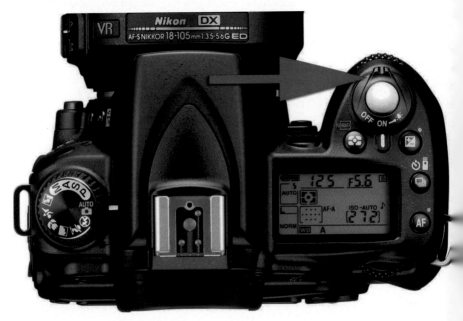

Figure 26A

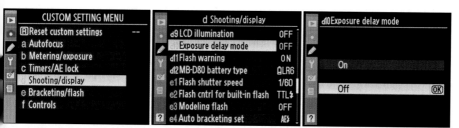

Figure 27 – *Custom Setting d10 (Exposure delay mode)*

This small vibration is not critical in most average shooting situations, but if you want to eliminate all possible vibration sources for the ultimate in camera stability, the exposure delay mode can help you.

Figure 27 shows the menu screens used to configure *Custom Setting d10*.

Here are the settings in *d10*:

On

Off (default)

On – The D90 first raises the mirror and then waits about 1 second before firing the shutter. This allows the vibrations from the mirror to dissipate before the shutter fires. Of course, this won't be useful at all for anyone shooting moving subjects or any type of action shots. But for slow shots of static scenes, this is great to get the sharpest pictures possible.

Off – Shutter has no delay when this setting is turned off.

Here are the steps to configure *Custom Setting d10* (see *figure 27*):

1. Press the *MENU* button and scroll to the *Custom Setting Menu* (pencil icon).
2. Select *d Shooting/display*, and then scroll to the right.
3. Select *d10 Exposure delay mode* from the menu, and then scroll to the right.
4. Select *On* or *Off* from the menu.
5. Press the *OK* button.

Use Exposure Delay Mode for Steady Shots

If you handhold your camera, shoot mostly static subjects, and want sharp pictures, this mode will help. If you are using a tripod, this is an excellent setting to use in addition to the camera's self-timer. If you don't have an electronic release cable, just set this delay and shoot with the self-timer. When you press the shutter release, the self-timer will count down however many seconds you've selected in *Custom Setting c3*. Then it will fire the shutter, but the exposure delay mode will be active and make the camera wait a full second with the mirror raised. This action will allow vibrations to die down and provide sharper scenic images. This is one of the settings I always place on *My Menu* for quick access (see chapter 9, "Retouch Menu, Recent Settings/MyMenu").

Custom Setting d11 (Flash warning)

(User's Manual page 183)

When you are shooting in one of the P,S,A,M exposure modes, the camera's built-in pop-up flash must be raised manually. Unlike in auto mode, where the camera decides when to use flash, you must make the decision. That's a good thing because you might be shooting a lovely scenic from a tripod, near dusk, and the pop-up flash would be entirely useless. So, the camera gives you control over the flash in the more advanced modes. However, what if you are shooting at an indoor party in one of the P,S,A,M modes and you've forgotten to raise the flash?

If you are in a dark area as you look through the viewfinder and you press the shutter release down halfway, you'll see a little lightning-bolt symbol blinking in the lower-right corner (see *figure 27A*). This is the flash warning that *Custom Setting d11* controls. You can leave it set to the default of *On*, which means it will warn you each time the camera senses that there is not enough light to hand-hold the camera without blur. Or, you can turn *d11* off, in which case the camera will no longer warn you when the flash is needed.

The screens to enable or disable *Custom Setting d11* are shown in *figure 27B*.

Figure 27A – Flash warning in viewfinder

Here are the steps to configure *Custom Setting d11*:

1. Press the *MENU* button and scroll to the *Custom Setting Menu* (pencil icon).
2. Select *d Shooting/display,* and then scroll to the right.
3. Select *d11 Flash warning* from the menu, and then scroll to the right.
4. Select *On* or *Off* from the menu.
5. Press the *OK* button.

Flash Warning is a Good Thing

I always leave *Flash warning* enabled. When I look at the readout on the bottom of my D90's viewfinder (before a shot), it will remind me that I might want to consider using the flash. How many times have you taken a picture and then realized that you should have used flash? I like the flash warning and just wish I'd pay more attention to it.

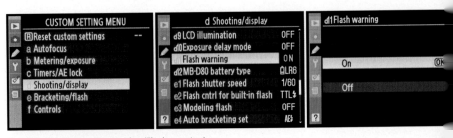

Figure 27B – Custom Setting d11 (Flash warning)

Custom Setting d12
(MB-D80 battery type)

(User's Manual page 184)

Since the smaller AA battery types, such as alkaline or lithium, have different performance levels, the camera needs to know the exact type of battery you are inserting into the MB-D80 Battery Pack. *Custom Setting d12* allows you to inform the camera of the current battery type.

If you do not have an MB-D80 Battery Pack for your D90, this does not apply to you. It also applies only when you choose to use AA-sized batteries of various types in your MB-D80. It does not apply when you are using normal Nikon EN-EL3e Li-ion batteries which are automatically communicating with the camera.

If you do have an MB-D80 and plan on using AA batteries, then you'll need to tell the D90 what type of AA batteries you're using for this session. It's *not* a good idea to mix AA battery types.

Figure 28 shows the menu screens used to configure *Custom Setting d12*.

Here are the selections available in *Custom Setting d12*:

LR6 – AA alkaline batteries

HR6 – AA Ni-MH rechargeable batteries

FR6 – AA lithium batteries

ZR6 – AA Ni-Mn rechargeable batteries

Here are the steps to configure *Custom Setting d12* (see *figure 28*):

1. Press the *MENU* button and scroll to the *Custom Setting Menu* (pencil icon).
2. Select *d Shooting/display*, and then scroll to the right.
3. Select *d12 MB-D80 battery type* from the menu, and then scroll to the right.
4. Select one of the battery types from the menu.
5. Press the *OK* button.

Which Battery to Use?

Nikon allows but does not recommend using AA batteries, especially alkaline, and Ni-Mn (nickel-manganese). Its primary objection to these two types (*LR6* and *ZR6*) is that they do not work well at lower temperatures. In fact, once you go below 68 degrees F (20 degrees C), an alkaline battery starts losing the ability to deliver power and will die rather quickly. You may not get as many shots out of a set of AA batteries, so your cost of shooting may rise. However, AA batteries are easily available and relatively cheap, so many people like the convenience of using them in emergency situations. If you do choose to use AA batteries, why not stick with lithium types (*FR6*)? They are the same type of cell used in the normal Nikon EN-EL batteries and they are not affected as much by low ambient temperatures.

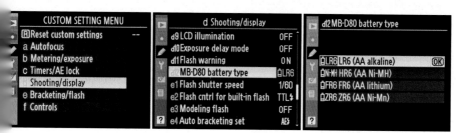

ʒure 28 – *Custom Setting d12 (MB-D80 battery type)*

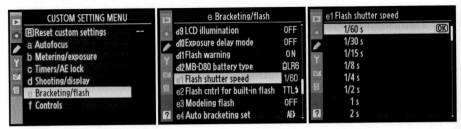

Figure 29 – *Custom Setting e1 (Flash shutter speed)*

Bracketing/Flash - Custom Settings e1 to e6

(User's Manual pages 185–195)

Custom Setting e1
(Flash shutter speed)

(User's Manual page 185)

This particular custom setting controls the minimum shutter speed your camera can use in various flash modes.

Figure 29 shows the menu screens used to configure *Custom Setting e1*.

Let's consider each mode and its minimum shutter speed:

Front-curtain sync (default), **Rear-curtain sync**, or **Red-eye reduction** – In *P-program* mode or *A-aperture priority* mode, the slowest shutter speed can be selected from the range of 1/60 second to 30 seconds (see *figure 29*). *S-shutter priority* mode and *M-manual* mode causes the camera to ignore *Custom Setting e1*, and the slowest shutter speed is 30 seconds.

Slow sync, Red-eye reduction with slow sync, or **Slow rear-curtain sync** – These three modes ignore *Custom Setting e1*, and the slowest shutter speed is 30 seconds.

The manual is a bit confusing on this subject, but the information in the preceding list is evident after study and testing. Therefore, *Custom Setting e1* is only partially used by the flash modes because the default is preset to 30 seconds in shutter priority and manual modes, as listed.

Here are the steps to configure *Custom Setting e1* (see *figure 29*):

1. Press the *MENU* button and scroll to the *Custom Setting Menu* (pencil icon).
2. Select *e Bracketing/flash,* and then scroll to the right.
3. Select *e1 Flash shutter speed* from the menu, and then scroll to the right.
4. Select a shutter speed from 1/60 s to 30 s from the menu.
5. Press the *OK* button.

Recommendation

Unless you want to take the time to really understand this custom control, just leave your camera set to the default of 1/60 of a second. Basically, you can use *Custom Setting e1* to control some of the flash modes, but not all.

Figure 30 – *Custom Setting e2 (Flash cntrl for built-in flash)*

Custom Setting e2
(Flash cntrl for built-in flash)

(User's Manual page 185–190)

If you are a frequent user of flash, *Custom Setting e2* and this section of the book will be very important to you. Please take the time to study this section in detail and you'll come away with a much greater knowledge of how to use your Nikon D90 within the powerful Nikon Creative Lighting System (CLS).

Figure 30 shows the menu screens used to configure *Custom Setting e2*.

Here are the steps to select the various modes:

1. Press the *MENU* button and scroll to the *Custom Setting Menu* (pencil icon).
2. Select *e Bracketing/flash,* and then scroll to the right.
3. Select *e2 Flash cntrl for built-in flash* from the menu, and then scroll to the right.
4. Select one of the four flash control modes from the menu.
5. See the following descriptions of the four settings to configure each mode.

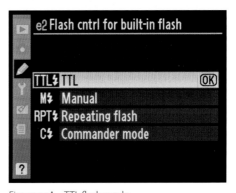

Figure 30A – TTL flash mode

The D90 has four distinct ways to control flash output:

TTL – Also known as iTTL, this mode is the standard way to use the D90 for flash pictures. TTL stands for *through the lens* and allows very accurate and balanced flash output using a preflash method to determine correct exposure before the main flash burst fires. This is a completely automatic mode and will adjust to distances along with the various shutter speeds and apertures your camera is using (see *figure 30A*).

M (Manual) – This mode allows you to manually control the output of your flash. The range of settings can go from full power to 1/128 power (see *figure 30B*).

1. **RPT (Repeating flash)** – This setting turns your D90 into a strobe unit, allowing you to get creative with stroboscopic multiple flashes. There are three settings, as shown in *figure 30C*:

 Output – You can vary the output of your D90 pop-up flash unit from 1/4 to 1/128 of the full power. Using more power per flash will cut down on the number of times the unit can fire (flash) per second. Here is a list of how many times the built-in pop-up flash can fire using the different output levels:
 - **1/4** = 2 times
 - **1/8** = 2–5 times
 - **1/16** = 2–10 times
 - **1/32** = 2–10 or 15 times
 - **1/64** = 2–10, 15, 20, 25 times
 - **1/128** = 2–10, 15, 20, 25, 30, 35 times

 Times – Refer to the preceding list to set the number of times the flash can fire. Increasing the power output—going toward 1/4—will lower the number of times, while decreasing the power—going toward 1/128—will increase the number of times the flash can fire like a strobe.

Frequency – This setting controls the number of times the flash will strobe per second, between 1 and 50. If you have the *Output* set to 1/128 and *Times* set to 5 and you set *Frequency* to 50, the D90 will fire its pop-up Speedlight at 1/128 power, five times, with each flash burst divided up into 50 pulses. Therefore, the flash will pulse a total of 250 times at 1/128 power.

2. **C (Commander mode)** – This mode allows your camera to become a commander, or controller, of up to two banks of an unlimited number of external Speedlight flash units. *Commander mode* in the Nikon D90 is a rather complex subject because it gets into the Nikon Creative Lighting System. Chapter 11 takes up where this *Custom Setting e3* section leaves off and is devoted to the subject of Nikon's Creative Lighting System (CLS). It provides full details on how to use the D90's built-in *Commander mode* to control external Nikon Speedlights. See chapter 11, "Nikon Creative Lighting System and the Nikon D90."

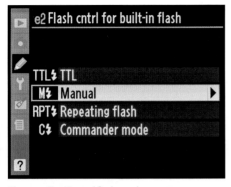

Figure 30B – *Manual* flash mode

Figure 30C – *Repeating flash* mode

 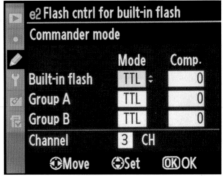

Figure 30D – *Commander mode*

Custom Setting e3 (Modeling flash)

(User's Manual page 191)

The *Modeling flash* setting allows you to press the depth-of-field preview button below the lens on the D90 and fire the flash in a special way. It will cause a fast series of pulses with the pop-up flash, or an external Speedlight, so that you can see how the light wraps around the subject.

Figure 31 shows the menu screens used to configure *Custom Setting e3*.

Here are the selections in *Custom Setting e3*:

- *On*
- *Off* (default)

On – This setting allows you to see (somewhat) how your flash will light the subject. If you have this setting turned to *On*, the depth of field preview button strobes the pop-up flash or any attached/controlled external SB Speedlight unit in a series of rapid pulses. These pulses are continuous and simulate the lighting that the primary flash burst will give your subject. The modeling flash can be used for only a few seconds at a time to keep from overheating the flash unit, so look quickly.

Off – This means that no modeling light will fire when you press the depth-of-field preview button.

Here is how to configure *Custom Setting e3* (see *figure 31*):

1. Press the *MENU* button and scroll to the *Custom Setting Menu* (pencil icon).
2. Select *e Bracketing/flash,* and then scroll to the right.
3. Select *e3 Modeling flash* from the menu, and then scroll to the right.
4. Select *On* or *Off* from the menu.
5. Press the *OK* button.

Recommendation

If you are serious about flash photography, you may find this function useful for testing your flash arrangement. This is especially true if you are using CLS and multiple flash units.

Warning About Modeling Flash!

I often forget that this is turned on when I want to check my depth of field on a product shot with the flash up. Instead of depth of field, I get the modeling light. It often startles me! The pulsing of the modeling flash sounds like an angry group of hornets about to attack your face.

Figure 31 – *Custom Setting e3 (Modeling flash)*

Custom Setting e4
(Auto bracketing set)

(User Manual pages 191)

This setting allows you to control how bracketing works within your D90. There are five different functions that allow bracketing, which we'll discuss in this section. This setting is designed to work in exposure modes P, S, A, and M but none of the scene modes.

Figure 32 shows the menu screens used to configure *Custom Setting e4*.

Here are the settings within *Custom Setting e4*:

- *AE & flash*
- *AE only*
- *Flash only*
- *WB bracketing*
- *ADL bracketing*

AE & flash – When you set up a session for bracketing, the camera will cause any type of shot you take to be bracketed, whether they're standard exposures or you're using flash. See "How to Use AE and Flash Bracketing" below.

AE only – Your bracketing settings will affect only the exposure system and not the flash.

Flash only – Your bracketing settings will only affect the flash system, and not the exposure.

WB bracketing – White balance bracketing is described in detail in chapter 3, "White Balance." It works in a similar way to exposure and flash bracketing except it is designed for bracketing color in "mired" values instead of light in EV step values.

ADL bracketing – Active D-Lighting bracketing provides two images, one not D-Lighted and the second with your current D-Lighting selection in the *Shooting Menu > Active D-Lighting* section.

Here is how to configure *Custom Setting e4* (see *figure 32*):

1. Press the *MENU* button and scroll to the *Custom Setting Menu* (pencil icon).
2. Select *e Bracketing/flash,* and then scroll to the right.
3. Select *e4 Auto bracketing set* from the menu, and then scroll to the right.
4. Select one of the five types of bracketing from the menu.
5. Press the *OK* button.

Figure 32 – *Custom Setting e4 (Auto bracketing set)*

Figure 32A – BKT button, main-command dial, and control panel LCD with bracket symbols

Now let's consider how to use the bracketing system. First, we'll look at the external camera controls for bracketing.

How to Use AE and Flash Bracketing

As shown in *figure 32A*, choose the number of shots in the bracket by pressing and holding the function *BKT* button on the front of the D90, near the label. Turn the rear main-command dial to select the number of shots in the bracket.

Look for the *BKT* symbol to appear on the top control panel LCD along with a set of characters on the top left. These symbols are presented in the following list (the number of shots in the bracket are represented by these characters):

- *oF* = Bracket not set
- *3F* = Three-shot bracket with order set in *Custom Setting e6*
- *-2F* = Two-shot bracket, normal and underexposed
- *+2F* = Two-shot bracket, normal and overexposed

Hold the *BKT* button and rotate the rear main-command dial to select any of these settings except *oF*. The D90 will take the total number of exposures represented by the character pattern in the preceding list.

You can use *Custom Setting e6* to set the order of the exposures. We'll discuss this in the section "*Custom Setting e6*" later in this chapter. The default order is MTR (normal) > underexposed > overexposed. You can change it to underexposed > normal (MTR) > overexposed if you'd like.

While holding the *BKT* button, you can rotate the front sub-command dial to change the EV step value of each image in the bracket, in steps of 0.3, 0.7, 1.0, 1.3, 1.7, or 2.0 EV, based on having selected 1/3 in *Custom Setting b1 (EV steps for exposure control)*. If you've selected 1/2 in *Custom Setting b1*, the EV step values in the bracket will be 0.5, 1.0, 1.5, or 2.0.

Therefore, these steps give you your desired bracketing range:

- *BKT* button plus rear main-command dial = number of exposures
- *BKT* button plus front sub-Command dial = EV step value of bracketed exposures (1/3 or 1/2 EV steps)

Figure 32B – Three exposures, bracket at 1.0 EV

Figure 32C – Two exposures, underexposure bracket at 0.7 EV

Figure 32D – Two exposures, overexposure bracket at 0.3 EV

In *figures 32B to 32D* are a series of images of the top control panel LCD set to various bracketing values.

Figure 32B shows a total of three exposures (3F) with 1.0 EV between each exposure (1.0).

Figure 32C shows a total of two exposures (-2F) with 0.7 EV between each exposure (0.7).

Figure 32D shows a total of two exposures (+2F) with 0.3 EV between each exposure (0.3).

How I Use AE and Flash Bracketing

I normally bracket with a 1 EV or 2 EV step value (1 or 2 stops) so that I can get a good spread of light values in high dynamic range (HDR) images. In most cases, I will do a three-image bracket, with one image overexposed and one image underexposed by 1 or 2 stops. This type of bracketing allows detail in the highlight and dark areas to be combined later in-computer for the HDR exposures everyone is experimenting with these days.

How to Use ADL Bracketing

Now let's look at Active D-Lighting (ADL) bracketing. This is a rather simple bracket because it takes only two images. The first image will be a normally metered image with no D-Lighting applied. The second image taken will be with whatever Active D-Lighting you've applied in the *Shooting Menu > Active D-Lighting* section.

Therefore, these steps give you your desired bracket:

1. Set *Shooting Menu > Active D-Lighting* to one of the Active D-Lighting selections, that is, *Low, Normal,* or *High.*
2. Select *ADL bracketing* in *Custom Setting e4* (see *figure 32*).
3. Press and hold down the *BKT* button and verify that *AdL* shows up on the upper control panel LCD. Do not release the *BKT* button.
4. Rotate the rear main-command dial until the small *BKT* symbol appears on the right side of the upper control panel LCD.
5. Release the *BKT* button.
6. Take two pictures of the same subject.

In any bracketing situation, except white balance (WB) bracketing, you can set your camera's release mode to *L* (CL) or *H* (CH) and fire off the frames of the bracket in one continuous burst. The camera will know how many frames to fire and will stop when the bracket is complete. White balance bracketing works differently in that all you have to do is press the shutter button once and the camera takes the one image, makes a copy, and applies the different WB bracketing values to each image. It then saves the two images with their differing WB settings under different filenames. (See chapter 3, "White Balance.")

Custom Setting e5 (Auto FP)

(User's Manual page 195)

This function allows you to use external flash units like the SB-600, SB-800, or SB-900 at shutter speeds beyond the normal 1/200 of a second maximum. *This setting will not work with the pop-up flash.*

The *FP* in *Auto FP* stands for focal plane and refers to the type of shutter used in the D90.

Auto FP works by firing the flash in a series of pulses instead of one big pop. Since any shutter speed above 1/200 of a second does not leave the image sensor fully uncovered by the shutter, the flash

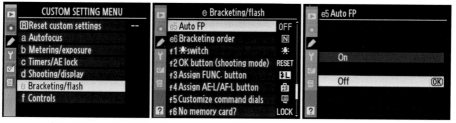

Figure 33 – *Custom Setting e5 (Auto FP)*

cannot just fire a single powerful burst or some part of the sensor will be blocked by the shutter. *Auto FP* solves that problem by pulsing the flash multiple times as the shutter moves across the face of the image sensor. This allows a normal exposure at shutter speeds up to 1/4000 second.

A drawback to using *Auto FP* is that it will lower the maximum power of the flash output because it is firing over and over rapidly (pulsing). You will not get the normal range out of your flash when using *Auto FP*. The higher you set the shutter speed, the shorter the distance your flash can cover because it has to pulse faster as the shutter speed goes up. However, that is offset by being able to use a very high shutter speed for special effects or to eliminate background ambient light.

Figure 33 shows the menu screens used to configure *Custom Setting e5*.

Here is how to configure *Custom Setting e5*:

1. Press the *MENU* button and scroll to the *Custom Setting Menu* (pencil icon).
2. Select *e Bracketing/flash,* and then scroll to the right.
3. Select *e5 Auto FP* from the menu, and then scroll to the right.
4. Select *On* or *Off* from the menu.
5. Press the *OK* button.

Make sure you remember that the built-in pop-up flash does not work with Auto FP. It cannot recycle fast enough to pulse like the bigger hot-shoe-mounted Speedlights.

Experiment with Auto FP

If you need to control the ambient light due to mismatched light sources or for things like outdoor portraits in very bright ambient light, you might want to experiment with *Auto FP*; otherwise, you'll probably not find much use for it. Don't be afraid to experiment. Just be sure to turn *Auto FP* off when you are done.

Custom Setting e6 (Bracketing order)

(User's Manual page 195)

Figure 34 shows the menu screens used to configure *Custom Setting e6*.

There are two bracketing orders available in the D90. They allow you to control which images are taken first, second, and third in the bracketing series.

- *MTR* = Metered value
- *Under* = Underexposed
- *Over* = Overexposed

Here are the selections in *Custom Setting e6*:

1. *MTR > under > over* (default)
2. *Under > MTR > over*

MTR > under > over – With this setting, the normal exposure (MTR) is taken first, followed by the underexposed image, then the overexposed image. If you are taking a group of three images in your bracket (see *Custom Setting e4*), the camera will take the images like this:

Normal exposure > underexposed > overexposed

Under > MTR > over – Using this order for bracketing means that the bracket will be exposed in the following manner:

Underexposed > normal exposure > overexposed

Here are the steps to configure *Custom Setting e6* (see *figure 34*):

1. Press the *MENU* button and scroll to the *Custom Setting Menu* (pencil icon).
2. Select *e Bracketing/flash,* and then scroll to the right.
3. Select *e6 Bracketing order* from the menu, and then scroll to the right.
4. Select one of the two bracketing orders from the menu.
5. Press the *OK* button.

Recommendation

I leave mine set to the default. This way, when the images are displayed in series by the camera, I can see the normal exposure first, and then watch how it varies as I scroll through the bracketed images.

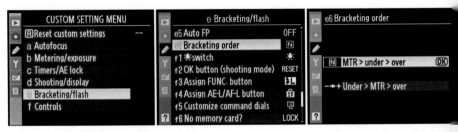

Figure 34 – *Custom Setting e6 (Bracketing order)*

Controls - Custom Settings f1 to f7

(User's Manual pages 196–201)

Custom Setting f1– (:⬤ switch)

(User's Manual page 196)

This function allows you to control how the backlight is displayed on both the upper control panel LCD, and the shooting info display, when the power switch ring around the shutter release button is turned past *On* to the location of the little backlight bulb (see *figure 35*).

Figure 35A shows the three screens used in setting up what this switch does.

Here are the selections available in *Custom Setting f1*:

- LCD backlight
- Both

LCD backlight – If this selection is made, the power switch ring turns on the backlight only for the upper control panel LCD. It stays on as long as the light meter is active. So, you can control this backlight's time-out period by changing *Custom Setting c2 (Auto meter-off delay)*. The factory default value is 6 seconds.

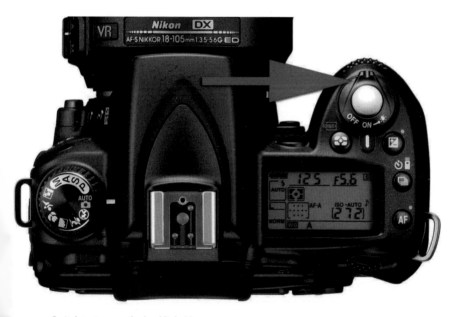

Figure 35 – Switch to turn on the backlight(s)

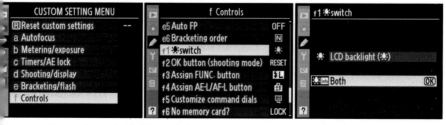

Figure 35A – *Custom Setting f1 (Backlight switch)*

Both – Using this selection means that the Power switch ring turns the backlights on for both the upper control panel LCD and the Shooting info display screen. Each of those displays has its own time-out period. The control panel LCD times out with the exposure meter in *Custom Setting c2 (Auto meter-off delay)*. The shooting info display times out with the *Shooting info display* setting in *Custom Setting c4 (Monitor off delay)*. So, in effect you can control two backlights with separate time-out periods. However, there is one caveat. The exposure meter will not shut off until after the shooting info display screen goes dark. So (in reality) the time-out period for the upper control panel LCD does not start until the shooting info display screen goes dark.

Here are the steps to configure *Custom Setting f1* (see *figure 35A*):

1. Press the Menu button and scroll to the *Custom Setting Menu* (pencil icon).
2. Select *f Controls*, and then scroll to the right.
3. Select *f1* switch from the menu, and then scroll to the right.
4. Select one of the two backlight choices from the menu.
5. Press the *OK* button.

Backlight Recommendation

I like having both the upper control panel LCD and the shooting info display screen become active when I turn the backlight on with the power switch ring, so I select *Both* in *Custom Setting f1*. Of course, that does drain battery power, so you might want to have the backlight come on only for the upper control panel LCD. You can always turn on the shooting info display screen with the info button.

Custom Setting f2
(OK button [shooting mode])

(User's Manual page 196)

This custom setting is designed to give you some control over what the *OK* button does during shooting mode operation, like using the autofocus system.

Figure 36 shows the screens used to configure *Custom Setting f2*.

These are the three selections you can make in *f2*:

1. *Select center focus point* (default)
2. *Highlight active focus point*
3. *Not used*

Select center focus point – Since the D90 has 11 AF points and you can scroll around them with the multi selector thumb switch, sometimes you may find the AF point over on the edge of the screen when you'd rather have it back in the middle. The D90 has a solution—simply press the *OK* button and the AF point will pop to the center of the viewfinder. That's the default for *Custom Setting f2*.

Highlight active focus point – This selection makes the *OK* button act the same as when you press the shutter button down halfway, except it does not cause autofocus or metering. The AF points all light up in red so that you can more clearly see which AF point is active

Not used – This is the same as off. When you press the *OK* button during shooting mode, it does nothing.

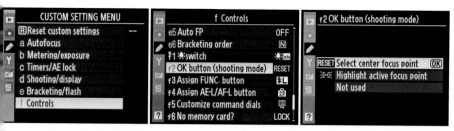

igure 36 – *Custom Setting f2 (OK button)*

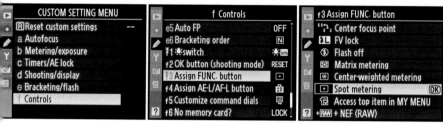

gure 37 – *Custom Setting f3 (Assign FUNC. button)*

Here are the steps to configure *Custom Setting f2* (see *figure 36*):

. Press the *MENU* button and scroll to the *Custom Setting Menu* (pencil icon).
. Select *f Controls,* and then scroll to the right.
. Select *f2 OK button (shooting mode)* from the menu, and then scroll to the right.
Select one of the three choices from the menu.
Press the *OK* button.

OK Button Recommendation

I like to use the default setting of *Select center focus point*. It is convenient to be able to bring the AF point to the center of the viewfinder by just pressing *OK* instead of scrolling back. The other selection is too much like what I do when I press the shutter release halfway down to be of much benefit to me.

Custom Setting f3
(Assign FUNC. button)

(User's Manual pages 197–199)

The *FUNC.* button (also known as the *Fn* button) is a multipurpose programmable button for your use. There are 10 specific functions from which you can select. The *FUNC.* button will then assume the particular function you've chosen, until you decide to change it. The *FUNC.* button falls under your second finger when you have your index finger on the shutter release button.

Figure 37 shows the screens used to configure *Custom Setting f3.*

Here is a list of the 10 functions you can choose from:

Framing grid – Press the *Fn* button and rotate the main-command dial to turn the on-demand grid lines on or off. This is equivalent to changing *Custom Setting d2 (Viewfinder grid display)*. (See page 9 in the User's Manual.)

AF-area mode – Press the *Fn* button and rotate the main-command dial to select the AF-area mode. This is equivalent to changing *Custom Setting a1 (AF-area mode)*. Select from *Single point, Dynamic area, Auto-area,* or *3D-tracking (11 points)*. (User's Manual page 173.)

Center focus point – Press the *Fn* button and rotate the main-command dial to choose either the center wide zone AF point or the center normal zone AF point. This is equivalent to changing *Custom Setting a2 (Center focus point)*. (See page 174 in the User's Manual.)

FV lock (default) – Press the *Fn* button to lock the flash value (FV) lock for your current subject. When you press *Fn* again, it unlocks the flash value. This applies only to the following flash units: pop-up built-in flash, SB-R200, SB-400, SB-600, SB-800, and SB-900.

- *FV lock* is used to lock the current flash value for a particular subject so that the next picture will accurately expose for that subject even if you zoom your lens or recompose the image. (User's Manual page 198.) To activate, it do the following:

a. Assign *FV lock* to the *Fn* button.
b. Make sure the flash is ready.
c. Focus on your subject.
d. Press the *Fn* button to lock the flash value (FV lock). The camera will fire a preflash to prepare for the final picture, then do an FV lock.
e. Recompose the image.
f. Take the picture.
g. Press the *Fn* button again to release the FV lock.

Flash off – The built-in pop-up flash or any hot-shoe-mounted flash unit will not fire while you press the *Fn* button. The manual states that the flash units "turn off," but in reality they only stop firing. When you release the *Fn* button, they will immediately fire again. This is handy in case you want to take a single picture without flash while your flash unit is on and available.

Matrix metering – Matrix metering becomes active while you press the *Fn* button.

Center-weighted metering – Center-weighted metering becomes active while you press the *Fn* button.

Spot metering – Spot metering becomes active while you press the *Fn* button.

Access top item in My Menu – If you have an item on your *My Menu* that you use frequently, just make sure it is the top item. You can select this to make the *My Menu* open and highlight the top item when you press the *Fn* button.

+ NEF (RAW) – If the camera is set to any of the JPEG modes (*fine, basic,* or *normal*) and you press the *Fn* button, the next picture will switch to NEF + JPEG and record both a RAW and JPEG file for the image. This allows you to shoot JPEG as your normal mode and record an NEF and JPEG for the next frame when a special subject presents itself. Press *Fn* again to turn it off, or turn the camera o

Here are the steps to configure *Custom Setting f3* (see *figure 37*):

1. Press the *MENU* button and scroll to the *Custom Setting Menu* (pencil icon).
2. Select *f Controls,* and then scroll to the right.
3. Select *f3 Assign FUNC. button* from the menu, and then scroll to the right.
4. Select one of the 10 choices from the menu.
5. Press the *OK* button.

Assign FUNC Button Recommendation

Personally, I choose the *Spot metering selection* for *Custom Setting f3*. I mostly use the matrix metering in my D90, but sometimes I want a spot meter. Pressing the *Fn* button gives me a temporary one for metering more difficult subjects. This is a rich selection of functions, and you may want to consider each of them to see if you use something often that can be placed under the *Fn* button's control.

Custom Setting f4 (Assign AE-L/AF-L button)

(User's Manual page 200)

This is another somewhat programmable button on your D90, with the exception that the available functions all have something to do with either exposure or autofocus. The AE-L/AF-L button is just to the right of the viewfinder's eyepiece on the D90.

Figure 38 shows the screens used to configure *Custom Setting f4*.

Here is a list of the functions. The one you select in *Custom Setting f4* will be assigned to the *AE-L/AF-L button*:

AE/AF lock (default) – Enabling this function causes AE (exposure) and AF (focus) to lock on the last meter and AF system reading while the *AE-L/AF-L button* is held down.

AE lock only – This allows you to lock AE (exposure) on the last meter reading when you hold down the *AE-L/AF-L button*.

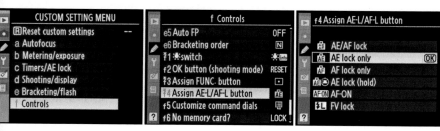

igure 38 – *Custom Setting f4 (Assign AE-L/AF-L button)*

AF lock only – When set, this function locks the AF system (focus) on the last autofocus reading while you hold down the *AE-L/AF-L button.*

AE lock (hold) – This allows you to lock AE (exposure) on the last meter reading when you press the *AE-L/AF-L button* once. To release the lock hold, press it again. If the meter goes off, it will also release the lock hold on the exposure.

AF-ON – Some people don't want to use the shutter release for autofocus. They'd rather the shutter release button *only* release the shutter. This function is for those individuals. You can separate the autofocus and shutter release by assigning autofocus to the *AE-L/AF-L button.* Once it's set, the *AE-L/AF-L button* must be pressed to make the camera autofocus. The shutter release will only release the shutter. Either one of the buttons will cause the meter to become active.

FV lock – The *AE-L/AF-L button* will cause the pop-up or external Speedlight to emit a monitor preflash and then lock the flash output to the level determined by the preflash until you press the *Fn* button a second time. (See page 198 in the D90 User's Manual for more info on FV lock.)

Here are the steps to configure *Custom Setting f4* (see *figure 38*):

1. Press the *MENU* button and scroll to the *Custom Setting Menu* (pencil icon).
2. Select *f Controls,* and then scroll to the right.
3. Select *f4 Assign AE-L/AF-L button* from the menu, and then scroll to the right.
4. Select one of the six choices from the menu.
5. Press the *OK* button.

Assign AE-L/AF-L button Recommendation

Personally, I choose the *AE lock only* selection from *Custom Setting f4.* I want to be able to lock my exposure but leave AF active so that I can meter from one area of the subject and then recompose for the picture.

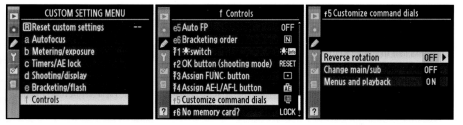

Figure 39 – *Custom Setting f5 (Customize command dials)*

Custom Setting f5
(Customize command dials)

(User's Manual page 201)

Figure 39 shows the screens used to configure *Custom Setting f5*.

There are three settings under *Custom Setting f5*, as follows:

* *Reverse rotation*
* *Change main/sub*
* *Menus and playback*

Reverse rotation – This setting allows you to change the functionality of the rotation direction of the command dials. There are two selections:

* **Yes** – The command dial rotation results are reversed from their default values. Pick up your camera, point it at a subject, and ratchet your command dials to the right and the left. Depending on

the program mode you are in, the shutter speed or aperture (and some other options) may go higher or lower. If you prefer to reverse the direction when you ratchet right (or left), just choose *Yes*.

* **No** – The direction of the command dials is left at the factory default.

Here are the steps to configure *Reverse rotation* (see *figure 39A*):

1. Press the *MENU* button and scroll to the *Custom Setting Menu* (pencil icon).
2. Select *f Controls,* and then scroll to the right.
3. Select *f5 Customize command dials* from the menu, and then scroll to the right.
4. Select *Reverse rotation* from the menu, then scroll to the right.
5. Select *Yes* or *No* from the menu.
6. Press the *OK* button.

Figure 39A – *Reverse rotation* on command dials

Figure 39B – *Change main/sub* on command dials

Change main/sub – This setting allows you to swap the functionality of the two command dials. The main-command dial will take on the functions of the sub-command dial and vice versa. Here are the two settings:

- **On** – When this is set to *Off*, the main-command dial controls shutter speed while the sub-command dial controls aperture. By selecting *On*, you reverse the functionality so that the sub-command dial controls shutter speed while the main command dial controls aperture.

- **Off** – The functionality of the command dials is left at the factory default.

Here are the steps to configure *Change main/sub* (see *figure 39B*):

1. Press the *MENU* button and scroll to the *Custom Setting Menu* (pencil icon).
2. Select *f Controls,* and then scroll to the right.
3. Select *f5 Customize command dials* from the menu, and then scroll to the right.
4. Select *Change main/sub* from the menu, then scroll to the right.
5. Select *On* or *Off* from the menu.
6. Press the *OK* button.

Menus and playback – This setting is designed to allow those who do not like the multi selector thumb button on the rear of the D90 for image review or menu scrolling. There are two selections for how the menus and image playback works when you would rather not use the multi selector button:

- **On** – While you're viewing images during playback, turning the rear main-command dial to the left or right scrolls through the displayed images. Turning the sub-command dial left or right scrolls through the data and histogram screens for each image. While you're viewing menus, turning the rear main-command dial left or right scrolls up or down in the menu screens. Turning the sub-command dial left or right scrolls left or right in the menus. The multi selector button works normally even when this is set to *On*. This setting simply allows you to have two ways to view your images and menus instead of one.

- **On (image review excluded)** – This works the same as *On* with the exception that during an image review

Figure 39C – *Menus and playback*

you cannot use the command dials to change the image being displayed. I'm not talking about image playback, where you press the *Playback* button to see images. What I am referring to is the image that appears immediately after you take a picture. That is image review, and the command dials do not work when that picture is being displayed.

- **Off** – This is the default action. The multi selector button is used to scroll through images and menus, as normal.

Here are the steps to configure *Menus and playback* (see *figure 39C*):

1. Press the *MENU* button and scroll to the *Custom Setting Menu* (pencil icon).
2. Select *f Controls,* and then scroll to the right.
3. Select *f5 Customize command dials* from the menu, and then scroll to the right.
4. Select *Menus and playback* from the menu, then scroll to the right.
5. Select *On, On (image review excluded),* or *Off* from the menu.
6. Press the *OK* button.

Custom Setting f6 (No memory card?)

(User's Manual page 201)

Figure 40 shows the screens used to configure *Custom Setting f6*.

This setting defaults to locking the shutter when you try to take an image without an SD memory card inserted in the camera. By enabling it, you can take pictures without a memory card. The only useful reason I can see for doing so is when you are using Nikon Camera Control Pro 2 software to send pictures directly to your computer. This software is not included with the D90. Here are the two settings:

LOCK- Release locked – By choosing this default setting, your camera will refuse to release the shutter when there is no memory card present.

OK - Enable release – Use this setting if you want to use the optional Camera Control Pro 2 software to send images from the camera directly to the computer.

Figure 40 – *Custom Setting f6 (No memory card?)*

Here are the steps to configure *Custom Setting f6* (see *figure 40*):

1. Press the *MENU* button and scroll to the *Custom Setting Menu* (pencil icon).
2. Select *f Controls,* and then scroll to the right.
3. Select *f6 No memory card?* from the menu, and then scroll to the right.
4. Select *Release locked* or *Enable release* from the menu.
5. Press the *OK* button.

Released Locked Recommendation

There's no point in setting anything but *Released locked* unless you are using Nikon Camera Control Pro 2 software to control the camera. In that case, the camera feeds pictures to your computer, not a memory card.

Custom Setting f7 (Reverse indicators)

(User's Manual page 201)

Figure 41 shows the screens used to configure *Custom Setting f7*.

Normally, any time you see the exposure indicators in your D90's viewfinder or shooting info display, the + is on the left, and the – is on the right. See *figure 41*, where I show the info screen and the exposure indicator.

If you want, you can reverse this indicator so that the – is on the left and the + is on the right. Notice how the third screen of *Figure 41* shows how the exposure indicator looks in normal and reversed modes. Here are the two settings:

+o– is the normal polarity (+/–) of the exposure indicator.

–o+ is the reversed polarity (–/+) of the exposure indicator.

Figure 41 – *Custom Setting f7 (Reverse indicators)*

Here are the steps to configure *Custom Setting f7* (see *Figure 41*):

1. Press the *MENU* button and scroll to the *Custom Setting Menu* (pencil icon).
2. Select *f Controls,* and then scroll to the right.
3. Select *f7 Reverse indicators* from the menu, and then scroll to the right.
4. Select the polarity of the positive and negative indicators from the menu.
5. Press the *OK* button.

Reverse Indicator Recommendation

Select your favorite indicator direction for maximum camera comfort. I leave mine set at the normal factory default setting.

Summary

Now that you've configured all the Custom Settings, your camera is customized to your preferences. This was one massive chapter, with 41 detailed settings to be considered. Just making it through this chapter is an accomplishment for you. Congratulations!

In our next chapter, we'll consider the *Setup Menu* and all the non-picture-related functions in your camera that need to be understood.

Setup Menu

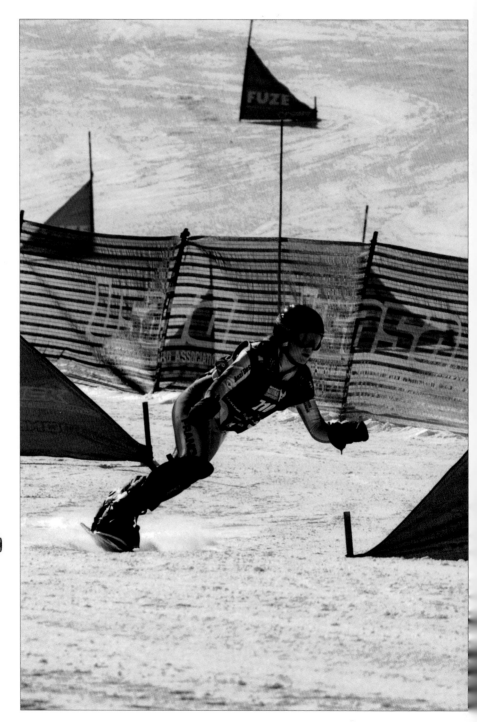

The *Setup Menu* on the Nikon D90 consists of a series of basic camera settings not generally related to taking pictures. They cover things like how bright you'd like the LCD, battery info, firmware version, the default language, and image sensor cleaning.

These settings are most likely the first you'll use when you prepare your new D90. You'll have to set your World time and date right away, format a memory card, and set your LCD brightness.

The *Setup Menu* is selected with a symbol that looks like a wrench. It is about midway down the menu tree, on the left. See *figure 1* for a look at the *Setup Menu* location.

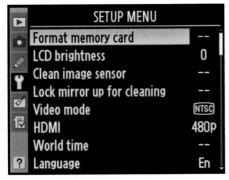

Figure 1 – The *Setup Menu*

In this chapter, we'll examine each selection in detail.

Format Memory Card

(User's Manual pages 30 and 202)
Before discussing using the menu to format a memory card, let's take a look at the easier method of using the external camera controls to do it.

Referring to *figure 2*, follow these steps to format a card with camera buttons:

1. Check the card to make sure it is ready for formatting. You have transferred all the pictures, right?

2. Hold down the delete and metering buttons at the same time until you see *For* and the image count number flashing over and over in the top control panel LCD.

3. Briefly release and reapply the delete and metering buttons again, and the memory card formatting operation will take place.

Notice how the delete and metering buttons have a dual purpose. They are normally used for image deletion and metering functions, but if you hold them down at the same time for several seconds, the format function is activated.

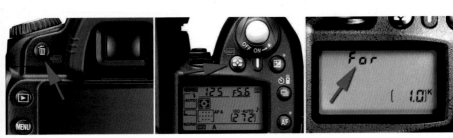

Figure 2 – External camera controls to format a memory card

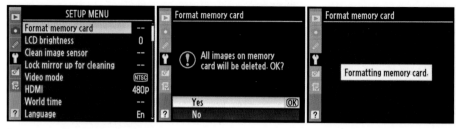

Figure 2A – Formatting a memory card

If you don't like using the external camera controls to format a memory card, the D90 allows you to do it with the *Format memory card* section of the *Setup Menu* instead.

You'll see four screens when formatting an SD memory card (*figure 2A* shows three of them). You'll make selections from only two of them. Here are the three steps to formatting a memory card:

1. Press the *MENU* button and scroll to the *Setup Menu* (wrench icon).
2. Select *Format memory card*, and then scroll to the right.
3. Select *Yes* from the screen with the big red exclamation sign and the words *All images on memory card will be deleted. OK?*
4. Press the *OK* button.

Once you press the *OK* button, you'll see the next two screens in quick succession. One says *Formatting memory card"* and the next says *Formatting complete*. Then the camera switches back to the *Setup Menu*'s first screen. The card is now formatted, and you are ready to take pictures.

LCD Brightness

(User's Manual page 202)

The *LCD brightness* selection is more important than many people realize. If the LCD is set too dim, you'll have trouble seeing your images in bright light. If it's set too bright, you might allow some images to be underexposed, thinking that they look fine on the LCD. If the LCD is too bright, even a seriously underexposed image will look okay.

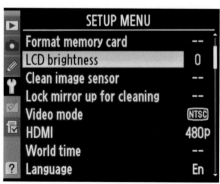
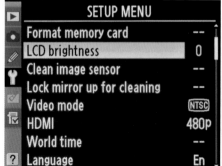

Figure 3 – *LCD brightness* settings

You can select from seven levels of brightness, from -3 to +3, as shown in *figure 3*. Here are the available values:

-3, -2, -1, 0, +1, +2, +3

Here are the steps to adjust the brightness:

1. Press the *MENU* button and scroll to the *Setup Menu* (wrench icon).
2. Select *LCD brightness*, and then scroll to the right.
3. Once you've selected *LCD brightness* from the *Setup Menu*, you'll see a screen like the one on the right in *figure 3*. Use the multi selector button on the back to scroll up or down through the values (-3 to +3).
4. Press the *OK* button once you've found the value you like best.

Recommendation

The camera defaults to 0 (zero), which is right in the middle, yet the resulting LCD is quite bright. I feel that 0 is a little too bright and makes my images look like they are exposed more brightly than when I see them later in the computer. Recently, I've been using -1 on my D90; that seems bright enough for outdoor use but doesn't make my images appear overly bright.

Using the bars with varying levels of brightness, as shown on the screen on the right in *figure 3*, adjust the brightness until you can barely make out a distinction between the last two dark bars on the left. That may be the best setting for your camera. Mine is best at -1 in normal outdoor light. Decide for yourself what looks best for you.

If you choose to set your camera to a level higher than about 0, just be sure that you check the histogram frequently to validate your exposures. Otherwise, you may find that you are allowing the camera to slightly underexpose your images. The D90 has one of the best exposure meters I've seen in a camera, yet it is not perfect and needs your help sometimes. Letting your LCD run too bright might mask those times that it needs help. Use your histogram!

Clean Image Sensor

(User's Manual page 244)

Dust is everywhere, and eventually it will get on your camera's imaging sensor. Fortunately, the D90 provides sensor cleaning by vibrating the low-pass filter in front of the sensor. These high-frequency vibrations will dislodge dust and make it fall off the filter so you won't see it as spots on your pictures.

The low-pass filter is directly in front of the imaging sensor, so dust should never really get on the sensor itself. However, if you go to the beach, where sand is blowing in the wind, and change your lenses a few times, you might develop a dust problem.

Here are the selections for *Clean image sensor*:

- *Clean now*
- *Clean at startup/shutdown*

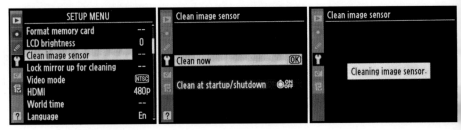

Figure 4 – Cleaning the image sensor

Clean now – This option allows you to clean the sensor anytime you feel like it. If you detect a dust spot, or just get nervous because you are in a dusty environment with your D90, you can simply select *Clean now* and the camera will execute a cleaning cycle. Here are the steps:

1. Press the *MENU* button and scroll to the *Setup Menu* (wrench icon).
2. Select *Clean image sensor*, and then scroll to the right.
3. To execute the cleaning function, select *Clean now*, as shown in the second screen of *figure 4*, and then toggle to the right with the multi selector button.
4. While the cleaning is taking place, you can briefly hear small squeaking sounds if you hold the camera close to your ear. A screen will appear that says *Cleaning image sensor*, and then another screen saying *Done*.

Clean at startup/shutdown – For preventive dust control, many users will set their cameras to clean the sensor at startup, shutdown, or both. There are four selections for startup/shutdown cleaning:

- *Clean at startup*
- *Clean at shutdown*
- *Clean at startup & shutdown*
- *Cleaning off*

These settings are all self-explanatory and do what they say. I find it interesting that I do not detect any serious startup or shutdown delay when using the startup/shutdown cleaning modes. I can turn my camera on and immediately take a picture. The cleaning cycle seems to be very brief when using this mode.

Let's select *Clean at startup & shutdown* as an example. This is the mode I recommend. If you prefer a different one, just

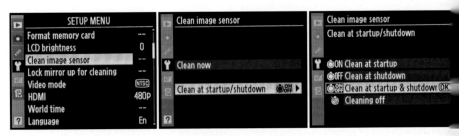

Figure 4A – Cleaning the sensor at startup and shutdown

use the following steps and substitute your choice (see *figure 4A*):

1. Press the *MENU* button and scroll to the *Setup Menu* (wrench icon).
2. Select *Clean image sensor*, and then scroll to the right.
3. Select *Clean at startup & shutdown* (or your choice).
4. Press the *OK* button.
5. Press the *MENU* button to return to the *Setup Menu*.

Nikon suggests that you have the camera at the same angle as when you are taking horizontal pictures (bottom down) when you use these modes to clean the sensor. A quick check with Nikon technical support explains the reason for that recommendation. Those high-frequency vibrations will indeed dislodge most dust particles, but if the camera is not positioned with the base down, you may end up only shaking the dust from one section in front of the sensor to another. It's similar to putting a grain of salt in your palm and shaking your palm left and right while it is facing the ceiling. The grain of salt may just move from one side of your palm to another. If you turn your palm 90 degrees (as if you were shaking someone's hand) and then vibrate it, the grain of salt has a better chance of falling off your palm.

Recommendation

As mentioned, I use the *Clean at startup & shutdown* setting on my D90. In the several months I've been using the D90, I have yet to see a dust spot. It's important to be careful about keeping dust off of your

camera as much as possible, especially when changing lenses, and this extra cleaning method seems to make a big difference compared to older digital Nikons I've used. When I am really concerned about cleaning the sensor, I use the *Clean now* method. That method seems to shake the low-pass filter for a longer period. I only suspect this because I tested how quickly I can shoot an image with *Clean at startup/shutdown* mode selected. However, even the seemingly brief shake of the filter on startup/shutdown should help prevent dust from staying on your filter.

Lock Mirror Up for Cleaning

(User's Manual pages 246–247)
If the high-frequency vibration method of cleaning your D90's sensor does not dislodge some stickier-than-normal dust, you may have to clean your sensor more aggressively.

In many cases all that's needed is to use a dust blower to remove the dust with a puff of air. I remember having to do this with my Nikon D100 in 2002, and I was always afraid I might ruin the shutter if I did it incorrectly. With the D100, I had to hold the shutter open in bulb mode with one hand while I blew off the sensor with the other.

The D90 helps out by providing this *Lock mirror up for cleaning* mode so you can more safely blow a stubborn piece of dust off the low-pass filter. This function is much safer, and you can use both hands.

Figure 5 shows the three screens you'll use to select this mode for manual sensor cleaning.

Here are the steps to move the mirror and shutter out of the way for cleaning:

1. Press the *MENU* button and scroll to the *Setup Menu* (wrench icon).
2. Select *Lock mirror up for cleaning*, and then scroll to the right.
3. Next, select *Start* from the second screen, then press the *OK* button.
4. When the camera is ready to lock the mirror and shutter in an open position and expose the low-pass filter in front of the sensor, you'll see the third screen, with the following message: *When shutter button is pressed, the mirror lifts and shutter opens. To lower mirror, turn camera off.* Press the shutter release.
5. The camera now raises the mirror and retracts the shutter. When you look inside the front of the camera, you'll see the bluish looking low-pass filter in front of the sensor. Carefully insert the tip of a blower, without touching the sensor, and blow off the dust with a few puffs of air.
6. To close the shutter and lower the mirror, turn the D90 off.

You'll need a good professional sensor-cleaning blower such as my favorite, the Giottos Rocket-Air blower with its long red tip for easy insertion (see *figure 5A*).

Special Note on Sensor Cleaning

If even an air blower fails to remove stubborn dust or pollen, you will have to either have your sensor professionally cleaned or do it yourself. Nikon states that you will void your warranty if you touch the low-pass filter. However, many people still wet- or brush-clean their D90's sensor. I've done it to various Nikons in the past, although I'll never admit it!

Figure 5A – Giottos Rocket-Air blower

I bought mine from the Nikonians Pro Shop (www.PhotoProShop.com).

Make sure you have a fresh battery in the camera because that's what holds the shutter open for cleaning. It must be above a 60 percent charge or the camera will gray out the menu selection, refusing to allow you to start the process.

It is *critical* that you are aware of the following information if you choose to wet-clean your sensor:

The Nikon D90 has a special tin-oxide coating on the low-pass filter that is designed to make it harder for dust to

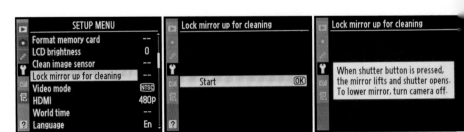

Figure 5 – *Lock mirror up for cleaning*

stick to its surface. Unfortunately, this coating is adversely affected by the cleaning fluids that have been used for several years to clean sensors. You must purchase the correct cleaning fluid to wet-clean the low-pass filter. It is called *Eclipse E2*, and it's safe for cleaning the filter without damaging the tin-oxide coating.

If all of this makes you nervous, then send your camera off to Nikon for approved cleaning, or use a professional service. Fortunately, a few puffs of air will often remove dust too stubborn for the high-frequency vibration methods to remove.

Recommendation

It helps to have the proper tools, such as Giottos Rocket-Air blower from the Nikonians PhotoProShop.com. I've used other blower types, but this one is the best and doesn't cost too much. It has a special check valve that allows air to blow out of the nozzle but not suck back in, since that might draw dust into the blower's squeeze bulb. It pulls air back into the bulb from the opposite end, not through the nozzle. It's an excellent design, with a strong air blast.

Video Mode

(User's Manual page 203)

If you plan on connecting your D90 to a video device, you'll need to be sure you use the correct video mode for communication with the device.

There are two video modes available in the D90:

- *NTSC*
- *PAL*

Here are the steps used to set the mode (see *figure 6*):

1. Press the *MENU* button and scroll to the *Setup Menu* (wrench icon).
2. Select *Video mode*, and then scroll to the right.
3. Select *NTSC* or *PAL* (probably *NTSC*) from the menu.
4. Press the *OK* button to set the mode and return to the *Setup Menu*.

You'll need to refer to the manual for your television, VCR, or other device to determine what video input it uses. Select the mode you want to use with the Video Out port under the rubber flap on the side of the D90.

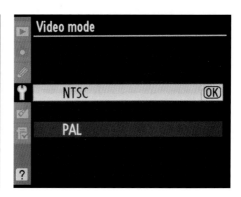

Figure 6 – *Video mode* selection

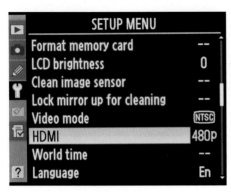
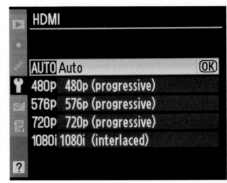

Figure 7 – HDMI format selection

High-Definition Multimedia Interface (HDMI)

(User's Manual page 203)

If you would like to display your images on a high-definition monitor or television, your D90 has the modes and connector you need. You'll need an HDMI Type C (HDMI 1.3) cable, which is not included with the camera but is available from many electronics stores.

Before you connect the camera to your HDMI display, you'll need to set one of these HDMI formats:

- *Auto* –Allows the camera to select the most appropriate format for displaying on the currently connected device
- *480p (progressive)* – 640 x 480 progressive format
- *576p (progressive)* – 720 x 576 progressive format
- *720p (progressive)* – 1280 x 720 progressive format
- *1080i (interlaced)* – 1920 x 1080 interlaced format

Here are the steps to choose a setting (see *figure 7*):

1. Press the *MENU* button and scroll to the *Setup Menu* (wrench icon).
2. Select *HDMI*, and then scroll to the right.
3. Select your choice of modes. (Not sure? Select *Auto*.)
4. Press the *OK* button.

Clearly, the D90 can interface with both progressive and interlaced devices. The HDMI display will take the place of the small LCD video monitor on the back of your D90. The camera monitor will turn off as soon as you connect an HDMI device.

Recommendation

Unless you are heavily into HDMI and understand the various formats, I would just leave the camera set to *Auto*. This allows the D90 to determine the proper format as soon as it is plugged into the display device.

World Time

(User's Manual page 204)

There are several functions to set under the *World time* section of the *Setup Menu*:

- *Time zone*
- *Date and time*
- *Date format*
- *Daylight saving time*

Time zone – *Figure 8* shows the *Time zone* configuration screens. You use a familiar world map interface to select the area of the world in which you are using the camera.

To set the time zone, perform these steps:

1. Press the *MENU* button and scroll to the *Setup Menu* (wrench icon).
2. Select *World time*, and then scroll to the right.
3. Select *Time zone*, and then scroll to the right.

4. Use the multi selector thumb switch to scroll left or right until your time zone is under the yellow vertical bar in the center of the world map screen.
5. Once you have your time zone selected, press the *OK* button to save the setting.

Date and time – *Figure 8A* shows the three *Date and time* configuration screens. The final screen in the series allows you to select the year, month, and day (Y, M, D), and the hour, minute, and second (H, M, S):

1. Press the *MENU* button and scroll to the *Setup Menu* (wrench icon).
2. Select *World time*, and then scroll to the right.
3. Select *Date and time*, and then scroll to the right.
4. Using the multi selector button, scroll left or right until you have selected the value you want to change. Then scroll up or down to actually change the value.

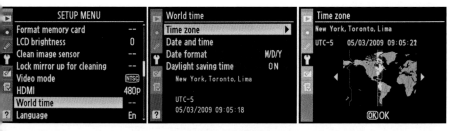

Figure 8 – Time zone setup

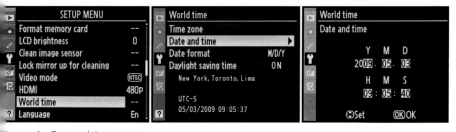

Figure 8A – Date and time setup

5. When you have set the correct date and time, press the *OK* button to save the settings. Please note that the time setting uses the 24-hour military-style clock. To set 3 p.m., you would set the H and M settings to 15:00. For your convenience, here is a listing of the 24-hour time equivalents:

24 Hour Time Equivalents

For your convenience, here is a listing of the 24-hour time equivalents:

A.M. Settings:

12:00 a.m. = 00:00 (midnight)
01:00 a.m. = 01:00
02:00 a.m. = 02:00
03:00 a.m. = 03:00
04:00 a.m. = 04:00
05:00 a.m. = 05:00
06:00 a.m. = 06:00
07:00 a.m. = 07:00
08:00 a.m. = 08:00
09:00 a.m. = 09:00
10:00 a.m. = 10:00
11:00 a.m. = 11:00

P.M. Settings:

12:00 p.m. = 12:00 (noon)
01:00 p.m. = 13:00
02:00 p.m. = 14:00
03:00 p.m. = 15:00
04:00 p.m. = 16:00
05:00 p.m. = 17:00
06:00 p.m. = 18:00
07:00 p.m. = 19:00
08:00 p.m. = 20:00
09:00 p.m. = 21:00
10:00 p.m. = 22:00
11:00 p.m. = 23:00

Interestingly, there is no 24:00 time (midnight). After 23:59 comes 00:00.

Date format – The D90 gives you three ways to format the date (see *figure 8B*):

- *Y/M/D* = Year/Month/Day (2010/12/31)
- *M/D/Y* = Month/Day/Year (12/31/2010)
- *D/M/Y* = Day/Month/Year (31/12/2010)

D90 owners in the United States will probably use the *M/D/Y* setting, which matches the MM/DD/YYYY format so familiar to Americans. People in other areas of the world can select their favorite date format.

To select the *Date format* setting you want to use, follow these steps:

1. Press the *MENU* button and scroll to the *Setup Menu* (wrench icon).
2. Select *World time*, and then scroll to the right.
3. Select *Date format*, and then scroll to the right.
4. Choose the format you like best from the three available formats.
5. Press the *OK* button.

Daylight saving time – Many areas of the United States observe daylight saving time. In the spring, many American residents set their clock forward by one hour on a specified day each year. Then in the fall, they set it back, leading to the clever saying "spring forward, fall back."

To enable the *Daylight saving time* setting, do the following steps (see *figure 8C*):

1. Press the *MENU* button and scroll to the *Setup Menu* (wrench icon).
2. Select *World time*, and then scroll to the right.
3. Select *Daylight saving time*, and then scroll to the right.
4. Select *On* or *Off* from the menu.
5. Press the *OK* button.

If you selected *On*, your D90 will now automatically "spring forward and fall back," adjusting your time forward by one hour in the spring and back one hour in the fall of the year.

Recommendation:
I always leave mine set to *On* because I want my camera to record an accurate time on each image. Anything that keeps me from having to remember an annual adjustment is appreciated. My computer adjusts its own time, and now my camera can do the same.

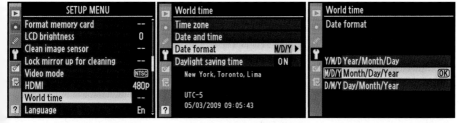

Figure 8B – *Date format* setup

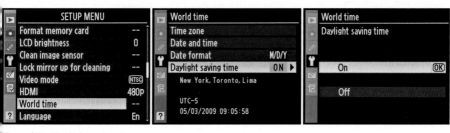

Figure 8C – *Daylight saving time* screens

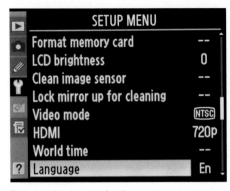

Figure 9 – *Language* selection

Language

(User's Manual page 204)

Nikon is a company that sells cameras and lenses around the world. For that reason, your D90 can display in up to 15 languages. In *figure 9* are the screens used to select your favorite language.

The following languages are included with the D90 using firmware version 1.0:

- Danish
- German
- English
- Spanish
- Finnish
- French
- Italian
- Dutch
- Norwegian
- Polish
- Portuguese
- Russian
- Swedish
- Traditional Chinese
- Simplified Chinese
- Japanese
- Korean

Your D90 should default to the language of the area in which you purchased it. However, you may choose to use a different language from your multilingual camera.

Here are the steps to select a language (see *figure 9*):

1. Press the *MENU* button and scroll to the *Setup Menu* (wrench icon).
2. Select *Language*, and then scroll to the right.
3. Choose your favorite language from the list of 17 languages. (You might have to scroll up or down in the menu to find yours.)
4. Press the *OK* button.

Image Comment

(User's Manual page 205)

This is a useful setting that you can use to attach a comment to each image you shoot. I attach the words *Copyright Darrell Young* to my images. Unfortunately, Nikon does not include the copyright symbol © in the list of numbers and letters or I would include that in my copyright notice.

The three screens shown in *figure 10* are used to add a comment to your image.

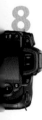

Here are the steps to create an image comment that attaches to each of your images:

1. Press the *MENU* button and scroll to the *Setup Menu* (wrench icon).
2. Select *Image comment*, and then scroll to the right.
3. From the second screen shown in *figure 10*, you'll select the *Input comment* line and scroll to the right with the multi selector button.
4. In the third screen, you'll see a series of symbols, numbers, and letters on top with a line of tiny dashes at the bottom.
5. To create a new comment, hold down the ISO–thumbnail/playback zoom out button and use the thumb multi selector switch to scroll back and forth within the new comment. When you have the small gray cursor positioned over a character, you can delete it with the garbage can delete button. To insert a new character, position the yellow cursor in the character list above and press the QUAL–playback zoom in button. Whatever character is under the yellow

cursor will appear on the name line below, at the position of the gray cursor. If a character is already under the gray cursor, it will be pushed to the right. *Limit your comment to 36 characters.*

6. Press the *OK* button when you have completed the new comment, and the camera will return to the previous menu.
7. Scroll down to the *Attach comment* selection.
8. Scroll to the right, one time, to "Set" the check box. You'll see the little check box receive a check on the left of the line (see the red arrows in *figure 10*).
9. Finally, scroll up to the *Done* menu selection, and then press the *OK* button.

I keep forgetting to finish the process with the *Done* selection and usually lose my comment. Make sure you complete the process or any comment you arduously entered will simply disappear! Your comment will be added internally to the metadata of new images. It *will not* show on the image itself.

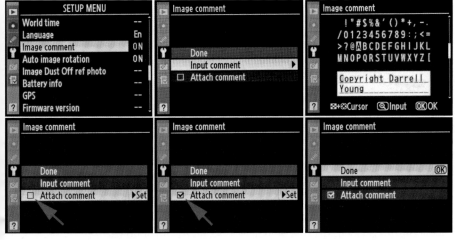

Figure 10 – *Image comment* setup

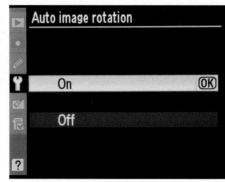

Figure 11 – *Auto image rotation* setup

Auto Image Rotation

(User's Manual page 205)

This function is concerned with how a vertical image displays on the back of your camera and later in software. Horizontal images are not affected by this setting. The D90 has a direction sensing device so that it knows how a picture is oriented.

According to how you have *Auto image rotation* set, and how you hold your D90's handgrip, the camera will display vertical images as upright portrait images with the top of the image at the top of the LCD monitor or as images lying on their sides in a horizontal direction with the top to the left or right.

Here, in *figure 11*, are the two screens used to set the *Auto image rotation* function.

You have two selections:
• *On* (default)
• *Off*

On - With *Auto image rotation* turned on, the D90 will automatically record the direction or orientation of an image within the image itself. In other words, it

records, as part of the image's metadata, whether you were holding your camera horizontally or vertically (handgrip down) and even upside-down vertically (handgrip up). It saves the orientation information *with* the image so that it will display correctly in computer software. It will display in the correct orientation on your camera's LCD monitor only if you have the *Playback Menu*'s *Rotate tall* function set to *On*. Many people do not fully understand that *Auto image rotation* and *Rotate tall* work together in how the image displays on your D90's monitor. *Auto image rotation,* lets the image "speak" for itself as to orientation, while *Rotate tall* let's the camera "listen" to the image and display it in the proper orientation.

Off - If *Auto image rotation* is turned off, the camera does not record orientation information with the image. The vertical image will be displayed as a horizontal image lying on its side in computer software and on the camera's LCD monitor. The top of the image will be on the left or right according to how you held the handgrip, up or down.

Here are the steps to enable *Auto Image Rotation* (see *figure 11*):

1. Press the *MENU* button and scroll to the *Setup Menu* (wrench icon).
2. Select *Auto image rotation*, and then scroll to the right.
3. Select *On* or *Off* from the menu.
4. Press the *OK* button.

If you are shooting in continuous frame advance mode (CL or CH), the way you are holding your camera for the first shot sets the direction in which the images are displayed, even if you change direction while shooting.

Remember, if you have *Auto image rotation* set to *Off*, the camera does not record orientation information for the image, so no matter how you have *Playback's Rotate tall* set, the image still will be displayed in a horizontal direction.

Recommendation:

The manual states that you might want to choose *Off* if you are "*taking photographs with the lens pointing up or down.*" However, I have tested it carefully, and the D90 seems quite good at determining when you have the camera held horizontally or vertically, even when you do have the lens pointed up or down. Test this for yourself and determine which you would prefer. I want all my images to have orientation information stored within them so I won't have to manually rotate dozens of images after an extensive shoot. I leave mine set to *On* and I've had no problems.

Image Dust Off Ref Photo

(User's Manual pages 206–207)

Maybe you've gone out and done an extensive shoot only to return and find that some dust spots have appeared in the worst possible place in your images. If you then create an image dust off reference photo, you can use it to remove the dust spots from your images and afterward go clean the sensor for the next shooting session. Here's how it works.

When you use the instructions that follow to create the dust off reference photo, you will be shooting a blank unfocused picture of a pure white or gray background. The dust spots in the image will then be readily apparent to Nikon Capture NX2 software. When you load the image to be cleaned into Capture NX along with the dust off image, it will use the dust off image to remove the spots in your production image.

The position and amount of dust on the low-pass filter may change. It is recommended that you take reference images regularly and use a reference image that was taken within one day of the photograph you wish to clean up.

Finding a Subject for the Dust Reference Photo

First, you need to select a "featureless" subject to photograph for the reference photo. The key here is to use a material that has no graininess, such as a bright-white, slick piece of plastic or a white card. I tried using plain white sheets of paper held up to a bright window, but the resulting reference photo was unsatisfactory to Capture NX2. It gave me

a message that my reference photo was "too dusty" when I tried to use it.

After some experimentation, I finally settled on three subjects that seem to work well:

- A slide-viewing light table with the light turned on
- A computer monitor screen with a blank, white word processor document displayed
- A plain white card in the same *bright* light in which your subject resides

All of these provided enough light and "featurelessness" to satisfy both my camera and Capture NX2. The key is to photograph something fairly bright, but not too bright. You may need to experiment with different subjects if you have no light table or computer.

Now, let's prepare the camera for the actual reference photo (see *figure 12*):

1. Press the *MENU* button on the back of your D90.
2. Select the *Setup Menu* and scroll down until you find the *Image Dust Off ref photo* menu selection. Select it and scroll to the right.
3. On the next screen, you will find the *Start > OK* selection. There is also a *Clean sensor and then start* selection. However, since I desire to remove dust

on current pictures, I won't use this setting. It might remove the dust bunny that is imprinted on the last 500 images I just shot! I'll clean my sensor *after* I get a good dust off reference photo. Select *Start* and press the *OK* button.

4. Press *OK* at the *Start > OK* option and your camera is ready to take the reference image. (See *Figure 12*)
5. After you have selected *Start > OK*, you will find the word *rEF* in the viewfinder and upper control panel LCD. This simply means that you are ready to create the image.
6. Once you have the camera ready, hold the lens about 4 inches (10 cm) away from the blank subject. The camera will not try to autofocus during the process, which is good because you want the lens at infinity anyway. You are not trying to take a viewable picture; you're just creating an image that shows where the dust is on the sensor. Focus is not important, and neither is minor camera shake. If you try to take the picture and the subject is not bright enough, or too bright, you will see the screen in *figure 12A*. If you are having problems with too much brightness, use a gray surface instead of white. Most of the time this error is caused by insufficient light.

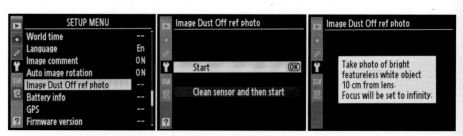

Figure 12 – *Dust Off Reference Photo* preparation

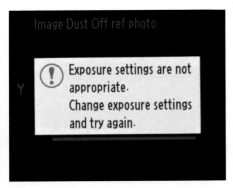

Figure 12A – *Exposure settings are not appropriate* warning

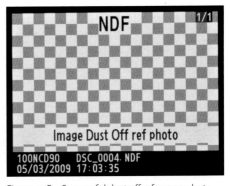

Figure 12B – Successful dust off reference photo

If you don't see the screen in figure 12A, and the shutter fires, you have successfully created a dust off reference photo. You'll find the image shown in figure 12B on your camera monitor. A 2-megabyte file is created on your camera's image card with a filename ending in .ndf instead of the normal .nef or .jpg (for example, DSC_1234.ndf). This NDF file is basically a small database of the millions of clean pixels in your imaging sensor and a few dirty ones.

You cannot display the NDF file on your computer. It will not open in Capture NX2 or any other graphics program that I tried.

Where to Store the Reference Photo

Copy the NDF file from your camera's memory card to the computer folder containing the NEF (RAW) images that have dust spots on them and for which you created this dust off reference photo. Later, when you are ready to post-process your NEF (RAW) images for dust spot removal, you'll have a reference photo with a picture of the dust only so that a program like Nikon Capture NX2 can automatically remove it for you.

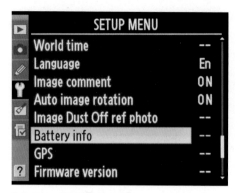

Figure 13 – *Battery info* screen

Battery Info

(User's Manual page 208)

The Battery info screen, as seen in *figure 13*, will let you know how much battery charge has been used (*Bat. meter*), how many pictures have been taken with this battery since the last charge (*Pic. meter*), and how old the battery is (*Battery age*).

To see the battery information screen, follow these steps:

1. Press the *MENU* button and scroll to the *Setup Menu* (wrench icon).
2. Select *Battery info*, and then scroll to the right.
3. View the *Battery info* screen.

The D90 goes a step further than most cameras. Not only does it keep you

informed as to the amount of "charge" left in your battery, it also lets you know how much "life" is left. After some time, all batteries weaken and won't hold a full charge. You'll know when the battery needs to be completely replaced by viewing the *Battery age* meter. It shows five stages of battery life, from new to ! (! = replace), or 0 to 4, so that you'll be prepared to replace it before it gets too old.

In my opinion, it's important to use a Nikon brand battery in your D90 so it will work properly with the camera. Aftermarket batteries may not charge correctly in the D90 battery charger. In addition, they may not report correctly in the *Battery age* section of the battery

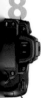

Figure 13A – The EN-EL3e battery, top and bottom

menu. There may be an aftermarket brand that works correctly, but I've not searched for it personally. Instead, I choose to use the batteries designed by Nikon to work with this camera. I am a bit afraid to trust a camera that costs this much to a cheap aftermarket battery of unknown origin.

Figure 13A shows the top and bottom of a genuine gray-colored li-ion Nikon EN-EL3e battery.

The *Battery info* screen is just for information. There is nothing to set. When you've finished examining your camera's current battery information, just press the *OK* button to exit.

GPS

(User's Manual pages 124 – 125)
Nikon has wisely included the ability to geotag your images with GPS location data, if you purchase an optional GPS unit, such as Nikon's new GP-1 GPS. If a GPS is connected when you shoot a spectacular travel image, you can rest assured that you'll be able to find that exact spot next year. The D90 will record the following

GPS information about your location in the metadata of each image:

- Latitude
- Longitude
- Altitude
- UTC time

The Nikon GP-1 GPS Unit

Nikon recently released a very small, hot-shoe-mounted GPS unit called the GP-1. This unit attaches to the D90 using its hot shoe and the GPS port on the lower-left side of the camera. If you purchase the GP-1 GPS unit, you will get with it two accessory cables. One cable plugs into the GP-1 and then into your D90's GPS port. The second cable plugs into any other Nikon camera with a round 10-pin port (D200, D300, D700, D2x, D2h, D3, D3x, etc.), so you can still use your GP-1 when you save up enough money to buy that D3x you've been wanting.

See *figure 14* for a look at the GP-1 GPS unit mounted on a Nikon D90.

The GP-1 GPS unit is powered by the camera, so you don't have to buy any

gure 14 – The D90 with GP-1 GPS unit in hot shoe

extra batteries. It will have an effect on camera battery life, so if you're shooting all day, make sure you have at least one extra camera battery with you.

There are several screens used in setting up the D90 for GPS use. First, a decision should be made about the exposure meter when a GPS unit is plugged into the D90. While the GPS is plugged in, your exposure meter must be active to record the GPS data to the image. You'll have to do one of two things:

- Set the exposure meter to stay on for the entire time that a GPS is plugged in, which, of course, will increase battery drain.
- Press the shutter down halfway to activate the exposure meter before finishing the exposure. If you just push the shutter button down quickly and the meter is not active, you may not record GPS data to the image. The meter must be on before GPS data will be added.

Figure 14A shows the screens to set the meter to stay on all the time the GPS is connected or to act normally and shut down after the auto meter-off delay

expires (see *Custom Setting c2*—defaults to 6 seconds).

You can select either one of the following options:

- *Enable* (default)
- *Disable*

Enable (default) – The meter turns off at the end of the *Auto meter-off delay* time, as set in *Custom Setting c2*. GPS data will be recorded only when the exposure meter is active, so take your time.

Disable – The exposure meter stays on all the time a GPS unit is connected. As long as you have a good GPS signal, you will be able to record GPS data at any time.

There is also a *Position* setting, as shown in the middle screen in *figure 14A*. If your GPS unit isn't attached, or isn't reading satellite positions, the *Position* selection is grayed out (can't be selected). Once a GPS is actively feeding data to the camera, you can select and scroll to the right on the *Position* selection. You'll then see a screen that shows the actual GPS location data being detected by the D90 (see *figure 14B*).

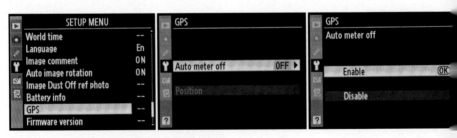

Figure 14A – GPS *Auto meter off* enable/disable screens

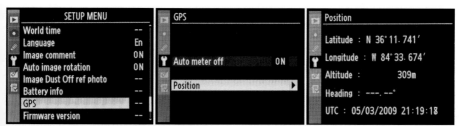

Figure 14B – *GPS Position* Information Screen

Figure 14C – *GPS* icon on top control panel

Figure 14D – Position information

When the D90 establishes communication with your GPS, it does three things:

1. A small *GPS* icon is displayed in the top control panel LCD (*figure 14C*).
2. Position information shows on the GPS menu screen (*figure 14D*).
3. An additional GPS information page may be displayed when you're reviewing the captured images (*figure 14E* and page 133 of the D90 User's Manual). To get to this screen, press the *Playback* button to display an image, then scroll up until you see the GPS information screen. You will only see this screen if there is GPS information attached. Also, you must have the *Playback Menu > Display* mode set to include the *Data* screens (see chapter 5).

Figure 14E – GPS information playback screen

Understanding the Nikon GP-1 GPS Unit

Once you've mounted your GP-1 GPS unit in the hot shoe of your D90 and plugged the cable into the GPS port, here's what to expect:

If the *GPS* icon is blinking on the control panel, it means that the GPS is searching for a signal. You'll also notice that the little LED light on the back of the GP-1 is blinking in red. If you take a picture with the *GPS* icon or GP-1 LED blinking red, no GPS data will be recorded.

If the *GPS* icon is not flashing and the GP-1 LED is green, it means that the D90 is receiving good GPS data and is ready to record data to a picture. Here is a list of what the LED light on the back of the GP-1 GPS unit can communicate to you:

- **Blinking red** – No satellites being tracked. Searching for satellites.
- **Blinking green** – Only three satellites being tracked, minimal accuracy.
- **Solid green** – At least four satellites being tracked for best accuracy (maximum 18 tracking channels).

If the D90 loses communication with the GPS unit for over 2 seconds, the *GPS* icon on the upper control panel LCD will disappear.

The Nikon GP-1 GPS unit does not provide compass (direction) information. It tracks longitude, latitude, altitude, and UTC (Coordinated Universal Time).

Figure 15 – *Firmware version* screens

Firmware Version

(User's Manual page 208)

This is a simple informational screen, like the *Battery info* screen. It shows you which version of the Nikon D90 software (firmware) you are running. A firmware update was not yet available at the time this book was published, so *figure 15* shows that my D90 is running the firmware it came with.

Follow these steps to see your camera's firmware version:

1. Press the *MENU* button and scroll to the *Setup Menu* (wrench icon).
2. Select *Firmware version*, and then scroll to the right.
3. View the *Firmware version* screen.

When a firmware update becomes available and you install it, this is the screen you'll use to validate that the firmware update was successful.

Summary

Now that you have your D90 fully set up, you're ready to take a large number of premium images.

The next chapter is about the *Retouch Menu* and the last two menus in the D90, *Recent Settings* and *My Menu*. The *Retouch Menu* is designed to help you work with images you've already taken and adjust them in-camera without having to resort to using your computer. *Recent Settings* displays items you've changed recently.

We'll also examine a special menu that is specific to you alone, *My Menu*. This menu is a place to store all your most-used settings for immediate use so you won't have to search through the dozens of settings in the D90.

This chapter covers the last three menu systems in the Nikon D90, the *Retouch Menu*, *Recent Settings*, and *My Menu*. There are two sections.

Section 1

The *Retouch Menu* is composed of 13 in-camera image adjustments that allow you to do things to the image that normally would only be done in a graphics program on your computer. If you don't particularly like using a computer or you aren't very good with Photoshop but you still want to shoot RAW images, the *Retouch Menu* options will be of great help to you.

Section 2

Recent Settings is a list of the previous 20 menu items you've changed from the *Playback*, *Shooting*, *Custom Setting*, and *Setup Menus*. If you've made a recent camera adjustment, it will appear here.

My Menu is whatever you want it to be. If you use certain menus or settings in the camera on a regular basis, you can add them to *My Menu* and then use them without searching through dozens of other menus.

Retouch Menus – Section 1

User's Manual pages 210–223)

There are two ways to get to the *Retouch Menu*:

Press the *Menu* button and select *Retouch Menu*, the fifth item down on the left.

Use the *Playback* button to review an image, and then press the *OK* button.

Either of these methods will allow you to get to the tools you can use to modify an existing image in various ways. Let's start at the top of the *Retouch Menu* and examine each item on it.

D-Lighting

(User's Manual page 212)

D-Lighting allows you to reduce the shadows and maybe even reign in the highlights a bit. You'll see the effect immediately upon using it. If an image is a little dark, or the shadows too dense, you can bring out detail with D-Lighting.

This works differently from just brightening or darkening an image. D-Lighting lowers the overall image contrast, which will help some images but may not benefit others. It is primarily used to bring out detail from slightly underexposed images, or from images in which the contrast is too high for the dynamic range between light and dark areas. If you are shooting on a bright sunny day, the light values between light and dark may be twice what the sensor can record. If you have exposed for the highlights, you can recover detail in some of the darker shadow areas. In a sense, D-Lighting is a quick form of high dynamic range imaging (HDRI). It has a similar effect, although not as pronounced, and with the addition of more noise in the image than with real HDRI.

If you like the effects D-Lighting brings to an image, you can save the image and the D90 will create a copy on the SD memory card. Your original is safe.

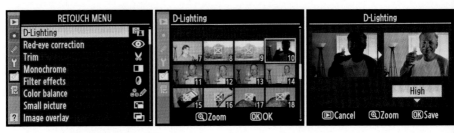

Figure 1 – *High selected* from *D-Lighting*

The steps to D-Light an image are as follows (see *figure 1*):

1. Press the *MENU* button and select the *Retouch Menu*. (paintbrush icon).
2. Select *D-Lighting* from the *Retouch Menu*, and then scroll right.
3. Select the image you want to modify with the Multi Selector and then click the *OK* button.
4. Choose the amount of D-Lighting you want for the selected image using the Multi Selector to scroll up or down. You'll choose from *Low*, *Normal*, and *High*. (in *figure 1*, *High* is chosen).
5. When the image on the right looks the way you want it to look, press the *OK* button to save the new file with a new filename. The D90 will display a brief *Image Saved* notice, and then switch to displaying the new file in full screen playback mode.

D-Lighting always lowers the image contrast (opens shadows). As I mentioned earlier, you can't use it to simply brighten or darken an image because it will always lower the contrast too. However, this gives you a nice level of control in adjusting the contrast of an image in-camera.

If you choose to experiment more deeply with D-Lighting, why not buy a copy of Nikon Capture NX2 and use its D-Lighting function in your computer. You'll have a larger screen to work with and much more control over how and where D-Lighting is applied. It is a quite powerful functionality. One of the only drawbacks of using D-Lighting is that it adds noise to the darker areas of the image because darker detail is lightened.

Note

If you see a little yellow box with an *X* in it on any image in the image selection screen (see the middle screen in *figure 1*), that simply means you can't use the D-Lighting function on that particular image. It has been adjusted in-camera already and is most likely a copy of a previous image.

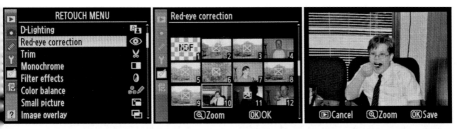

Figure 2 – *Red-eye correction* screens

Red-Eye Correction

(User's Manual page 212)

Red-eye correction is a convenient way to remove those aggravating red pupils that sometimes occur in a flash picture. The camera will locate the red pupils and color them black. It is quite effective!

If you used flash to create the picture, the *Red-eye correction* function will work only if it can detect red-eye. Sometimes, if the person's face is too small in the image, the D90 cannot find the red-eye, even though you can see that it's there. If it can't detect red-eye in the image, it will not open the red-eye system but will, instead, briefly display a screen informing you that the camera was *Unable to detect red-eye in selected image*.

If flash was not used, the D90 will put a little yellow x-box on the image, meaning that you cannot select it. If you still try to select it, the D90 will tersely inform you, *Cannot select this file*.

The steps to execute the *Red-eye correction* function on an image are as follows:

1. Press the *MENU* button and select the *Retouch Menu* (paintbrush icon).
2. Select *Red-eye correction*, and then scroll right.

3. Select the image you want to modify with the Multi Selector. You can't select images that have little yellow x-boxes on them.
4. Press the *OK* button and the *Red-eye correction* routines will execute. You'll see an hourglass on your screen for several seconds.
5. After red-eye correction is done, you can zoom in on the image and see how well it worked.
6. Press *OK* to save the file with a new filename.

I really like this *Red-eye correction* function! If I'm shooting flash pictures at an event, I'll invariably get a few red eyes in the image. Since red-eye can make a person look "possessed" or evil, I tend to want to remove it. This function makes it easy.

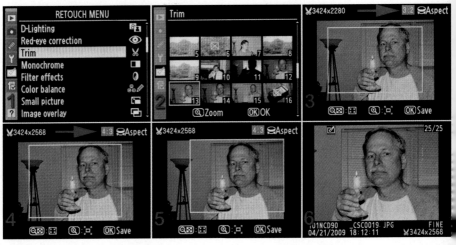

Figure 4 – Cleaning the image sensor

Trim

(User's Manual page 213)

The *Trim* function allows you to crop an image in-camera and/or change the aspect ratio of the trimmed section and then save the file out to a new image. Your original image is not modified. *Trim* is merely another word for cropping the image.

You can trim up to six crop levels deep, the smallest of which crops a 640 x 424 pixel section out of the 4288 x 2848 pixel image (in the 3:2 aspect ratio). These can be cropped from anywhere in the image by moving the yellow trim frame around with the Multi Selector. Here are the six crop levels for a D90 default 3:2 aspect ratio image:

- 3424 x 2280
- 2560 x 1704
- 1920 x 1280
- 1280 x 856
- 960 x 640
- 640 x 424

Also, here are the aspect ratios you can select:

- 3:2
- 4:3
- 5:4

These aspect ratios are controlled by the rear, main-command dial. When you have the image and the yellow crop rectangle showing, just turn the command dial.

Here are the steps to trim an image in the D90 (see *figure 3*):

1. Press the *MENU* button and select the *Retouch Menu* (paintbrush icon).

2. Select the *Trim* function, and then scroll right.

3. Select the image you want to modify and press the *OK* button.

4. You'll be presented with a screen that has a crop outlined in yellow. Using the normal zoom buttons (ISO–thumbnail/playback zoom out and QUAL–playback zoom in), you can zoom in for a deeper crop or zoom out for a lesser crop. Zoom until you find your best crop position. Move the yellow trim frame until it is exactly positioned in the image.

5. Select the aspect ratio of the crop by rotating the rear main command dial. Your choices are 3:2, 4:3, and 5:4. See the red arrows in *figure 3* that show where I changed from 3:2 to 4:3 ratio using the rear main-command dial. Notice how the yellow frame changed size to the new ratio between images 3 and 4.

6. Once you have the crop correctly sized and the aspect ratio set, press the *OK* button to save the new image with a new filename. You can see the final cropped file in the last image of *figure 3*.

I haven't found a way to turn the yellow box upright so that I can make a vertical out of the center of a horizontal image. However, for a basic crop it does a sufficient job.

Remember that these functions are for convenience and quick "in-the-field" use. If you are serious about post-processing (or have many images to modify), it is much easier to accomplish this type of work in-computer with a good graphics package.

Monochrome

(User's Manual page 214)

The *Monochrome* functions in the D90 are fun to play with and can make some interesting images. You can convert a normal color image into a black-and-white, with two types of toning.

You can choose from three different types of monochrome:

- *Black-and-white*
- *Sepia*
- *Cyanotype*

Here are the steps to create a monochrome image from one of your existing color images on the SD memory card:

1. Press the *MENU* button and select the *Retouch Menu* (paintbrush icon).
2. Select *Monochrome*, and then scroll right.
3. Select a monochrome tone (*Black-and-white*, *Sepia*, or *Cyanotype*), and then scroll right.

4. Select the image you want to modify with the Multi Selector, and then press the *OK* button.
5. You'll be presented with an image converted and toned to the tint you selected. I've included a sample of each in the last few images of *figure 4*.
6. Press the *OK* button to save the new image with a new filename or the *Playback* button to cancel.

If you are serious about making black-and-white images with the D90, why not use the *MC–Monochrome* setting under *Shooting Menu > Set Picture Control* (see chapter 6). *MC-Monochrome* allows you to shoot initially with various levels of tinting, far exceeding the basic conversion and three tints of the *Retouch Menu's* version.

Use the *Retouch Menu's Monochrome* function to convert a color picture to one of three types of monochrome. It's easy and effective.

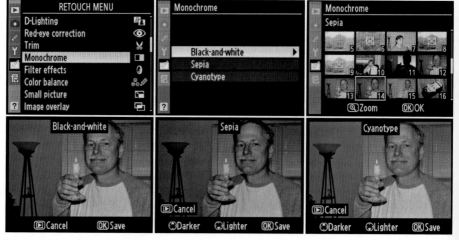

Figure 4 – Monochrome screens

Filter Effects

(User's Manual page 215)

The D90 allows you to add six filter effects to any previously taken image. You can intensify the image colors in various ways and add starburst effects to points of light.

Here is a list of the effects that are available:

- *Skylight*
- *Warm filter*
- *Red intensifier*
- *Green intensifier*
- *Blue intensifier*
- *Cross screen* (starburst filter)

Skylight – This effect is rather mild and removes the blue effect caused by atmospheric diffraction in distant scenes. Basically, by using this you will make the image slightly less blue (see *figure 4A*). Here's how to set the *Skylight* effect: Start by pressing the MENU button and selecting the Retouch Menu (paintbrush icon).

1. Select *Filter effects* from the *Retouch Menu*, and scroll right.
2. Select *Skylight*, and scroll to the right.
3. Choose an image with the Multi Selector and press the *OK* button.
4. You will be presented with the image with the *Skylight* effect added.
5. Press the *OK* button to save the image under a new filename or press the *Play-back* button to cancel.

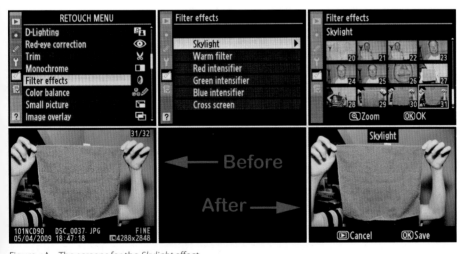

Figure 4A – The screens for the *Skylight* effect

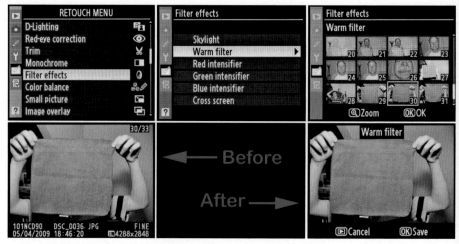

Figure 5 – The screens for the *Warm filter* effect

Warm filter – Adds red to the image to make it appear a little warmer. In fact, it adds a mild red cast to the image (see *figure 5*). Here's how to set the *Warm filter* effect:

1. Select *Filter effects* from the *Retouch Menu*, and scroll right.
2. Select *Warm filter*, and scroll to the right.
3. Choose an image with the Multi Selector and press the *OK* button.
4. You will be presented with the image with the *Warm filter* effect added.
5. Press the *OK* button to save the image under a new filename, or press the *Playback* button to cancel.

Red intensifier – Intensifies the reds in an image while also adding a red cast. This effect can be controlled by making an initial selection, then increasing or reducing the effect by using the Multi Selector to scroll up or down when the image is onscreen. Even though it doesn't tell you, there are three levels of intensity. Up one for maximum effect and down one for minimum effect (see *figure 6*). Here's how to set the *Red intensifier* effect:

1. Select *Filter effects* from the *Retouch Menu*, and scroll right.
2. Select *Red intensifier*, and scroll to the right.
3. Choose an image with the Multi Selector and press the *OK* button.
4. You will be presented with the image with the *Red intensifier* effect added.
5. Scroll up or down with the Multi Selector to intensify or reduce the effect.
6. Press the *OK* button to save the image under a new filename, or press the *Playback* button to cancel.

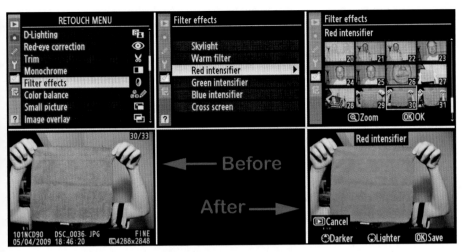

Figure 6 – The screens for the *Red Intensifier* effect

Green intensifier - Intensifies the greens in an image, while also adding a green cast. This effect can be controlled by making an initial selection, then increasing or reducing the effect by using the Multi Selector to scroll up or down when the image is onscreen. There are three levels of intensity: the default, up one for maximum effect, and down one for minimum effect. Here's how to set the *Green intensifier* effect (see *figure 7*):

1. Select *Filter effects* from the *Retouch Menu*, and scroll right.

2. Select *Green intensifier*, and scroll to the right.

3. Choose an image with the Multi Selector and press the *OK* button.

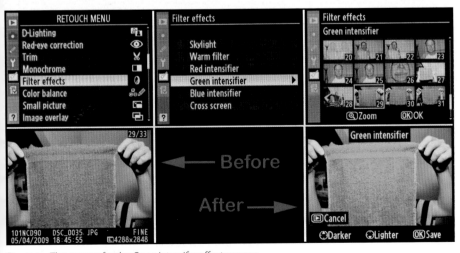

Figure 7 – The screens for the *Green intensifier* effect screens

4. You will be presented with the image with the *Green intensifier* effect added.

5. Scroll up or down with the Multi Selector to intensify or reduce the effect.

6. Press the *OK* button to save the image under a new filename, or press the *Playback* button to cancel.

Blue intensifier - Intensifies the blues in an image while also adding a blue cast. This effect can be controlled by making an initial selection, then increasing or reducing the effect by using the Multi Selector to scroll up or down when the image is on-screen. There are three levels of intensity: the default, up one for maximum effect, and down one for minimum effect Here's how to set the *Blue intensifier* effect (see *figure 8*):

1. Select *Filter effects* from the *Retouch Menu*, and scroll right.

2. Select *Blue intensifier*, and scroll to the right.

3. Choose an image with the Multi Selector and press the *OK* button.

4. You will be presented with the image with the *Blue intensifier* effect added.

5. Scroll up or down with the Multi Selector to intensify or reduce the effect.

6. Press the *OK* button to save the image under a new filename, or press the *Playback* button to cancel.

Cross screen – This effect is designed to work like a cross-screen filter and adds a starburst (rays) effect to any points of light. There are four different adjustments to this effect, along with a *Confirm* and a *Save*. To create the starburst rays effect, do the following (see *figure 9*):

1. Select *Filter effects* from the *Retouch Menu*, and scroll right (see *figure 9*).

2. Select *Cross screen*, and scroll to the right.

3. Choose an image with the Multi Selector and press the *OK* button.

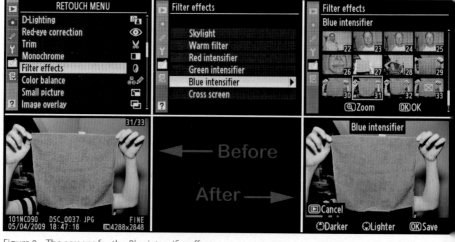

Figure 8 – The screens for the *Blue intensifier* effect

Figure 9 – The *Cross screen* effect screens

Your first available option will be at the top of the image, allowing you to select the Number of points (4, 6, or 8) in the star effect's rays with the two screens shown in Figure 9A. You will actually see the number of rays in the graphic, followed by the number of points. Scrolling to the right allows you to change the setting. Accept the change with your *OK* button. You will be doing this same procedure for the next available options, which include adjusting brightness, filter angle and the lengths of the points on the cross screen star.

Select the filter amount with the two screens shown in *figure 9B*. This affects the brightness of the light sources.

Select the filter angle (ray clockwise rotation) with the two screens shown in *figure 9C*.

Select the length of points (longer rays) with the two screens shown in *figure 9D*.

Press the *Confirm* button to see the effect. This is like an update button. You can repeat the this step multiple times, confirming/updating each time, until you have the effect just the way you want it to look. In the screen on the left in *figure 9E*, I changed the *Number of points* value from 4 to 8 points, then I confirmed the effect in the screen on the right. The number of rays changed from 4 to 8.

Select the *Save* menu item and then press the *OK* button. You'll then be presented with the full-sized image in normal playback mode (*figure 9F*).

Figure 9A – The *Cross screen* effect's *Number of points* screens

Figure 9B – The *Cross screen* effect's *Filter amount* screens

Figure 9C – The *Cross screen* effect's *Filter angle* screens

) Figure 9D – The *Cross screen* effect's *Length of points* screens

Figure 9E – The *Cross screen* effect's *Confirm* screen

Figure 9F – The *Cross screen* effect's save and presentation screens

Color Balance

(User's Manual page 216)

The *Color balance* function allows you to change the color of your image after the fact. You might just want to warm things up a bit by adding a touch of red or cool things down with a touch of blue. Or, you could get creative and easily add various color casts to the image for special effects. You'll see what I mean when you try it.

Figure 10 shows the *Color balance* menu screens to use.

To modify the color balance of an image, follow these steps:

1. Press the *MENU* button and select the *Retouch Menu* (paintbrush icon).

2. Select *Color balance*, and then scroll right.

3. Select the image you want to modify with the Multi Selector, and then press

Figure 10 – The *Color balance* retouch screens

Figure 10A – Four *Color balance* tint variations

the *OK* button. You'll see a screen with a series of histograms on the right and a small color selection box on the bottom left.

4. Use the Multi Selector to move the tiny black indicator square in the center of the color box toward whatever color tint you'd like to use. Watch the histograms as they display the changing color relationships between the red, green, and blue color channels. You can see the color changes as they are applied to the small version of your image in the upper-left corner of the screen (see *figure 10A*).

5. Press the *OK* button to save the new image under a new filename or the *Playback* button to cancel.

Small Picture

(User's Manual pages 216–217)

If you want to convert an existing image on your SD memory card to a smaller size than normal, you can use this function. This is handy when you want to send someone an image over the Internet or display it on a TV or web page or if you would rather give someone a small version that can't be easily enlarged and printed.

There are three levels of "smallness" available in the *Small picture* setting (in pixels):

- 640 x 480
- 320 x 240
- 160 x 120

Here are the steps to make use of the small picture reduction function (see *figure 11*):

1. Press the *MENU* button and select the *Retouch Menu* (paintbrush icon).
2. Select *Small picture*, then scroll right.
3. Select *Choose size*, and scroll right.
4. Select one of the three sizes, and press the *OK* button.
5. The camera will return to the *Small picture* screen.
6. Now choose *Select image*, and scroll to the right (see *figure 12*).
7. Use the ISO–thumbnail/playback zoom out button and the Multi Selector to select one or more images for conversion to a small size. You'll see a tiny resize box appear in the upper-right corner of the selected images (see the red arrow in *figure 12*, right screen on the top).
8. When you have selected all the images you want to resize, press the *OK* button.

Figure 11 – *Small picture* size selection screens

9. A screen with the question *Create small picture?* appears and gives you a Yes/No choice. Choose *Yes* and press the *OK* button.

10. You'll see an hourglass for a few seconds, then the words *Image saved*.

11. Next, the newly converted images appear in normal playback mode. If you selected multiple images to convert, the playback screen will be showing the last image in the series. Scroll backwards to see all of them. You'll be able to identify the images converted to small size by the large gray border, the paintbrush icon in the upper-left corner, and the small size (i.e., 640 x 480) listing in the lower-right corner (see *figure 12*).

You cannot zoom into the smaller files the way you can the normal-sized ones. Now that you have made the small size conversion, you can plug your SD card into a computer and transfer the smaller files for whatever use you have for them.

Image Overlay

(User's Manual pages 218–219)

This particular function only works with NEF (RAW) files. No need to try it with a JPEG because you won't be able to see JPEG images in the image selection screen.

Image overlay allows you to overlay two existing images from your SD memory card and then save the overlaid image as a brand-new image with a different image number. Your original images are protected. You can also vary the lightness/darkness (gain) on each image before overlaying it. According to Nikon, images overlaid this way are "noticeably better than overlays created in an imaging application."

You'll need to use multiple screens to overlay the two images. Here's the procedure:

1. Press the *MENU* button and select the *Retouch Menu* (paintbrush icon).

2. Select *Image overlay*, and then scroll to the right.

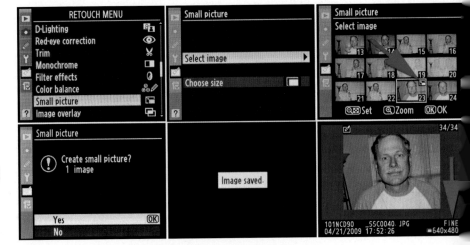

Figure 12 –*Select image* screens for the *Small picture* function

3. You'll now see the screen that allows you to select the two images you'll be overlaying. The yellow selection box should be surrounding the *Image 1* area, with the word *RAW* in a small box (see *figure 13*).

4. Press the *OK* button and you will be presented with any NEF (RAW) images on your SD memory card. If none are there, the camera won't display anything.

5. Scroll through the available NEF (RAW) images and then press the *OK* button to select *Image 1*. The image selection screen appears again.

6. Move the yellow selection box to the *Image 2* area with the Multi Selector (see *figure 14*).

7. Press the *OK* button, and you'll be presented with a display of any NEF (RAW) images on your SD memory card.

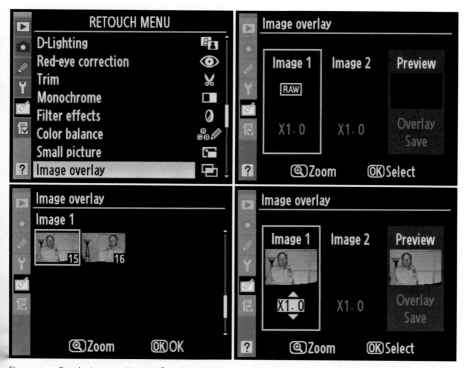

Figure 13 – Overlaying two images: first image selection

Figure 14 – Overlaying two images: – second image selection

Figure 15 – Overlaying two images: changing image gain

8. Select an image that's different than the first selection you made, unless you want to overlay the same image twice. Press the *OK* button to select your second image. The image you select becomes the second image in the overlay.
9. You now have the two images you are going to overlay in their respective *Image 1* and *Image 2* boxes (see *figure 15*).
10. Next, you'll need to select and change the gain on each image (if you want to add this step). Notice the X1.0 characters below each image? Use your Multi Selector to scroll up or down on these X1.0 (gain) settings. You'll see that you can scroll up to X2.0 or down to X0.1. While you are scrolling the X-gain numbers, pay attention to what is happening in the preview box to the far right. As you increase the gain in one of the images, it gets darker in the preview box. If you decrease the gain, the

Figure 16 – Overlaying two images: finishing the process

image in the Preview box gets lighter. Use the X-gain function on both images 1 and 2 until you have the previewed image looking just the way you want it to look.
11. Now, scroll the yellow selection box to the preview area. You have two selections available, *Overlay* and *Save* (see *figure 16*).

Using *figure 17* as a guide, if you se-
lect *Overlay* and press the *OK* button,
the camera will overlay the image and
show you a larger version of it. (You
can preview before selecting *Overlay*
by pressing the QUAL–playback zoom
in button.) If you don't like the looks
of the image and want to readjust the
gain, simply press the ISO–thumbnail/
playback zoom out button and it will
return you to the main overlay configu-
ration screen. The word *Preview* will
have been replaced with *Overlay*. If you
press *OK* on the *Overlay* screen (middle
screen in *figure 17*), please skip step 12
(next) since the save will take place im-
mediately.

12. Once you are happy with the overlaid
image, simply scroll to the *Save* menu
item in the new *Overlay* section and
press the *OK* button. The final image
will now be created with a new file-
name containing the next available
image number and will be displayed in
normal playback mode (see *figure 17A*).
This is the second way to save an over-
laid image, only this one does it with-
out an overlay preview.

Figure 17 – Overlaying two images: previewing and saving the overlay

Figure 17A – Overlaying two images: – saving the overlay

NEF (RAW) Processing

(User's Manual pages 220–221)
Without using your computer, you can process a RAW file into a JPEG, right in-camera. Why is this different from just shooting an NEF (RAW) + JPEG fine at the same time? (See the section on the *Shooting Menu's Image quality* option in chapter 6.)

Well, when you shoot a JPEG, all settings are applied to the image immediately—and irreversibly. *NEF (RAW) processing* gives you an opportunity to take an existing NEF (RAW) file, which has no permanent settings applied, and use it to create whatever type of JPEG you want. It's an after-the-fact, or post-processing method, that Nikon has given us. Conversion from NEF to JPEG with *your* settings!

You can apply the following settings to your new JPEG:

1. *Image quality*
2. *Image size*
3. *White balance*
4. *Exposure compensation*
5. *Picture Control*

Let's look at the screens and steps involved with converting from NEF (RAW) to JPEG in-camera:

1. Press the *MENU* button and select the *Retouch Menu* (paintbrush icon).
2. Select *NEF (RAW) processing*, and then scroll to the right.
3. Select a RAW image from the list with the camera's Multi Selector, then press the *OK* button (see *figure 18*).

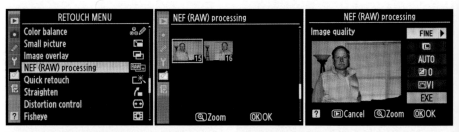

Figure 18 – The *NEF (RAW)* processing screens

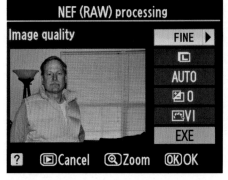
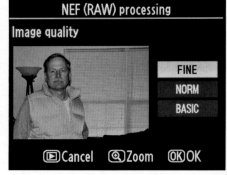

Figure 19 –*Image quality*

Figure 20 – *Image size*

Figure 21 – *White balance*

4. Select one of the *Image quality* set-
 tings—*Fine*, *Norm*, or *Basic*—from the
 Image quality menu. *Fine* gives you the
 best possible quality in a JPEG im-
 age (see *figure 19*). Select the setting
 you want to use, and then press the
 OK button to return to the main *NEF
 (RAW) processing* configuration screen.

5. Select one of the *Image size* set-
 tings—*L-Large (4288x2848)*, *M-
 Medium (3126x2136)*, or *S-Small
 (2144x1424)*—from the *Image quality*
 menu. *Large* gives you the biggest pos-
 sible size in a JPEG image. Select the
 setting you want to use, and then press
 the *OK* button to return to the main
 NEF (RAW) processing configuration
 screen.

6. Select one of the *White balance* settings
 for your new JPEG. You can choose
 from *AUTO, Incandescent, Fluorescent,
 Direct sunlight, Flash, Cloudy, Shade,
 Choose a color temp.*, and *PRE* (preset
 manual from a previous ambient light
 white balance reading). Please review
 chapter 3 for detailed information on
 each of these selections. As you scroll
 through the list of settings, you'll be
 able to see the color temperature of the
 image change. Select the setting you
 want to use, and then press the *OK* but-
 ton to return to the main *NEF (RAW)
 processing* configuration screen. (You
 can modify the colors of the individual
 white balance settings for this image by
 scrolling to the right and changing the
 value in the color adjustment box. You'll

Figure 22 – *Exposure compensation*

Figure 23 – Picture Controls

see your fine-tuning adjustment change the color temperature of the image.)

7. Now you have an opportunity to lighten or darken the image by selecting an *Exposure compensation* value of +/- 3 stops in either direction (*figure 22*). When the image looks just right, press the *OK* button to return to the main *NEF (RAW) processing* configuration screen.

8. Now you can apply a Nikon Picture Control or one of your own custom Picture Controls, if you've created any, from the list shown (see chapter 6, "Shooting Menu"). These controls make changes to how the image looks. You can increase the contrast, adjust for greater or lesser color saturation, or even change it to

monochrome. Choose from *SD-Standard*, *NL-Neutral*, *VI-Vivid*, *MC-Monochrome*, *PT-Portrait*, *LS-Landscape* (*figure 23*), or any of your custom controls that appear on the list. When the image looks just right, press the *OK* button to return to the main *NEF (RAW) processing* configuration screen.

9. Now, scroll down to the *EXE* menu selection (*EXE* = Execute?) and press the *OK* button. The hourglass shows for a few seconds while the new JPEG is being created with your carefully crafted settings, an *Image saved* screen appears briefly, and the new JPEG is shown in a normal playback screen.

Figure 24 – Saving the new JPEG

Figure 25 – *Quick retouch* screens

This is a convenient way to create specialized JPEG images from NEF (RAW) files without using a computer. How much longer will it be until our cameras come with a keyboard, monitor, and mouse ports? They are computerized after all!

Quick Retouch

(User's Manual page 221)

If you want to simply adjust an image so that all parameters are within viewable range, that's the purpose of this *Quick retouch* function. It creates a new copy of an existing image with "enhanced saturation and contrast." D-Lighting is automatically applied to your old image and the new image is supposed to look better. You can scroll up and down in the preview screen to see the range of enhancements

that can be applied when the new image is created. Here are the steps:

1. Press the *MENU* button and select the *Retouch Menu* (paintbrush icon).
2. Select *Quick retouch*, and scroll to the right.
3. You'll be presented with the images on your SD memory card that are eligible for a quick retouch. Scroll to an image you want to retouch with your Multi Selector, and press the *OK* button to select it.
4. Use your Multi Selector *to* scroll up or down, selecting *High*, *Normal*, or *Low*. You can preview the effect of your changes on the image by looking at the before and after images (see *figure 25*).
5. Press the *OK* button when you're satisfied with the look, and the new image will be created and shown to you in the playback window.

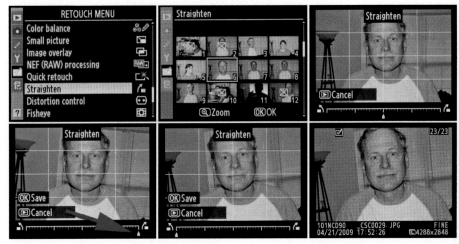

Figure 25A – Straightening an image

Straighten

(User's Manual page 221)

This is another really cool function that I'm glad to see and use. Often, I'll be shooting a landscape or ocean view hand-held, and in my excitement I'll forget to level the horizon. Now, without using my computer, I'll be able to adjust the image to level before anyone else sees it.

You can rotate an image up to 5 degrees clockwise or counterclockwise. You use the Multi Selector to scroll right or left through a graduated scale line. Each increment is equal to about 1/4 degree (0.25). As you rotate the image, the camera will automatically trim the edges so that the picture looks normal. Of course, this means you are throwing away some of the edges of the image and making it smaller. However, it's better for the image to be a little smaller and have a nice level horizon, don't you think?

Here are the steps to straighten or level an image (see *figure 25A*):

1. Press the *MENU* button and select the *Retouch Menu* (paintbrush icon).

2. Select *Straighten*, and scroll to the right.

3. You'll be presented with the images on your SD memory card. Select the one you want to straighten with the Multi Selector, and press the *OK* button to select it.

4. Now, rotate the image to the right (clockwise) or the left (counterclock-wise) in 0.25 degree increments with the Multi Selector.

5. When you are happy with the straight-ness of the new image, press the *OK* button to save it, or press the *Playback* button to cancel.

6. You'll be presented with the newly saved image in a normal playback win-dow.

In my example in *figure 25A*, I certainly didn't straighten the image. In fact, I took a relatively straight image and tilted it to the right, to the left, then finally saved it. The degree of tilt I added to the image shows how much you can adjust the level of any image. Notice the little yellow selection pointer where the red arrow is pointing. This will move as you use the Multi Selector. You'll see the image tilt, and the gridlines will help line things up well.

Distortion Control

(User's Manual page 222)

This *Distortion control* function is a companion to the *Straighten* function. Where the *Straighten* function is concerned with leveling the image left to right, the *Distortion control* function is concerned with barrel and pincushion distortion. Barrel distortion causes the edges of a subject to bow outward, like a barrel. Pincushion distortion is the opposite; the edges bow inward, like an hourglass. Using this control will remove some of the edge of the image as distortion compensation takes place.

There are two settings in the *Distortion control* function:

* *Auto*
* *Manual*

Auto is usable only if you have a D or G type lens on your D90. You select *Auto* when you want the camera to makes its best adjustments, and then you can make more yourself if you think the new image needs it.

Manual is entirely your operation. You can adjust the image until you feel that it looks best, without interference from the camera.

Here are the steps to let the camera make an *Auto* distortion adjustment (see *figure 26*):

1. Press the *MENU* button and select the *Retouch Menu* (paintbrush icon).
2. Select *Distortion control*, and scroll to the right.

) Figure 26 – *Distortion control - Auto*

3. You'll be presented with the images on your SD memory card. Select the one you want to fix with the Multi Selector, and press the *OK* button to select it.

4. The camera will automatically make its best adjustment and will then present you with the adjusted image.

5. If you are not satisfied with the camera's *Auto* adjustment, then use the Multi Selector to move the yellow pointer along the scale to the left to remove pincushion distortion (add barrel) or to the right to remove barrel distortion (add pincushion).

6. When you are happy with the appearance of the image, press the *OK* button to save it or the *Playback* button to cancel.

7. You'll be presented with the new adjusted image in a normal playback window.

The effect is not easy to see in these small images, nor even on the monitor of the camera. However, if you look closely at *figure 26, image 4* (bottom left) and then compare it to *image 6* (bottom right), you'll see that the subject's face appears a little wider. In *image 5* (bottom middle), I introduced barrel distortion by pushing the slider all the way to the left, toward the barrel distortion symbol.

This works the same way for the *Manual* distortion adjustments presented next, except that the camera does not make an *Auto* adjustment before presenting you with an image to manually adjust.

Here are the steps to let the camera make an *Auto* distortion adjustment:

1. Press the *MENU* button and select the *Retouch Menu* (paintbrush icon).

2. Select *Distortion control*, and scroll to the right.

3. You'll be presented with the images on your SD memory card. Use the Multi Selector to select the one you want to fix, and press the *OK* button to select it (see *figure 27*).

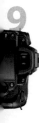

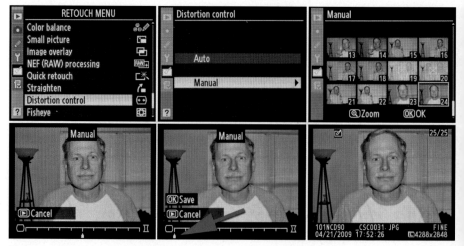

Figure 27 – *Distortion control - Manual*

4. Move the yellow pointer along the scale to the left to remove pincushion distortion (add barrel) or to the right to remove barrel distortion (add pincushion).

5. When you are happy with the appearance of the image, press the *OK* button to save it or the *Playback* button to cancel.

6. You'll be presented with the new adjusted image in a normal playback window.

Once again, as with the *Auto* distortion adjustment (*figure 26*), the effect is rather hard to see. If you look closely at *Figure 27*, *image 4* (bottom left) and then compare it to *image 6* (bottom right), you'll see that the subject's face appears a little wider. In image 5 (bottom middle), I introduced barrel distortion by pushing the slider all the way to the left, toward the barrel distortion symbol.

Fisheye

(User's Manual page 222)

This function is quite fun! You can "fisheye" your friends and make hilarious distortions that will make everyone laugh. While the results are not true circular fisheye images, they do have a similar distorted appearance. *Figure 28* shows three images. The first is normal, the second somewhat distorted, and the third fully "fisheyed!" What do you think?

Here are the steps to select and distort one of your images:

1. Press the *MENU* button and select the *Retouch Menu* (paintbrush icon).

2. Select *Distortion control*, and scroll to the right.

3. You'll be presented with the images on your SD memory card. Select the one you want to "fisheye" with the Multi Selector, and press the *OK* button to select it.

4. Now press the Multi Selector to the right and watch the yellow pointer move and the distortion grow.

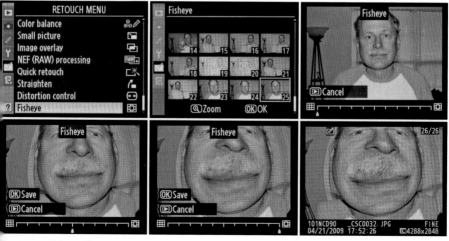

Figure 28 – *Fisheye effect* screens

5. Once you've found the perfect distortion amount (to the max, right), simply press the *OK* button to save or the *Playback* button to cancel.

6. You'll be presented with your fisheye creation in a normal playback window.

Just be careful with this one! If you publish many of your friends with this effect, I'm afraid that they'll start running when they see you with your camera.

Side-by-Side Comparison
(User's Manual page 223)
Now that you've learned to use all these new tools for image adjustment, you may find yourself wanting to view the original image and the retouched image side by side. You can enjoy a before-and-after view of the two images.

This particular *Side-by-side comparison* function is not available on the *Retouch Menu* by selecting it directly. The only way to get to it is to view a "retouched" image in the normal playback window and then press the *OK* button. One of the menu selections you'll find is *Side-by-side comparison*. It's down at the bottom of the available selections (see *figure 29*, middle image).

Let's look at what the *Side-by-side comparison* function does for us. Here are the steps:

1. Using the normal image playback system, find an image that has been retouched. You can tell when you've found one because it will have a small square in the upper-left corner with a brush and pallet.

2. Press the *OK* button to open up the special retouch image menus.

3. Scroll down until you find the *Side-by-side comparison* selection, and then press the *OK* button.

4. You'll be presented with an informational side-by-side view of the original and retouched image so that you can compare them.

If you happen to be looking at an image that was created from an overlay, then it has two source files. One of the originals appears along with the retouched version. You can select the first original and then scroll up or down with the multi selector to see the other original. *Side-by-side comparison* will not work if the original has been deleted from the SD memory card.

) Figure 29 – *Side-by-side comparison* screens

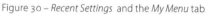
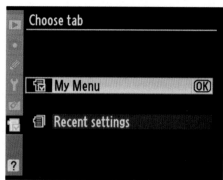

Figure 30 – *Recent Settings* and the *My Menu* tab

Recent Settings/My Menu – Section 2

(User's Manual pages 224–226)

I was a bit confused when I first read about the *My Menu*. I could not find it in the normal list of menus in the D90. It is not on the left with the other menus like *Shooting* and *Custom Settings* as a factory default.

I finally found it by noticing a selection called *Choose tab* at the bottom of my *Recent Settings* menu. Aha! There it is!

Using the *Choose tab* selection, I found that I could toggle one of two menus to live on my main menu tab system bar on the left. As *figure 30* shows, *Choose tab* lets me select either *Recent settings* or *My Menu* for the last menu slot (the menu tab on the bottom of the left screen in the figure). Basically, Nikon didn't want to put an extra menu on the menu tab, so it made one optional, the *My Menu* system. *Recent Settings* is the factory default. I like *My Menu* better!

Let's consider both of these menus. You can then choose which one you want to live on your menu tab bar.

Recent Settings

Recent Settings is very simple. It is a menu that remembers the last 20 distinct changes you've made to your D90 camera. Each menu in which those changes were made is stored in a temporary menu called *Recent Settings*.

If you change something in your camera that is not already on the *Recent Settings* menu, it will be added to the menu; if there is no room left, it will replace the oldest (or least recent) change. This can be convenient if you need to find something you've changed recently but have trouble remembering where it is on the main menu systems.

Figure 31 – *Recent Settings* menu

Recommendation

If you want a more permanent menu for your "favorite" changes to the D90, you need to enable the *My Menu* system instead of the *Recent Settings* menu. *Recent Settings* is fine, but I want to directly control what menus I have quick access to without searching. *My Menu* is "my" menu!

My Menu

The D90 is quite a complex camera. There are key functions and settings that each of us use frequently. For instance, I often turn *Exposure delay mode* (*Custom Setting d10*) on and off. Instead of having to search through all those custom settings and trying to remember which is exposure delay, I simply added that one to *My Menu*. Now, whenever I want to add a delay to my exposure so that mirror vibrations can settle down, I just go to *My Menu* and enable *Exposure delay mode*.

There are several other functions and settings I keep in *My Menu* along with *Exposure delay mode*. I'm sure you'll have a few you use often too. Let's examine the menu screens you'll use to add and remove items from *My Menu*.

When you first open *My Menu*, you'll find only four menu choices, as shown in *figure 32*:

1. *Add items*
2. *Remove items*
3. *Rank items*
4. *Choose tab*

Let's examine each of these menu choices in detail.

Add Items

To add an item to *My Menu*, you'll need to locate the item first. Search through the menus until you find the item you want to add and then make note of where it is located. You could do this from within the *Add item* screen, but I find that it's harder to find what I am looking for if I have not already confirmed in my mind where it lives. Is it under the *Custom Settings* or the *Shooting Menu*, for instance?

Once you have found the item you want to add, and made note of its location, do the following:

1. Select *Add items* from the *My Menu* screen. You'll notice that I already have *Set Picture Control* and *Active D-Light-*

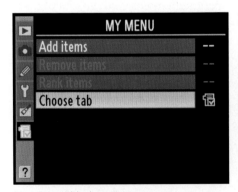

Figure 32 – A blank *My Menu* screen

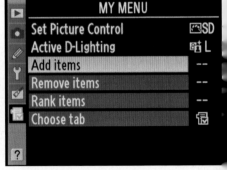

Figure 32A – *My Menu* screen with *Add items* ready

ing added to *My Menu* (see *figure 32A*). Let's add something else.

2. Use the Multi Selector to scroll right and you'll find a list of menus to choose from. These menus are all the menus available in the D90 except for *My Menu* (see *figure 32B*).

3. In this example, I will add *Custom Setting d10 (Exposure delay mode)* to *My Menu*. I already looked and know that *Exposure delay mode* is under the *Custom Setting* menu, so I scroll down to it. After selecting it, I'll scroll to the right (see *figure 32C*).

4. Now I see the Custom Setting bank and Custom Settings a–f (see *figure 32C*). I scroll down to *d-Shooting/display*. Then I scroll right again so that I can select the actual custom setting I want.

5. Now that I have found *Custom Setting d10*, all I have to do is highlight it and press the *OK* button (see *figure 32C*). Once I've done that, the D90 switches

to the *Choose position* screen (*figure 32D*).

6. Since I already had a couple of other items added to *My Menu*, I now have to decide in which order I want them to be presented. The new *d10 Exposure delay mode* item is on top because it is the newest entry. I think I'll move it down to the bottom and let *Set Picture Control* have the top position. To move the position of the selected item, I simply scroll down two rows. *D10 Exposure*

Figure 32B – *Add items* screen with *Playback menu* selected

Figure 32C – Adding *Custom setting d10* to *My Menu*

Figure 32D – Choosing a bottom position for *d10 Exposure delay mode*

delay mode stays highlighted with a yellow box surrounding it. As I scroll down two rows, a yellow underline moves to the bottom position. (see the red arrow in *figure 32D,* middle screen). This yellow underline represents the place to which I will finally move *d10 Exposure delay mode.* Once I have decided the position and have the yellow underline in place, I just press the *OK* button. *D10 Exposure delay mode* moves to the bottom position. The screen pops back to the beginning *My Menu* screen, with everything arranged the way I desired (see the screen on the right in *figure 32D*).

Remove Items

Now that you know how to add items, let's examine how *Remove items* works. I've decided that one of my items, Active D-Lighting, is not used often enough to waste a spot on *My Menu,* so I'll remove it. Here's how:

1. Select *Remove items* from *My Menu* and scroll to the right (see *figure 32E*).
2. The *Remove items* screen presents a series of check boxes. Whatever items I check will be deleted when I select *Done.* You can check the boxes by highlighting the line item and pressing the *OK* button, or you can scroll right on each item you want to check. I like to

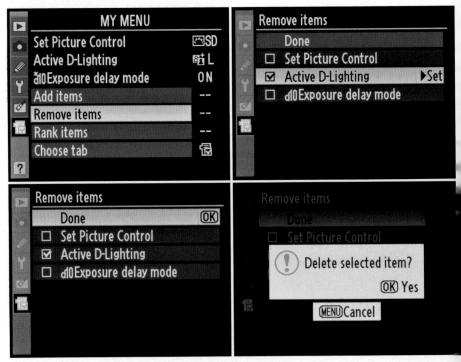

Figure 32E – Removing *Active D-Lighting* from *My Menu*

use the *OK* button method because trying to uncheck a selection by scrolling left doesn't work; it takes you back to the *My Menu* screen. Pressing in the *OK* button acts like a toggle and will check or uncheck a line item.

3. Once I have checked the items I want to delete, I'll simply scroll back up to the *Done* selection and press *OK*. A small white box pops up and asks, *Delete selected item?* Press the *OK* button again, and the item is removed from *My Menu*. A box pops up informing you that the item has been deleted, and then the D90 switches to *My Menu*'s main screen.

Rank Items

Ranking items is similar to positioning new additions in *My Menu*. All the *Rank items* selection does is move an item up or down in *My Menu*. You can switch your most-used *My Menu* items to the top of the list. Here's how:

1. Select *Rank items* from My Menu and scroll to the right (see *figure 32F*).
2. The *Rank items* screen and all the current *My Menu* items appear. I have decided that *d10 Exposure delay mode* is used more than *Set Picture Control*, so I'll move the former to the top. I move my yellow highlight down to *d10 Exposure delay mode* and press the *OK* button to select it.
3. A yellow underline can now be moved around with the Multi Selector. I moved the yellow underline up to the top to represent where I am finally going to position *d10 Exposure delay mode*. *Exposure delay mode* is still highlighted with a yellow box surrounding it. Once my yellow underline is at the position I want, I press the *OK* button and *d10 Exposure delay mode* moves to the top. If I like the current order, I can simply press *OK* and I'm back at *My Menu*'s main screen.

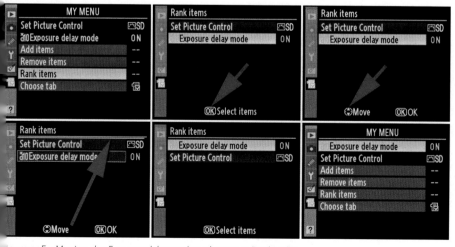

Figure 32F – Moving *d10 Exposure delay mode* to the top, or "ranking" it

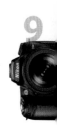

Figure 33 – Switching from *My Menu* to the *Recent Settings* menu

Choose Tab

As you've already discovered at the begin-
ning of this section, this selection lets
you switch between *Recent Settings* and
My Menu. To change from *My Menu* back
to *Recent Settings*, simply select *Recent
settings* from the *Choose tab* screen (see
figure 33).

Summary

Whew! The D90 is surely a complicated little beast. I guess that's the price of putting semipro-level functionality in a relatively small DSLR body. Complex as it is though, I'm certainly delighted with the camera. In fact, it's one of my favorite cameras of all time.

Now, let's spend some time working thought the autofocus system. We'll consider the Multi-CAM 1000 autofocus module and its functionality. Plus, we'll consider information that supports accurate autofocus, like tracking, frame rate, and other functions. I've tried to pull everything related to autofocus into one chapter so you can get an overview of the system in a way that will help you understand it well. Next, chapter 10, "Multi-CAM 1000 Autofocus."

Multi-CAM 1000 Autofocus

The first autofocus camera I owned was a "pro-level" film SLR back in the late 1980s. I remember shooting a football game and trying to get the autofocus (AF) to stay locked on my chosen subject. Often it would lose the subject and the lens would rack back and forth very slowly as it tried to recover. Then, when it found the subject, it was probably the wrong one. And that was on a pro-level camera!

I'm not complaining, just remembering. Back then, autofocus was almost a novelty. There were few AF lenses and even fewer cameras with AF. The majority of my lenses were lovely single focal-length, manual-focus primes. Those times have gone.

The autofocus in the Nikon D90 is so far advanced in comparison to those early days of AF that it's like comparing one of today's cars with a car from the 1940s. Most American cars from the '40s were big, heavy, slow, and not all that safe or comfortable. Today's cars are smaller, lighter, faster and are computer controlled for comfort and safety. The AF system in the Nikon D90 is, likewise, very advanced and feature rich.

I wrote this chapter to help you get the most use out of a somewhat complex but powerful system. Let's examine each aspect of the AF system in detail.

What Is the Multi-CAM 1000 Autofocus Module?

Inside your Nikon D90 is a Multi-CAM 1000 autofocus module. It has the ability to handle autofocus with the normal viewfinder, but it also works with Live View.

Basically, this module examines the scene under your selected AF focus point and uses advanced technology to obtain a correct focus.

There are several ways to autofocus a camera:

- **Active AF** – Either ultrasonic sound waves or an infrared beam is sent out to find the subject. When the return reflection is detected, the time lapse is measured and autofocus distance is calculated from that delay. This is sort of like the old submarine movies where the sub is pinging the surroundings looking for a subject in the water.

- **Passive AF** – The autofocus system simply does an analysis of whatever it sees in its view. It can then use phase detection or contrast detection to find the subject and focus on it. If it is too dark, sometimes a passive system will get a little more active and shine a nice infrared beam on the subject to help in its analysis (camera dependant).

- **Contrast detection AF** – The autofocus system detects intensity differences between pixels next to each other on the camera's sensor. This is a very slow but accurate method of autofocus. It doesn't work very well in dim light when contrast is quite low.

- **Phase detection AF** (D90 default) – Remember how you used to use a split-prism viewfinder screen in your film camera back in the "old days"? Well, that is rather similar to how phase detection AF works. The incoming image is split into two beams with a beam splitter, and they are compared. In a sense, the camera is doing what you used to do with your own eye, bringing two split images together in the split-prism circle. Few of today's cameras have a split-prism viewfinder for human use because AF is handled automatically by the camera.

The Nikon D90 uses the third and fourth methods, contrast detection AF and phase detection AF. TTL phase detection AF is the primary autofocus method used for day-to-day shooting. Contrast detection AF is used when in Live View mode. We'll talk more about them later in the chapter.

The D90's Multi-CAM 1000 has a 420-pixel RGB sensor. With so many contrast-sensing elements in the AF system, it will autofocus in low- to high-light levels and at high speeds.

So, the Multi-CAM 1000 AF module is basically a flexible multimode autofocus system designed to assist or replace your eye in getting a good focus on your lenses' subject.

As we proceed through this chapter, I'm going to call the Multi-CAM 1000 autofocus Module by the simpler name AF module.

The AF module has four AF-area modes:

1. *Single-point AF*
2. *Dynamic-area AF*
3. *Auto-area AF*
4. *3D-tracking (11 points)*

It also has three autofocus modes:

1. *AF-A, or auto select*
2. *AF-S, or single-servo*
3. *AF-C, or continuous-servo*

What's the difference? Basically, think of the AF-area modes as *where* the AF module focuses and the autofocus modes as *how* it focuses.

In addition, the D90 allows you to control how fast and how often a picture is taken. We'll look at how the image frame rate works in relation to the AF system (release modes L and H). The frame rate used to be controlled by the "motor-drive" speed in days gone by. Tied in closely with the AF system is the release mode. This determines how the camera takes the picture, one at a time or in continuous bursts.

With the controls built into the D90's body, you'll be able to select whether the

AF System Override With Lens Setting

If you'd like, you can use the A-M switch found on most AF Nikkors to set the lens to manual focus and override the AF system completely. If the AF Nikkor lens supports autofocus with manual priority (M/A), you can use the AF module to obtain primary focus and then fine-tune it manually.

AF module uses one or several of the 11 AF sensors to find your subject. You'll also select whether the camera grabs the focus and "locks" on a static subject or whether it continuously seeks new focus if your subject is moving—and how fast, in frames per second (fps)—to capture the images.

You can turn AF off completely with a switch on the front of the camera (AF or M) and simply use manual focus. This may be useful when you are taking an extreme close-up picture with a macro lens. There is so little depth of field in a close-up that it is often easier to manually focus the lens. You can then select the exact area that you want in focus. This may only be a few millimeters at macro ranges.

You can look through the viewfinder to compose or use the Live View mode (LV). Live View enables the large LCD monitor on the back of the D90 to be used as a viewfinder instead of the normal viewfinder, as with a point-and-shoot camera.

The AF module has seven *Custom Settings*, a1 through a7. We examined each one in detail in chapter 7, but we will review their use here.

Let's consider the various features of the Multi-CAM 1000 AF module in detail.

Understanding the Autofocus, AF-Area, and Release Modes

The D90 has distinct modes for *how* and *when* to focus. We'll examine each of those modes as a starting point for understanding autofocus with the Multi-CAM 1000 AF module. We'll tie together information about the focus, AF-area, and release

Figure 1 – Unlocking the focus selector lock

modes since they work together to acquire and maintain good focus on your subject.

In fact, this chapter encompasses information found in the D90 User's Manual chapters on autofocus (pages 54–60, and 173–176) and release modes (pages 64–69). It goes deeper than merely looking at the AF module alone, since other related camera functions such as the release modes directly affect how the AF system performs.

All this information is available in the User's Manual, but it is spread out in various places in a way that makes it hard to connect it all together. This chapter is designed to help you bring the information together in a way that will assist you in remembering how to use it.

To get started in our examination of the autofocus system, let's unlock the AF point sensor selector (the focus selector lock). This control will need to be set properly so that you can take full advantage of the flexibility of the AF system. If you leave it locked, you will be unable to move and select individual AF sensors with the multi selector thumb control.

Notice in *figure 1* that there is a focus selector lock switch just below the multi selector thumb rocker switch. It has an *L* and a dot. Move the switch to the dot setting, which unlocks the internal AF sensor point in use. With the focus selector lock in the unlocked "dot" position, you can move the AF sensor point around the viewfinder with the thumb switch. You can select which of the 11 AF points is best to focus on your subject. You can do this in three of the four AF-area modes: *single point*, *dynamic area*, and *3D-tracking*. In auto-area mode, the camera completely controls all 11 AF sensors and decides which to use, on its own. (See "Custom Setting a1, AF-area mode", in chapter 7.)

If you want to use the D90 as a point-and-shoot camera, just leave the lock on L and *Custom Setting a1* set to *Auto-area*. The camera will handle autofocus for you.

I leave mine unlocked all the time, but then I check when I'm focusing to make sure I'm using the AF sensor I want to use. This comes from years of experience with thumb-select switches on the back of Nikons. You may find that your thumb has a habit of accidentally grazing the selector switch and rocking the AF point in all different directions. If you can't train your thumb to stay out of the way, it might be best to keep your lock on. You can move a single AF sensor, or a group of sensors, around the array of 11 available sensors with the thumb multi selector switch. If you look at your viewfinder, you'll notice the 11 tiny squares that represent the AF sensors. Surrounding one of them (except in auto-area mode),

you'll see a larger bracket that represents your "selected" AF focus point. You can move this large bracket around with the multi selector thumb switch. Make sure the focus selector lock is unlocked or you won't be able to select a different AF point.

When you have *Custom Setting a1* set to *Single point* and move the AF point, you are only moving the one active AF point. When *a1* is set to *Dynamic area*, you're actually moving up to five points, even though you can see only one moving. The 4 sensors surrounding the one you can see moving are also active. In *3D-tracking* mode, all 11 sensors are active and you are moving a selected sensor among them. Only in auto-area mode do you give full control to the camera. We'll talk more about this later and will use some graphics to help reinforce the concept.

One of the 11 AF sensors on the D90 is a cross-type sensor, which means that it will initiate focus in a horizontal or vertical direction. *The center AF sensor point is the only cross-type.* All other AF points are sensitive only in a horizontal direction.

Autofocus Modes in Detail

(User's Manual pages 54–60)

The autofocus modes allow you to control how the autofocus works with static and moving subjects. They allow your camera to "lock" focus on a subject that is not moving or is moving very slowly. They also allow your camera to "follow" focus on an actively moving subject.

In *figure 1A* are pictures of the controls you'll use in combination to change how the camera focuses and captures images.

Figure 1A – External autofocus controls

To set the autofocus modes, press and hold the AF button, turn the rear main-command dial, and notice the top control panel LCD as it changes to *AF-A*, *AF-S*, or *AF-C*.

Here are the three *autofocus modes* in the D90:

1. *AF-S*, or single-servo AF
2. *AF-C*, or continuous-servo AF
3. *AF-A*, or auto select AF

Let's consider each of the autofocus modes to see when and how you might use them best.

Single-Servo AF Mode (AF-S)

Subject is not moving: When you press the shutter release button halfway down, the AF module quickly locks the focus on your subject and waits for you to fire the shutter. If you don't release pressure on the shutter button and refocus and your subject starts moving, the focus will be obsolete and useless. Once you have focus lock, take the picture quickly. This is perfect for nonmoving subjects, or in some cases, even very slowly moving subjects. The shutter will not release unless the little green dot viewfinder "in-focus indicator" is on.

Subject is regularly moving: This will require a little more work on your part. Since the AF system locks the focus on your subject, if your subject moves even slightly, the focus is no longer valid. You'll have to lift your finger off of the shutter release and reapply pressure halfway down to refocus. If the subject continues moving, you'll need to press the shutter release button halfway down, over and over, to keep the focus accurate. If your subject never stops moving, is moving erratically, or stops only briefly, single-servo AF (*AF-S*) is probably not the best mode to use. Continuous-servo AF (*AF-C*) is better because it never locks focus and you can better follow movement. You could also use auto select (*AF-A*) since it will automatically switch to continuous-servo AF (*AF-C*) if the subject moves.

Continuous-Servo AF Mode (AF-C)

Subject is not moving: When the subject is standing still, continuous-servo AF acts a lot like single-servo AF, with the exception that the focus never locks. If you have camera movement, you may hear your lens chattering a little as the autofocus motor makes minute adjustments in the focus position. Since it never locks in this mode, you'll need to be careful that

you don't accidentally move the AF sensor off of the subject or it may focus on something in the background instead.

Subject is moving across the viewfinder: If your subject moves from left to right or up and down in the viewfinder, you will need to keep your AF sensor on the subject if you are using *single-point* AF mode. If you are using *dynamic-area* AF, *auto-area* AF, or *3D-tracking*, your camera will have the ability to track the subject across a few

Example of Use

If you are shooting an air show, for instance, in 65 milliseconds a fast-moving airplane can move enough to slightly change the focus area by the time the shutter opens. If you press the shutter in one smooth motion all the way to shutter release, first autofocus occurs, then the mirror moves up and the shutter starts opening. That takes about 65 milliseconds in the D90. In the time it takes for the camera to respond to your shutter release press, the airplane has moved slightly, which just barely throws the autofocus off. The camera's computer predicts where the airplane will be when the image is actually exposed and adjusts the focus accordingly.

Additional Example of Use

Let's say you are playing a ball game and you throw the ball to a running player. You would have to throw the ball slightly in front of the receiving player so that he and the ball arrive in the same place at the same time. Predictive focus tracking does something like that for you so that you don't have to focus your camera in front of your subject and wait 65 milliseconds for it to arrive. That would be a bit hard to time!

or all of the 11 AF sensors. We'll cover this in more detail in the upcoming section "AF-Area Modes in Detail."

Subject is moving toward or away from the camera: If your subject is coming toward you, then another automatic function of the camera kicks in. It is called predictive focus tracking, and it figures out how far the subject will move before the shutter fires. Once you've pressed the shutter button all the way down, predictive focus tracking moves the lens elements slightly to correspond to where the subject should be when the shutter fires a few milliseconds later. In other words, if the subject is moving toward you, it focuses slightly in front of your subject so that the camera has time to move the mirror and get the shutter blades out of the way. It takes 65 milliseconds for the camera to respond to pressing the shutter release.

Predictive Focus Tracking Tips

Lens movement, especially with long lenses, can be interpreted by the camera as subject movement. Predictive focus tracking, in that case, is tracking your camera movement while simultaneously trying to track your subject. You can drive your camera crazy by attempting to handhold a long lens. Use a vibration reduction (VR) lens or a tripod for best results. Nikon says that there are special algorithms in predictive focus tracking that notice sideways or up and down movement and shuts it down. So, predictive focus tracking is not activated by the D90 for sideways or up and down subject movement or panning.

Auto Select AF Mode (AF-A)

This mode is the best of both worlds for a less-experienced user or someone who doesn't want to be bothered with selecting AF modes.

Subject is not moving: The camera sees a static subject so it uses single-servo AF (*AF-S*) mode automatically. Focus is static on the subject and does not continue updating. However, in my experience it is not really "locked" as when you are using normal AF-S mode.

Subject is moving: The D90 uses continuous-servo AF (*AF-C*), and as long as the subject is moving, the camera keeps seeking the best focus.

My observations: Quoting the User's Manual on page 54, "The camera automatically selects single-servo autofocus when subject is stationary, continuous-servo autofocus when subject is moving. Shutter can only be released if camera is able to focus."

I have done some tests on this mode and here is what I found:

When I focus on a static subject, the focus seems to lock. However, if I move the camera to a different subject, the D90 will often clearly go into *AF-C* mode and start autofocusing again. So, the focus only appears to be locked. It is not really locked, like in *AF-S* mode where you have to tap the shutter release to get a refocus. If the subject, or your camera, moves and a different focus plane is required (near to far), the camera will refocus.

When I focus on a moving subject, the camera will often hesitate to fire the shutter while there is no clear focus, but it sometimes seems to be a bit unsure and will fire anyway. Maybe it is switching rapidly between *AF-S* and *AF-C* modes as it detects movement from a previously static subject? I think the point of *AF-A* mode it that the camera detects subject movement, or the lack thereof, when you first press the shutter release to focus. However, the camera seems to be able to detect movement in a subject that was previously static and then switch to *AF-C* mode. I can't find any verification of this, but my own observations seem to bear it out. Try it yourself and see what you think.

Recommendation

Personally, I use *AF-S* most of the time because I often shoot static nature subjects. If you are shooting active events with moving subjects, *AF-S* will probably not work well for you and you should use *AF-C* mode. *AF-A* mode is an in-between mode that tries its best to deal with difficult subjects, often static but sometimes moving. If I were an inexperienced photographer, I would leave my camera set to *AF-A* mode. It works well enough to keep you out of trouble most of the time. I look at *AF-A* as I do any of the automatic camera functions. It is convenient, but I use it only when I need convenience. If I am doing critical work, I want full control and will generally turn off any automatic modes.

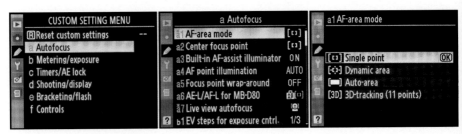

Figure 2 – *AF-area mode* selection screens, Single-point AF

AF-Area Modes in Detail

(User's Manual pages 173–176)

The AF-area modes are designed to give you control over how many AF sensors are in use at one time and offer various ways to track subject movement. Let's carefully examine each of the focus "area" modes. (See *Custom Setting a1* in chapter 7 and page 173 in the User's Manual.)

Here are the four AF-area modes in the Nikon D90:

1. *Single-point AF*
2. *Dynamic-area AF*
3. *Auto-area AF*
4. *3D-tracking (11 points)*

Figure 2 shows the AF-area mode screens in the D90.

Single-Point Autofocus

This mode uses a single AF focus sensor point out of the array of 11 points to acquire a good focus. Usually, the center AF sensor point is the one that provides focus information. You can control which sensor provides focus information if you have the AF focus points unlocked. You can use the thumb multi selector switch to select on of the 11 sensors.

Here is a common problem with single-point AF. If two people are standing next to each other, with a gap in the middle, your single center AF point will be examining the space between the two subjects. That will lead to a nice sharp picture of the background, with your friends out of focus. You can do one of three things to overcome this problem:

One, you could get the focus first by pointing the center sensor at the face of one of your subjects, pressing the shutter release button halfway to get a focus, then holding it down while recomposing the image. When you have recomposed the shot, you'll press the shutter release the rest of the way and take the picture. This is called the "focus and recompose" method.

Two, with the focus selector lock in the unlocked "dot" position (see *figure 1*); you can move the AF sensor point selector bracket around the viewfinder with the thumb switch. You can compose the picture first by centering it however you'd like, then using the thumb multi selector to move the single AF sensor until it rests on the face of one of your subjects. Then you'll press the shutter button halfway down to get good focus and the rest of the way down to take the picture.

Three, you can use auto-area AF with its ability to find the nearest subject and focus on it.

Example of Use

If a subject is not moving (a tree or a standing person, for example), then single-point AF and single frame release will allow you to acquire focus. Once the focus is acquired, the AF module will "lock" focus on the subject and it will not change. If the subject moves, your chosen focus point may no longer be perfect and you'll need to recompose while releasing and then pressing the shutter release button halfway again. Often, if the subject is moving very slowly or sporadically, I'll not even use continuous low speed (CL) release mode but will leave it in single frame (S) release mode. I'll tap the shutter button halfway to acquire focus when the subject moves and tap it again as needed. When I'm ready, I simply press the shutter release the rest of the way down, and I've got the shot.

Widen the Center AF Focus Point

If you want to make the center AF focus point significantly wider, change *Custom Setting a2* to *Wide zone*. You'll see that the center AF sensor brackets are much farther apart. This makes it easier to keep focus on a slowly moving subject while using single-point AF. *Wide zone* is not available in *Auto-area AF*. (See chapter 7, "Custom Setting Menu," and page 174 in the User's Manual.)

Any of these methods will solve the problem of having a perfectly focused background with out-of-focus subjects caused by a center AF sensor concentrating on the background between them.

Many of us will use single-point AF mode most of the time. It works particularly well for static or slowly moving subjects. When I'm out shooting beautiful nature images or at a party "snapshooting" pictures of my friends, I'll most often use *single-point AF area* mode, *single-servo AF (AF-S)*, and *single frame (S) release* mode.

Anytime I'm shooting a static or slowly moving simple subject, I'll use single-point AF along with single frame (S) or continuous low speed (CL) release mode. (See pages 64 and 74 of your D90 User's Manual.)

Now, let's move on to Dynamic-area AF, and see what benefits it offers us.

Dynamic-Area Autofocus
This mode is best used when your subject is moving. Instead of a single AF sensor used alone for autofocus, several sensors surrounding the one you have selected with your thumb switch are also active. *Figure 3* shows the *Dynamic-area AF* selection screens.

Once you've selected *dynamic area*, your camera has the capability to do

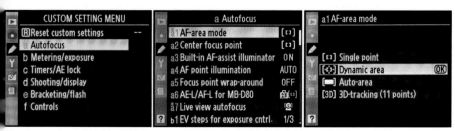

Figure 3 – *AF-area mode* selection screens, Dynamic-area AF

some basic subject tracking. When you look into the viewfinder, you won't see anything that helps you know you are in that mode. The viewfinder screen looks just like it does when the camera is in single-point AF mode. You still just see the one big bracket surrounding a small square AF point, and you can move it around among the 11 points with the multi selector thumb switch. However, there is a difference that is not visible.

In single-point AF mode, you are truly using a *single* AF focus point to get autofocus. Even though dynamic-area AF looks the same, there are in fact up to five AF focus points being used in this mode. Imagine a cross-shaped pattern of AF sensors, with the big-bracketed one in the center. You are still selecting a single AF point to start the autofocus in this mode. However, if the subject moves a bit and the selected AF sensor is no longer on the subject, the AF focus points surrounding the selected focus point will start providing autofocus services. They will take over when needed to keep the focus accurate. In *figure 4* is a look at the otherwise invisible cross-shaped pattern that can be

moved around the viewfinder with the multi selector thumb switch.

Notice how you lose one AF sensor in the pattern when you move it to the edge of the viewfinder in any direction. The only time you'll have five active sensors seeking a subject is when the selected AF sensor point is directly in the middle of the viewfinder. On the edges, only four sensors are active. The image on the left in *figure 4* shows the center pattern, while the image on the right shows the right edge pattern.

Can you see how flexible the dynamic-area AF mode is? Maybe you're doing some macro shots of a bee on a flower and the bee is moving around the blossom. The extra AF points allow you to track it around the small area without moving the camera.

11 Point Focus Tracking

We'll talk more about focus tracking with all 11 points later in this chapter by considering another pattern called 11 points (3D-tracking). This mode allows your D90 to use all its AF points for tracking and to pay attention to the color and brightness of the subject to improve tracking accuracy with some subjects.

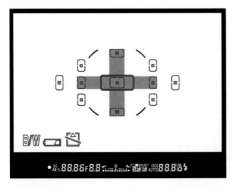

Figure 4 – *AF-area* mode sensor point patterns in dynamic-area AF

Or, you might be panning with a running person during a football game and use the extra AF points to stay with the subject without losing the focus, even if your main AF point leaves the subject briefly.

Auto-Area Autofocus

This mode turns the D90 into an expensive point-and-shoot camera. Use this mode when you simply have little time to adjust your camera but would still like to get great images. The AF module decides what the subject is and selects the AF sensors it thinks work best. *Figure 5* shows the *AF-area mode* selection screens.

When you use this mode, you'll notice how the camera itself selects various AF points as it examines the entire view its lens finds. Usually, it will select the closest and brightest subject, with special emphasis on human shapes.

According to Nikon, if you are using a D or G lens, there is human recognition technology built into this mode. Since most of us will be using *auto-area AF* only

when we want to shoot for fun—say, at a party—the human subject that is closest to the camera is the most likely subject anyway. Your D90 can usually detect a human and not focus on the background instead. Face recognition technology has come a long way in the last few years. Nikon has given you a great tool for taking sharp pictures of people when you use *auto-area AF* mode.

If you are shooting nonhuman subjects, just pay careful attention to what the camera considers to be the subject. Usually, it will select what you want it to select. However, if you are focusing on an object in the middle distance and the camera notices a brighter and closer object between you and your subject, it may very well choose the closer object. Using this mode means that you must keep watch on what the camera thinks the subject is and move slightly if it won't focus where you want it to focus.

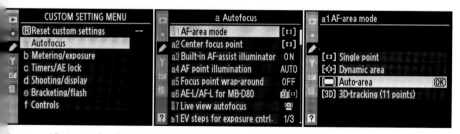

igure 5 – *AF-area mode* selection screens, auto-area AF

3D-Tracking (11 points) Autofocus

This mode is designed for action shooters. Images of sports, moving animals, races, and air shows all benefit from the camera tracking a subject. You'll select your subject by using one of the AF sensor points. If the subject moves, the camera will hand off the AF responsibility to other sensors. As the subject travels across the viewfinder, the adjacent sensor will take over. You can see this progression because the D90 displays which AF sensor point is active at any particular moment. *Figure 5A* shows the menu screens to select 3-D tracking (11 points).

An easy way to see how this works is to select *3D-tracking* with *Custom Setting a1*. This mode is only available if you have *AF-A* or *AF-C* focus mode active. If you have *AF-S* selected, *3D-tracking* will be grayed out on the menu. Now, focus on a static subject and slowly move your camera away from the subject. You'll be able to see the tracking happen as the AF sensor in use changes to a different one. It is quite fascinating to see how this happens when you are focusing on a moving subject.

Example of Use

Let's imagine that you are photographing a bird perched in a tree but you want some shots of it in flight. You are patiently waiting for it to fly. You have *Dynamic-area AF* selected with all 11 AF points active so the camera will track the bird instantly when it starts flying. You've already established focus with the sensor you selected using the thumb multi selector switch and are holding the shutter release halfway down to maintain focus. You've also previously set the release mode to CH -continuous high speed so that you can fire off rapid bursts of images (up to 4.5 per second). Suddenly, and faster than you can react, the bird takes to flight. By the time you can get the camera moving, the bird has moved to the left in the viewfinder, and the focus tracking system has reacted by instantly switching away from the primary sensor you established focus with and is now using other AF sensors, within the 11, to maintain focus on the bird. You press the shutter release all the way down, and the images start pouring into your SD memory card. You are panning with the bird, firing bursts, until it moves out of range. You've got the shot, yet again!

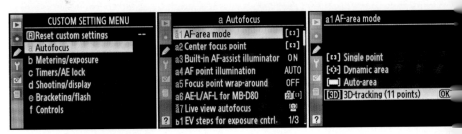

Figure 5A – *AF-area mode* selection screens, 3D-tracking (11 points)

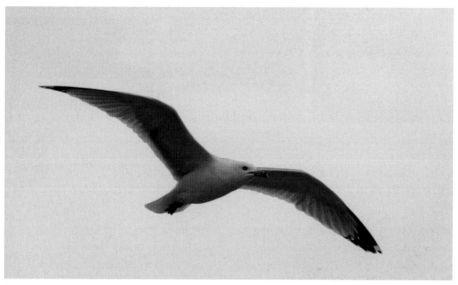

Figure 6 – Picture of a flying seagull taken using focus tracking

As a bird flew across the sky and my camera moved while I panned with it, it was gratifying to see the AF focus points jumping around on the viewfinder as my aim varied. The focus stayed right with the bird, and I was able to capture several sharp images.

In *figure 6* is a picture of a bird that I took using focus tracking as described in my example.

Nikon says that the camera uses color and brightness information to track your moving subject when you use *3D-tracking (11 points)*. Here is a direct quote from a Nikon website: "When using *3D-tracking (11 points)* mode, the camera uses your subject's color and brightness information to keep it in sharp focus as you change the composition."

Recommendation

I normally use single-point AF most of the time since my static subjects call for it. However, when I am shooting images like the one of the flying bird, I'll switch immediately to *3D-tracking (11 points)*. I use dynamic-are AF when I am shooting macro shots primarily. I even use auto-area AF at parties. I recommend that you use all these AF-area modes as your needs vary. Don't be afraid to learn them well. It will definitely improve your photography if you learn when to switch between these modes. One thing to test for yourself is whether or not any particular mode is fast enough for you. Anytime the camera has to process more data, or "think deeper thoughts," it will take a little more time to obtain a good focus.

We've covered the focus and AF-area modes pretty well, so now let's move on to the release modes.

 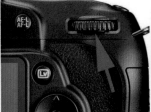

Figure 7 – Release mode selection with the external camera controls

Release Modes in Detail

(User's Manual pages 64–69)

The D90 has several release modes, which determine how many and how fast images can be taken. *Figure 7* shows the release mode button and the rear main-command dial. You press the button and turn the dial to select the release modes.

Now let's look at each release mode in more detail.

1. *S* – single frame (S)
2. *L* – continuous low speed (CL)
3. *H* – continuous high speed (CH)

In the good-old film days, these three release modes would have been called "motor-drive" settings because they are concerned with how fast the camera is allowed to take pictures. We've already talked about these modes to some degree earlier in this chapter in our consideration of the AF-area modes. However, let's look at each of the three release modes in greater detail now.

Single Frame (S) Mode

This is the simplest frame rate because it takes a single picture each time you depress the shutter release fully. No speed here. This is for those shooting a few frames at a time. Nature shooters will often use this mode since they are more concerned with correct depth of field and excellent composition.

Figure 8 – Single frame mode indicator

Continuous Low Speed (L or CL) Mode

This mode allows you to select an image taking rate (frame rate) between 1 and 4 frames per second (fps). The default frame rate from the factory is 3 fps, which seems about right for most of us. If you want more or less frame rate speed, simply adjust *Custom Setting d6(CL mode shooting speed)* and select your favorite frame speed. (User's Manual page 64 and chapter 7 in this book.)

Figure 9 – Continuous low speed mode indicator

Continuous High Speed (H or CH) Mode

This high speed mode is designed for when you want to always go fast! The camera will attempt to capture 4.5 frames per second every time you hold the shutter release button down. This is a great mode for action shooters who want to get as many frames as possible to select the best ones for later use. Think about it: in

Figure 10 – Continuous high speed mode indicator

about 10 seconds you can fire off up to 40 frames if your shutter speed allows it. If you like to hold down the shutter release and get lots of pictures, your camera is happy to oblige!

Recommendation

Once again, here's functionality that may require you to use all the modes at one time or the other. I usually have my camera set to *S*-single frame mode since trees and mountains are not known to move around quickly. However, sometimes I'm shooting an event that requires mashing the shutter release and hoping for some great shots. I like to shoot birds in flight and even bigger birds at air shows. In those situations, I'll set my camera to *L*-continuous low speed (*CL*) or *H*-continuous high speed (*CH*) and fire away. I select the speed according to how many images I want to capture per second. If I want all the images I can possibly cram onto my memory card, I'll select *CH* and get my 4.5 frames per second. If I want fewer frames but still want to fire quickly, I'll use *CL* and set the frame rate between 1 and 4 frames per second. Learn to use all three of these modes for the best camera control.

More Release Modes are Available

There are three more modes available in the release modes. Since this is a special chapter to bring together information related to effectively using the Multi-CAM 1000 autofocus system, I did not cover *Self-timer, Delayed remote,* or *Quick-response.* Those three are covered thoroughly in chapter 7.

 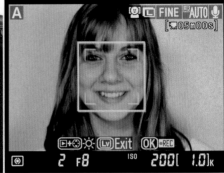

Figure 11 – Live View (LV) mode

Live View Autofocus

(User's Manual pages 43–47)

Live View (LV) Mode

Normally one would not use the LCD monitor to compose an image because that is not as stable as holding the camera close to your body and could result in shaky images.

However, in some instances a live view through the monitor is quite useful. For instance, what if you want to take an image of a small flower growing very close to the ground? You could just lie down on the ground and get your clothes dirty, or you can use *LV* mode instead. Or, what if you need to shoot over the heads of a crowd to get the arrival of a dignitary? *LV* mode allows you to see what your camera's lens sees, without using the viewfinder.

Anytime you need to take pictures high or low, or even on a tripod, the D90 will happily give you that power with its *LV* mode. How hard is it to get the camera into LV mode? Simply take off your lens cap and press the *LV* button on back of the D90.

There are three modes in Live View that we need to consider:

1. *Face priority*
2. *Wide area*
3. *Normal area*

Now, let's take a look at the external camera controls we'll use to select one of the three modes (*figures 11, 12, and 13* all show face priority mode). There are two primary ways to select *LV* autofocus modes. You can use external camera controls or *Custom Setting a7* menus.

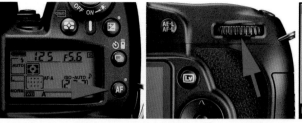

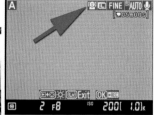

Figure 12 – External controls to select Live View autofocus modes

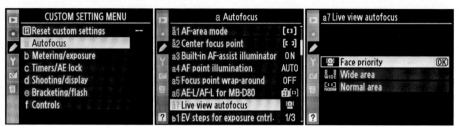

Figure 13 – *Custom Setting a7* menu to select Live View AF modes

Figures 12 and *13* both show ways to set LV autofocus modes.

Figure 12 shows the external camera controls: the AF button, the rear main command dial, and the rear main LCD screen.

In *figure 13* is the *Custom Setting a7* menu for configuring Live View AF (instead of using external camera controls).

Here is a detailed look at each of the Live View autofocus modes.

Face Priority Mode

If you take a lot of Live View pictures of people, this is your mode. The D90 has face recognition technology. In fact, it probably smiles when *you* pick it up!

If you use this mode, your D90 will search for faces and focus on them automatically. You'll see a little yellow double-framed square surrounding the face. (First frame is solid, second frame

Figure 14 – Face priority LV autofocus

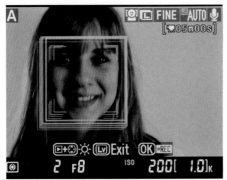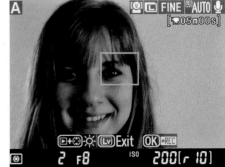

Figure 14A – *Face priority sees a face*

is broken; see *figure 14A*.) The camera will follow the face if you move it slowly. Try it! From experimentation, I have found that the D90 does not see profiles but must be looking directly into a face to find it. It looks for the eyes evidently, because wearing sunglasses usually prevents the camera from seeing the face. I had my wife put her hand over her eyes, and the D90 lost her face. I had her cover her mouth, and it still saw her face. When she covered her nose and mouth, the D90 lost her face again. So, it seems to me that the camera is looking for an eye/nose relationship to recognize a face. In fact, when the little yellow square appears, it seems to expand from and center on the tip of the nose.

When taking a close-up of a face, I've noticed that the little green AF square might select an eye to do final AF (see *figure 14A*, the image on the right). Why not experiment with this yourself?

Figure 14A shows the frames that you'll see if your D90's face priority mode detects a face. When it first finds the face, it displays the yellow frame. When you are autofocusing on the face, the frame turns green. If it can't autofocus on the face successfully, the frame turns red. While you are preparing to take the shot, the little yellow frame is tracking the person's face. If the person or your camera moves, the yellow frame will jump around a bit. You can see the frame moving in the first image in *figure 14A,* which is a handheld shot.

If you see only a little green square, with no double frame, then the D90 cannot see any faces in the image. Ask your subject to turn her face directly into the camera so that the D90 can see both eyes. If the D90 can't find a face, it acts like it's using the wide area mode. The green frame looks the same.

Let's look at the wide area mode next.

Wide Area Mode

The wide area mode (*figure 15*) is used mostly for shooting landscapes or other subjects needing a broad autofocus area. The little autofocus square is at least twice as large as it would be in normal mode. It considers a broader area for contrast detection. You can move the AF square around the screen to any point in the frame. This gives you autofocus flexibility, although the slow speed of contrast detection AF will hold you back from using it with anything but the slowest moving subjects.

At first the AF square will be red because the camera is probably in an unfocused state. When you press the shutter release halfway down, the camera will attempt to focus and the AF square will flash green. The AF square will stop flashing and will simply be green if focus is good. When focus is achieved, you'll hear a quiet beep. If it can't focus, it will flash red, but be careful because you can still press the shutter and get an unfocused picture.

Figure 15 – Wide area LV autofocus

Normal Mode

This mode is for more precise tripod work, such as close-ups and images in which a small area provides the focus point of interest. The AF square gets rather small, but you can still move it to any part of the screen and focus where you'd like (*figure 16*).

It works just like normal mode otherwise, with the same flashing green while AF is happening, solid green and a beep when AF has been successful, and flashing red if it can't get accurate autofocus.

Figure 16 – Normal mode LV autofocus

Auto Focus During Video Recording

Since you can go into video recording mode while in Live View merely by pressing the *OK* button, you should be aware that autofocus does not work at all during video recording. You should obtain your autofocus before you press *OK* to start recording videos. If you zoom your lens during a video, you may have to refocus manually. Feel free to zoom in and out, refocus, and have fun capturing videos from LV mode.

Recommendation

Of the three available modes, I most often use the *normal* mode because I use LV mode mostly for macro and close-up work. I've found that bending over a camera for periods of time while doing some types of macro work can cause neck or back strain. It is much easier to use LV mode and focus on my subject.

Figure 17 is an image of a lovely "hot-out-of-the-oven" chuck roast with potatoes, carrots, and onions that I "captured" just before it was devoured by several hungry children and my wife.

I find LV mode to be quite easy to use for macro work, and I recommend it. The contrast detection is somewhat slow, but I can zoom in for very accurate views of my subject. You can use the normal zoom in and out buttons (*figure 18*) to get accurate autofocus on very specific areas of your subject.

Figure 18 – LV mode zoom in and out buttons

Figure 17 – Chuck and round roast macro

My Conclusions

I've followed the development of the Nikon autofocus systems since the late 1980s. My first camera with autofocus was the Nikon F4 professional film SLR. Through 21 years, I've experienced each new level of autofocus released by Nikon. It's gotten better and better with each new generation!

Autofocus with the D90 is a real pleasure. Nikon has really learned how to make excellent technology. The D90 has a more powerful AF system than any enthusiast camera before it, and yet it's somewhat simplified in its operation. Great job, Nikon!

The AF system is still necessarily complex though. If you'll spend some time with this chapter, and chapter 7 on *Custom settings a1 to a7*, you should come away with a much greater understanding of the D90's AF module. Moreover, you'll learn how to adapt your camera to work best for your style of photography.

Enjoy your D90's excellent Multi-CAM 1000 autofocus system!

Nikon Creative Lighting System and the Nikon D90

What Is the Nikon Creative Lighting System (CLS)?

The Nikon Creative Lighting System (CLS) is an advanced wireless lighting technology that allows you to use your imagination in designing "creative" lighting arrangements. No wires are used, and the remote flash units are controlled by a central "commander." You can use the commander mode built into the D90 or on a hot-shoe-mounted commander device such as the SB-800 and SB-900 Speedlights, or the SU-800 Commander Unit.

You can easily experiment with setups and flash output, with visual preview of how things look. You do this by firing the pulsed modeling capability within Nikon's Speedlights when you press the D90's depth-of-field preview button.

There is no need to figure complex lighting ratios when you can control your flash groups right from the camera and see the results immediately. CLS simplifies the use of multiple flash unit setups for portraiture, interiors, nature, or any situation where several Speedlights need to work in unison.

You can simply position the flash units where you'd like them to be and let CLS automatically figure the "correct" exposure, or you can change the lighting ratios directly from the *Commander mode* menu of your D90 or hot-shoe-mounted Commander Unit.

Nikon's Creative Lighting System is world-class in power and not too difficult to use. The Nikon D90 camera contains everything you need to control a simple or complex CLS setup. Let's learn how to use it!

How Does the D90 Fit into the CLS Scheme?

The Nikon D90 camera commands attention, both in a crowd and in commander mode as a controller for multiple Nikon Speedlight flash units. While the professional-level Nikon D3 *requires* the separate purchase of a hot-shoe-mounted commander unit, full Nikon Creative Lighting System (CLS) technology is built right into the D90 body .

You can use normal i-TTL (intelligent through-the-lens) flash technology with the D90's pop-up flash (Nikon calls it a Speedlight) or use *Commander mode* and the pop-up to control up to two banks of an unlimited number of external Nikon Speedlight flash units. Nikon makes the powerful SB-800 flash unit, along with its slightly less-powerful SB-600 brother and several other smaller Speedlight units, such as the SB-400 and SB-R200. Many of us using the D90 will have an external flash unit, and it will usually be the SB-800 or SB-600, so we'll consider those in detail in this chapter. The Nikon D90 is happy to let you arrange professional lighting setups using these relatively inexpensive and very portable Speedlights.

Later in this chapter, we'll also consider how the D90 can use the SB-800 Speedlight's *Commander mode* or the SU-800 Commander Unit instead of the built-in commander mode since the external units provide maximum range and flexibility in large flash bank arrangements. The cool thing about the D90 is that it can *be* a CLS flash commander or it can *use* Nikon's other CLS flash commanders at will. You have great control with this fine camera!

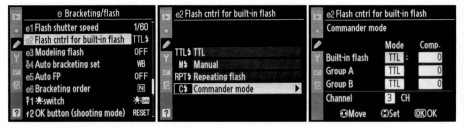

Figure 1 – *Commander mode* setup screens

What Is Commander Mode and How Does it Work?

Commander mode is controlled from a screen in the menu of your D90. (See *figure 1.*)

If you examine this built-in flash mode screen, you'll see that you have controls for the built-in flash and two groups, or banks (A and B), for external flash units. You'll also see that you can set exposure compensation for them.

If you leave *Custom Setting e3 (Modeling flash)* set to the factory default setting of *ON*, you can test-fire your Speedlight's built-in modeling lights by pressing and holding the D90's depth-of-field preview button. Or, if you prefer, simply take a picture and look at it.

If the main light is too bright, you can either move it farther away or dial its power down by setting compensation (*Comp.*) to underexpose a little. You can set *Comp.* in 1/3 stop increments so you have very fine control of each group's flash output. The point is that you have control to experiment until you get the image just the way you want it. Sure, you could do things the old way: use a flash meter or get your calculator and figure out complex fill ratios. Or, you can simply use CLS to vary your settings visually until the image is just right.

This sample CLS Photo by J. Ramón Palacios (jrp) required one SU-800 as commander coordinating with two SB-800 Speedlights.

Isn't it more fun to simply put some initial settings in your *Commander mode* screen and then take a test shot? If it doesn't look right, change the settings and do it again. Within two or three tries, you'll probably get it right and will have learned something about the performance of your CLS system. In a short time, you'll have a feel for how to set the camera and flash units and will use your flash/camera combo with authority.

That's about the time your happiness will overflow and you'll start buying flash umbrellas and light stands and begin offering your portrait services to any subject that you can find — just for the fun of it!

Using the Nikon D90 in Commander Mode

Gather up your Nikon D90 and its user's manual. Keep them close by since we will refer to the camera and manual for additional details.

Let's start by putting the Nikon D90 camera into commander mode. We'll do that by changing *Custom Setting e2* to *Commander mode*.

Normally, Custom Setting e2 defaults to TTL instead of Commander Mode. We can see both selections in the list shown in the second screen of *figure 2*.

TTL represents the single-flash i-TTL technology used by the camera's pop-up Speedlight or by any i-TTL compatible flash unit you put in your Nikon D90's hotshoe. Since this chapter is about controlling multiple flash units, we'll select *Commander mode* as shown in the second screen of Figure 2. The third screen allows us to configure how our D90 will control up to two banks of an unlimited number of Speedlight flash units.

Let's discuss the settings. First we'll look at the *Commander mode* in TTL, which is the easiest to use because it allows you to set exposure compensation for each of your flash groups. Next we'll look at *M* mode because that gives you adjustable steps to control your flash

Monitor Pre-Flashes

What are monitor pre-flashes? Here is a short tutorial: When you press the shutter release button with the flash open, the D90's pop-up Speedlight fires several brief pre-flashes and then fires the main flash. These pre-flashes fire anytime your camera is set to i-TTL mode, even if your D90 is controlling multiple flash units. The camera can determine a very accurate exposure by pre-flashing your subject, adjusting the exposure, and then firing the main flash burst.

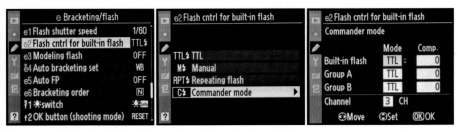

Figure 2 – *Commander mode* menu screens

from full power to 1/128 power. We'll briefly look at AA mode. Then finally we'll consider the -- mode, which prevents the D90 pop-up flash from firing the main flash output but does not stop the necessary monitor pre-flashes.

When your D90 is controlling multiple Speedlights you must *always* raise the pop-up flash on your D90. The D90 communicates with the external flash units during the monitor pre-flash cycle.

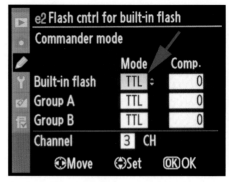

Figure 3 – The *Mode* selection screen for *Commander mode*

> **Speedlight Tip**
>
> Position the sensor windows on the external Speedlights where they will pick up the monitor pre-flashes from the built-in flash. Take particular care when not using a tripod.

Nikon D90 Commander Mode Settings

Basically the *Commander mode's* Mode fields will display the following selections. Use your thumb toggle switch to change the values, as shown in *figure 3*.

1. *TTL*, or i-TTL mode
2. *AA*, or auto aperture mode
3. *M*, or manual mode
4. *--*, or double-dash mode (what else would one call it?)

TTL mode – The *TTL* setting represents using the full power of i-TTL technology. By leaving *Mode* set to *TTL* (as shown in *figure 3*) for *Built-in flash*, *Group A*, and *Group B*, you derive maximum flexibility and accuracy from all your flash units. In this mode, the *Comp.* setting (*figure 3*)

will display exposure values from -3.0 EV to + 3.0 EV, a full 6-stop range of exposure compensation for each group of Speedlights. You can set *Comp.* in 1/3 EV steps for very fine control.

AA mode – I am only briefly touching on the *AA* mode because that is an older non–i-TTL technology included for those accustomed to using older technology. With the SB-800, it is used primarily by cameras not compatible with the Creative Lighting System. It is not available for the built-in pop-up Speedlight on the D90 or for the SB-600. You can safely ignore the AA mode unless you want to experiment with it. It may not provide as accurate a flash exposure as *TTL* mode though, since it is not based on the amazing i-TTL technology. Otherwise, it works pretty much the same as *TTL* mode.

M mode – This allows you to set different levels of flash output in 1/3 stops for the pop-up flash or the Speedlights in groups A or B. The settings you can put in the *Comp.* field are between 1/1 (full) and 1/128. The intermediate 1/3 stop settings are presented as decimals within the fractions. For example, 1/1.3 and 1/1.7 are

1/3 and 2/3 stops below 1/1 (full). Many people are used to working with flash units this way, so it may seem more familiar. CLS is willing to oblige those experienced in working manually.

-- **mode (double-dash mode)** – The built-in pop-up Speedlight will not fire the main flash in this mode. It will fire the monitor pre-flashes because it uses them to determine exposure and communicate with the external flash groups. Be sure you always raise the D90's pop-up flash in any of the commander modes; otherwise, the flash groups will not receive a signal and won't fire their flashes.

When setting *Mode* for Group A or B to double-dash -- mode, that entire group will not fire any flash output. You can use this mode to temporarily turn off one of the flash groups for testing purposes.

Pre-Flashes May Effect Lighting

Since the pop-up's monitor pre-flashes always fire, be careful that they do not influence the lighting of your image. Use a smaller aperture, or move the camera farther away from your subject if the pre-flashes add unwanted light.

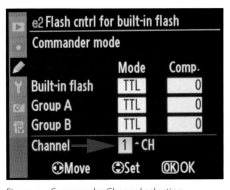

Figure 4 – Commander Channel selection

Setting the Channel (CH) for Communication

Look at *figure 4*, or your D90's *Commander mode* screen, and you'll notice that just below *Group B* you'll see a Channel 1 *CH* selection. The number 1 (factory default) is the communication channel your D90 is expecting to use to talk to the external flash groups.

You can select any number from 1 to 4. There are four channels available, just in case you happen to be working in the vicinity of another Nikonian who is also using *Commander mode*. By using separate channels, you won't interfere with each other.

It is important that you realize that all your external flashes in all the groups must be on the same channel. This involves setting up your individual flash units to respond on a particular channel. They might be in separate groups or banks, but they must be on the same channel.

Now, which Speedlight flash units can you use with your new Nikon D90 commander mode knowledge?

Figure 5 – SB-900 Speedlight

Figure 6 – SB-800 Speedlight

Figure 7 – SB-600 Speedlight

Figure 8 – SB-R200 Speedlight

Selecting a Nikon Speedlight Flash Unit

Nikon makes several Speedlight units that work very well with the Nikon D90. I personally have used the SB-600, SB-800, and SB-900 units with the D90. There are also the R1C1 flash units (SB-R200), which are designed to be used in small groups, such as for a ring-light arrangement. *Figure 5* shows an SB-900 Speedlight.

I really enjoy using the Nikon SB-900 Speedlight unit. It's very powerful and easy to use in the CLS arrangement because it has external controls for setting remote mode. It can also be used as a CLS commander when needed.

The SB-800 Speedlight unit is close to the power of the SB-900 (one stop less) and also has the ability to be a CLS commander (*figure 6*). The controls are not as easy to use as the SB-900's controls, but the cost is less for almost the same level of power. I've used these successfully for several years.

The Nikon SB-600 Speedlight unit is the low-cost flash for users on a budget (*figure 7*). It is about one stop less powerful than the SB-800 unit and costs considerably less. Buying several of these won't set you back much in cost and will allow you to set up a great CLS system with your D90. If you are just getting started in CLS, these might be your best investment. The SB-600 doesn't have a built-in commander mode itself, like the SB-800 and 900, but you don't need it because your D90 does.

Then there are the SB-R200 Speedlight units (*figure 8*). These are primarily designed to use in special arrangements on brackets that Nikon created for them. You'll see these Speedlights in use if you

watch many crime dramas on TV because the investigators often use them for close-up flashes of crime scene evidence.

My Conclusions

The Nikon D90 gives you control over the world-class Nikon Creative Lighting System. It is the envy of many other camera brand manufacturers and users.

Rocky Nook / Nikonians Press has an excellent book dedicated to this subject. Check Amazon.com and book stores for *The Nikon Creative Lighting System: Using the SB-600, SB-800, SB-900, and R1C1 Flashes* by fellow Nikonian Mike Hagen (*figure 9*).

I recommend that you buy a copy of Mike's book as an excellent way to increase your knowledge of the Nikon CLS system. My book covers CLS only in relation to the Nikon D90 camera body. Mike's book goes into great detail on

using Nikon cameras to control all the major flash units that Nikon currently makes. With these two books and some practice, you can become a Nikon Creative Lighting System expert!

I also suggest that you find a good book on lighting techniques and study it carefully. You'll have to learn how to control shadows and reflections. Plus, you'll have to understand something about lighting ratios so that you can recognize a good image when you see one.

Buy a couple of light stands and some cheap white flash umbrellas and set up some portrait sessions of your family or even some product shots. With the Nikon D90 and even one extra Speedlight, you can create some very impressive images with much less work than ever before.

The really nice thing is that the Nikon Creative Lighting System, executed by your Nikon D90's commander mode and external Speedlight flashes, will allow you to shoot without worrying so much about detailed exposure issues. Instead, you can concentrate on creating a great-looking image.

Figure 9 – *The Nikon Creative Lighting System,* by Mike Hagen

Figure 10 – Single Flash Nikon CLS compared to direct flash

D-Movie Mode: Video on Demand

A short while after unpacking our brand-new D90, I was preparing to take off for an out-of-town convention with my wife. We were making preparations and—of course—packing our cameras. The preparations led to an interesting conversation. It went something like this:

"Well, honey, what camera equipment are we going take with us?" I asked. "I think we should take our D90 and your video camera."

Brenda replied with raised eyebrows, "Well, I agree with you about the D90, but why do we need a video camera too? The D90 takes great video and we'll only need one bag!"

"Hmm, you're right. We don't need the extra weight and aggravation of carrying two pieces of equipment when just one will do," I answered, while thinking, "*I'm glad I married this woman. She's the one who wanted a D90 in the first place.*"

So, off we went to our convention with the Nikon D90. We took lots of pictures and several videos and learned some things in the process. How well does D-Movie mode work? What are the pros and cons of using the D90 compared to using a regular video camera? Can the D90's D-Movie mode replace a dedicated video camera? Let me tell you what I found—after we discuss some video basics that you really ought to know (if you don't already).

Basic Video Standards Information

I don't want to get too deep into theory in this chapter because most people are not really interested in reading a technical manual. However, since the Nikon D90 is also capable of video camera functions, it's good to understand some basics.

High-Definition (HD) Video

Before shooting your first D-Movie, you'll need to configure the camera for the correct video frame size; that is, the number of pixels that are in each frame. We'll look into the actual configuration in a later section. For now, let's just discuss some basics.

Here are the available D-Movie frame sizes in your D90 (User's Manual page 170):

1. 1280 x 720 pixels (720p - 16:9 format HD) – 24 fps
2. 640 x 424 pixels (3:2 format SD) – 24 fps (default)
3. 320 x 216 pixels (3:2 format SD) – 24 fps

A video frame is much smaller pixel-wise than a normal still image frame. While your D90 can create beautiful 12-megapixel still images, its best high-definition video image is just below 1 megapixel, at 921,600 pixels, or 0.9 megapixels.

Whoa! How can less than one megapixel be considered high-definition (HD)? Simply because it matches one of the broadcast resolutions for high-definition television (HDTV). In the good old days of standard-definition television (SDTV) that we all grew up watching, there was

even less resolution. Would you believe that the old TV you have stored in the garage displays only 345,600 pixels, or 0.3 megapixels?

I've been talking about the number of megapixels, but that's not normally how HD devices are rated. Instead of the number of pixels, most HD information refers to the number of "lines" of resolution. There are several HD standards for lines of resolution. The standards that are probably the most used are 720p, 1080i, and 1080p. The *p* and *i* after the numbers refer to *progressive* and *interlaced*. We'll talk about what that means in the next section.

The D90's best D-Movie mode captures in 720p, which is a broadcast-quality HDTV standard. The 720 simply means that your camera captures and displays HD images with 720 lines of vertical resolution. Each of those lines can be 1,280 pixels long, which allows the D90 to match the 16:9 aspect ratio expected in HDTV. An older SDTV usually has an aspect ratio of 4:3, which is taller and narrower than the HDTV 16:9 aspect ratio.

If you are interested in more extensive information on this topic, there's a huge amount of technical detail available. Here are a few good links at Wikipedia.org:

http://en.wikipedia.org/wiki/
 High-definition_television

http://en.wikipedia.org/wiki/
 Aspect_ratio_(image)

http://en.wikipedia.org/wiki/
 Frame_rate

These references will get you started, and you can use your favorite search engine to find even more. I'm covering only the high points in this chapter.

Progressive vs. Interlaced

What's the difference between progressive and interlaced? Technically speaking, *progressive* video output displays the video frame starting with the top line and then draws the other lines until the entire frame is shown. The D90 displays 720 lines progressively from top to bottom of what the imaging sensor captured (lines 1,2,3,4...720, etc.).

Interlaced displays every even line from top to bottom, then comes back to the top and displays every odd line (Lines 2,4,6,8...720, then 1,3,5,7...719, etc.) .

Here are two Wikipedia.org references to help you read up on video scan types:

http://en.wikipedia.org/wiki/
 Progressive_video

http://en.wikipedia.org/wiki/
 Interlaced_video

Usually, progressive output provides a better-quality image with less "flicker" and a more cinematic look. I'm sure that's why Nikon chose to make D90s shoot progressive video.

Now, let's set up our cameras and make some D-Movies!

Camera Setup for Making D-Movies

We discussed this subject briefly in chapter 1, "Using the Nikon D90"; however, we'll now go into much more detail. Later in this chapter, we'll also examine some D-Movie mode limitations about which you should be aware.

Before you make your movie, you need to adjust three settings on your D90:

- *Setup Menu – Video mode – Encoding method* (*NTSC* **or** *PAL*)
- *Shooting Menu – Movie settings – Quality*
- *Shooting Menu – Movie settings – Sound*

Which Video Encoding Method?

The D90 allows you to record using either NTSC or PAL encoding methods. These are two different video encoding systems, with NTSC being the standard in North America, Japan, some of South America, and a few other areas, and PAL the standard in most of Europe, Asia, and Australia. There is very little quality difference between the two encoding standards.

Figure 1 shows the *Setup Menu* screens used to select the encoding mode (User's Manual page 203).

Here are the steps used to set the mode:

1. Press the *MENU* button and scroll to the *Setup Menu* (wrench icon).
2. Select *Video mode*, and then scroll to the right.
3. Select *NTSC* or *PAL* from the menu. (You'll need to refer to the manual of your display device to determine what video encoding type it uses.)
4. Press the *OK* button to set the mode and return to the *Setup Menu*.

Recommendation

If you live in the United States, you'll probably use NTSC (which stands for National Television System Committee). If you live in Europe, you probably use PAL (Phase Alternating Line). Check your display device manuals and guides.

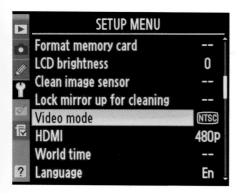
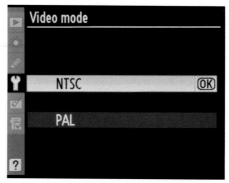

Figure 1 – Video encoding mode

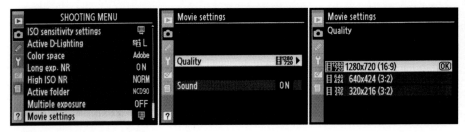

Figure 2 – D-Movie *Quality* settings

Selecting a D-Movie Video Quality

There are three basic D-Movie *Quality* settings available in the D90. The first, 1280 x 720, is for when you want to shoot high-definition video for display on HD devices. The other two settings, 640 x 424 and 320 x 216, are standard-definition modes for display on SD devices.

Figure 2 shows the *Movie settings* screens (User's Manual page 170).

As mentioned in a previous section, there are three available D-Movie frame sizes in your D90:

1. 1280 x 720 pixels (720p) (16:9 format HD) – 24 fps
2. 640 x 424 pixels (3:2 format SD) – 24 fps (default)
3. 320 x 216 pixels (3:2 format SD) – 24 fps

To select one of the *Quality* settings, do the following:

1. Press the *MENU* button and scroll to the *Shooting Menu* (small green camera).
2. Select *Movie settings*, and then scroll to the right.
3. Select *Quality*, and then scroll to the right.
4. Select one of the three available *Quality* settings.
5. Press the *OK* button to select a setting.

The *Quality* setting also changes how large the resulting video movie is to store on your computer's hard drive. It has been my experience that the D90 uses the following amounts of storage memory when recording videos. These are approximations and will vary with the subject matter's detail:

- **1280 x 720**: 585 MB for a 5-minute video, 1950 KB per second. Full-length movie fits on a DVD or CD. For storage and later copying to a computer.
- **640 x 424**: 248 MB for a 5-minute video, 992 MB for 20 minutes, 826 KB per second. *Full-length movie can be stored on a DVD only.*
- **320 x 216**: 119 MB for a 5-minute video, 447 MB for 20 minutes, 398 KB per second. Full-length movie fits on a DVD or CD for storage.

Remember, these values may vary greatly according to how complex the scene and how much motion is in the video. These are just base values I found by videoing a medium-complexity subject with little movement. Depending on your capture, your storage experience may vary.

The D90's factory default video mode is set to 640 x 424 pixels (3:2 aspect ratio),

which is good for keeping the video file sizes down somewhat. However, it is not an HD mode. If you want to make even smaller videos, you can choose the 320 x 216 pixels (3:2 aspect ratio) mode. Each of these two modes allows you to shoot up to 20-minute video clips. That is a generally sufficient length for many uses.

The video clips are limited in length to 5 minutes for high-res 1280 x 720 (16:9 aspect ratio) and will record video of sufficient resolution to be displayed on an HD device, such as an HDTV.

The file format used by the D90's video is the popular AVI format. This is handled by virtually all computer movie players and is the default format for Microsoft Windows Media Player. AVI stands for Audio Video Interleave.

A computer should display any of the video formats, as will a standard TV (SDTV). Any of the video modes, including the HD 1280 x 720, will play on your SDTV through the "included in the box" AV cable. The HD mode displays in the wide-screen format with a black space at the top and bottom of the picture. Using an HDMI mini (Type C) to HDMI standard (Type A) cable, you can play full HD videos on an HDTV. This HDMI cable is not included with the camera. It is easily available online and in many electronics stores. There will be more about how to display video in a later section, including pictures of the cables.

Note

The actual video frames recorded inside the AVI file are in OpenDML JPEG video or Motion JPEG (M-JPEG) format.

Recommendation

I like to shoot longer videos, so I often use the 640 x 424 mode. It has enough resolution that I can display it on my computer monitor and it easily works on a standard television (SD) for Grandma and Grandpa to see. If their TV doesn't have RCA jacks to plug in the AV cable, their VCR usually does. The 20-minute length of 640 x 424 is usually sufficient for what I am shooting and displays full screen on an SDTV. If I know I can get by with a 5- minute length, I may switch to HD mode (1280 x 720), especially if I am shooting a video of some spectacular place. HD video will display in wide-screen format on an SDTV directly from the camera.

CD Storage Recommendation

Since the segment length is limited to 5 minutes in the HD 1280 x 720 mode, the file size is not a big concern. It should fit on a standard recordable CD. If you want to use 640 x 424 mode to send files to friends on a CD, just remember to limit your video length to about 12 minutes, 10 to be absolutely safe. A full-length 20-minute segment at 640 x 424 will not fit on a CD. A 20-minute segment in 320 x 216 mode *will* fit on a CD.

Dealing with Sound on D-Movies

Sound recording on the D90 is accomplished with a little monaural (as opposed to stereo) microphone that is located just above the D90 logo on the front of the camera. It looks like a three tiny holes in a triangular shape (see *figure 3*).

Be careful about accidentally covering the pickup microphone with a finger or you will have very muted sound. Also, be careful about letting wind blow directly

Figure 3 – Sound recording microphone

Figure 4 – Small speaker on camera handgrip

on the microphone when recording. The wind might cause a rushing sound that interferes with the sound you are trying to record.

The sound is output during playback through a small speaker on the bottom of the camera's handgrip near the back of the camera (see *figure 4*). You'll see seven small holes in a circle. This little speaker can output an amazing amount of volume.

In order to record sound in sync with your video, you'll need to make sure *Sound* is enabled on the D90, using the *Shooting Menu* screens in *figure 5* (User's Manual page 170):

You can select either *On* or *Off*. Here are the steps:

1. Press the *MENU* button and scroll to the *Shooting Menu* (small green camera).
2. Select *Movie settings*, and then scroll to the right.
3. Select *Sound*, and then scroll to the right.
4. Select either *On* or *Off*.
5. Press the *OK* button.

The D90 only shoots mono (monaural) sound, and there are no external connectors to record in stereo. This is a limitation of a primarily still camera that shoots video. There's not a lot to say about the sound except that it is reasonably good

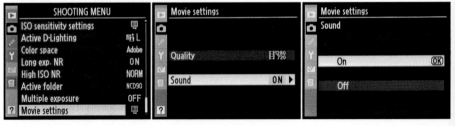

Figure 5 – D-Movie *Sound* setting

and does the job well enough. If you are a sound fanatic, why not carry a quality stereo digital sound recorder with you? Record the video with the mono sound turned on as a reference and then replace the mono with your stereo sound recording in a computer editing program.

Of course, if you are willing to go that far for quality, you probably have a high-end video camera with stereo sound already! The D90 is simply a still camera that also captures video with sound. Use it to the best of its abilities.

Recording a Video with Your D90

Now let's look at the process of recording a video. It is rather simple! There are approximately five steps.

To start recording a video, simply follow these steps:

1. Turn the camera on, and remove the lens cap.
2. Press the LV button on the D90's back (*figure 6, image 1*).
3. Prefocus the camera on your subject by pressing the shutter release button halfway down until the little green square stops flashing (*figure 6, image 2*).
4. Press the *OK* button to start the video recording (*figure 6, image 3*).
5. When you are finished, press the *OK* button again to stop recording.

Amazingly, that's all there is to it. You have a cool video camera built into your still camera. It is available with the press of two buttons: *LV* and *OK*.

The actual recording of video is an automated process. Your camera does not give you much control over exposure. In a sense, the video system is like the auto exposure mode. What you see is what you get. The camera decides how to deal with changes in exposure, motion, and so on.

In most cases, unless you really want to try to control the camera, just shoot your video and enjoy what you captured. The camera will make a good exposure in most all circumstances.

Dealing with Lack of Autofocus in D-Movie Mode

The autofocus (AF) system does not work once you press the *OK* button to start recording a video. You can consider this to be an aggravation or an asset, according to how you create video.

Primarily, be sure that you've prefocused on your subject before you start the video. If you zoom your lens or change to a closer or more distant subject, you'll probably need to refocus the lens.

For those of us who can remember a time before autofocus cameras, this is not a big deal. However, if you've always

Figure 6 – D-Movie external camera controls

used autofocus, it might be a good idea to use Live View mode and learn where the focus ring is on your favorite lenses. In LV mode, don't use the shutter button to autofocus, just do it yourself. It works just like taking a video.

Learn how it looks to see an out-of-focus (OOF) image. Learn how to bring the image into focus quickly—or slowly for special effects. Controlling the focus yourself may not be as convenient as using AF, but it gives you greater control over what you are videoing. When you combine manual focus with the information on aperture and depth of field control in the next section, you can create some cool cinematic effects, like deliberately starting the video on your subject with the lens completely out of focus and then turning the focus ring until your subject's face is in focus. It can be quite dramatic.

Or you can focus on one person in the foreground and then change the focus to another person in the background. Limited depth of field can be fun to experiment with and is not available in many standard video cameras. Some perceived limitations can be benefits, after all. When you find lemons, make lemonade!

Controlling the Aperture and Exposure During Video Capture

This section is for people who love to experiment with the edges of what their camera is capable of doing and try to wring out as much control as possible. If you are content to just take simple videos, you may not need to read this section. The camera is perfectly capable of controlling itself during D-Movie creation. However,

if you like manually controlling your camera in still image mode, you'll probably like this section.

You do have some control over the aperture, and the exposure too. It is not intuitive or well-documented, and it's a bit inflexible, but it is a bit of control over the important depth of field (DOF) and exposure. (For a review of depth of field, see chapter 4 "Aperture and Shutter Speed".)

I called Nikon technical support and discussed my experimental findings extensively with the technician, who then went to his "lab" with a D90 and validated many of my findings. (Nice guy!) He told me that Nikon does not usually give them (the techs) information on that level. So we are on our own.

Here is what I found through direct experimentation and partial validation by Nikon's technicians:

1. ***How does exposure control work?*** Once you have started taking a video, the aperture doesn't change. Nor have I seen any indication of a shutter speed change. The only way the shutter could change is by speeding up or slowing down how fast it captures a video frame (scan rate), and since that is locked at 24 frames per second, the shutter speed is inflexible. How does the camera control the exposure? It appears that the camera simply varies the sensitivity of the complementary metal-oxide semiconductor (CMOS) image sensor to match the current need for light. You can prove this to yourself by videoing in a darker area and noticing how grainy the video looks. It is

apparent that the ISO of the camera is being varied according to how much light the scene needs to expose correctly.

2. ***How can I override the camera's choice of exposure settings?*** You can control the exposure, overriding the camera, in two ways:

a. By holding down the exposure compensation button and turning the rear main command dial. The camera will then adjust the exposure using your new settings. It won't over- or underexpose the video when you add or subtract exposure compensation. It just adjusts the ISO from the new base level that you provided. You can force the camera to use a higher or lower ISO as a base by several stops (up to five). Turn the compensation to the overexposure side and the camera will lower the base ISO used and vice versa. By adding compensation to the plus side, you are forcing the D90 to let in more light by overexposing, so it must lower the ISO sensitivity to compensate, keeping the exposure correct.

b. By setting *Custom Setting f4 (Assign AE-L/AF-L button)* to *AE lock (hold)*. Then when you want to stop the camera from varying its exposure, you simply press and lock the exposure. When the AE-L/AF-L button is pressed, the camera locks the exposure until you press it again. It acts like a toggle, turning *AE lock* on and off with each press of the button. If you don't want to set *Custom Setting f4* to *AE lock (hold)*, you can leave it set to *AE lock*

only instead. Then you must hold the AE-L/AF-L button in to lock the exposure, and it unlocks as soon as you release the button. What this auto exposure lock does is force the camera to use whatever exposure level (or ISO) it initially selected and never vary from it. The exposure is locked. This is useful for when you are recording in a room with ambient light and also some bright windows here and there. If you don't lock the exposure, the D90 will see the bright window as you scan the room videoing and will adjust the exposure for the outside light instead of room light. Anyone sitting in front of or near the window will be underexposed. Locking the exposure allows you to record right on past a bright window without the camera making an exposure adjustment. You can then capture a good exposure of your subject sitting in front of the bright window.

3. ***How can I control depth of field?*** This is a very important section for those who really want to control DOF in their videos. The D90 *will* allow you to set the aperture anywhere between the maximum aperture your lens can use (wide open) and f/8. In other words, if your lens has an f/3.5 maximum aperture, you can set it between f/3.5 and f/8. (See chapter 4 to review DOF.) Here's how it works:

a. Set your camera's mode dial to A (aperture priority, see *figure 7*).
Once you have the camera set to aperture priority, you have some control. Whatever aperture you set the camera

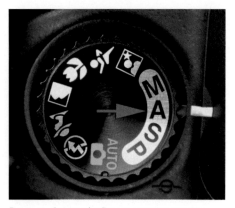

Figure 7 – Setting the D90 to aperture priority mode

to—between the maximum aperture and f/8—will be the aperture the camera uses for the entire video recording. Please understand the previous sentence. The aperture will not vary during the entire video clip, no matter how the light changes. The camera will keep right on using the ISO sensitivity of the sensor to control exposure, only it uses your chosen aperture the entire time. No matter how much you crank the main command dial 'round and 'round, it will not vary the aperture once the video has begun. I tested this over and over by starting my video in dark places and then walking out into the light. I even went so far as to start the video in a dark closet and then shine an intense flashlight beam into the lens. The aperture blades never moved—even when I tried to move them with the command dial! (Even in auto exposure mode, it starts with a wide open aperture and never moves it.)

b. The camera doesn't seem to allow you to set the aperture any smaller than f/8. I'm not entirely sure why Nikon limited this to f/8, but that's where my D90 stops. Maybe D-Movies need a minimum amount of light to determine proper exposure at the beginning of a video? Not sure! However, I am glad that Nikon gives us this much control, even though it doesn't document it anywhere that I can find.

c. What does this mean for you? Do you want to shoot a dreamy, shallow-focused video, carefully isolating your subject and blurring the background? Set your mode dial to A, use a lens with a big aperture like f/1.8 to f/3.5, and select the wide open aperture *before* you start the video. Your entire video clip will be shot at the selected wide aperture, and depth of field will be minimized. If you want some depth of field, such as for a beautiful scenic waterfall or landscape video, just select an initial aperture of f/8. That's where I shoot 90 percent of the time anyway when I'm shooting "still" landscapes. Now, when I'm shooting video, I can have the same deeper DOF benefits.

d. The fact that the D90 has a nice large CMOS sensor is a benefit to you compared to regular video cameras. The larger the sensor, the less the DOF. With this new knowledge, and your "fast" lenses, you can now control the DOF in your videos in a way that you can with few other video camera types.

You can also control certain aspects of the "look" of the video, by using the various *Shooting Menu* Picture Controls, but that's about it. We'll discuss Picture Controls in the next section.

Using Picture Controls and Scene Modes

Another form of control you have over the "look" of your D-Movies is using the Nikon Picture Controls included with your camera or even your own custom Picture Controls. I'm not going to go into a great deal of information here on using or modifying Picture Controls because this subject is covered thoroughly in chapter 6, "Shooting Menu."

However, once you've understood Picture Controls (and even modified a couple), you will realize that your videos will benefit from using different ones.

For instance, let's say you are shooting a video on an overcast, low-contrast day and you want to add some "snap" to your movie. You can simply select the *Vivid* Control, which will saturate the colors and darken the shadows.

Or, you might be shooting on a very high-contrast sunny day and want to tone down the contrast a bit. Simply select the *Neutral* control, which will open up the shadows and extend the dynamic range of the sensor for a lower-contrast look.

Maybe you are shooting a video of a lovely colorful autumn scenic and want to maximize the colorful look. Simply select the *Landscape* control and your video will be optimized for beautiful scenics.

Here's how to select and adjust Picture Controls (User's Manual pages 108–118).

At the bottom of the list in *figure 8*, middle image, you'll even see one of the custom Picture Controls that I created by modifying and saving the tonal curves of a Nikon Picture Control. It's called *STANDARD-03*, which is my unimaginative name for a modified *Standard* Nikon Picture Control.

Here is a list of the available Nikon Picture Controls:

- SD - Standard
- NL - Neutral
- VI - Vivid
- MC - Monochrome
- PT - Portrait
- LS - Landscape

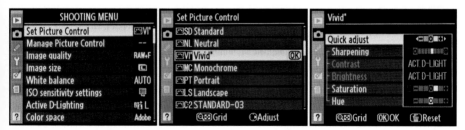

Figure 8 – Selecting a Picture Control

Here are the steps to select a Picture Control for your next video:

1. Press the *MENU* button and select the *Shooting Menu* (small green camera).
2. Scroll to and select *Set Picture Control*, and then scroll to the right.
3. Select one of the Nikon Picture Controls from the menu, I have selected *Vivid* in *figure 8*. Now scroll to the right.
4. If you want to modify the control to have different sharpening, contrast, brightness, saturation, or hue, then scroll to the right for the fine-tuning screen (see the image on the right in *figure 8*).
5. Press the *OK* button to make the selected control active. The two-letter abbreviation for the control will show on the *Shooting Menu*. (In the left image in *figure 8*, to the right of Set Picture Control you'll see *VI* for *Vivid*.)

See chapter 6 for more information on selecting, adjusting, and using Picture Controls.

Scene modes are not very useful in D-Movie mode, or at least they have undocumented effects. These are the creative photography modes on the mode dial, like Sports, Close up, and Portrait. See the section "Full Auto and Scene Modes" in chapter 2, "Exposure Metering System, Exposure Modes, and Histogram," for more information.

Even the Nikon technician I spoke with commented that he has no documentation as to what effect they each have on the D-Movie mode. When I am videoing, and turn the mode dial to a scene mode, I can see contrast changes in the video with scene modes like landscape. I assume that these modes use various Picture Controls, and I might be seeing them change the scene's contrast as I turn the mode dial.

Since Nikon has chosen to self-control the camera so deeply in D-Movie mode, I feel that the scene modes will probably have little effect. In still photography they modify things like the aperture, shutter speed, and frame rate to obtain certain effects. It is highly unlikely that any of the normal scene mode effects will be applied to the video capture other than Picture Control changes within a mode.

If you would like to experiment, you might discover some useful information.

Displaying D-Movies

Now the fun begins! The whole point of this chapter is to allow you to capture some great videos. After reading the previous information and learning about a few "gotchas" later in this chapter, you'll soon have quite a collection of video clips.

There are three ways to play back one of your cool D-Movies from the camera itself (User's Manual pages 146–147):

- By playing it back on the large LCD monitor on the camera's back
- By using the "included in the box" AV cable and connecting to a standard definition TV (SDTV)
- By using an HDMI cable that you've purchased to connect to a high-definition TV (HDTV)

Let's talk about each of these three display methods.

Displaying a D-Movie on the Camera LCD

The method to view a movie on the D90's LCD screen is simplicity itself, just like capturing a video. Here are the steps:

1. Press the *Playback* button to start displaying images on the LCD. (See reference #5 on page 5 in the User's Manual , to identify the Playback button. It's the same button you use to look at a series of your pictures.)

2. Locate the video you want to replay by scrolling through your images and videos with the multi selector thumb switch. (See reference #13 on page 5 in the User's Manual to identify the multi selector button.)

3. When the video shows on the D90's LCD screen, you'll be able to identify it by three things. On top of the screen you'll see a small D-Movie icon and a minutes and seconds counter, and at the bottom of the screen you'll see the words *OK Play*. The image you see is the first frame of the video (see *figure 9*).

4. Press the *OK* button, and the video will start playing.

The LCD screen on the D90 is big enough for a couple of people to enjoy one of your videos. Don't be afraid to show off a bit; your camera is Nikon's first DSLR to offer video capture.

Displaying a D-Movie on a Standard Definition TV (SDTV)

You can plug in the standard AV cable included in the box with your D90 and display videos directly on your SDTV. The AV cable looks like the one shown in *figure 10*.

This AV cable has a standard "mini stereo" black plug that you'll insert into your D90 and two RCA jacks, yellow and white. The yellow jack carries the video signal, and the white jack carries the mono sound. *Figure 11* shows the port on the side of your D90 where you'll insert the AV cable's black plug into the camera.

Figure 10 – AV cable for connecting to an SDTV

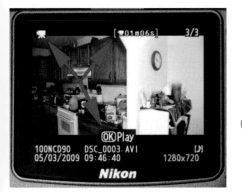

Figure 9 – Viewing a video on the camera screen

Here are the steps to display a video on your SDTV or another device, like a VCR:

1. Turn your camera off temporarily. I never like plugging things into live devices. It may not hurt it, but why take a chance?

2. Open the rubber flap on the left side of your D90, and insert the AV cable mini stereo plug into the AV OUT port (see *figure 11*).

3. Insert the RCA jacks into their respective ports on the display device. Be sure to match the colors. Yellow is video, white is sound. If your SDTV has no RCA jacks, you can often feed the signal through an attached VCR or DVD player.

4. Set your TV to channel 3, which seems to be the standard for displaying video. (If channel 3 doesn't work, try 4. Consult your TV's manual if those don't work. They should!)

5. Some TVs require you to press a button on the remote that puts it into "video" mode. This drove me crazy at first because I had everything hooked up and no video would show on my TV. I was about to give up and leave the room when my sweet wife found the TV/Video button on the remote. After pressing that, it worked fine. Thank goodness for wives!

6. Turn on the camera, press the *Playback* button, and then locate the video you want to show off.

7. Press the *OK* button to play the video on your TV. (Or record it on your VCR or DVD burner.)

I've found that any of the three available video quality modes will display just fine on my older SDTV. I was surprised when the 720p HD mode video played (1280 x 720). It used the wide-screen

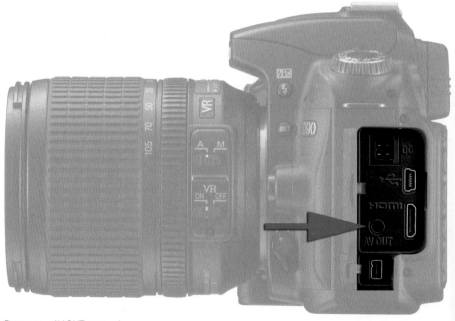

Figure 11 – AV OUT port

format with a black space at the top and bottom of the screen, often referred to by the term *letterboxed*. The 640 x 424 mode video filled the whole TV screen. The smaller 320 x 216 mode played in the center of the screen.

You'll enjoy playing video for your family and friends on their TVs. The screen is big enough to see things well, and the video quality is good too.

Displaying a D-Movie on a High-Definition TV (HDTV)

This mode works like the SDTV mode except that you will display your 720p HD videos in their native size and format full-screen on an HDTV. You'll need an HDMI cable with a mini HDMI (Type C) end to insert into your D90, and the other end will have to match your HDTV's HDMI port, which is usually HDMI standard (Type A). We'll talk more about the cable specs in a moment, but first let's discuss your camera's HDMI output frequencies.

Before you attempt to connect your Nikon D90 to your HDTV, be sure that you've correctly configured your HDMI output to match what your HDTV needs or you won't get a picture. Use the *Setup*

Menu's *HDMI* setting to select a specific output type, or just select *Auto* so that the camera and HDTV can figure it out for you. .

Select one of the following HDMI output formats in your D90 (User's Manual page 203):

1. *Auto* – Allows the camera to select the most appropriate format for displaying on the currently connected device
2. *480p (progressive)* – 640 x 480 progressive format
3. *576p (progressive)* – 720 x 576 progressive format
4. *720p (progressive)* – 1280 x 720 progressive format
5. *1080i (interlaced)* – 1920 x 1080 interlaced format

Here are the steps to choose a setting (see *figure 12*):

1. Press the *MENU* button and scroll to the *Setup Menu* (wrench icon).
2. Select *HDMI*, and then scroll to the right.
3. Select your choice of modes. (Not sure? Select *Auto*.)
4. Press the *OK* button.

Figure 12 – Setting up HDMI

Now your camera is ready to output video to a compatible HDTV. *Figure 13* shows what a compatible HDMI cable's ends look like. Unfortunately, you'll have to purchase an HDMI cable because one is *not* included in the box with your D90. The cable you'll need is an HDMI mini (Type C) to HDMI standard (Type A) cable. Adapter cables and plugs for HDMI

Figure 13 – HDMI standard and mini cable ends

are readily available at your local Radio Shack or online sources.

And, of course, you'll need to plug your HDMI cable into the correct port on the D90. *Figure 14* provides a look at the port you'll need to use with your HDMI mini (Type C) connector.

Here are the steps to display a video on your HDTV:

1. Turn your camera off temporarily. Why take a chance on blowing up your camera from a static spark?

2. Open the rubber flap on the left side of your D90, and insert the HDMI mini (Type C) cable end into the HDMI port (see *figure 14*).

3. Insert the HDMI standard (Type A) cable end into one of your HDTV's HDMI ports. (Both video and sound are carried on this one cable.)

Figure 14 – HDMI mini port on D90

4. Your HDTV *may* have multiple HDMI ports, and you may have other devices connected, like a cable box or satellite receiver. When you plug the D90's HDMI cable into your HDTV, be sure to select that input or you won't see the D90's video output. You may have to select the input from your remote or use another method. If in doubt, check your HDTV's manual. (If your TV has only one HDMI port, please ignore this step.)

5. Turn on the camera, press the *Playback* button, and then locate the video you want to show off.

6. Press the *OK* button to play the video on your HDTV.

The HDMI display will take the place of the small LCD video monitor on the back of your D90. The camera monitor will turn off as soon as you connect an HDMI device.

Recommendation:

Unless you are heavily into HDMI and understand the various formats, I would just leave the camera set to *Auto* because that allows the D90 to determine the proper format as soon as it's plugged into the display device and the HDMI input is selected (if the TV has multiple ports).

Limitations in D-Movie Mode Video Capture

Next, let's look at a few things that are limitations in the Nikon D90's implementation of video capture. No multiuse device can have all the features of a dedicated device, consequently, the D90 has some limits in how it captures video.

The D90 uses a CMOS sensor to record video. This type of sensor uses what is called a rolling shutter and has three potential issues that we need to discuss: skew, wobble, and partial exposure. We'll discuss each of these in some detail in the next section.

How the Rolling Shutter Works in D-Movie Mode

Since video is captured at 24 frames per second (fps), the D90 has an electronic shutter in addition to the normal mechanical shutter.

Have you ever used your D90 in continuous release mode where you are capturing up to 4.5 still images per second? The mechanical shutter activation combines with mirror movement to make this cool "chicka-chicka-chicka" machine-gun sound that causes passersby—with their little point-and-shoot cameras—to look at you in awe. However, you don't hear that sound when using the D-Movie mode, do you? That's because your D90 does not use the mechanical shutter when shooting movies. If it did. you would wear the camera's shutter out with only an hour or two of video capture. Remember, the camera captures video at 24 fps. An hour of video requires 86,400 frames at

that speed. You would quickly exceed the "tested" lifetime 100,000 image capacity of the mechanical shutter.

Instead, the camera uses its electronic shutter and turns the sensor's pixel rows on and off, as needed, in a scan from top to bottom. In other words, the camera records each video frame by scanning it—one line at a time—from top to bottom. Not all parts of the image are recorded at exactly the same time! This can produce a skewed and/or wobbly video with rapidly moving subjects like a race car or flying bird. This is called a *rolling shutter*.

Rolling shutters are used by video cameras that have CMOS sensors, like the Nikon D90. Most dedicated video cameras have charge coupled device (CCD) sensors, with global shutters that do not scan the image. They are mostly immune to the effects we are about to discuss.

Here is a list of the effects that can be experienced in extreme circumstances when a CMOS sensor's rolling shutter is used:

Skew – The image leans in one direction or another as the camera or subject moves. This is often seen in the edges of buildings and other static objects.

Wobble – This effect is harder to describe. The whole image wobbles in a strange way. It looks like the top of the image is out of sync with the middle and bottom of the image. Since video is a moving picture, the whole video can wobble back and forth in a very unnatural and dizzying way.

Partial exposure – If another camera's flash goes off in the shot, the burst of light may be present for only some of the rows of pixels in that frame of video. The top part of the frame may be brightly lit by the flash while the bottom part appears dark. The partial exposure appears as a bright band in one or a few frames, depending on how long the brighter light lasts. Some older forms of fluorescent light have slow ballasts and can cause the video to have a series of moving bands as the light flickers. Our eyes can't see it, but the fast video captures it well. If you are shooting images of an ambulance with its light flashing, it too can cause banding. Anything that has intense bursts of light for short periods may cause partially exposed bands to appear in the video.

To understand skew and wobble better, let's compare our camera to a copy machine or scanner. It works in a similar way. If you place a paper document on a scanner and press the scan button, you'll see the little row of light under the glass travel from the top to the bottom of the document as it records it one line at a time. At the end of the scan, you have a copy of the document in your computer's memory that can be saved to your computer's hard drive. You usually put the scanner's lid down on a paper document to hold it flat and keep it from moving.

Now, let me ask you to imagine something. What if you were scanning a paper document on your desktop scanner and

halfway through the scan you moved the paper a little? The top part of the scan would look normal because it had already been captured by the scanner's sensor, but the bottom part of the scan would be at a different angle than the top part, or you could say that it is "skewed" away from the original angle. This is an example of the skew issue I mentioned earlier.

Or, what if you grabbed the paper and rotated it back and forth all the way through the entire scan? The final scanned document would be a series of zigzags, with some parts at one angle and other parts at a different angle. The end result would not be very clear, would it? This is an example of the *wobble* issue mentioned earlier.

The D90 records video in a similar manner except much faster than a scanner. It records a frame of video in 1/24 of a second, or 24 fps. Since the Nikon D90 is scanning the image the lens sees at 24 fps, there isn't a problem in most cases. Most movement is too slow to be zigzagged (wobble) or off-angled (skew).

Skew and wobble becomes especially evident when a person is walking and videoing at the same time. The subject of the video is moving, and the person taking the video is moving too. These combined movements can be enough to cause the strange wobbly look to the video. I call this the jellywobble effect. Like a bowl of Jello, your video looks like it's wobbling. What can you do?

Avoiding the Jellywobble Effect

Primarily, you have to be careful not to allow too much camera movement. It truly is best to use the D90 on a good quality fluid-head video tripod if you want great results. I've found that Nikon's vibration reduction (VR) lenses help when you don't want to use a tripod because they stabilize the camera a little. VR won't help much if you're walking while videoing since the camera movements are often too great for the VR system to overcome. If you're standing quietly and doing your best to hold the camera perfectly still, it will help overcome small movements caused by your heartbeat and breathing.

This is one of the main differences between a dedicated video camera and a hybrid like the D90. Most dedicated video cameras use a CCD sensor instead of a CMOS sensor like the D90 has. A CCD sensor does not have a rolling shutter; it uses a global shutter instead. *Global shutter* simply means that a dedicated video camera is not scanning the image one line at a time. It's using the whole sensor at once to grab the image, not individual lines of the sensor. There are some newer low-cost video cameras on the market that use a rolling shutter, but the better video cameras use a global shutter.

This is probably the worst problem we'll discuss concerning D90 video. True videophiles will turn up their noses at a rolling shutter. They'll buy a dedicated video camera with three separate CCD sensors—one for each basic RGB color—and efficient global shutters for

no jellywobbles. And, they'll pay several thousand dollars for the privilege of owning that equipment.

You, however, realize that the D90 is primarily a very high-quality still camera with added video capabilities. Since video is combined with still image capability, you'll have both with you when carrying your camera. You may be standing in a superstore parking lot one day when an alien spacecraft just happens to land. If that happens, you can get both still images and cool video from the same camera (and a few jellywobbles in your video won't matter). One of the rules for getting great video is to have a video camera with you. With the D90, you have one at all times—with no extra effort. You do keep your camera with you, just in case, don't you?

Avoid Jellywobble Effects

Try to hold your camera still and any jellywobble effects will be greatly reduced. Use a tripod when you can, or even a VR lens. Anything that helps stabilize the camera will give you much higher-quality video.

My Conclusions

At the beginning of the chapter I asked a series of questions, and I will now answer them (my opinion, yours may vary).

Q. *How well does D-Movie mode work?*

A. It works quite well, is easy to use, and is always with you when you have your Nikon D90 in your bag.

Q. *What are the pros and cons of using the D90 compared to using a regular video camera?*

A. Pros:
- No need to carry another video camera and bag.
- Good image quality.
- Shallow depth of field for cinematic look.
- Huge variety of lenses available for various effects.
- Picture Controls allow an interesting "look" to the video.
- Video clips are immediately usable on your computer.
- People don't know you are videoing when using the D90.

Cons:
- CMOS rolling shutter can cause skew, wobble, and partial exposure.
- Lack of autofocus is difficult for some users.
- Lack of detailed control over the camera's functions.
- Short 5-minute video clips in HD mode.
- Limited storage on memory cards.
- Basic mono sound quality.

Q. *Can the D90's D-Movie mode replace a dedicated video camera?*

A. Yes and no. The fact that it's always with you means that you have it to take video when you otherwise wouldn't. On the other hand, a dedicated video camera will record for hours and hours without stopping. And, since a normal video camera usually has a CCD sensor with a global shutter, you have no rolling shutter effects. The true answer to this question will be based on your shooting needs.

FYI: Nikon has a site with various sample D-Movies. Check it out here:

**http://chsvimg.nikon.com/products/
 imaging/lineup/d90/en/d-movie/**

Video Editing Software

If you've already been shooting videos and editing them on your computer, you probably won't need much advice. However, if you're new to digital computer movie shooting and editing, you need to know that there are several great programs out there (including some free ones) that allow you to create cool movies with intros and effects.

Here is a list of excellent editing software that you can purchase. Most sell for less than $100:
- Adobe Premier Elements
- Corel VideoStudio
- Roxio Creator
- CyberLink PowerDirector
- Nero

Then, my favorites, a list of freeware or shareware video editing software that you can download online:
- Microsoft Windows Movie Maker (Easiest to get since it is built into Microsoft Windows XP, Service Pack 3, or available as a free download and is easy to use. Google "Download Windows Movie Maker.")
- Apple iMovie (Free if you buy a new Mac)
- Avid FreeDV (Available for both PC and Mac)
- Wax
- Zwei-Stein

Recommendation

If you are using a PC, try Windows Movie Maker. It's the one you've seen advertised on TV; in the ad, a 7-year-old is assembling movies and pictures into a presentation. If you use a Mac, buy a new one and get iMovie, or check to see if you already have it on your newer Mac. You can purchase it from Apple, if you don't. Both programs are easy to use.

I am well pleased with my D90's D-Movie mode. I have true "video on demand," and I use it often. Until I got the D90, I had little interest in video, but now I am really enjoying it. You can even sell video clips these days at many stock image sites on the Internet.

When I go up into the ancient Great Smoky Mountains, I now can take great still images as well as set my D90 up on a tripod by the many rivers and waterfalls in the Smokies and capture some great, relaxing home videos. Later, I can assemble both types of images into a longer presentation combined with music for my family and friends to enjoy. Having video in our DSLR cameras will revolutionize photography as we know it.

Go make some great videos!

Credits for Chapter Opening Images

Chapter 1
Edmund DePinter (PROWLER69)
Windmill
D90 and AF Zoom-NIKKOR 80-200mm
 f/2.8D ED
Edmund's Description: The Old Hook Mill
 was built in 1806 and is located in East
 Hampton, New York, USA.
1/60 sec – f/11 – ISO 200 – Lens at 18mm

Chapter 2
Kevin Todd (lovemyd90)
Fruit Bowl
D90 and AF-S VR Zoom-NIKKOR 70-300mm
 f/4.5-5.6G IF-ED
Kevin's Description: This shot was taken
 in my yard with the bowl positioned on a
 wooden border around my garden. I waited
 until the sun was as low as possible to get
 the desired lighting, using a crack in my
 fence to light the fruit. The sun was going
 down and kept moving off my subject. It
 took a couple of tries.
1/320 sec – f/5.6 – ISO 200 – Lens at 260mm

Chapter 3
Brenda Young (DigitalBrenda)
Horses in Cades Cove
D90 and AF-S DX Zoom-NIKKOR 18-70mm
 f/3.5-4.5G IF-ED
Brenda's Description: This shot was taken at
 Cades Cove in the Great Smoky Mountains
 National Park, Tennessee, USA.
1/1000 sec – f/4.5 – ISO 400 – Lens at 35mm

Chapter 4
Dwight Dover (bullet_trap9)
Grinder
D90 and AF-S DX NIKKOR 18-105mm
 f/3.5-5.6G ED VR
Dwight's Description: This is a self-portrait in
 my lawn mower and chainsaw repair shop
 in Canton, Georgia, USA. I am sharpening
 a mower blade. I set the camera on a tri-
 pod and my wife pushed the button on the
 Nikon ML-L3 wireless remote.
1/20 sec – f/4.8 – ISO 800 – Lens at 48mm

Chapter 5
Brian Kushner (bkushner)
American Goldfinch
D90 and Sigma APO 150-500mm
 F5-6.3 DG OS HSM
Brian's Description: This shot was taken
 in my backyard last winter. Hundreds of
 American Goldfinches were feeding on
 three different thistle seed feeders. These
 little birds are small and fast, but I got
 lucky with this shot.
1/800 sec – f/6.3 – ISO 200 – Lens at 500mm

Chapter 6
Christian Coombes (chiefmasterjedi)
Flower's Pond Sunrise
D90 and AF-S DX Zoom-NIKKOR 12-24mm
 f/4G IF-ED
Christian's Description: This shot was
 taken behind the Percy Flowers store on
 Hwy 42 and Buffalo road in Clayton, North
 Carolina, USA. The RAW image was post
 processed in PS4 to change the white
 balance and contrast, and other small
 tweaks were performed.
1/25 sec – f/5.6 – ISO 200 – Lens at 12mm –
 Handheld

Chapter 7
Dave Waycie (dwaycie)
Bubbling Glass
D90 and Sigma 70mm F2.8 EX DG MACRO
Dave's Description: This image was set up on
my dining room table. Shot with the Sigma
Macro lens and SB-600 Speedlight. The
on-camera flash set in Commander Mode
at -0.3EV. The SB-600 in remote mode was
on the left side and a bit to the rear of the
goblet—probably about 120 degrees off
the lens axis. Two layers of white silk were
draped over the SB-600 as a diffuser.
1/200 sec – f/11 – ISO 200

Chapter 8
Ron Markey (ronmarkey)
Snowboard Competition
D90 and AF-S DX VR Zoom-NIKKOR
55-200mm f/4-5.6G IF-ED
Ron's Description: This shot was taken at
the USASA Snowboard Nationals at
Copper Mountain, Colorado, USA. This is a
vertical crop of a horizontal original.
1/500 sec – f/13 – ISO 200 – Lens at 200mm

Chapter 9
Hector Molina (pafindr)
Violin
D90 and AF-S DX NIKKOR 18-105mm
f/3.5-5.6G ED VR
Hector's Description: This picture was
taken in a small home studio using a
black cotton backdrop.
1/3 sec – f/4.2 – ISO 540 – Lens at 34mm

Chapter 10
John Gamble (jgamble)
Bald Eagle
D90 and AF-S NIKKOR 300mm
f/4D IF-ED lens
John's Description: This adult eagle was
leaving a nest in downtown New Smyrna
Beach, Florida, USA. The nest is a block off
US Highway 1, behind a motel and within
view of a few local resturants.
1/1000 sec – f/8 – ISO 560 – Lens arrangment
included a TC-14EII

Chapter 11
Abraham Jacob (Elyone)
Daughter at 7-Months
D90 and AF Zoom-NIKKOR 80-200mm
f/2.8D ED
Abraham's description: Light coming from a
very large window behind the camera, and
an incandescent house light to the left
of the camera and just behind the baby
(no flash).
1/160 sec – f2.8 – 1000 ISO – Lens at 155mm
– Handheld

Chapter 12
Benjamin Ho (hobeno2)
Taiko Drummer
D90 and AF-S DX VR Zoom-NIKKOR
18-200mm f/3.5-5.6G IF-ED
Benjamin's Description: Little Tokyo
Cherry Blossom Festival near downtown
Los Angeles, California, USA. Handheld at a
shutter speed at 1/10 of a second,
this provides a good testimonial to the
vibration reduction (VR) capabilities of
the lens. White Balance set to Sunny.
1/10 sec – f/25 – ISO 200 – Lens at 150mm

Nikonians Gold Membership

Nikonians® – Worldwide home for Nikon users
nikonians.org

With over 190,000 members from over 160 nations, Nikonians.org is the largest Internet community for Nikon photographers worldwide.

Index